ITALIAN AND SPAN
1600-1750

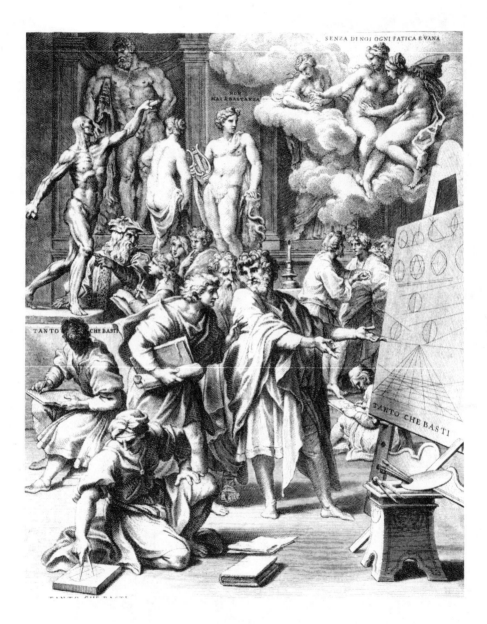

An Academy of Painting, conceived in allegorical terms, as engraved by Nicolas Dorigny after a drawing by Carlo Maratti. The symbolism is discussed in Bellori's Life of Maratti.

Italian and Spanish Art

1600–1750

SOURCES AND DOCUMENTS

Robert Enggass

Jonathan Brown

NORTHWESTERN UNIVERSITY PRESS
Evanston, Illinois

Northwestern University Press
Evanston, Illinois 60201-2807

First published 1970 under the title *Italy and Spain 1600-1750* by
Prentice-Hall, Inc. Copyright © 1970 by Prentice-Hall, Inc. North-
western University Press edition published 1992 by arrangement with the
authors. All rights reserved.

Printed in the United States of America

ISBN: 0-8101-1065-2

Library of Congress Cataloging-in-Publication Data

Enggass, Robert, 1921–
 Italian and Spanish art, 1600–1750 : sources and documents /
 Robert Enggass, Jonathan Brown.
 p. cm.
 Originally published: Italy and Spain, 1600–1750. Englewood
 Cliffs, N.J. : Prentice-Hall, 1970. (Sources and documents in the
 history of art series).
 Includes bibliographical references and index.
 ISBN 0-8101-1065-2
 1. Art, Italian. 2. Art, Modern—17th–18th centuries—Italy.
 3. Art, Spanish. 4. Art, Modern—17th–18th centuries—Spain.
 I. Brown, Jonathan, 1939– . II. Enggass, Robert, 1921– Italy
 and Spain, 1600–1750. III. Title.
 N6916.E5 1992
 709'.45'09032—dc20 92-27108
 CIP

The paper used in this publication meets the minimum requirements of
the American National Standard for Information Sciences—Permanence
of Paper for Printed Library Materials, ANSI Z39.48-1984.

Preface

Apart from the very short passage from Chantelou's diary (which is taken from the French) the source materials that follow in Chapter 1, Italy, were all written in Italian. I am most grateful to Harper and Row and to the University of South Carolina Press for permission to use their translation of Bellori's *Idea;* and to the Princeton University Press for having given me permission to use their translations of the materials on Caravaggio. (However, the translations into rhymed verse, in these passages as well as elsewhere in the Italian section of this book, are my own.)

All the other translations were made by me specifically for this book. In so doing, I leaned heavily on the advice and assistance of my wife, Catherine Enggass, whose experience as a professional translator far exceeds my own.

In making these translations my first aim was clarity. I have not hesitated to use a free rather than a literal translation where the literal translation seemed to me unclear. At the same time I have tried to carry over into English something of the bombast and the decorative flourishes that are part of the ornament of an ornamental age. I have also thought it best to avoid altogether the use of ellipsis marks, because when these are frequent (as they would have to be in a work of this sort) they break up the natural flow of sentences and make the text hard to read.

Of the various secondary sources I consulted, by far the most fundamental was Julius Schlosser Magnino, *La letteratura artistica,* 3rd ed., enlarged by Otto Kurz (Florence and Vienna, 1964). Special mention should also be made of Rudolf Wittkower, *Art and Architecture in Italy: 1600-1750,* 2nd ed. (Harmondsworth, 1965); R. and M. Wittkower, *Born under Saturn* (New York, 1963); and Francis Haskell, *Patrons and Painters* (London, 1963).

I would like also to thank for their help and good counsel Don Cipriano Cipriani, O.S.B., Archivist of St. Peter's Basilica; Fr. Umberto Damiano, S.J., of the Church of the Gesù; Dr. Hellmut Hager, Adjunct Professor, Pennsylvania State University; Dr. Italo Faldi, Director of the National Gallery in Rome; Dr. Rudolf Preimisberger of the Biblioteca Hertziana; Dr. Luigi Salerno, Director of the Calcografia Nazionale,

Rome; Dr. Eric Schleier, of the Biblioteca Hertziana; and above all Dr. H. W. Janson, Professor of the Institute of Fine Arts, New York University, and the editor of this series.

ROBERT ENGGASS

All the translations in Chapter 2, Spain, were made expressly for this book. As a rule, I have aimed at fluent expression rather than literal accuracy. Most of these texts were written by men for whom writing was an avocation, and their problems with Spanish prose not only tax the reader's understanding, but often mislead him. They often misled me, for that matter, and had not Raymond S. Willis, Professor of Spanish, Princeton University, put his profound knowledge of Spanish and his fine sense of prose style at my disposal, I would have gone down many a linguistic dead end. I also have James Anderson, Professor of Spanish, University of Texas, to thank for his assistance with parts of the translation. And T. Leslie Shear, Jr., Professor of Art and Archaeology, Princeton University, helped with the Latin passages.

I was fortunate enough to be able to draw on the experience of Harold E. Wethey, Professor of Art History, University of Michigan, and Marilyn Stokstad, Professor of Art History, University of Kansas, for the crucial matter of selection of texts. My wife, Sandra, by reading the text on several occasions, saved me from obvious errors that I never would have seen.

<div align="right">JONATHAN BROWN</div>

Contents

I

Italy

INTRODUCTORY NOTE

The Italian section of this book is divided into treatises on art and lives of the artists. Among the vast variety of source materials and documents available to the student of Italian Baroque painting and sculpture, it is these categories that most frequently provide us with the broad view.

Within these divisions the arrangement is chronological, except that we begin with Bellori's Idea, *which was written in 1664, about halfway through the period this book covers. We begin with the* Idea *because it is the classic statement of the artistic theory of classicism. And the theory of classicism is, in turn, the dominant artistic theory of the age. There is some artistic theory that anticipates the* Idea *(the best example is that of Agucchi) and a very great deal that follows, but Bellori's statement of the theory is the clearest and by far the most influential.*

Surely the most significant aspect of artistic theory in Italy in the Baroque age is that the age produced no theory of the Baroque. There is no systematic body of theory that examines or attempts to explain the revolutionary new stylistic developments that today we call Baroque, developments, for example, in the mature style of Bernini or Cortona or Baciccio.

Not all the art was at odds with the theory, but a lot of what was was much admired by contemporary patrons and connoisseurs. In such cases it was possible to pretend that the new art really fitted, or almost fitted, the theory after all. Or one could ignore the theory altogether. A third course, much rarer and more difficult, was to recognize that the new was indeed new and to praise it for its innovations. Even more, when it became apparent that the art could not be made to correspond to the theory, a few bold heretics might even question the theory.

This third approach, though never systematically developed, though always fragmentary and incomplete, offers our best insight into the awareness that the age had of the Baroque as a stylistic concept. For this reason I have searched hard for fragments of this sort, and have given them an importance far beyond what they would earn on the basis of frequency of occurrence or quantity. I include Marino above all for his emphasis on fantasy and the free play of the imagination; Scannelli because championing of the School of Bologna leads him to question the hegemony of Raphael; Boschini because his enthusiasm for and understanding of Venetian paintings brings him to celebrate those forms that today we call painterly and identify especially (though not exclusively) with the Baroque.

Giustiniani and Galileo are of interest for the suggestion (it should

be read as no more than that) that at the beginning of the century the dichotomy was between mannerism and antimannerism, not between classicism and anticlassicism. Baldinucci's Veglia *is valuable as an indication of what enormous strides had already been made (not in Germany but in Italy, quite contrary to what is widely believed) toward the development of a methodological framework for the historiography of art. The last entry under Treatises is really not a treatise at all but a series of arguments and counterarguments all focused on a single proposal: to move a statue from a rather out-of-the-way spot to a prominent position in Bernini's most famous church. As the dispute develops, the opposing parties weave elaborate aesthetic and religious arguments that are marvels of sophistication and sophistry.*

In the section on the Lives, my first concern was to provide a balanced selection. Most of the artists included worked chiefly in Rome (I have tried to suggest the variety of stylistic currents in that city) but there are representatives of Naples, Bologna, and the north Italian mainland. Even so, everyone is likely to find one or more of his favorites missing. Whether it would have been better to drop Lanfranco and include Domenichino, or to eliminate Giordano but add Solimena, is in the end a personal decision. My own chief regret is that it was not possible to include any of the great Venetians of the eighteenth century. For Canaletto, Guardi, and Tiepolo the contemporary sources provide only scraps and shreds—no individual biography worthy of the name exists.

Even among the artists with extensive early biographies those discussed amply are not always discussed well. I have included more on Salvator Rosa than on Pietro da Cortona, not because I consider Rosa the better artist—quite to the contrary—but because Rosa's flamboyant personality provides the natural materials of biography (he also wrote brilliantly about himself), whereas the sources on Cortona, though adequate, are less rich by far.

The Lives provide us with views of the artist as his own age saw him—views that for the most part are available in no other way. Reni's extreme continence and his compulsive dread of women was thought even in his own day to somehow account for the "purity" of his Madonnas. The complaints of Guercino's clients that shadows consumed substantial parts of the figures in his paintings and that much of the detail was lost brought heavy pressure on him to make his style less Baroque and more classical. Magnasco, on the other hand, working a century later in a very different era (but long before the advent of impressionism) was to receive special praise for his disembodied figures and landscapes that dissolved in a welter of brushstrokes. Insights such as this and many others like them are the reason for this book.

TREATISES ON ART

Bellori

"Bellori," wrote Julius Schlosser, "is without doubt the most significant phenomenon in the artistic historiography of the seventeenth century." [1] *In terms of artistic theory he was a classicist, as were almost all of his contemporaries. His essay "The Idea of the Painter, Sculptor and Architect" is the most authoritative statement of classical artistic theory that the seventeenth century produced. Bellori's concepts were not especially original, but they were thought of as definitive. They can thus serve as a model against which various changes in the concepts— anticipations, modifications, or even attacks—can best be understood.*

Giovanni Pietro Bellori was born in Rome in 1613, the son of a poor farmer, but was brought up in the household of Francesco Angeloni, a well-to-do writer, collector, and antiquarian. What we know of his life is based chiefly on studies made by Kenneth Donahue. [2] *It was Angeloni who established the intellectual climate in which Bellori's interests developed. Angeloni assembled, probably with Bellori's help, what was then one of the finest private collections of classical antiquities, important enough to be noted in contemporary guidebooks. In the field of modern art his preference was for the classicists, above all Annibale Carracci and Domenichino. At Angeloni's house Bellori could have met most of the prominent amateur archaeologists, art scholars, and connoisseurs of early seventeenth century Rome, among them Giovanni Battista Agucchi, Cassiano dal Pozzo, Vincenzo Giustiniani, and Cardinal Maffeo Barberini.*

Bellori seems to have studied briefly as a painter under Domenichino, but his chief interests were literary. His long poem On Painting, *which appeared in 1642 as an introduction to Giovanni Battista Baglione's* Lives of the Artists, *shows his tastes still relatively indiscriminate and his artistic theory not yet formulated. His* Notes on Museums, *a guide to the art treasures of Rome, which appeared in 1664, contains an addendum on the remains of ancient Roman painting that is said to be the first essay ever written on this subject. Both before and after this date he worked on his* Lives of the Modern Artists, *which was published in 1672.*

[1] Julius Schlosser, *La Letteratura artistica*, 2nd ed. (Vienna, 1956), p. 511.

[2] Kenneth Donahue, *Marsyas*, III (1943-1945), 107-38; but especially in the *Dizionario biografico delgi italiani*, VII (1965), 781-89.

From this are taken the extracts from the lives of Annibale Carracci, Caravaggio, Lanfranco, and Algardi that appear in translation in this book. Toward the end of Bellori's life his interest centered on archaeology. He wrote essays on the arches of Titus and Constantine and the columns of Trajan and Marcus Aurelius, surveys of ancient Roman painting, and the like. The year of Bellori's death, 1696, saw publication of his elaborate description of Raphael's frescoes in the Vatican.

When Angeloni died in 1652 his collection was dispersed, but the collection Bellori built for himself reflects much the same interests. It too contained ancient coins, gems, medals, and bits of sculpture. It also included paintings by Titian, Tintoretto, Van Dyck, Annibale Carracci, and Maratti. During the latter part of his life Bellori worked in Rome for that most famous of Catholic converts, Queen Christina of Sweden. He served first as a connoisseur, helping her to assemble her collection of drawings and medals, then later as her librarian. In May of 1670 Pope Clement X named Bellori Commissioner of Antiquities of Rome. This position of high distinction he held for almost a quarter of a century, until his declining health forced him to resign. He died in 1696.

Bellori was undisguisedly pro-French. This bias was in part a reflection of the long shadow that the image of the Sun King then cast over Europe. But probably even more it grew out of the interest he shared with so many French artists then in Rome in the ideals of classicism. In his later years Bellori was a close friend and constant companion of Nicolas Poussin, that most erudite of painters, whose work was later to provide a paradigm for so much of the classical theory that was broadcast by the French Academy. Bellori must have discussed with Poussin the artists he was to write about in his Lives, *and Poussin's concepts are thought to have contributed to the formulation of Bellori's artistic theories. Bellori was also close to Charles Errard, director of the French Academy in Rome, who helped him publish his* Lives. *He dedicated the book to Jean-Baptiste Colbert, patron of archaeology, founder of the French Academy, chief minister of Louis XIV. In 1689 the French reciprocated by making Bellori an honorary member of the* Académie Royale du Peinture et Sculpture *in Paris.*

Bellori's artistic theories are set forth in the following essay, which he read to the artistis of the Academy of St. Luke in 1664 and published, as the preface to his Lives, *ten years later.*[3] *As Panofsky has pointed out, the introductory section of Bellori's essay is little more than a reiteration of basic neoplatonic concepts developed in the Renaissance and modified during the age of mannerism.*[4]

[3] Giovanni Pietro Bellori, *Le Vite de' pittori, scultori ed architetti moderni* (Rome, 1672), pp. 3-13.

[4] Erwin Panofsky, *Idea, a Concept in Art Theory*, trans. Joseph J. S. Peake (Columbia, S.C.: University of South Carolina Press, 1968), pp. 105-6.

Even half a century after Galileo's telescope had confirmed the discoveries of Copernicus, Bellori, like most of his contemporaries, begins with the premise (implicit but unstated) of a Ptolemaic universe composed of concentric spheres with the earth as its center. The prototype or Idea for each thing in this universe is brought into being by God ("the highest and eternal intellect"). These Ideas then find reflection, with pure and undiminished beauty, in the heavens, or in other words, in all spheres beyond the earth, from the moon outward. The components of these celestial spheres remain immutable and eternal. Only the sublunar zone, that is, the earth, is subject to the laws of time and change and decay. Thus the divine Ideas that are reflected with such perfection and beauty in the celestial zones find in terrestrial objects only an imperfect and corrupt reflection. The artist must thus form in his own mind "an example of superior beauty," that is, an image of the uncorrupted celestial form, and then use this mental image to refine and make more beautiful the images of earthy objects. In other words, through his concept of divine beauty the artist is to emend and improve on what he finds in nature.

In sharp contrast to the teachings of mannerist theorists such as Lomazzo,[5] Bellori's Idea does not have a metaphysical origin nor does it enter the mind mystically. Rather it originates from the artist's own sensory perception. As Bellori indicates in the title of his essay, it is the task of the artist to select the most beautiful parts of individual objects and to combine these parts so as to form an object more perfect and thus more beautiful than anything found in nature. He illustrates this principle with the story, found in both Cicero and Pliny and endlessly repeated from the Renaissance onward, of how the Greek painter Zeuxis, in order to depict the legendary beauty of Helen of Troy, chose the five most beautiful maidens of the city of Croton and then copied the most beautiful parts of each. By such a process of selection the artist can create an image of a human being more beautiful than anything in nature, which by definition is imperfect. Bellori even goes so far as to claim that the Trojan War was waged not for the real Helen, whose beauty was found defective, but rather that Greeks and Trojans fought ten years over a statue of Helen that was taken to Troy in her place! Bellori adds that since the ancients had already come closest to perfection in selecting and synthesizing that which is most beautiful in the human form, it was also possible for an artist to grasp the Idea by studying the sculpture of classical antiquity.

What Bellori prized in art was an idealization of the real, as found in Raphael or in the seventeenth century, in the classically oriented work of Annibale Carracci, Guido Reni, Domenichino, or Carlo Maratti. All

[5] Giovanni Paolo Lomazzo, *Idea del Tempio della Pittura* (Milan, 1590).

other artistic currents met with his disapproval. In Bellori's view Cara-
vaggio was a realist who erred in copying directly from nature, without
selectivity. Bamboccio (the Dutch artist, Pieter van Laer, who was active
in Rome in the years 1625-1639) was still worse in that he not only copied
nature, but instead of copying the best that nature had to offer, delib-
erately reproduced the most imperfect figures in genre scenes of low life.
Bellori condemns equally those who work di maniera, *"from the style*
of others," so that they "create spectres instead of shapes," or who develop
out of their own minds, without reference either to nature or convention,
forms that are fantastic and bizarre. It is generally assumed that here
Bellori refers only to the Mannerists. Such passages, considering that they
are written well after the middle of the seventeenth century, must also
refer to the high Baroque art of such men as Bernini, Cortona, and
Borromini, all of whom Bellori banishes from his Lives of the Modern
Artists.

From *L'Idea del pittore, dello scultore, e dell'architetto*

The highest and eternal intellect, author of nature, in fashioning
his marvelous works looked deeply into himself and constituted the first
forms, called Ideas, in such a way that each species was expressed by
that original Idea, giving form to the marvelous context of things cre-
ated.[1] But the celestial bodies above the moon, not subject to change,
remained forever beautiful and well-ordered, so that we come to know
them from their measured spheres and from the splendor of their aspects
as being eternally most just and most beautiful. Sublunar bodies on the
contrary are subject to change and deformity; and although nature al-
ways intends to produce excellent effects, nevertheless, because of the
inequality of matter the forms change, and human beauty is especially
disarranged, as we see from the infinite deformities and disproportions
that are in us. For this reason the noble Painters and Sculptors, imitating
that first maker, also form in their minds an example of superior beauty,
and in beholding it they emend nature with faultless color or line. This
Idea, or truly the Goddess of Painting and Sculpture, when the sacred
curtains of the lofty genius of a Daedalus or an Apelles are parted, is
revealed to us and enters the marble and the canvases. Born from nature,
it overcomes its origin and becomes the model of art; measured with
the compass of the intellect it becomes the measure of the hand; and
animated by fantasy it gives life to the image. Certainly, according to
the statements of the major philosophers, the exemplary motives reside

[1] This translation of Bellori's *Idea* is taken from the English edition of Erwin
Panofsky, *Idea, A Concept in Art Theory*, trans. by Joseph J. S. Peake (Columbia, S.C.:
University of South Carolina Press, 1968), pp. 155-75.

with assurance in the spirits of the artists forever most beautiful and most perfect. The Idea of the Painter and the Sculptor is that perfect and excellent example of the mind, to which imagined form, imitating, all things that come into sight assimilate themselves: such is Cicero's fiction in his book on the orator, dedicated to Brutus: "Ut igitur in formis et figuris est aliquid perfectum et excellens, cuius ad excogitatam speciem imitando referuntur ea que sub oculis ipsa cadunt, sic perfectae eloquentiae speciem animo videmus, effigiem auribus quaerimus." [2] Thus the Idea constitutes the perfection of natural beauty and unites the truth with the verisimilitude of what appears to the eye, always aspiring to the best and the most marvelous, thereby not emulating but making itself superior to nature, revealing to us its elegant and perfect works, which nature does not usually show us as perfect in every part. Proclos confirms this value in *Timaeus* when he says that if you take a man fashioned by nature and another formed by sculptural art, the natural one will be less excellent, because art fashions more accurately. But Zeuxis, who formed with a choice of five virgins the most famous image of Helen, given as an example by Cicero in the *Orator,* teaches both the Painter and the Sculptor to contemplate the Idea of the best natural forms in making a choice among various bodies, selecting the most elegant.

Hence I do not believe that he could find in one body alone all these perfections that he sought for in the extraordinary beauty of Helen, since nature makes no particular thing perfect in all its parts. "Neque enim putavit omnia, quae quaereret ad venustatem uno in corpore se reperire posse, ideo quod nihil simplici in genere omnibus ex partibus natura expoluit." [3] Thus Maximus Tyrius claims that the image of the Painters taken this way from different bodies produces a beauty such as may not be found in any natural body that approaches the beautiful statues. Parrhasius conceded the same to Socrates, that the Painter who has placed before him natural beauty in each of its forms must take from various bodies together what each has most perfect in its individual parts, since it is impossible to find a perfect being by itself. Thus nature is for this reason so inferior to art that the copyist artists and imitators of bodies in everything, without selectivity and the choice of an Idea, were criticized. Demetrius was told that he was too natural, Dionysius was blamed for having painted men resembling us and was commonly called *anthropographos,* that is, painter of men. Pausanias and Peiraikos were condemned even more for having imitated the worst and the most vile, just as in our time Michelangelo da Caravaggio was criticized for being too natural in painting likenesses, and Bamboccio was con-

2 Cicero, *De Oratore,* II, 7 ff.
3 Cicero, *De Inventione,* II, 1.

sidered worse than Michel Angelo da Caravaggio. Thus Lysippus re-
proached the vulgarity of the Sculptors who made men as they are found
in nature, and prided himself for forming them as they should be, fol-
lowing the advice given by Aristotle to Poets as well as Painters. This
shortcoming was not attributed to Phidias, on the other hand, who made
marvels of the forms of heroes and gods and imitated the Idea rather
than nature. Cicero asserts that Phidias, in shaping Jupiter and Minerva,
did not look at any object that he could have taken for a likeness, but
conceived a form full of beauty, in whose fixed image he guided his
mind and hand to achieve a likeness. "Nec vero ille artifex cum faceret
Iovis forman aut Minerve, contemplabatur aliquem, a quo similitudinem
duceret, sed ipsius in mente insidebat species pulchritudinis eximia
quaedam, quam intuens in eaque defixus ad illius similitudinem artem
et manum dirigebat." [4] Hence it appeared to Seneca, although he was a
Stoic and a severe judge of our arts, to be a great thing, and he marveled
at how this Sculptor, never having seen either Jupiter or Minerva, had
nevertheless conceived their divine forms in his mind. "Non vidit Phidias
Iovem, fecit tamen velut tonantem, nec stetit ante oculos eius Minerva,
dignus tamen illa arte animus et concepit Deos et exhibuit." [5] Apollonius
of Tyana teaches us the same thing, that fantasy makes the Painter wiser
than imitation, because the latter creates only those things that are seen,
while fantasy creates even those that are unseen. Now if we want to
confront the precepts of the sages of antiquity with the best methods of
our modern teachers, Leone Battista Alberti maintains that we love in
all things not only the likeness but mainly the beauty, and that we must
select the most praiseworthy parts from the most beautiful bodies. Thus
Leonardo da Vinci taught the painter to form this Idea, to consider
what he saw and to consult himself, choosing the most excellent parts of
everything. Raphael of Urbino, the great master among those who know,
wrote thus to Castiglione of his Galatea: "In order to paint a beauty
I would have to see several beauties, but since there is a scarcity of beau-
tiful women, I use a certain Idea that comes to my mind." Guido Reni,
who surpasses all the other artists of our century in creating beauty,
wrote to Monsignor Massani, housemaster for Urban VIII, when he sent
the painting of Saint Michael to Rome for the Church of the Capuchins:
"I would have liked to have had the brush of an angel, or forms from
Paradise, to fashion the Archangel and to see him in Heaven, but I could
not ascend that high, and I searched for him in vain on earth. So I
looked at the form whose Idea I myself established. An Idea of ugliness
may also be found, but that I leave to the devil to explain, because I

[4] Cicero, *De Oratore*, II, 9.
[5] Seneca the Elder, *Rhetores Controversiae*, X, 34.

flee from it even in thought, nor do I care to keep it in my mind." Thus Guido also boasted that he painted beauty, not as it appeared to his eyes, but as he saw it in the Idea; hence his beautiful abducted Helen was esteemed as an equal of that by Zeuxis. But Helen was not as beautiful as they pretended, for she was found to have defects and shortcomings, so that it is believed that she never did sail for Troy but that her statue was taken there in her stead, for whose beauty the Greeks and the Trojans made war for ten years. It is though therefore that Homer, in order to satisfy the Greeks and to make his subject of the Trojan War more celebrated, paid homage in his poem to a woman who was not divine, in the same way that he augmented the strength and intelligence of Achilles and Ulysses. Hence Helen with her natural beauty did not equal the forms of Zeuxis and Homer; nor was there ever a woman who had so much extraordinary beauty as the Venus of Cnidos or the Athenian Minerva, known as the beautiful form; nor did a man exist of the strength of the Farnese Hercules by Glycon, nor any woman who equaled in beauty the Medicean Venus of Cleomenes. For this reason the best Poets and Orators, when they wanted to celebrate some sublime beauty, turned to a comparison of statues and paintings. Ovid, describing Cyllarus, the most beautiful Centaur, praises him as most like the most famous statues:

> Gratus in ore vigor, cervix, humerique, Manusque
> Pectoraque Artificum laudatis proxima signis.[6]

And elsewhere he wrote in high praise of Venus that if Apelles had not painted her, she would have remained until now submerged in the sea where she was born:

> Si Venerem Cois numquam pinxisset Apelles
> Mersa sub aequoreis illa lateret aquis.[7]

Philostratus upholds the beauty of Euphorbus as similar to statues of Apollo and he claims that Achilles surpassed the beauty of Neoptolemus, his son, as beauties are surpassed by statues. Ariosto, in creating the beauty of Angelica tied to the rock, likens her to something moulded by the hands of an artist:

> That she was feigned, a thing of alabaster
> Or finest marble, so Ruggiero thought,
> And that thus to the rock in this way bound,
> Through artifice a clever sculptor wrought.

In these versus Ariosto imitated Ovid, describing the same Andromeda:

6 Ovid, *Metamorphoses,* XIII, 397.
7 Ovid, *Ars Amatoria,* III, 401.

Quam simul ad duras religatam bracchia cautes
Vidit Abantiades, nisi quod levis aura capillos
Moverat, et tepido manabant lumina fletu,
Marmoreum ratusesset opus.[8]

Marino, in celebrating the Magdalena painted by Titian, hails the work
in the same way and places the Idea of the artist above natural things:

To what the learned artist feigned
Nature does yield, the Real gives way,
So fine, so live is that which from
His thoughts and soul he did portray.

It appears that Aristotle, on Tragedy, was unjustly criticized by Castel-
vetro, who maintains that the virtue of painting is not in creating a
beautiful and perfect image, but in resembling the natural, either beau-
tiful or deformed, for an excess of beauty lessens the likeness. This argu-
ment of Castelvetro is limited to icastic painters and portraitists who
keep to no Idea and are subject to the ugliness of the face and body,
unable to add beauty or correct natural deformities without violating
the likeness. Otherwise the painting would be more beautiful and less
accurate. The Philosopher does not mean such icastic imitation, but he
teaches the tragedian the methods of the best, using the example of good
Painters and Makers of perfect images, who rely on the Idea. These are
his words: "Since tragedy is the imitation of the best, we should imitate
the good painters, because, in expressing the form proper to their sub-
jects, they create them more beautifully, ἀποδιδόντες τὴν οἰκείαν μορ-
θήν, ὁμοίους ποιοῦντες, καλλίους γρά θουπιν.[9]

However, making men more beautiful than they ordinarily are and
choosing the perfect conforms with the Idea. The Idea is not one beauty;
its forms are various—strong, noble, joyful, delicate, of any age and both
sexes. We do not, however, praise with Paris on lovely Mount Ida only
soft Venus, or extol the tender Bacchus in the gardens of Nyssa, but
we also admire in the wearying games of Maenalos and Delos, the quiver-
bearing Apollo and Diana the huntress. The beauty of Jupiter in Olympia
and of Juno in Samos, as well as of Hercules in Lindos and Cupid in
Thespiae, was certainly different again. Thus different forms conform
with different people, as beauty is nothing else but what makes things
as they are in their proper and perfect nature, which the best Painters
choose, contemplating the form of each. In addition to which we must
consider that Painting being at the same time the representation of
human action, the Painter must keep in mind the types of effects which
correspond to these actions, in the same way that the Poet conserves the
Idea of the angry, the timid, the sad, the happy, as well as of the laugh-

[8] Ovid, *Metamorphoses*, IV, 671.
[9] Aristotle, *Poetics*, XV, 11.

ing and crying, the fearful and the bold. These emotions must remain more firmly fixed in the Artist's mind through a continual contemplation of nature, since it would be impossible for him to draw them by hand from nature without first having formed them in his imagination; and for this the greatest care is necessary, since the emotions are only seen fleetingly in a sudden passing moment. So that when the Painter or Sculptor undertakes to reproduce feelings, he cannot find them in the model before him, whose spirit as well as limbs languish in the pose in which he is kept immobilized by another's will. It is therefore necessary to form an image of nature, observing human emotions and accompanying the movements of the body with moods, in such a way that each depends mutually upon the others. Moreover, in order not to exclude Architecture, it too uses its own most perfect Idea: Philo says that God, as a good Architect, looking at the Idea and at the example he had conceived himself, made the visible, from the ideal and intelligible world. So that since Architecture depends upon the example of reason, it also elevates itself above nature. Thus Ovid, describing Diana's cave, envisages that nature, in creating it, took its example from art:

Arte laboratum nulla, simulaverat artem
Ingenio Natura suo; [10]

Torquato Tasso perhaps recalled this in describing the garden of Armida:

Nature appears like art, that for delight
Jestingly imitates her imitator.[11]

Moreover, it is such an excellent edifice that Aristotle argues: if construction were a natural thing, no different from Architecture, it would be executed by nature, which would be compelled to use the same rules in order to give it perfection, just as the habitations of the gods themselves had been imagined by Poets with the diligence of Architects, arranged with arches and columns, as they described the Realm of the Sun and of Love, thereby raising Architecture to heaven. Hence this Idea and divinity of beauty was conceived in the minds of the ancient cultivators of wisdom, by observing always the most beautiful parts of natural things, because that other Idea, formed for the most part from experience, is ugly and base, according to Plato's concept that the Idea should be a perfect understanding of the thing, starting with nature. Quintillian teaches us that all things perfected by art and human ingenuity have their origin in the same nature, from which the true Idea springs. Hence those who without knowing the truth follow common

[10] Ovid, *Metamorphoses*, III, 158.
[11] Torquato Tasso, *Gerusalemme liberata*, XVI, 10.

practice in everything create spectres instead of shapes; nor are they dissimilar from those who borrow from the genius and copy the ideas of others, creating works that are not natural children but bastards of nature, so that it seems as though they are wedded to the paintbrushes of their masters. Added to this evil, arising from lack of genius or the inability to select the best parts, is the fact that they choose the defects of their teachers and form an idea of the worst. On the other hand, those who glory themselves with the name of Naturalists have no idea whatever in their minds; they copy the defects of the bodies and satisfy themselves with ugliness and errors, they, too, swearing by the model, as their teachers. If the model is taken from their sight, their whole art disappears with it. Plato likens these first Painters to the Sophists, who did not base themselves on truth but upon the false phantom of opinion; they resemble Leucippus and Democritus, who compose bodies of the vainest atoms at random. Thus the art of Painting is degraded by these Painters in concept and practice, since, as Critolaos argues, eloquence should be a manner of speaking and an art of pleasing, *tribe* (in Greek, *tribe* and *kakotechnia* or *atechnia*), a habit without skill and reason, taking function away from the mind and turning everything over to the senses. Hence what is supreme intelligence and the Idea of the best Painters, they would prefer to be common usage, equating ignorance with wisdom; but the highminded spirits, elevating thought to the Idea of the beautiful, are enraptured by the latter alone and consider it a divine thing. Yet the common people refer everything they see to the visual sense. They praise things painted naturally, being used to such things; appreciate beautiful colors, not beautiful forms, which they do not understand; tire of elegance and approve of novelty; disdain reason, follow opinion, and walk away from the truth in art, on which, as on its own base, the most noble monument of the Idea is built. It remains to be said that since the Sculptors of antiquity used the marvelous Idea, as we have indicated, a study of the most perfect antique Sculptures is therefore necessary to guide us to the emended beauties of nature and with the same purpose direct our eyes to contemplate the other outstanding masters. But we will leave this matter to its own proper treatise on imitation, in order to satisfy those who find fault with the study of the statues of antiquity. So far as Architecture is concerned, we say that the Architect must conceive a noble Idea and establish it in his mind, so that it can serve as law and reason for him, placing his inventions in the order, in the disposition and in the measure and just proportion of the whole and of its parts. But with regard to the decoration and ornamentation of the orders, he is certain to find the established and confirmed Idea in the examples of the Ancients, who established a successful method in this art after long study.

When the Greeks set the best limits and proportions for it, which have been confirmed by the most educated centuries and by the consensus of a succession of learned men, they became the laws for a marvelous Idea and an ultimate beauty. There being one beauty only for each species, it cannot be changed without being destroyed. Hence, unfortunately, those who change it with innovations deform it, since ugliness is close to beauty, just as vice touches on virtue. We recognize such an evil in the fall of the Roman Empire, along with which fell all the five arts, and Architecture most of all, because the barbarian builders, having contempt for the Greek and Roman models and Ideas as well as for the most beautiful monuments of antiquity, adopted indiscriminately so many different fantastic caprices for orders that they made it monstrous with the most unsightly confusion. Bramante, Raphael, Baldassare, Giulio Romano and most recently Michelangelo have worked tirelessly to restore antiquity to her original Idea and aspect from the heroic ruins, choosing the most elegant forms from the ancient structures. But today, instead of giving thanks to these most learned men, the latter are ungratefully vilified along with the Ancients, almost as though one had copied from the other without esteem for genius or originality. Moreover, everyone conceives in his mind a new Idea and appearance of Architecture in his own way, displaying it in the square and on façades—men certainly devoid of any science that pertains to the Architect, whose name they vainly bear. Not content with deforming buildings, cities and memories, they adopt crazy angles, broken spaces and distorted lines, and discompose bases, capitals and columns with yokes of stuccoes, fragments and disproportions; and yet Vitruvius condemns similar novelties and holds the best examples up to them. But the good Architects retain the most excellent forms of the orders. Painters and Sculptors, choosing the most elegant natural beauties, perfect the Idea, and their works exceed and remain superior to nature—which is the ultimate value of these arts, as we have shown. This is the origin of the veneration and awe of men with regard to statues and paintings, and hence of the rewards and honors of the Artists; this was the glory of Timanthes, Apelles, Phidias, Lysippus, and of so many others whose fame is renowned, all those who, elevated above human forms, achieved with their Ideas and works an admirable perfection. This Idea may then well be called the perfection of Nature, miracle of art, foresight of the intellect, example of the mind, light of the imagination, the rising sun, which from the east inspires the statue of Menon, and fire, which in life warms the monument of Prometheus. This is what induces Venus, the Graces and the Cupids to leave the gardens of Idalus and the shores of Cythera and dwell in the hardness of marble and in the emptiness of shadows. In its honor the Muses by the banks of Helicon tempered colors

to immortality; and for its glory Pallas scorned Babylonian cloth and vainly boasted of Daedalian linens. But as the Idea of eloquence yields to the Idea of painting, just as a scene is more efficacious than words, speech therefore fails me and I am silent.

Giustiniani

Vincenzo Giustiniani (1564-1637) was perhaps the most cultivated and sophisticated of the small group of wealthy connoisseurs who were patrons of contemporary art in Rome at the turn of the century.[1] The series of essays that he wrote on music, architecture, scupture, painting, the hunt, and travel suggests something of the range of his interests. His famous collection of ancient marbles was published in two volumes in 1631.[2] His collection of modern art was even larger. Sandrart tells us the Great Gallery of Palazzo Giustiniani contained 120 canvases. The inventory of paintings and tapestries that was compiled shortly after Vincenzo Giustiniani's death in 1637 lists no less than 581 items.

Giustiniani was an important early patron of Caravaggio. He owned a number of his canvases, and it was he who bought Caravaggio's first St. Matthew and the Angel *after it had been rejected as unsuitable for the altar of the Contarelli chapel of S. Luigi dei Francesi. But, as the following selection from his essay on painting shows,[3] he was equally enthusiastic about the works of Annibale Carracci. In fact he placed both artists (along with Guido Reni) in the highest category. He was very much aware of the gulf between these painters and the mannerists. But he saw the art of Caravaggio and the Carracci as essentially two sides of the same coin: both combined realism with formalism; the difference was merely one of emphasis. Only at a later date, when artistic theory hardened and art was interpreted so as to conform to it, did the two artists seem in conflict. And only then were Caravaggio's paintings viewed as examples of unmitigated realism, stripped of any degree of abstraction.*

From a letter written by Giustiniani to Amayden

I am able to confirm to you, Sir, that I have reports that the Fleming is a more than mediocre painter. In order that you may be able to better understand this reply I will set up certain categories, concerning the

[1] For more on his activities see Luigi Salerno, "The Picture Gallery of Vincenzo Giustiniani," *Burlington,* CII (1960); Francis Haskell, *Patrons and Painters* (London, 1963); Robert Enggass "L'Amore Giustiniani del Caravaggio," *Palatino,* XI (1967).

[2] *Galleria Giustiniani,* 1631.

[3] The essay, in the form of a letter from Giustiniani to his friend Amayden, appears in *Raccolta di lettere sulla pittura, scultura ed architettura,* ed. Giovanni Bottari, VI (Rome, 1768), 247-53.

methods of painting and the rankings of painters, based on a bit of experience I have had of this profession.

The first method is by pouncing,[1] which may be painted according to the inclination of the painter or the one commissioning the work.

The second method is to copy from other paintings, which can be done in many ways: either by simply looking at it briefly; or by longer observation; or with graticulations or tracing, which demands much care and experience in the handling of colors in order to imitate the originals well. The more excellent the painter is, provided he has patience, the better the copy will turn out to be, to the point that sometimes it will be indistinguishable from the original and sometimes it will even surpass it. On the other hand if the copier is inexpert and mean in spirit the difference between the original and the copy will easily be recognized.

The third way is to know how, by drawing with pencil, watercolor washes, umber or pen, to copy what the eye sees. This method is useful as training for those who dedicate themselves to painting, especially if they teach themselves by copying antique statues, or good modern ones, or paintings by worthy masters.

The fourth method is to know how to make good portraits of individuals, especially to fashion the heads so that they are good likenesses. The artist should also see to it that the rest of the portrait, that is to say, the garments, the hands and the feet and, if full length, the pose of the figure, are well painted with fine symmetry. This is something that ordinarily does not turn out well, unless it is done by someone who is a good painter.

The fifth method is to know how to portray flowers and other tiny objects. This requires two things above all. The first is that the painter know from long experience how to handle colors and the effect they make, in order to be able to draw with facility the many positions of small objects seen in different lights. It is very difficult for those who do not have a good command of this kind of painting to succeed in uniting these two circumstances and conditions. Great patience above all is needed. Caravaggio said that to make a fine painting of flowers was as much work for him as to make one of figures.

The sixth method is to know how to paint perspectives and architecture. This requires one to have some experience with architecture and to have read books that deal with it, such as books on perspective,

[1] Pouncing is a method of transferring a drawing from one surface to another, usually from paper to a prepared panel or a wall surface that is to be painted, by making perforations all along the lines of the drawing and dusting it with pounce, a fine powder or charcoal, which passes through the perforations and into the prepared surface.

in order to have an understanding of regular and visual angles, so as to see to it that everything is in harmony and is painted without blunders.

The seventh method is to be able to recapture some fine thing such as a façade, an ancient monument, or a near or distant landscape. There are two ways of doing this. One way is to depict minute objects without taking pains, but rather to suggest them by dabs and blobs, but with the fine skill of a man well grounded in painting, or to express each object boldly. This is the manner of landscapes by Titian, Raphael, the Carracci, and Guido Reni, and others. The other way is to paint landscapes with greater care, studying every detail of each object as did Civetta (Hendrick de Bles), Jan Breugel, Paul Brill, and others, who were for the most part Flemish. They have patience in painting natural objects, which they depict with great distinction.

The eighth method is painting grotesques. This method is very difficult since it is necessary that the painter examine many things, specifically that he study ancient paintings that are found below or above ground, from which that sort of painting derives. It is thus necessary to have an erudite knowledge of antiquity and to examine many and various things pertaining to history and mythology. One must also know the proper manner of painting, and such modern inventions as appeal to the taste of the person who orders work. It is difficult also because to paint these grotesques the painter must be many-sided, but with a natural inclination for this kind of work. Besides the other things already mentioned he must know how to draw well and to paint, especially in fresco, and he must have a high degree of creativity. He must also know how to handle and apply colors since he has to paint large and small human figures in accordance with what the design calls for, as well as animals, plants, flowers, and *quadri riportati* [frescoes that give the illusion of being easel paintings transferred to the ceiling] with histories. He must be able to paint medallions and perspectives, to simulate metals, to paint life size, and to know how to lay out the orders distinctly, either wide or narrow, according to what the site permits.

The ninth method is to paint like Polidoro da Caravaggio, and Antonio Tempesta, powerfully drawn scenes taken from life. Such scenes were in black and white, in copper engravings. In originality and good design, especially in the battles, hunts, and other scenes with people and animals in motion, they are generally very much esteemed, even though they did not attain that level in oil painting as their works bear witness.

The tenth method is what is called *di maniera*. In other words, the painter with long experience in drawing and painting from his imagination, without any model, creates in a painting what he has in

his imagination: heads, full-length figures, as well as complete historical scenes or any sort of thing with pleasing design and color.

In our times Baroccio, Romanelli, Passignano, and Giuseppe Cesari, Cavaliere d'Arpino, painted in this way. In d'Arpino's frescoes in the Campidoglio this method is especially prominent. Many other artists have made pleasing and praiseworthy oil paintings in this style.

The eleventh method is to paint directly from natural objects before one's eyes. Be warned however that it is not enough to make a mere reproduction. Rather it is necessary that the work be well designed, with fine well-proportioned contours. It must have pleasing and appropriate coloring, which comes from the experience of knowing how to handle colors and almost from instinct, and is a gift granted to few. Above all, one has to know how to give the right light to each part so that the grayed colors are not harsh but are done smoothly and harmoniously. However the dark areas and the lighted areas must be distinct so that the eye is satisfied by the blending of the lights and dark without alteration of the true color and without harming the spirit of the painting. Leaving the ancients aside, those who painted this way in our time are Rubens, Giuseppe the Spaniard [Giuseppe Ribera], Gherardo [Gerard van Honthorst], Enrico [Henrick Berckmans], Teodoro [Theodore Heemskerck], and others like them. Most of them were Flemish but were active in Rome and had a good sense of color.

The twelfth method is the most perfect of all since it is the rarest and most difficult. It is the union of the tenth with the eleventh method, that is to say, to paint *di maniera* and also directly from life. In our time, this is the way that Caravaggio, the Carracci, Guido Reni, and other world-famous painters of the highest rank painted. Some of them were inclined more toward nature than the *maniera* and some more toward the *maniera* than toward nature, without however abandoning either method, and emphasizing good design, true colors, and appropriate realistic lighting.

In these twelve methods of painting, the talents and abilities of the painters have varied. Some have painted better in fresco than in oil and others better in oil than in fresco. Some painted in oil without having painted in fresco, whereas others have painted in fresco but not in oil. We must not be prejudiced against those who failed to work in certain areas, although in others they were excellent, equalling the splendid painters of antiquity and surpassing those of their own day. Many things can be attributed to the various needs of great princes, or, on the other hand, the painter's own requirements, since sometimes a painter does excellent and most praiseworthy work and then never does anything like it again; as is the case with Zuccaro in the niche of the Annunziata del

Collegio. Some painters do well in large scale but not in small, and others do well in small scale but not in large, according to their natural inclinations. Others have done well in composition and in devising themes. Others excel at coloring exquisitely a few well-drawn figures seen in the foreground plane. Others do well in perspective drawing following the rules of architecture. Others excel in depicting narrative scenes, with both near and distant views, executed with good design, and with well-formed spatial planes in which figures and things are placed in relation to the horizon, the perspective lines, and the angle of vision. Thus each in his own area has achieved high esteem in the profession of painting.

I will not speak here of those who invented the art of painting, or of those who have added to it and improved it in its course throughout the various centuries. Nor will I discuss the various modes and manners, the various changes that painters have made to improve their work. Rather I make reference to the many books that deal with these things and to how much can be learned from those who are professional painters.

The profession of painting today is at the peak of esteem, not only for the usual things that come onto the Roman market, but also for what is sent forth to Spain, France, Flanders, England, and elsewhere. In truth it is marvelous to contemplate the great number of ordinary painters, and many persons who maintain large and populous studios, who also get ahead, solely on the basis of being able to paint in various ways and with inventiveness. And this is true not only in Rome and in Venice but in other parts of Italy. Also in Flanders and in France recently they have begun to adorn palaces with paintings as a variation from the sumptuous wall hangings that were used in the past, especially in Spain during the summer. This new usage provides very favorable opportunities for the sale of the painters' works, and this situation must continually improve in the future, if the Lord God through his kindness preserves the peace, as all of us must ceaselessly desire.

Galileo

Galileo Galilei (1564-1642), the great astronomer and physicist, took a lifelong interest in the arts.[1] From his father Vincenzo, who was a famous musician he gained a love of music and the ability to play the flute uncommonly well. He especially admired the poetry of Ariosto on which he wrote a lengthy commentary. He also wrote poetry himself. The letter below reveals his lively interest in painting and sculpture.[2]

[1] See Erwin Panofsky, *Galileo as a Critic of the Arts* (The Hague, 1954).
[2] From *Le Opere di Galileo*, ed. A. Favaro, p. 1890ff, as reprinted in Panofsky, *Galileo*, pp. 32-34.

Galileo wrote the letter to his close friend and fellow Florentine, Ludovico Cigoli. Cigoli (1559-1613) was a painter whose position in Florence was not unlike that of the Carracci in Bologna and Rome in that he wished to turn painting away from Mannerism and back to the simpler, more naturalistic forms of the High Renaissance. Cigoli had been trained in mathematics and perspective by the same teacher who had taught the young Galileo, and was not without some understanding of science. After he went to Rome, at Galileo's request, he made a series of observations of sunspots so as to demonstrate that the conclusions Galileo had published in his Siderius Nuncius *(Florence, 1610) were not the result of local atmospheric phenomena or of defects in an individual telescope. Cigoli was also the first painter whose art shows the influence of the new telescopic astronomy. In the Pauline Chapel of S. Maria Maggiore in Rome he painted the moon on which the Virgin stands not as it had been represented throughout history, as a smooth spherical surface (which is how the naked eye sees it), but instead with jagged contours filled with indentations or craters (as Galileo's telescope had shown it to be).*

Galileo's letter is in reply to Cigoli who had apparently sent him a set of written arguments affirming the superiority of sculpture over painting and had asked Galileo to supply him with appropriate answers. The debate as to which is the better of the sister arts, painting or sculpture, extends far back into antiquity, as Panofsky has pointed out.[3] The argument was revived enthusiastically in the Renaissance, especially by Leonardo da Vinci, but also by Michelangelo and others. By the second half of the sixteenth century it had become something of an intellectual game. The participants sought elaboration and elegance, but contributed nothing really new. On the other hand Galileo's essay, in the words of Panofsky, constitutes "the only original contribution to the subject since Leonardo da Vinci." [4] Especially novel in this context is Galileo's experiment to prove that the effect of mass in sculpture depends on light and shadow. He shows that if in dealing with a three-dimensional object such as a piece of sculpture, we painted the lighted surfaces dark and the dark surfaces light, then the object will lose its sense of three-dimensonality and seem flat. He is also novel in advancing the proposition that the more unlike the medium is from that which it is used to represent (the more difficulties it has to overcome), the more admirable is the representation. But Galileo ends with the caution that such arguments are a game that serves to delight the amateur but should be avoided by the professional.

[3] Panofsky, *Galileo*, p. 1.
[4] Panofsky, *Galileo*, p. 7.

From a letter written by Galileo to Cigoli

That sculpture is more admirable than painting for the reason that it contains relief and painting does not is completely false. For that very reason painting is more marvelous than sculpture, since the relief that is seen in sculpture does not look like sculpture but like painting. I shall explain this. By painting one means that faculty which imitates nature by means of light and shade. Now to the extent that works of sculpture have relief to that extent they are tinged in one section with light and in another section with shadow. And experience itself demonstrates to us that this is true, because if we expose a figure in relief to light and in that way color it by making the light part dark so that the color is completely unified, it will be totally stripped of relief. Rather, how much more admirable painting must be considered if, having no relief at all, it appears to have as much as sculpture! But why do I say as much as sculpture? It is a thousand times more admirable, considering that it is not impossible for it to portray on the same plane not only the relief of a figure that implies a depth of one or two cubits, but a distant landscape and the immense extent of the sea. As for those who respond that the deception would be demonstrated by touch, they speak like weak-minded persons, implying that sculptures and paintings were made to be touched no less than seen. Moreover, those who admire the use of relief in statues do so, I believe, because they think that by that method they may more easily deceive and appear realistic to us. Now take note of this argument. Painting, like sculpture, makes use of that type of relief which deceives the eye. Painting, in fact, does so more. Besides the light and shade, which produce, so to speak, the visible relief in sculpture, it possesses very realistic colors, which sculpture lacks. It remains then that sculpture excels painting in that kind of relief that is subjected to the sense of touch. But those who think that sculpture is able to deceive the sense of touch more than painting are simple minded. What we mean by "deceiving" is performing in such a way that the sense to be deceived judges the object not to be what it is but what it is meant to imitate! Now who would believe that anyone, touching a statue, believes it to be a live man? No one, certainly. That sculptor who, not knowing how to deceive the eye, wants to demonstrate his excellence by deceiving the sense of touch is certainly in a sorry plight, since he is not aware that not only the elevations and depressions (which constitute the relief of a statue) are subjected to the sense of touch, but also soft and hard, hot and cold, smoothness and roughness, heaviness and lightness, all indications of the statue's deceit.

The statue does not possess relief by being wide, long, and deep,

but by having light and dark areas. And note, for proof of this, that of the three dimensions only two are subject to the eye, that is to say, length and width (that is, the surface that the Greeks called *epifania,* the periphery or circumference). Of the objects that appear or are seen, one sees nothing but the surface. Depth cannot be perceived by the eye because our sight cannot penetrate opaque bodies. Therefore the eye sees only length and width, certainly not the depth, that is to say, not thickness. Thus since depth is not exposed to view, we will not be able to comprehend other than the length and width of a statue. From this it is clear that we see only the surface of it, which is nothing more than the width and length without depth. Therefore we recognize the depth not as an object of sight by itself, absolutely, but by chance, and in relation to light and shadow. And all this, light, shade, length, width, is in painting no less than in sculpture. In sculpture Nature herself bestows light and shade while art gives it to painting. Therefore for this reason also an excellent painting is more admirable than an excellent sculpture.

Turning now to what the sculptors say, that Nature creates men by sculpture and not by painting, I reply that she creates them painted no less than sculpted since she sculpts them and she colors them. However this is a flaw in their position. It very greatly diminishes the merit of sculpture because the more distant the means are from the objects to be imitated so much more marvelous is the imitation. In ancient times that type of actor who by movements and gestures alone could tell a whole history or fable was much more admired than those who gave expression to the tragedy or comedy with words. This is because the actors of the first type used such diverse means, and a method of representation so different from the actions represented. Will we not admire the musician, who by singing and representing the laments and the sufferings of a lover, moves us to compassion—will we not admire him much more than if he did so by weeping? This is because the song is a means not only diverse but contrary to the expression of sorrow, whereas tears and lamentations are very similar to it. We would admire him even more, if voicelessly, by means of an instrument alone, by harsh and dramatic musical accents he accomplished the same thing, since the inanimate strings are less suited to awakening the secret passions of our heart than the voice is to relate them. For this reason, therefore, what is so marvelous in the imitation of "Nature the Sculptor" by sculpture itself, or in representing relief with relief? Certainly nothing or little. The most technically skilled imitation is that which represents relief by its opposite, which is a flat surface. In this respect, therefore, painting is more marvelous than sculpture.

The argument of longlastingness is worthless. It is not sculpture that makes the marble durable but the marble that makes the sculpture

enduring. This quality indeed belongs no more to it than to a rough rock, since sculptures and paintings are perhaps equally subject to destruction.

I state in addition that sculpture imitates more tangible reality and painting more the reality that is visual. Besides the use of figures, which it has in common with sculpture, painting adds colors, a characteristic of vision.

Finally, sculptors always copy and painters do not. The former imitate objects as they are and the latter as they appear. But since objects exist in only one way but appear in an infinite number of ways it is therefore very much more difficult for the painter to attain excellence in his art. From this one may conclude that excellence in painting is very much more admirable than in sculpture.

This is as much as I can now reply in response to the reasons given by the supporters of sculpture, which arrived this morning having been sent on your order via our Signor Andrea. But I would advise you not to go on any further with them in this argument, since it seems to me that it is better for the exercise of the wit and cleverness of those who do not profess either one or the other of these two arts, which are truly admirable when they are practiced on a high level of excellence. You have now with your canvases made yourself as worthy of glory as our divine Michelangelo with his marbles.

And now I most cordially kiss your hand, and pray you to continue your affection for me, and also your observations of the sunspots.

Agucchi

Giovanni Battista Agucchi (1570-1632), who was born into a prominent Bolognese family, began his career as an administrative aid to his uncle, Filippo Sega, who was then papal nuncio to Paris and later a cardinal in Rome.[1] On Sega's death in 1596 Agucchi transferred to the service of Cardinal Pietro Aldobrandini, the nephew of Clement VIII and his secretary of state. Early in 1621 Agucchi became the personal secretary of the Ludovisi Pope, Gregory XV, who also came from Bologna. When Gregory died two years later, his successor, Urban VIII, named him papal nuncio to the Republic of Venice, a post he held until shortly before his death.

Agucchi's contribution to artistic theory is contained in his Trattato della Pittura, *which was probably written during the years 1607-1615, when, temporarily withdrawn from public service, he devoted himself*

[1] For Agucchi's life see the entry under his name by R. Zapperi in the *Dizionario biografico degli italiani,* I (Rome, 1960), 504-5.

to the study of art, history, mathematics and astronomy. Like Cigoli he made observations of the sunspots for Galileo (see p. 21).

Agucchi's Trattato survives only in fragmentary form. His friend, Giovanni Antonio Massani, writing under the pen name of Giovanni Atanasio Mosini, published in 1646 a section of it in his preface to a book of engravings made by Simon Guillain after the drawings of Annibale Carracci. Massani says in his preface that the Trattato was written by a certain Gratiadio Machati, which is a name known to Malvasia and others as a pseudonym for Giovanni Battista Agucchi.[2] The Trattato has been considered by some as a joint work by Agucchi and Domenichino, though this view is no longer generally accepted. During the period when, apparently, Agucchi was writing his Trattato, Domenichino was a member of his household. There can be little doubt that Agucchi drew heavily on his discussions with the painter for practical advice. We have no reason, however, to believe that Domenichino contributed to the development of the artistic theory per se.

Agucchi's importance lies in his having anticipated, to a notable degree, concepts that were later systematized and elaborated by Giovanni Pietro Bellori (see pp. 5-16), and which spread from Bellori throughout much of Europe, becoming, especially in France, a sort of paradigm of classical artistic theory.[3] These concepts would have been readily available to the young Bellori through Francesco Angeloni, in whose household Bellori grew up. Early sources record the friendship between Angeloni and Agucchi.[4] Both worked in the service of the Aldobrandini. Both were good friends of Domenichino. Both celebrated the art of Annibale Carracci and the new current of Baroque classicism.

Agucchi starts by saying that the origins of art are to be found in the imitation of nature, and that many artists still do no more. But the finest artists are those who attempt to ennoble and make more beautiful that which they find in nature. Such artists are appreciated by the enlightened few, while the imitators of nature please the vulgar mob.

Though his thoughts are not expressed as clearly as Bellori's, Agucchi shares with the younger theoretician the Renaissance neoplatonic concept of nature as an imperfect reflection of the divine, impeded in achieving perfection by the corruption inherent in earthly existence. The artist achieves the Idea of Beauty by reproducing nature not as it is but as it ought to be. In Agucchi too we find the concept (though not nearly

2 Carlo Cesare Malvasia, *Felsina pittrice,* II (Bologna, 1678), 504; and *Le pitture di Bologna* (Bologna, 1686), p. 24.

3 Agucchi was largely ignored by modern writers until his role as an innovator was made known by Denis Mahon in a brilliant essay, "Agucchi and the *Idea della Bellezza,*" in *Studies in Seicento Art and Theory* (London, 1947), pp. 111-54.

4 G. F. Tomasini, *Elogia Virorum Literis & Sapientia Illustrium* (Padua, 1644), pp. 24f.

as fully stated as in Bellori) that the artist is to select and synthesize those parts of nature that are the most beautiful.

Agucchi and Bellori both agree that the modern artist who has most fully achieved the Idea of Beauty is Annibale. It is he who has done the most to save art from the decline it suffered during the recent past (the age of mannerism), and it is he who has restored it to the heights achieved in the High Renaissance, above all by Raphael. For an example of the artist who celebrates the worst in nature (that is, the painter of low-life genre) Bellori chooses Pieter van Laer, one of the bamboccianti; *whereas Agucchi, who belongs to an older generation, chooses the family of Venetian mannerist painters called Bassano.*

In the following extract we have eliminated most of the second part of what survives from Agucchi's Trattato, *because it deals chiefly with the development of the Carracci's career.*[5]

From Agucchi's *Trattato della Pittura*

Very likely what took place in the beginning in all the arts occurred at the outset to that most ingenious art of painting. That is, that it began with very simple and imperfect principles, and that it reached the peak of perfection only after a long period of time and a multiplicity of practitioners who, one after the other, added to what their antecedents had invented and were able in this way to perfect the art. And what the writers all say can be held to be true. That is, that the first principle was taught by Nature herself, with the shadows cast by bodies receiving light, and that in this way they began to delineate the outlines of the shadows and from thence to distinguish the members and then to distinguish the illuminated parts from those that were shaded. And one may say that, as Pliny affirms, painting's first destiny was the outline, and Ardice of Corinth and Telephanos of Sicyon were the first to practice it without colors, simply putting lines between the figures to simulate shadows.

In another, more important, matter painters have always differed amongst themselves, that is to say, concerning, more or less, the investigation of the beautiful. Since some of them, imitating several kinds of things, dedicated themselves solely to imitating what, as a rule, appears to the eyes, their aim was directed to the perfect imitation of the natural as it appears to the eye without trying to do anything more. But through intelligence others rise higher. They embrace in their Idea the excellence of the beautiful and the perfect: that which Nature wished to accomplish even though she does not do so in any one object because of many

5 The following text is taken from *Diverse figure da Annibale Carracci intagliate in rame da Simone Guilino* . . . (Rome, 1646), as reprinted in Mahon, *Studies in Seicento,* pp. 241-49, 256-57.

factors that impede her, such as time, matter, and so forth. Like worthy artists, if she does not perfect one individual completely, she tries at least to do so discretely in many, making one part perfect in this one, another part in that one. Other painters are not content with imitating what they see in one object alone. Instead they regularly collect the segments of beauty scattered in many parts and unite them with subtle judgment, painting things not as they are but as they would have been if they had been perfectly realized. Given that, it is easy to understand to what extent [if any] painters who only imitate things as they are found in nature deserve praise. The estimate may be made of them that the common herd makes. Since they never arrive at an understanding of that beauty which nature would like to express, they dwell on what they see, even though they find it very imperfect. From this it comes about that the objects painted and imitated directly from nature are pleasing to the common people, since they are accustomed to seeing such things, and the imitation of what they already know well delights them. But the knowledgeable man, lifting his thought to the Idea of the beautiful, to the concept that Nature demonstrated she wished to make, is enraptured by it and contemplates it as a thing divine.

Do not therefore think that we do not here wish to confer well-deserved praise on those painters who paint portraits excellently. But in order to work with perfection one need not know the face of Alexander or Caesar but only what face a king would have, or a magnanimous and powerful captain. Nevertheless the most worthy painters, without departing from the likeness, have aided nature with art. They have portrayed the faces as more beautiful and more noteworthy than in life, indicating, even in this kind of work, a recognition of that greater beauty which, in that particular object, nature had not completely perfected.

It then follows that one must consider whether the artists of the past had their own particular style, as was hinted above. It does not, therefore, follow that there must be as many styles of paintings as there were painters, but that one style alone may be deemed that which was followed by many, who, in their imitation of the true, the lifelike, or simply the natural, or the most beautiful in nature, follow the same path and have the same intention, even though each one has his peculiar and individual differences. Hence, although the ancients had a multitude of painters, we discover that the Greeks at first had painting of two kinds: the Hellenic, or that which is actually the Greek, and the Asiatic. Later the Hellenic divided into the Ionic and the Sicyonic and became three. The Romans imitated the Greeks, but nevertheless had a different style, and therefore the ancients had four styles of painting.

In modern times, after having been as if buried and lost for many centuries, painting almost had to be born again from those early, crude,

and imperfect principles of its ancient beginnings. Nor would it have been so quickly reborn and perfected, as actually happened, if modern artists had not had before their eyes the light of the ancient statues preserved up to the present day. From these statues, as from the architectural works, they were able to learn that refinement of design that has so greatly opened the road to perfection.

One must give great praise to all of those who began to draw forth the field of painting from the dark shadows of barbarous times and, endowing it with life and spirit, brought it into the most brilliant light. One could name many excellent Italian masters and those from other nations who worked ingeniously and worthily. Nevertheless, since others have already alluded to these things and have already described the lives of these very artists, we will restrict ourselves here to just those who by common agreement among the knowledgeable are considered masters of the first order and leaders of their particular school, and we will make mention of them briefly on a suitable occasion.

If we divide the painting of our times in the way the Ancients did, we may say that the Roman School, whose leaders were Raphael and Michelangelo, followed the beauty of statues and drew close to the creations of the ancients. But the painters of Venice and the Marches and Treviso, whose leader is Titian, imitated instead the beauty of nature as it appeared in front of them. Antonio da Correggio, the leader of the Lombards, was almost a greater imitator of nature, since he followed her in a tender, easy, and equally noble way. By himself he created his own style. The Tuscans [that is the Florentines] created a manner that was different from those above, since it possesses much fine detail, accuracy, and reveals much skill. Leonardo da Vinci and Andrea del Sarto hold first place among the Florentines, since Michelangelo, so far as style is concerned, does not show himself to be very Florentine. Domenico Beccafumi and Baldassare Peruzzi were the first among the Sienese.

Thus four types of painting came into being in Italy—the Roman, the Venetian, the Lombard, and the Tuscan. Outside of Italy Albrecht Dürer formed his school and is worthy of the praise he receives throughout the world. Germany, Flanders, and France have had many other worthy artists who have achieved fame and renown.

Now it is true that the above-mentioned masters, and many other worthy men who following in their footsteps, led the way to the perfection of art and brought glory to our centuries to equal that of antiquity when the Apelles and when Zeuxis, with works of marvelous beauty, caused tongues and pens to celebrate their brushes. We can thus confirm that which is not concealed to persons of healthy understanding. That is to say, that during our century the leaders of the above-mentioned schools or styles flourished, and all the other artists with good taste and

knowledge studied and imitated them. Then there came about the decline in painting from the peak it had gained. If it did not again fall into the dark shadows of the early barbarianism, it was rendered at least in an altered and corrupt manner and mistook the true path and, in fact, almost lost a knowledge of what was good. New and diverse styles came into being, styles far from the real and the lifelike, based more on appearance than on substance. The artists were satisfied to feed the eyes of the people with the loveliness of the colors and rich vestments. Using things taken from here and there, painting forms that were gross in outline, rarely well joined together, and straying into other notable errors, they went, in short, far from the good path that leads one toward perfection.

While the profession of painting was infected, so to speak, in this way with so many artistic heresies it was in real danger of going astray. But in the city of Bologna there arose three citizens who were closely joined by blood and no less united by their resolve to use every form of study and effort to arrive at the greatest perfection of arts.

They were Ludovico, Agostino, and Annibale Carracci of Bologna. The first named was a cousin of the other two, who were blood brothers. Since he was the oldest he was also the first to dedicate himself to the profession of painting. From him the other two received their first training in the art. And since all three were happily endowed with the gift of natural ability, which this very difficult art so greatly demands, very soon they saw that it was necessary to restore art from the state it had fallen because of the corruption we have discussed.

While the city was being enriched with many works by their hands, they also founded an academy of design [called the Accademia degli Incamminati]. There they studied constantly from nature, not only living bodies but often the dead: cadavers obtained from the execution of justice, in order that they could learn the true relaxation that bodies possess. They gradually rose to greater and still greater excellence. These masters, and their superior manner of painting, were the reason that many youths were so attracted to the beauty of art, and dedicating themselves to the same profession they also produced objects of great worth and became famous in the world.

As we have stated above, during the last century, Raphael and the Roman School, by following the style of the antique statues, had imitated the best more than the others. Bassano was like Peiraikos in representing the worst. A great many of the moderns did the same, and among them Caravaggio who was most excellent in color but must be compared to Demetrius, because he deserted the Idea of Beauty and preferred to give himself over completely to realism.

We now turn to the School of the Carracci and Annibale in par-

ticular. It remains to compare him with the above-mentioned painters, both the ancient and the modern. In regard to color, he endeavored to express its rarest beauty. Having pursued that goal, he proposed on his arrival in Rome, to unite the mastery of design of the Roman School with the beauty of color of the Lombard. It can be said that in this kind of work, which touches the most sovereign beauty, he achieved a level of highest eminence.

Marino

Giovanni Battista Marino (1569-1625) is the most famous poet of the early Seicento. In Naples, where he was born, he studied first law, at the prompting of his father, then literature, with the encouragement of Tasso. In 1600 he was forced to flee Naples because he had forged documents in an attempt to save the life of a friend. He came directly to Rome, where he gained fame as a poet and a pension from Cardinal Pietro Aldobrandini (the nephew of Clement VIII), to whose household he remained attached for almost a decade. During this period he presumably had ample contact with the art theorist and connoisseur Giovanni Battista Agucchi, who administered the cardinal's household.[1] *Later he transferred his services to the Duke of Savoy, Carlo Emanuele I, who awarded him with knighthood in 1609 and a pension a year later. Some of Marino's best work was done in Turin, where he remained until 1616. At that time Marie de' Medici called him to Paris in the service of the French court. There he met, became friendly with, and apparently profoundly impressed the young Poussin, whom he encouraged to move to Rome. In 1624, by then a sick man, he returned to Italy to receive a hero's welcome, first in Turin and Rome, where he stopped briefly, then in Naples, where he died.*

Marino's artistic theory is found chiefly in his Sacred Discourses, *the first of which is entitled "Painting, or the Holy Shroud."* [2] *The shroud to which Marino refers is a famous relic, long in the possession of the House of Savoy, which is said to bear the dual imprint, front and back, of the body of Christ.*

The first section of the dialogue is a conventional defense of painting as being divine in origin, politically useful, and the like. Our extract is from the second section.[3] *Here, after a brief bow to the standard analogy between painting and poetry (not included below) Marino turns*

[1] For Agucchi, see pp. 24-30.

[2] Giovanni Battista Marino, *Dicerie sacre* (Turin, 1614). I have used the second edition, published by Violati in Venice in 1615. For the following comments I am indebted to Gerald Ackerman, "Gian Battista Marino's Contribution to Seicento Art Theory," *Art Bulletin*, XLII (1961), 326-36.

[3] Marino, *Dicerie*, pp. 55r-56r, 57r-58r.

to an analysis of the components of painting. Following long-accepted practice, he holds that the two main elements of painting are "color" and "design." This last, he goes on to say, has two aspects: internal and external. By this he means that design is both the abstract concept as seen in the mind's eye and the concrete exemplification as seen by the human eye. Marino has taken over this duality directly from Federico Zuccari, whose Idea, *though published in 1607 at the very end of his long life, clearly relates to the mannerist art of the previous century.*[4]

Where Marino breaks from Zuccari (apart from the passages given over entirely to religious mysticism) is in his analysis of "external design," in which he stresses the importance of fantasy, or the free play of the imagination. Such a position, with its clear implication that it is not necessary to abide by rules or models, is ultimately incompatible with classicism but highly adaptable both to mannerism and the Baroque.

It is, of course, not as an art theorist but as a poet that Marino won fame. His lifelong interest in the visual arts, above all in contemporary painting, is reflected in The Gallery, *a delightful collection of epigrammatic poems about real and imaginary pictures that was published in 1620.*[5] *The poem we reproduce below is about a real painting. It is a documented work by Caravaggio and is now in the Uffizi Gallery in Florence.*

From *Dicerie sacre*

There are, in my opinion, two things that make painting admirable: excellence of design and excellence of color. And in both these aspects we can say that the divine painting of this sacred canvas [the Holy Shroud of Savoy] is most admirable. As for the first [design], it can be considered in two aspects. The one is intellectual and internal, the other is practical and external. Both the one and the other refer only to the form or shape of corporeal things, whether externally or internally, and to the congruence of the whole, that is [so arranged that] each part is placed in its proper position. The internal intellect meditates upon these forms [as they exist] in the concept of the painter, in accordance with his knowledge. The external aspect, that aspect which is put into practice, displays these forms on paper, canvas, or in any other material way, so that they may be judged with the corporeal eye. Then, in accordance with the secret rites [of art], they are refined and corrected to the point of ultimate perfection.

The Christian soul can contemplate this same thing in this mar-

[4] Federico Zuccari, *L'Idea de' pittori, scultori e architetti* (Turin, 1607).

[5] Giovanni Battista Marino, *La Galleria* (Venice, 1619). I have used the text in the edition by Ciotti (Venice, 1626), p. 40.

velous painting of Christ [the Holy Shroud, which contains] internal design and external design, love and pain. The one is in the spirit, the other in the senses; the one is in the volition, the other in the execution. The one offers, the other suffers. The one chooses to suffer, the other actually suffers. The internal one is content to undergo an ugly and ignominious death for the salvation of mankind. The other submits and subjects himself to all those martyrs and suppliants that the sins of men have earned. And who knows if this mystery is expressed in the duplication of the Holy Shroud itself. In the cloth, both on the one and on the other side, one sees the figure duplicated, almost as if to make reference to these two types of design.

The practice of design, whose function is to put into effect the concepts of the imagination, or objects that are seen, ordinarily operates among earthy painters in three different ways. The one is to make things up out of one's own brain, that is to say, to do it from practice, or from fantasy. Another is to be guided precisely by the rules of perspective. The third is to draw on [examples found in] nature.

The first method, being the most rapid of the three, is also the one most used by the majority of those who paint. Those who use it profit from what, through long practice in drawing, they have stored up in their minds. And this method usually turns out well or less well according to the degree of the painter's talent and application.

The second method, without doubt, is the most certain and secure. That way nothing is done by accident, but instead for good reasons and on the basis of proof and infallible demonstrations. Besides this provides the size, the diminution and the recession of constituted or imagined objects that one wishes to set back in space on a slant, or in reference to the visual pyramid, according to the different horizon lines, views and distances from which they are to be seen [in the painting]. This method teaches how to draw everything, as for example the various angles that apply to the various points of view.

But just as it is easy to draw regularly shaped objects in perspective, so it is difficult and takes a long time to draw the irregularly shaped ones. Thus it is more expedient for painters to use the third method, which is half way between the other two and makes use of both. This method is to copy visually, from nature, the things that are to be painted, or to reproduce them from models made for that purpose, or with the help of some mathematical instruments.

Neither of these last two methods was used by God in his Design. He made use neither of natural objects nor of the geometrician's compass, having no need of them. Being, besides, the Mind Eternal in which all concepts are resplendent, he could find no created thing that could

express so lofty an idea. What mathematical measure could circumscribe that love which had no measure?

The Head of Medusa on a Shield
By Michelangelo da Caravaggio

IN THE GALLERY OF THE GRAND DUKE OF TUSCANY

What foe will not, Sir, find himself congealed
Into cold stone on seeing on your shield
That Gorgon wild whose plentitude of snakes
So horribly, so very grimly makes
Among her locks a terrifying display?
But why, I pray?
List monsters not nor arms among your needs;
Your true Medusa is your valiant deeds.

Mancini

Giulio Mancini (1588-1630), like Agucchi, belongs to that new breed of critic-amateur who were neither professional artists, as were most of the critics of the sixteenth century, nor professional writers and scholars, as was Bellori later in the seventeenth. Mancini was a physician. He was born in Siena and attended the University of Padua, where he studied medicine, astrology, and philosophy. In Rome he practiced medicine successfully but without special distinction until 1623, when he became personal physician to the Barberini Pope, Urban VIII, one of the great art patrons of all time. In 1628, two years before Mancini's death, the pontiff made him an apostolic protonotary and a canon of St. Peter's.

Mancini's writings remained unpublished until this century. He left in manuscript form what is perhaps the first modern guide to Rome: modern in the sense that it was written to identify not relics for the pilgrim but paintings for the art lover.[1] Mancini's principal work, his Thoughts on Painting, *was published only in 1956.[2] He completed it largely between 1617 and 1621, but seems to have made additions and corrections until the time of his death.*

Mancini was above all an art lover and a connoisseur. The most interesting and original parts of his treatise are those in which he offers advice to the collector. This includes how to arrive at the correct price for a painting, how to determine in what technique the work was made, how to discover in what period it was executed, to what country it be-

[1] Giulio Mancini, *Viaggio per Roma per veder le pitture che in essa si trovano,* ed. Ludwig Schudt (Leipzig, 1923).

[2] Giulio Mancini, *Considerazioni sulla pittura,* ed. Adriana Marucchi and Luigi Salerno, 2 vols. (Rome, 1956-1957).

longs, to which region, and the like. He even discussed how paintings should be cleaned, varnished, and framed.

Already by the early seventeenth century the business of how to distinguish an original painting from a copy had become sufficiently troublesome for Mancini to devote a sizable section to the problem. We are amused at the sophistication of the Seicento shyster (new paintings aged in smoke or newly forged on genuine old canvases) but the thought of trying to uncover such forgeries now, after they are three and a half centuries old, is enough to make the head spin.

Mancini's passage on the proper placement of paintings has special relevance for the history of patronage. It tells us that the art market in Rome had grown to the point where, early in the seventeenth century, it was sustained at least in part by the petit *bourgeoisie, that is, by persons of such modest circumstances that they could afford no more than two principal rooms, a living room and a bedroom. Even here he tells us where the paintings should go, so that we have some chance of imagining them in their intended environment. Mancini still lived under the shadow of the Council of Trent, but the shadow was fading. He cautions the collector against the public display of paintings that might be considered erotic, but his warning seems perfunctory. The burning of art, even erotic art, to improve public morals (as was done during Savonarola's theocratic rule of Florence in the late fifteenth century) quite obviously appalled him.*[3]

From *Considerazioni sulla pittura*

Above all [it is important to know whether a painting] is a copy or an original, because sometimes the originals are so well imitated that it is difficult to tell. Besides, those who want to sell copies for originals darken them with smoke from wet straw, so as to give the painting a certain coating similar to that which time produces. Thus, when the bright strong colors that new pictures have has been removed, they seem old. Moreover, in order to make the deception more effective, they take old panels and paint over them. Even with all this, those who are experienced unmask all these forms of deception. The first thing to consider is whether the painting in question has the degree of perfection that is characteristic of the artists under whose name the work is offered and sold. Moreover, one should consider whether the painting reveals the assurance of the master himself, above all in those parts that are executed with a degree of boldness that cannot be well imitated. This is

[3] The following sections are translated from Mancini, *Considerazioni*, I, pp. 134-35, 141-44.

especially true of the hair, the beard, and the eyes. When they have to imitate the ringlets of hair, they do so with a certain awkwardness that is apparent in the copy. But if the copier decides not to imitate it, then the copy lacks the degree of perfection that the master's work has. And those parts of the picture are like those passages and sections of writing that require the boldness and resolution of the master. You can see the same thing in those touches and dabs of highlights, scattered here and there. The master places them [on the canvas] instantly and decisively, with brushwork that cannot be imitated. The same thing can be seen in the folds and highlights of cloth, which depend more on the imagination and the fantasy of the master than on the actual appearance of the object.

Despite all these observations on how to distinguish a copy from the original, nevertheless it happens sometimes that the copy is so well made that it fools us anyway, even if both the artist and the buyer are intelligent. And what is more, having both the original and the copy, sometimes it happens that you cannot tell which is which. The Grand Duke Cosimo de' Medici, of happy memory, was heard to say that in such cases the copy should be preferred to the original because it contained both skills, that of the originator and that of the copier. Besides, it often happens that some painters enjoy imitating the manner of a famous and renowned master so well that it fools the most intelligent people. They have their works sold as by the hand of the famous painter not for the sale itself, which is a certain form of deception, but through their desire for honor, and in order to make themselves known and gain a reputation.

After the paintings are obtained they must then be put in place. Various owners differ as to the quality and commodiousness of their homes. Princes, who have a variety of residences, have many places where they are able to place pictures. In the case of a private person with a small amount of living space, we cannot apply rules for placing pictures in different locations, rooms and residences, but only in different kinds of light. For those who have only a bedroom, a living room and little more, the only rule is to decide the light that is suitable and that the artist had in mind in making them. They should also be placed so there is no difficulty in seeing and enjoying them. Moreover, they should be arranged with some distinction [as to subject matter]. Devotional works should be put in the bedroom, whereas cheerful secular works should go in the living room. In the case of the religious paintings, the small ones should go at the head of the bed and above the faldstools. Paintings of Christ, the Virgin, and similar subjects should face the door to remind whoever enters that he is in a private devotional place.

This is for a private house. Returning to the case of princes living in palaces with a variety of apartments, great care must be taken in the placement of works, both in respect to convention and to the emotions such works might evoke in those who look at them, for the prince is both the head of a family and a public personage. Thus, according to Ficino, discrimination should be used not only in placement, but also in what sort of person should be shown the paintings. Those who see them should be differentiated as to disposition and temperament, age, sex, usage, and the way of life one desires to maintain, augment, diminish, correct, or change for the opposite. Thus by pious edict it was forbidden to publish a picture that had not first been considered by the superiors. But in this regard I do not approve of the great severity shown by Savonarola, who had so many pictures burned in Florence for having a bit of paganism and eroticism in them, because in this way many fine paintings and remains of the old nobility went up in smoke. Vainly influenced by him, those families burned them without giving warning either to the Friar or to the people of Florence. Here in Rome in the churches there is respect for paganism, as one can see in S. Andrea in Cacobarbara and S. Costanza, and elsewhere. Besides, if they burned the ancient paintings that were perfect, modern painters would not be able to learn how to make pictures for our own religion. Hence Pius V, of blessed memory, being well aware of this, let [the statues of] the ancient gods remain in the Vatican Palace, although they contained something of the erotic. As for other similar gods and erotic things in the Sacred Palace, I let others judge.

In the case of a private individual with diverse living quarters and a varied family, this is the method that should be followed. Landscapes and cosmographies should be placed in the galleries, and the places where anyone may go. Sensual themes such as Venus, Mars, the Seasons, and female nudes should go in the galleries on the garden side and in the private rooms on the ground floor. The pictures of the gods should be put in the more generally accessible rooms on the lower floors. Erotic works should go in the private chambers. If the owner is the head of a family he should keep them covered, and should only uncover them when he goes there with his wife or a person in his confidence.

Paintings depicting civic affairs, or peace, or war, should be placed in the chambers and antechambers through which pass those who wait and who come to do business. Similarly, the portraits of persons illustrious for peace or war or for their contemplation, as well as the portraits of popes, cardinals, kings, emperors, and other rulers should be placed in the areas where anyone is allowed to go. There too may be placed coats of arms, emblems, and other paintings of the same sort. Those of Christ, the Madonna, the Saints, and, in short, the paintings of religious sub-

jects, should be placed in the chamber and antechamber where one sleeps. The miniatures and the small pictures richly ornamented should go at the head of the bed. But these places are not always sufficient to take care of the large quantity of pictures. Then, because this abundance of paintings provides richness and edification, one may make a picture gallery for all the paintings that are too numerous for the other rooms. Place it in some convenient spot where the light and air are good; where it is brushed by the north winds and shielded from the winds from the south.

Mancini, like Agucchi, belongs to a period of transition, around 1620. It was clear by then that mannerism was finished and that the realism of Caravaggio and his followers was losing ground in the face of the increasing success of the classicism of Domenichino, and Guido Reni. The High Baroque was not yet in being. Mancini was favorable to classicism, but without the fervor of Agucchi or Bellori. His writings contain no attacks on the mannerists. He had no objection to unidealized realism (he goes so far as to praise the erosions of old age) provided no aspect is inappropriate to the subject that the artist has chosen to represent.

Mancini draws on Renaissance neoplatonism and the Aristotelianism of the mannerists, but his borrowings are fragmentary and at times unclear. He acknowledges briefly the divine origins of beauty, but primarily he identifies it with decorum. In fact, the doctrine of decorum lies at the heart of his theory. He sees it under two aspects. Decorum signifies the elimination of anything vulgar or indecent. It also means the inclusion of all aspects (appearance, attitude, movements, clothing, environment) that are appropriate to the character and circumstances of the person whom the artist represents. Thus, for Mancini, Caravaggio had violated the doctrine of decorum by showing the Madonna as a vulgar peasant or worse. But elsewhere he writes that in the case of the beauty of a young peasant decorum consists in depicting the type of body structure, coloring, attitude, and ability needed to work vigorously at peasant tasks. Even deformity has a beauty of its own.

The "Idea of Beauty" as an empirically based synthesis that improves on nature is a concept of great importance to Agucchi and central to the theory of Bellori, but it does not appear in Mancini at all. In the end he remains a dilettante. The voluminous but diaphanous overlay of theory that fills his writings serves to color but not to mask the physician's sensuous enjoyment of art.[1]

[1] The following passages are from Mancini, *Considerazioni*, I, 120-21, 125-27.

From *Considerazioni sulla pittura*

Before going any further, we must consider the custom of painting figures in such a way that they have in the effigy those emotions and actions through which we wish to express the characteristics of a person performing such an action. Here we can see what a bad job some of the modern artists do. In order to depict the Virgin, Our Lady, they go and make a picture of some dirty harlot from the marketplace, as Michelangelo da Caravaggio used to do. That is what he did in the *Death of the Virgin* [now in the Louvre], that painting for S. Maria della Scala that the good fathers of the church did not accept for that reason. Perhaps the poor fellow suffered much distress upon reading that a painter in Constantinople lost a hand for having made a picture of Christ based on a statue of Jupiter, and that Epiphanius forbade the depiction of living persons as saints. And I marvel that the Madonna of Torre Borgia by Pinturicchio or Pietro Perugino has not been taken down.

Decorum, thus, of necessity, implies the beauty of the figure. It is not, to our way of thinking, that which attracts by its pleasurable qualities, but that which has the proportions and conditions appropriate to each age and person. Thus those proportions that are appropriate will constitute that beauty. But let us clarify more precisely what this beauty of painting is. First of all it must have the expression appropriate to what it represents. Then it must have the proportion of its components that is appropriate to what is being imitated, as well as the coloring that is found in such an entity. Thus, pictorial beauty is made manifest through form, proportion, and the appropriate colors. Therefore beauty appears in all things, in all the animals, and in men of every type and occupation: in servants, in slaves, even in persons who are deformed, even in things that are horrible. Since this beauty of proportion and color possesses the power and faculty of being able to perform well acts appropriate to it, pictorial beauty will therefore also have to have an expression of this power. This power, since it appears first in the form and proportion, has for its foundation that proportion, which has in it something of the divine, being made by the creative faculty, which, as Aristotle says, contains something of the divine.

Because of the quality it has of functioning on the appropriate level, we call this beauty decorum. In other words, what we call beautiful is the propriety of the entity and the manner of functioning as is required for that particular type of thing. Therefore, decorum is the degree of beauty confined to a specific level, together with the attitude and disposition to function well on that level. In the case of the beauty of a young peasant, in other words, decorum is nothing else but the body

structure and coloring that reveal the attitude and ability to work vigorously at peasant tasks.

So it is in the other categories. The beauty of youth, being hindered in its functioning, is not absolutely beautiful, but beautiful rather in expectation, and through the color of its abundance of spirit. The beauty of virility, in possessing the power to function perfectly, is absolutely beautiful and has natural beauty. In regard to this type of beauty the ancients were consistent in always representing Jupiter at the same age, in order to show his perfection. There is finally the beauty of old age, which is so constituted and of such a temperament that such an age is sought for its prudence and counsel. Along with the beauty limited to this category there is added distinction and veneration. Old age attracts honor, and is revered. For this reason it is venerated and regarded as superior.

There is, in short, grace in all the categories of beauty. It is present when beauty, together with decorum and distinction, in any category whatsoever, not only functions but does so in the most perfect way that it is able. And this fine functioning is nothing else but the wit and spirit by which it makes itself known. This combination of beauty, decorum, and veneration is not always elegant in all its manifestations. One kind of grace is present in singing, another in laughing, another in weeping, and others in various other actions.

Nor is grace denied to old age. Old age may possess grace in actions that are pleasing, for example in walking straight, with the gravity of age, which, together with decorum and veneration, delights us and is lovely, because it shows that to be old is not miserable, nor does it cause distaste when we see it. We see also the way some old women deceive themselves. In their youth, having been delightful for their ability to sing and play musical instruments, in their old age, toothless and with shriveled fingers, they want to do the same. In order to conceal their unattractiveness a little they make up their faces with cosmetics, thus covering their ugliness with filth.

Scannelli

Francesco Scannelli (1616-1663) is typical of the amateur-connoisseur who in the seventeenth century begins to replace the artist-writer as the major source of art criticism and artistic theory. Scannelli was born in Forlì and attended the University of Perugia. Like Mancini he was a physician with a strong attraction to the arts. He knew Guercino well, and on occasion visited Reni and Albani in Bologna. Most important, he was an art consultant and a buyer for Francesco d'Este, the Duke of Modena, who was one of the greatest collectors in Italy. Scannelli's

career with the d'Este family is thus in many ways parallel to that of Baldinucci's in the employ of the Medici (see pp. 109-10). Both trained their powers of connoisseurship in serving the art interests of well-informed, sophisticated patrons. Both traveled widely to acquire works of art, and used their travel to gather information that they could incorporate in their writings.

Scannelli's only book is his Microcosmo della Pittura.[1] *It appeared in 1657 and was dedicated to Francesco d'Este. Although the title page suggests that the whole first half of the book deals with theory, most of it is really criticism. As one would expect from a man actively engaged in problems of connoisseurship, Scannelli is interested above all in individual works and individual artists. He developed no unified body of artistic theory. There are, nevertheless, a good many theoretical passages woven into his lengthy, rambling text.*

The first passage we give from the Microcosmo della Pittura *shows that Scannelli borrowed freely from Renaissance neoplatonism. Painting, in dealing with beauty, provides us with an earthly reflection or recollection of the divine. It must therefore manifest true grace, which derives from the perfect correspondence of all the parts.[2]*

Scannelli goes on to say that painting and poetry are sister arts, the one no more praiseworthy than the other.[3] This too is an old idea. It was developed in the Renaissance by neoplatonists as a means of raising the position of the artist in society from the level of a mere craftsman, who worked with his hands, to the status already enjoyed by the poet, whose work was metaphysical. The parallel, once established, permitted the Renaissance writer of artistic theory, in search of classical precedents, to compensate for the embarrassing absence of any known body of artistic theory in the writings of ancient Greece or Rome. To remedy this all that was necessary was to transpose to the visual arts such theories as the ancients had developed for literature.[4] The same passage in Scannelli is of interest for its praise of the spontaneity that is often the hallmark of the first act of the creative process. By implication Scannelli's predilection is for the Baroque rather than for classicism.

When Scannelli tells us that the purpose of painting is to be morally

[1] *Il Microcosmo della pittura, ouero trattato diuiso in due libri. Nel prima spettante alla theorica si discorre delle grandezze d'essa Pittura . . . nel secondo . . . s'additano l'opere diuerse più famose . . . di Francesco Scannelli* (Cesena, 1657). A facsimile edition published by Labor in Milan in 1966 includes a few unpublished letters by Scannelli, plus a brief introduction and an excellent analytic index by Guido Giubbini.

[2] Scannelli, pp. 107-8.

[3] Scannelli, pp. 128-29.

[4] These ideas are fully developed by Rensselaer Lee in his brilliant, book-length article, " 'Ut pictura poesis': the Humanistic Theory of Painting," *Art Bulletin*, XXII (1940).

elevating and purifying (la Pittura purgativa, *as he calls it*) *he is repeating the concepts of the great fifteenth century neoplatonist Marsilio Ficino.*[5] *This didactic and moral role permits the figurative arts to be classified not merely with history and poetry, but even with philosophy and theology.*

The very title of Scannelli's book, the Microcosmo della Pittura, (The Microcosm of Painting) *is derived from the idea that the human body, being created in God's image, is a microcosmic (though imperfect) reflection of the entire universe. This is an old image, but what Scannelli does with it is quite new. He represents the allegorical corpus of painting as a human body of which Michelangelo is the backbone, Titian the heart, Correggio the brain, Raphael the liver, the Carracci and their followers the skin, and Veronese the organs of generation.*

This quaint image reflects, in the choice of the artists selected, Scannelli's strongly regional orientation. His treatise deals with all of Italy, but it is an Italy seen from very much of a North Italian point of view. The first half of his treatise is devoted chiefly to a description of the three main schools of Italian art: the Tuscan-Roman School, led by Raphael; the Venetian School, led by Titian, and the Lombard School, led by Correggio. We include in our text one short section on each.[6] *Scannelli follows the traditional classifications. The Tuscan (or Florentine) School is noted for its "disegno," or "design," by which is meant not merely drawing but the intellectual aspects of painting such as anatomy, foreshortening, perspective, convincing three-dimensional modeling, and also a certain formal idealizing quality (what Scannelli elsewhere calls the* bella Idea). *The Venetian School is famed for* spiritosa naturalezza, *by which is meant vigorous realism, together with an informal spontaneity and a certain freedom of technique. Elsewhere the Venetian School is characterized by an interest in color. Up to this point Scannelli is following traditional classifications. He breaks new ground when he boasts of the supremacy of the Lombard School, which, following the lead of Correggio, combines the best aspects of Florence and Venice* (bella Idea *and* buona naturalezza) *but with the addition of delicacy and grace.*

Scannelli was North Italian to the core. He began with the simple idea of celebrating the artistic virtues of his own region, which writers in the main art centers (among them, Vasari in Florence) often found remote and unattractive. His natural rivals were Florence and Rome. But since Florence and Rome, where almost all Seicento art criticism originates, were strongholds of classicism, Scannelli was often led to take

[5] Scannelli, pp. 131-32.
[6] Scannelli, pp. 90, 209-10, 268-69.

an anticlassical position. It is this that gives him an importance in Seicento artistic theory far greater than is generally acknowledged today.

In the next to the last section below, Scannelli recognizes both disegno *and* colore *as the dual bases of the art of painting.*[7] *"Design" can be acquired only by intensive study and prolonged effort. By implication, the gift of "color" is unlearned, instinctive. Although Scannelli recognized that most critics held "design" superior to "color," he treated them both as equal. In this he was ahead of his time. The argument between "design" and "color" was not to come to a head until the end of the century, and then not in Italy but in France, especially at the French Academy in Paris. There lengthy debates took place between the supporters of Rubens, the great protagonist of "color" and of Poussin, the great proponent of "design."*

In the last selection, which comes toward the very end of the lengthy treatise, Scannelli asserts that those works that are the result of the artist's inspiration are superior to those that reflect the effects of prolonged study.[8] *In Scannelli's opinion Raphael, who made endless preliminary drawings, was not the equal of Correggio, who made none at all. To rank Correggio over Raphael would by itself be heresy in the eyes of most seventeenth century critics, for whom Raphael was supreme. But still more important—and it is this that makes Scannelli's position so radical—is his implicit rejection of the whole position that painting must necessarily be an intellectual process laboriously acquired.*

Had Scannelli consistently followed the implications of this position he would have had to reject the entire body of classical theory. He did not, but it did lead him in the end to prefer spontaneity and color to design (today we would call this preference a painterly approach). He disapproved of the later, clearly classicizing phases of Domenichino and Guido Reni. Above all he priased the early works of Guercino. These dark, warm, painterly, fully Baroque canvases were, for Scannelli, the finest paintings that contemporary art had produced.

Excerpts from *Microcosmo della Pittura*

The sound observer whose judgment is now firmly based on a true understanding of the value [of painting], that most worthy profession, will also come to realize that in every period there is not always that greatly desired beauty that reflects the Supreme light [of God]. Like the radiance of an expression of the Divine, composed with perfect proportion in its parts and articulated with pleasing colors, it is left on earth as a relic and a pledge of that which is celestial and immortal. Grace, which de-

7 Scannelli, pp. 102-103.
8 Scannelli, pp. 358-60.

rives from perfection and the fitting correspondence of all the parts, displays such beauty that it is by itself sufficient to ravish the heart with love and to generate, unseen, a sense of gratitude and good will. This is built up on various foundations through well-established measures and suitable proportions. It also reveals itself in various forms, as in the representation of majestic and terrible gods, who are shown appropriately as more or less serious, severe, or benign according to the needs of the given situation, and similarly in the representation of the mean and the humble. Thus on finding a firm correspondence between the characteristics of the action and what needs to be represented, the quality of decorum, which is so prized by the intelligent person, will be quickly revealed. Such parts, all eminently meritorious and equally necessary, will be acknowledged by good artists as the worthy goal of fine painting. They are expressed in the highest degree in the most perfect works of the best and truly great masters, which continue to live in the eyes of the connoisseur as the true model of art.

There is a quality, so to speak, that is shared by these two virtues, poetry and painting, and because of which they are sisters in high esteem. Even as a good poet achieves recognition by a line, that is to say, by a verse, so one knows the praiseworthy painter also by his line, that is to say, by the contour. Through the workings of destiny they alone among all the other professions have this singular characteristic, that it is possible to determine from a small work the excellence or insufficiency of their way of working. For this reason the wise ones in this famous profession of painting, those blessed with the purest taste, are wont to value above all else the first lines and simple contours that take shape under the learned hand. And this is because they come directly from the first impetus, reflecting the true enthusiasm of the spirit in action. They are thus extraordinarily lively, and full of the most vivid effects. As a result they are prized by persons of good taste and the intelligent members of the profession. These are the lines, in fact, through which one distinguishes the true masters from other artists. This is also how one can distinguish artists who are equal in ability, because the ordinary differences between them at any given time become evident in their individual works.

One can say that painting is purifying, and that it does not corrupt the emotions. Thus it shares common ground not only with poetry, rhetoric, and history, but also as well with philosophy and with moral theology. This last, to demonstrate virtue, needs at the same time to reveal the opposite, which is vice. Indeed, even in the Holy Scriptures themselves virtue is revealed notwithstanding vice: virtue so one may

follow it and vice so one may flee from it. Vice is thus able to aid in our understanding of the effect of lust, with which it is linked to make more beautiful the human race, and with chastity so as to acquire great merit through abstinence. And those who would learn more concerning the value of painted images should read Ficino.

Upon reflection those who are knowledgeable will clearly understand that apart from the most famous and accomplished heroes of Greece, heaven has not endowed any nation as richly as Italy. One sees this clearly when one comes to know that the three most famous and most important schools of painting are in this one area. In every period they produce, in accordance with the soil [from which they spring], the finest effects of this good fortune, and they continue to maintain the position of the practicing artist. The First School is said to have originated in Tuscany. In the time of Michelangelo and of Leonardo da Vinci it achieved extraordinary growth, and through such excellent artists it maintained a firm foundation. Immediately after them came Raphael, who made the school supreme by the perfection of his style. One can believe this school is the first, and regarding its origins, that it was well rooted and had solid foundations in Tuscany, and afterwards in Mother Rome, thanks to the perfection of Raphael. This worthy school continues to exist in Rome through its successors, men for the most part with extremely solid grounding, well known in painting and capable. Thus I judge it superfluous at the present time to point out the merits of all those who up till now have not lacked enough writers from those areas to make known widely in many ways every one of these masters and their individual works.

[This section deals with] some famous and worthy painters and paintings with fine compositions that preceded the great Titian of Cadore, the sole head of the Second School, in the Venetian nation. Here in this worthy part of Italy the able observer of painting can easily discover the clear indications of what the learned writer of today promises concerning the renewal of that worth. For in complete confirmation of the most copious and vigorous realism in its style, it continues to bring to light a plenitude of most beautiful pictures. The very scholarly Tuscans and the other great leaders of the First School are recognized as the chief creators of the finest and most solid principles. But it does not follow that one cannot recognize what is obvious to everyone: that is, that the Second School has greatly enlivened the art of painting, over and above its basic needs, by the greater animation and by the superior realism of its style. On the basis of sound foundations laid in the beginning, the Venetian School has shown the most realistic formation. Hence subse-

quently, on the basis of the abundance, rare facility, and great beauty of its paintings, one could say that it contained within itself the procreative power to sustain the art of painting through an unceasing flow of fine artists.

After having discussed the Venetian School, we still have to consider the numerous and excellent creations, equal to those of any other part of the world, that are produced by the Third School, that of Lombardy. [There may be] those who have difficulty in agreeing with this point of view because they are already impressed with other schools, and because they believe that the most famous sections of those schools are of the highest level and incomparable in their perfection. But they will be able to accept such a possibility easily anytime if, spurred by curiosity, they discover, in that lovely part of Italy, the very finest pictures, which demonstrate the highest skill in painting to be found in modern times. This region, which was able to grow all things in abundance, could also in the case of painting generate an abundant crop of excellent artists, equal and perhaps superior to those of any other, albeit more commended, clime. But Vasari demonstrated that he was of a contrary sentiment. He had the audacity to leave in writing this maxim: "Sad is that bird born in an evil vale." This saying is altogether inappropriate to a country so rich and ever fertile both in land and in genius. We continually find proof of this when we see the many fine works of the masters. [These include the works of] Andrea Mantegna, [Donato] Bramante of Milan, Ercole [Roberti] of Ferrara, [Francesco] Francia of Bologna, but above all the paintings of the unique and supreme head of this great body of painting: Antonio Allegri da Correggio. By himself alone he is enough to reveal to those who love painting the glory of Lombardy. Lombardy is indeed the center of the most exquisite and beautiful work. It is gradually being recognized as such by the best minds. The truth of this becomes all the more clear when we consider the collaboration provided by the most distinctive and graceful works of Parmigianino.

After the decline in the merit of painting [that is, after the excesses of mannerism] the art of painting was reformed by the most excellent Carracci [Ludovico, Agostino, and Annibale] and their many fine works. These and their followers, [Guido] Reni, [Domenico] Zampieri [called Domenichino], [Francesco] Barbieri [called Guercino], [Francesco] Albani, [Giovanni] Lanfranco, and many other worthy modern masters, have in our day made the School of Lombardy conspicuous to all and have rendered it famous and immortal everywhere. No one can or should doubt such sentiments, for the examples are clear and well known by themselves. Moreover, the most worthy and capable Carracci were themselves greatly praised by painters who belonged to the

other schools. Influenced by the fame [of Correggio] and stimulated by his innate genius, they [the Carracci] studiously examined the supreme accomplishments of this true leader of the Third School, and of the whole art of painting. In vain did [Lodovico Cardi called] Cigoli, [Federico] Baroccio, [Francesco] Vanni, and others like them show their own works, with their insufficiency of grace, of delicate unity, of the concept of beauty, and fine naturalism—all things that were unusual in those times and not always admired. Nor were they able to partake of that excellent and exceptional beauty that one finds only in Correggio.

Continuing along the lines of the discussion already under way, I will say that the greater number of good artists have recognized as an incontrovertible concept the following idea. The vast corpus of painting, by analogy like an immense construction, ordinarily moves along firmly on two feet. The first of these is sound design and the other is appropriate color. In regard to the latter, it seems that by regularly observing nature, it is possible to acquire the pleasing quality of a well-composed painting. But the former, being more difficult and pervasive, was found to be the more worthy, because it requires greater application of the intellect. Hence it appears that it cannot be acquired without long study and extraordinary effort. And this abundant font branches out into various streams, an understanding of which is necessary. This appears clearly in the composition of narrative pictures, since certainly no one would be able to make compositions of that type without an adequate degree of inventiveness. And besides, who would know how to compose without a suitable understanding of diminution and a good grounding in perspective? In the same way those who lack profound learning and a knowledge of the orderly rules of architecture will not be able on occasion to avoid showing their deficiency. In fact, to walk on both these feet is a great virtue and it provides advantages in many different ways. However, it often happens that the lack of these essential foundations becomes visible in the makeup of inadequate paintings.

There are very different opinions as to what is necessary for those who want to become good painters. I would say briefly, however, that good composition together with continual studious effort are the true means that lead to this laudable end. If both aspects appear in a student of painting this serves to demonstrate his complete competence. But in point of fact such an intense union of all aspects, when not actually repugnant, turns out at the very least to be exceedingly difficult to obtain. What comes from nature is extraordinarily helpful, and can soon be put into operation, easily, beautifully, and naturally. But he whose taste is formed by studious effort over a long period of time is

never completely satisfied. Like the industrious bee he continually extracts from the flowers the most various and beautiful aspects. From this he forms a specific concept, which is certainly lovely and scholarly, but in comparison with the other work that is more natural, his painting is more contrived. Each artist has a given way of working that corresponds to his talent and his early training.

Raphael of Urbino and Francesco Mazzuola called Parmigianino, among the modern masters, can serve as examples of one of the methods. With long effort and intensive study they constructed a specific, precisely researched concept of the beautiful. So fluent and accomplished were they in drawing that they may easily be said to be the very best in the practice of this studious activity. Among these artists, making allowances for each individual's early training, what prevails is the artificial concept, constructed over a period of time and with continual study.

The other side can be seen in the Painter from Correggio. It is apparent in the natural proclivity of his tremendous talent, by means of which he creates—rapidly, almost automatically, and in a manner more divine than human—the most exquisite beauty that painting has to offer. He disliked the practice of making designs. At various times, when he was asked for the designs that were expected for commissioned works, in the manner that was said to be customary for Raphael and Parmigianino, he used to reply that he had his designs at the tip of his brush. And this was not because it was not valid to make excellent designs corresponding to his own divine painting. Rather it is because he was endowed with so great a natural ability to paint with the most beautiful colors, and in the most truly naturalistic manner, whereas the other two painters, with different preferences and methods, made designs with extreme perfection. As a result Correggio left only sketches of his [preliminary] ideas. These he cast aside to find fulfillment through pigment, and in the highest type of art.

The same thing can be seen in our day in the case of Guido Reni, who, as I mentioned earlier, also composed with studious and time-consuming effort, in accordance with his own extraordinary talent, in his own individual manner, and with the unique concepts [idea] that he extracted from examples of the rarest beauty. But often, especially toward the end of his life, not being able to satisfy himself with his concept, he would more than once paint out what he had begun, so that only with great effort was he able to finish the work in the way that he wished. In order to avoid the impression that the creation of beautiful paintings came easily to him [I recount the following]. Once when I found myself with others in his room, some cavaliers said that the master worked in this manner as a game. To this he replied at once that only persons who

did not know how difficult the art of painting was would speak in this way. But he, Reni added, who experimented with everything, could only say, in regard to the whole business, that he always gave his greatest effort, now more than ever, to satisfy both himself and others. We see this sort of ability in similar artists who, as a result of intensive study and training, paint works that are well proportioned and beautiful in concept, being composed with extraordinary skill.

On the other side there are those masters who, carried along by the force of their innate impulses, quickly achieve a truer resemblance to nature. Guided by genius, it seems that they are much more successful in imitating a given object than in the study of diverse and excellent works. Thus it follows that those on the one side are generally superior in study, proportions, intellect, and the concept of beauty [*bella idea*], while the others, besides having suitable proportions, are superior in their less contrived and more realistic naturalness.

Boschini

Boschini is the anti-Bellori of the Seicento. His writings contain the closest thing we have to a theory of Baroque art written in the Baroque age. He was not an intellectual like Bellori, nor did he ever develop what could seriously be called a systematic body of art theory. But his peculiar blend of lively art criticism and fragments of art theory includes both attacks against specific tenets of the theory of classicism and an enthusiastic appreciation of the stylistic components of Venetian painting—components that for the most part we would today call Baroque.

But it is doubtful that Boschini would have thought of himself as a defender of the Baroque, even if he had known the word. Like most critics of his day his position was to a considerable extent the product of his patriotism. He was born in Venice and he loved Venetian painting (it was, in fact, the only regional school he knew more than casually). Above all he loved and understood Venetian art of the later sixteenth century: mature Titian (d. 1576), Veronese (d. 1588), Jacopo Bassano (d. 1592), and Tintoretto (d. 1594). From this it follows that he had a lively appreciation of the work of seventeenth century artists who studied Venetian painting and who drew heavily on it in the formation of their own style—men such as Cortona, Rubens, and Velázquez.

Marco Boschini was born in 1613.[1] He himself tells us that in his

[1] Most of the information on Boschini used here is taken from Anna Pallucchini's excellent introduction to Marco Boschini, *La Carta del Navegar pitoresco, edizione critica con la "Breve Instruzione," premessa alle "Ricche Minere della Pittura Veneziana,"* ed. Anna Pallucchini (Venice, 1966).

youth he studied under Palma Giovane, an artist much influenced by Tintoretto and Veronese. His apprenticeship must have been brief, however, since he would have been only fifteen in 1628, the year that Palma died. There is no reason to believe that among his many other activities Boschini ever devoted much time to painting. He was primarily a printmaker and a writer, but he was also an art dealer, a restorer, and at one time even a dealer in imitation pearls and glass beads. Nonetheless, his early training seems to have set the direction of his artistic preferences. It is significant that his one work for a Venetian church, a Last Supper *now lost but once in S. Gerolamo, was described as being very much in the manner of Tintoretto.*

Early in his career Boschini made a good number of prints to illustrate books and pamphlets, and later he made quite a reputation as cartographer, but we know him today chiefly for his writings. In 1660 he published his Map of Pictorial Navigation, *a poem of epic proportions in Venetian dialect cast in the form of a dialogue between an unidentified Senator, whose role is that of a cultivated amateur, and a "professor de Pitura" who is Boschini himself. The ideas on painting that Boschini developed in this poem are summarized in his "Brief Instructions," an essay he published in 1674 as the introduction to the second edition of his* Rich Mines of Venetian Painting. *It is from this introduction that the passages below have been taken.*[2] *The text that follows the "Brief Instructions" is an extensive, objective guide to the immense wealth of paintings to be found in the churches and confraternities of Venice. Boschini's last book,* The Pictorial Jewels, *which appeared in 1676, is a detailed survey of the paintings in Vicenza.*[3] *There are few signs of his activities after this date, but he lived on into the opening years of the eighteenth century, dying in 1705.*

In the passages we have chosen Boschini discusses what for him are the three essential components of painting: design, color, and invention. By "design" he means roughly what the Florentine-Roman School means by the word: all those devices, such as linear perspective, foreshortening, and modeling with chiaroscuro, that enable the artist to provide the illusion of realistic three-dimensional objects on a two-dimensional surface. He is quite sure that the Venetian artists do this sort of thing better than anyone else. Witness, for example, their skill in illusionistic ceiling painting, a technique with special significance in the development of Baroque painting and one which, for Boschini, represents the highest possible attainment in the field of design.

[2] My translations are from the Pallucchini edition, pp. 748-56.

[3] Marco Boschini, *I giojelli pittorici, virtuoso ornamento della città di Vicenza* (Vicenza, 1676).

But apart from its possibilities for the creation of dramatic spatial effects, Boschini is not really too impressed with the discipline of design. He is aware of the argument that the great artists of antiquity have created objects more perfect than anything in nature, but he does not for a moment believe it. If nature is imperfect, he tells us, well then, so are the statues.[4] The good gray Bellori would have been appalled at such blasphemy. For Boschini design is no more than a preliminary step. "Without color" he writes, "design remains imperfect."

Color, in most cases, had a very limited significance for the Florentine-Roman School. In general it tended to serve as the overlay of a structure built up by other means. But in Venetian painting from Giorgione and Titian onward the colors are the basic components out of which the painting is built. For Boschini color is the crowning glory of painting, that which brings it alive and "adds blood to the flesh." This section is especially valuable because of Boschini's extraordinary knowledge of the complex technical achievements of Venetian painting. He tells us a good deal about the many and widely different layers of paint—thick or thin, opaque or translucent, wet or dry—that are used to create the final brilliant effects. We know that for this knowledge he relied not only on his own training but on the information gathered from those who had been closest to the great masters: from Tintoretto's son, Domenico, for example, and from Gabriele Caliari, the son of Veronese.

But Boschini reserves his highest praise for invention, the process of creative imagination by which a work of art is brought into being. Here again his ideas are developed empirically, by reference to the nature of Venetian painting, which grows in part out of rapid brush strokes laid on spontaneously with an instinctive sense for the necessary harmonies. "The first oil sketches and rough outlines," he writes "they derive from the concepts in their mind without reference to nature or even," he adds sarcastically, "to statues." Without invention all other knowledge is futile. It is this point of view, even more than his emphasis on color over design, even more than his recognition of the great painters of the High Baroque, that makes Boschini so refreshing. In a world dominated by classical criticism, where art is an intellectual process to be learned painstakingly and with much effort, Boschini sees it as above all an act of the imagination. Though it requires technical skill, it is essentially an exercise of "fantasia." And this is more or less the way we see it today.

4 Deucalion and Pyrrha, to whom Boschini refers in this passage, are the Noah and his wife of Greek mythology. The only survivors of a flood by means of which the gods wished to wipe out the degenerate race of man, they landed on Mt. Parnassus. When they enquired of an oracle how to renew the race they were told to throw behind them the bones of their mother. Taking this to mean stones, they threw stones behind them, and from these sprang a new race of men and women.

From *Ricche Minere della Pittura Veneziana*

DESIGN

I say then that design is the principal foundation and base of the edifice. Just as a building without a foundation cannot stand, so painting without a design is a structure that cannot hold up. Some think that design consists solely of the outlines. But I say that although the outlines are a necessary part of design, they can be compared to the skeleton of the human body, which must be covered with flesh to be perfect. This is one of the most important parts of design because the painter must bring the fleshy parts into relief on the basis of these outlines. In order to make myself clear I will give this example. He who wants to make [a picture of] a round ball certainly has to make a circle with a compass. But this is not enough, because if it lacks shadows, highlights, and halftones, that outline, ring, or circle could never be said to be a globe or a ball but [only] a simple mathematical circle, of a sort that needs to be rounded out in all its parts with the techniques of chiaroscuro. That is to say, naturalism awaits the brushstrokes that artificially give it color. Thus without color, design remains imperfect.

Some hold the opinion that to have mastery of design one must make use of statues as true examples and that if a person does not study them, he cannot become a good painter. They add that the statues are derived from that which is beautiful in nature and increased in their perfection by those talented sculptors, and that one finds little in nature that is perfect. As to this there is also the contrary opinion. Granting that all the things in nature are imperfect, nevertheless it is also possible to say the same about the statues.

They reply that that is true but that they are talking about the good ones. But the others add that nature does not get perfection from statues but rather the statues from nature. The first group replies that ancient statues such as the Laocoön, the Farnese Hercules and the Venus de' Medici are absolutely perfect. The others answer that the most ancient figure is the human figure, created by the Prime Mover, and for this it is ranked above statues. And then smiling, they say that the fabulous age, in which Deucalion and Pyrrha made men and women come forth from stones, no longer exists. They say in conclusion that sculpture and painting both imitate nature, and that one can just as well say that the sculptor must study fine paintings such as the *Last Judgment* by Tintoretto in the church of S. Maria dell'Orto, and many others [by Tintoretto] in the Scuola di San Rocco, and finally they said that every man admits he enjoys being a man and not a statue. The

truth is this, that our outstanding painters have studied the one and the other, taking the best of both and making of it a combination of true perfection, which gives good reason for the whole world to acquire Venetian paintings for much gold.

But let us pass on, and show the figure in action, in various attitudes. One of the elements of design is the imitation of that action that comes from the soul. And just as the soul is invisible, being hidden in the body, so by means of the artifice of chiaroscuro those spirituous movements are hidden, without definite rules and precise measurements, only with the intellect functioning keenly. And in regard to this it is enough to see in the Sala dello Scrutinio, near the Sala del Maggior Consiglio [in the Palazzo Ducale in Venice] *Thè Taking of Zara* by Tintoretto, where the figures that one sees are so bold and so skillfully colored that it seems impossible [to believe] that they will not step out of the canvas. O, these are truly spirituous movements; they give the lie to statues and terror to men! And that's enough.

But the techniques of design do not end here. They also comprise foreshortening, one of the most difficult aspects of design, for which measurements and form no longer help. Rather it is with deformity that the eye must be deceived, and through imperfection that perfection will appear. For example if one represents an arm that recedes and is out of proportion [because it is foreshortened] it will appear in proportion to the eye. If one wants to measure it, it will turn out to be not even a fifth of what it would be if drawn fully extended. And this is one of the main things that marks the painter as superior to the statue-maker. For the statue-maker can easily make use of measurements, whereas the painter uses form without form, even with form deformed, [and finds] the true formation in fluid form. Thus does one search out pictorial art. And he who wants a small example of this divine understanding should take a look at the dead body spread out on the ground feet first in the Scuola di San Marco, when Tintoretto depicted the *Discovery of the Body of St. Mark.* These riches can be drawn in abundance from our mines [of Venetian painting].

But these things do not exhaust the capacities of design. For difficult as foreshortening is on a flat surface, it is still more difficult to do in the air. Nor can one make statues fly. But our learned Venetian painters make human figures fly. Among the splendid figures of this type it is enough to see as an example the very light nude figure depicting *Venus in the Act of Crowning Ariadne* that one sees in the room over the stairs that leads to the Collegio [in the Palazzo Ducale], a painting by the immortal Tintoretto.

But design does not end even here. Instead, rising to a high level of glory, it sets up on ceilings actions that one may well call celestial. For when Virtue makes us see the impossible, then one must admit to

having passed beyond the Pillars of Hercules. Oh incomparable and colossal design, which gives evidence to all the world that similar deeds have not been done by anyone in the world except by our great Venetian designers. And to you, O Great Tintoretto, goes the title of the Monarch of Design. But design is joined with inner and outer arts. The fullest participation of design, color and invention is the true trinity of perfection.

Color

Entering now into a discussion of the second point, concerning color, I say that painting gains its good name by virtue of the learned brush of the excellent painter, who, clothing design with color, brings it to life. Without this color design could be said to be a body without a soul. Color may be reasonably compared to light. Just as light lets us see clearly what there is on the earth and in the sky, so color makes us aware of the differences among all things, as a result of the various hues. Thus color adds the blood to the flesh and can be called a brilliant sun that with its luminous rays lets us see the perfection of each detail.

I will say then that just as design has many branches, so color too spreads out in various circumstances and details. Sometimes color is used in a thick mixture as the foundation; sometimes it is used for open brushwork, and this is style; for the blending of colors, and this is delicacy; for tinting or shading, and this provides differentiation of the parts; sometimes it is used to raise and lower the relief by means of colors, and this is to round out; or for "scornful touch," and this is the bold freedom of coloring; or to lay a thin veil [of color over a surface of similar color already dry], or as they say, to stroke the surface lightly, and these are retouches to give greater unity. In these ways and with other similar devices is the coloring of Venice formed. By "coloring" we mean the coloring of the nude human figure. For the coloring of other things different devices are needed. But since the coloring of the human figure is the main thing, the explanation must be as clear as possible.

Venetian painters—and I speak of the best ones—when painting on large canvases, after having blocked out on it the figures of the historical narrative or mythology that they wish to represent, first went about sketching in the figures with underpainting that provides the base and fundament of the painter's individual form of expression. These first oil sketches and rough outlines they derived from the concepts in their minds, without reference to nautre, or even to statues or reliefs. In this their greatest concern was to arrange the inner and outer parts so that the figures would be clear in terms of chiaroscuro, which is one of the most important aspects of color and design, and of invention as well.

When these essentials had been taken care of and when the oil

sketches were dry, they turned their attention to nature and also to statues, but without letting themselves be completely bound by them. Rather, by reference to a few brief sketches, they finished their figures in a naturalistic way. Taking hold of their brushes, they began to lay on strokes over the oil sketches, coloring in the flesh. They used earth colors more than any others. What they used most was a bit of cinnabar, red lead, and lacquer, avoiding like the plague blue carbonate of copper, chrome yellow, azure blue, Naples yellow, and similar glossy colors and varnishes. After the second coat of paint was dry they might for example veil a figure with a thin layer of low saturation in order to emphasize another figure nearby by making it stand out more. They might, for example, use the brush to place some highlights on another figure, for example on the top of the head or on a hand or foot, picking it out from the canvas, so to speak. All this we may see in the church of S. Rocco, to the right of the high altar, where Tintoretto skillfully painted the Imprisonment of St. Roch. Thus with many of these clever retouchings laid on dry in various places the painters seasoned their harmonious blend. Note that they never covered all the figures. Thus bejeweling them with vigorous brush strokes and often veiling the shadows with a thin overlay of bitumen, they breathed their spirit into it, always leaving great masses of half tones with many shadows and few areas in the light.

INVENTION

But what must be said of Invention, treasure conserved in the jewel box of fantasy, power of the soul, that lifts up the images and, guided by a fine understanding, consigns them to the governing hand that transmutes them into practice. It is this that arranges the whole together with the parts, places the substances, introduces the shapes, reconciles the occurrences, and renders the elements of the composition harmonious. This is the most essential part of painting. Without this it is not possible to begin the least thing, since it is the first and chief foundation of everything. The capable inventor must pay attention not only to the subject of the historical narrative or history that he must depict, but also all that happens in it and the circumstances. That is to say [he must be concerned with] the proper number of the individuals, the variety of the objects, the harmony of the colors, the site where the actions take place, the placement of the figures, the poses of the bodies, the passions of the soul, the diversity of the garments, the bizarreness of the thoughts, and the newness of things. He who has not this one main thing is not held worthy by others, nor will he ever be considered to be a master. But he who has a good understanding of how to express himself well cannot help but turn out to be a distinguished painter.

The number of distinguished and prodigious inventions is infinite. But I cannot be content without recalling the *Banquet at Cana* in Galilee painted by Paolo Veronese in the refectory of the Benedictine Monks at S. Giorgio Maggiore. [In this painting] invention is the queen of all the representations that have been made up to the present day by all the masters whatsoever. It makes all the other works tributaries and vassals, because in this painting there is invention, in the first place, in the forms of the buildings [which are designed] with greater architectural majesty than ever seen before. There is invention in the rich displays and in the ornamentation, invention in the becoming and extravagant garments, invention in the beauty of the color scheme, invention of arrangements in the poses of the figures, which are appropriate to [the individual roles of] the guests, the servants, and the attendants. There is invention too in the concepts, which are so various and so natural that one could not wish for anything more. But in the concept of the Savior and of the Blessed Virgin we see examples of Paradise, which stimulate in us the desire to venerate them. But the invention of the musical concert with four musicians could not be better conceived. With it Veronese wished to add flavor to his immortal work, for in those four figures he expressed the essence of what is fine in painting. The old man who plays the bass viol is Titian, the other who plays the flute is Giacomo Bassano, the one who plays the violin is Tintoretto, and the fourth, dressed in white, who plays the viola, is Veronese himself.

He who can better arrange musical harmonies in painting, let him step forward with his instrument. All told, neither in the composition of the whole nor in the details is there an invention so skillful, so exemplary, and so decorous! You, Veronese, are the savior of painting, for from you others draw extracts of the purest forms of beauty. You are that universal painter who pleases and amazes the whole universe. I regret only that I lack the invention to invent concepts that are sufficient for such merits.

Baldinucci

Filippo Baldinucci (1625-1696) is widely known for his historical and philological writings, which are discussed in the introduction to the section on Bernini (see pp. 109-11). He is not, strictly speaking, a theorist, but his role as a connoisseur and art counsellor lead him into theoretical considerations. In 1681 he published a letter (really an essay) addressed to Vincenzo Capponi, which deals with the problem of advising art lovers and collectors on how to acquire works of art, how to distinguish the style of one artist from another, and how to tell an original work of

art from a copy.[1] *We give below sections taken from Baldinucci's La Veglia,*[2] *a treatise which he published in 1684, in part as a defense of his monumental series on the lives of the artists, the* Notizie de' professori del disegno da Cimabue in qua. *From our standpoint, however, La Veglia is important for those sections that attempt to develop criteria for the evaluation of documents and source material.*

The essay takes the form of a veglia, *or conversation lasting long into the night, between two men, called Amico and Publio ("the Friend" and "the Public"), who are passing the time while caught in a downpour at an inn. Baldinucci, in the guise of Amico, cautions the historiographer against the naïve and uncritical acceptance of sources at face value. The scholar, he urges, should distinguish between manuscripts that seem merely to be a record of gossip, and others that are obviously chronicles, written down with serious historical intent. He should try to discover who wrote the manuscript in question, and if the writer was a man of good repute. The scholar attempting to judge the validity of his source materials should ask if the writer was in a position to have firsthand knowledge of the affairs about which he was writing. Did he live at the same time as the events he was describing? Was he at the scene to record the matters he describes, or would they have been available to him only indirectly (and thus less accurately) in another town, another region, another country? Most of these are questions the art historian still asks today. In formulating such questions at this early date (even though he makes little attempt to provide the answers) Baldinucci is taking an important step toward the development of a body of art historical methodology. If his advice was seldom taken in the century that followed, it is perhaps because he was too much ahead of his time.*

From La Veglia

Publio: It seems to me that your discussion proceeds with great fullness to the proof of your point. I also know that although it is prudent not to rush immediately to the conclusion that something is true, nevertheless it is also rash to wish immediately to condemn it as false. However I still have some difficulty as to what faith one should put in the manuscripts cited by Vasari. It seems to me (speaking in general, however) that for those who would write history and produce new informa-

[1] *Lettera di Filippo Baldinucci Fiorentino nella quale risponde ad alcuni quesiti in materie di Pittura, all'illustrissimo e clarissimo Signor Marchese e Senatore Vincenzo Capponi . . .* (Rome, 1681).

[2] Filippo Baldinucci, *La Veglia. Dialogo di Sincero Veri in cui si disputano e si sciolgono varie difficoltà pittòriche* (Lucca, 1684); republished in F. Baldinucci, *Raccolta di alcuni opuscoli sopra varie materie di pittura, scultura ed architettura* (Florence, 1765), pp. 58-62.

tion, there is considerable uncertainty as to the worth of private manuscripts.

Amico: You could not have added anything better in your discussion than the words "speaking in general," and in so doing you have touched me on a sore point. You may indeed know that if ever I were inspecting works [whose attribution] was supported by private (rather than public) manuscripts, which did not have those requisites that I think such writings must have to provide conclusive evidence, then I would not believe anything about them at all. The reason is this. I have observed that Mother Nature, liberally dispensing her gifts, does not hesitate to spread them among the multitudes without anyone's consent. Thus we see among those endowed with an inclination toward the most noble arts and the most important sciences not only those of high lineage but also those of the most humble birth. Among these latter are not only those whom Nature has endowed with considerable intelligence, but also those who are dull and stupid.

What happens in the case of an inclination toward the arts and toward the sciences occurs also in the inclination toward history. This last, Aristotle remarks, one encounters very frequently among all sorts of people. He proves it with the brilliant observation that children in general from the time they leave their mother's womb, have the desire to listen to stories, and that these stories are in substance nothing but mythical history. This did not surprise me at all, since I have seen the same thing with my own eyes. In examining materials in various archives and bookstores, there passed through my hands old diaries written by the most insignificant craftsmen. These diaries were filled with a great variety of events, related apparently with great precision, in such a way that you would have said that they came from the pen of some painstaking historian. However, on reading further in them I clearly recognized that the information in them had no greater foundation than that which the blockhead who wrote the diary could gather together every day from the talk in the square or the chatter of his fellow workers. Now because these manuscripts are old and full of news and descriptions, do they deserve to be believed? Anyone who believed them would have to be soft in the head.

Publio: What you say reminds me of a certain foreigner who had made a long journey in the course of which he also passed through our region. He also had an itch to write, and wanted to make, all by himself, a description in the form of a travel book. He inflated his writings with long rambling descriptions of places and customs and the like. He also had a lot to say about our affairs. Then he gave the manuscript to the printer. When the book got into the hands of people who were really knowledgeable and they got a whiff of its contents, they concluded

for certain that a good part of it was made up of the comments that he had gathered from place to place, from the innkeeper or waiter, while he was sitting at the table after he had paid the bill, or from the coachman or the boatman. And all he got out of his book was damage to his reputation and shame.

Amico: It served him right. We should then conclude that the old manuscripts (always exempting public writings) are to be believed when they have those qualities that in my opinion they must have to be believed.

Publio: And what are those qualities?

Amico: I will tell you what I think, and also I will give you some reasons for it, supporting my opinion by those who know more than I do.

I. First of all, that the things written about seem probable. That is, that they do not contain anything inappropriate, which would show that they are more of fables than truth. This is especially true in dealing with great and extraordinary events that take place in public. Since such things in general are widely acclaimed in their own day, it is hard to believe that we must rely on private individuals for information about them.

II. That the writings be of the sort that show that they have been composed with a sense of method, and with the thought in mind of writing historical information. For that which lacks order and a certain sense of purpose cannot be believed even though it is done with effort and diligence.

III. That the information does not contain a lie, even in the smallest part, because it is well known that he who gives out as a certitude something that he certainly does not know is not trustworthy. In regard to this Monsignor Lodovico Incontri of Volterra, a gentleman with wide experience and a great lover of these arts, used to say that he admired the boldness of a person who took up the trade of handling the brush more than that of anyone who was in any other line of work. This is because he has to give evidence with his own hand against himself, not only for his own times but also for future ages—evidence, that is, of his untruthfulness, every time he has a failure, even if it is not in anything important.

IV. That there be some signature or name or profession or some other aspect of the writer sufficient to give some idea of who he is. Because many people say a lot of things and many people write a lot of things, but it is not the writings as writings but men as individuals who win the faith of the experts. And when some of these circumstances are lacking they can be supplied in large measure by the knowledge that good writers have made use of such private manuscripts and have demonstrated their faith in them.

V. That the writer deals with material he knows something about. In this regard you may note that Vincenzo Borghini, a most learned man, had faith in what Villani wrote about Florentine coinage because he knew that that author had been director of the Mint.

VI. That the writer belongs to the same period of time as the things about which he writes. Here one recalls that Borghini himself by no means rejected various things in the *Ricordano Malaspini* and in the writings of Giovanni Villani, which discuss things that did not take place in their own period. For this reason they are very dubious and should not be approved.

VII. That they contain accounts of things that took place in their own country, or in those about which they could easily have information. If you ever read the works of Strabo and Stephanus, both famous authors [known for their geographies, first century B.C. and *c.* 500 A.D., respectively] you would have found that they were most accurate in their descriptions of Greece and the Levant but less accurate in the lands in the West. In these sections their descriptions were very much shorter, and often not as careful in the small-scale details that frequently throw a good deal of light on the discussion. Hence, just as one places greater reliance [on their writings] when they deal with places they visited often, so one places less faith in [what they say of] those places that they did not frequent, or that they never saw. Now figure it out yourself. Put it this way. If such a description must apply to the faith one puts in the writings of the great authors, what faith should one have in ordinary private manuscripts, which sometimes, indeed often, turn out to be left by stupid, enormously credulous men who should have hidden their own thoughts and weaknesses, instead of giving evidence of such things to posterity?

Le Gros and the Jesuits

In the room where St. Stanislas Kostka died, at the Jesuit novitiate besides Bernini's church of S. Andrea al Quirinale, is the famous statue of the saint on his deathbed by Pierre II Le Gros (1666-1719).[1] Though he was born in Paris, Le Gros spent most of his life in Rome. Easily the outstanding sculptor in the papal capital during the early years of the eighteenth century, he carried out several major commissions for the Jesuits, among them the central figure for the altar complex in the chapel of St. Ignatius at the Gesù, and the huge altar dedicated to St. Louis Gonzaga in S. Ignazio.

[1] For Le Gros see Pierre d'Espezel, "Notes historique sur l'oeuvre et la vie de Pierre II Le Gros," *Gazette des Beaux-Arts*, 6th series, XII (1934), 148-60.

It was apparently Le Gros who proposed that the statue of St. Stanislas Kostka be transferred from the novitiate to the church. This proposition, which the Jesuits at S. Andrea opposed, was judged sufficiently important to have been examined at a conference over which the Jesuit General himself presided. The following documents, which Francis Haskell discovered in the Jesuit archives, contain: first, the Jesuits' reasons for rejecting the proposal; next, the rejoinder by Le Gros; and last, the Jesuits' rebuttal of Le Gros' rejoinder.[2] The discussion is notable at this date, early in the eighteenth century, for the sophistication of the arguments, which deal at length with both devotional and aesthetic aspects of a work of religious art in relation to its setting.

Le Gros' marble figure is remarkable for its polychromy, which greatly increases its realism. The sculptor used white Carrara marble for the head, hands, and feet of the figure plus black Belgian marble for the Jesuit habit. The saint (who is referred to in the documents as the Blessed Stanislas because at the time of writing he had been beatified but not yet canonized) lies on a mattress made of mottled yellow marble (giallo antico) set on a green marble base (verde antico). Now the statue is lit by electric lights that rob it of most of its suggestiveness, but reports in the eighteenth and nineteenth centuries stress its shock effect. Coming into the dimly lit, low-ceilinged room where the saint died, many recoiled at seeing on the bed the barefoot, black-robed figure, which at first they mistook for a corpse. The Jesuits were quick to grasp the value of this sense of the physical presence of death as an incitement to piety. It is so completely consistent with the methods used by the founder of their order, St. Ignatius of Loyola. In his Spiritual Exercises *the exercitant is continually urged to employ all his senses to recreate metaphysical reality in physical terms. The obvious fascination that Le Gros' statue has for many people, as well as the revulsion it has for some (they speak of it as being "in bad taste" and "shocking"), in both cases owe a great deal to its macabre quality.*

For the Jesuits then, the first considerations were religious. If the

2 Francis Haskell, "Pierre Legros and a Statue of the Blessed Stanislas Kostka," *Burlington*, XCVII (1955), 287-91. In the same article Haskell publishes a document indicating that the Jesuits resolved to commission the statue in 1702 and that Le Gros had finished the work by 1703. Although the three briefs dealing with the proposal to move the statue are neither signed nor dated, Haskell is certainly correct in assuming that the second is by Le Gros, both on the basis of the internal evidence and because the final report is headed "Note Concerning some Errors in Monsieur Legros' Report." At the same time it would seem probable that Le Gros had the help of a lawyer who provided some of the legalistic language that crops up in his report. The documents are undated, but they must have been written before Le Gros' death in 1719 and after 1706, at which date the decorations of the Chapel of St. Philip Neri in S. Girolamo della Carità, to which Le Gros refers in his rejoinder, were completed.

marble statue were moved to the church and a plaster copy put in its place, the copy would not stimulate the same degree of piety.

Le Gros' counterarguments are ingenious. The multiplication of images increases the piety, not the other way around. Those who say otherwise, he suggests, come close to the position of Molinos, "who forbade all sacred images except one." This was a real rapier thrust: the Jesuits had only recently made an all-out effort to condemn as heretical the cult of Quietism, which was promulgated by the Spanish priest Miguel de Molinos. Quietism was a new, extremely passive form of mysticism with strong tendencies towards apathy. In the last quarter of the seventeenth century it had swept Rome, not without the hint of scandal. After the most strenuous efforts the Jesuits succeeded in having Molinos condemned to prison, where he died in 1697. In the first years of the eighteenth century his memory still haunted the pragmatic, worldly leaders of the Society of Jesus.

Le Gros' other arguments about the proposed copy are less telling. It is not entirely true, in the case of the statue of St. Stanislas, that "it is not the material that stimulates piety." Plaster cannot be as finely worked as marble, nor given the same smooth luminous surface. It is all very well for Le Gros to point out rather smugly that "images are adored, not caressed." Nevertheless, it is the Jesuits who are right when they argue that statues are cleaned (especially when placed where the dust is easy to see and remove) and anyone familiar with the plaster or "stucco" figures in the churches of Rome knows they are easily broken—much more so than marble.

The most extensive arguments of the Jesuits are the aesthetic ones. The statue would be out of proportion to the chapel in the church. To emphasize the chapel of St. Stanislas through the addition of special embellishments would destroy the over-all unity of Bernini's design. The church as it was was an artistic masterpiece.

In order to know what both sides are talking about it is necessary to visualize the church. Sant'Andrea is a rather small building, not nearly as large on the inside as it seems in most photographs. The lateral chapels, being small and rather shallow, lend visual support to the Jesuits' contention that they were planned for paintings, not statues. However, both sides indulge in sophistry. Le Gros throws up a smoke screen about square vs. arched niches—a purely terminological argument—whereas the Jesuits argue curiously about the illumination. They say that in the chapel the light comes from above, so that Le Gros' figure would receive light on its shoulders while its face was in shadow. In point of fact the whole church is lit chiefly by the lantern and the large windows at the base of the dome. On a good day this light fills the center of the church and passes directly into the chapels. There it provides

excellent frontal lighting for anything over the altar as long as it is not too high. The side chapels have one small window high up below the vault. It provides almost none of the light that falls on the face of the altarpiece.

To our way of thinking the Jesuits' strongest argument is that to make the chapel of St. Stanislas more lavish than the others—above all, to give it a different facing than the rest—would be to ruin the aesthetic unity of Bernini's church. Certainly Bernini must have insisted that the lateral chapels be uniform. Because of their ample entrance and shallow depth they become visual extensions of the nave.

The examples Le Gros gives of individual chapels that have been made more lavish than others in the same church are, for one reason or another, all inapplicable to Sant'Andrea. The Sistine and Pauline chapels in S. Maria Maggiore, though huge, almost like separate churches, are entered through relatively small, low archways, not from the nave but from the side aisles. As a result, in spatial terms, they are quite separate from the rest of the church.

Le Gros also mentions the Chapel of St. Louis Gonzaga in S. Ignazio. It is in the right transept. At the center of its altarpiece is an enormous marble bas-relief by Le Gros. Certainly Le Gros' altar must have seemed out of proportion for not very long after the left transept was provided with an almost identical altarpiece adorned with an equally large marble relief by Filippo della Valle.

The altar of St. Ignatius at the Gesù, in which Le Gros' sculpture plays a major role, occupies the left transept. Being more lavish than the others it produces an aesthetic imbalance. Had the Jesuits been able to carry out their original plan to dedicate the high altar (instead of a transept altar) to their founder, this would not have happened. As it was, patronage problems intervened. Besides, entirely unlike that of Sant' Andrea, the decorative program at the Gesù was not developed in accordance with any master plan. Instead it evolved in a series of campaigns that were not concluded until more than a century after the architect who designed the church had died.

The Jesuits had further aesthetic arguments, such as the one about the visual effectiveness of alabaster when seen at a distance—arguments that demonstrate extraordinary sensitivity to the properties of stones used in architectural decoration. But also, being practical men, their final argument was financial. There simply was not enough money to do the job properly.

Throughout the whole controversy both Le Gros and the Jesuits provide us with a fascinating glimpse of the eighteenth century man— just beginning to emerge at the dawn of the Age of Enlightenment— carefully examining a work of religious art.

From the Jesuit Archives: a Set of Briefs and Counterbriefs

The transfer of the statue of the Blessed [Stanislas Kostka] from the little chapel to the church is universally rejected for several reasons. The first is that it would ruin the chapel to do away with the piety the statue instills both in residents [of the Novitiate] and outsiders, including cardinals and priests. In that place where it is now, among the shadows of the room, it appears to those who enter like a dead man on a bier and moves them greatly. In the church it will inspire as little piety as the statues of the saints do on the altars where their bodies lie. With the diminishment in piety will come a diminishment also in the esteem in which the work is held, because it is appreciated more from nearby than at a distance. Nor will it help maintain the devotional aspect of the chapel and the frequency of visits to it to bring in another statue like it made out of plaster, because in a short time it will be damaged and have parts broken off by whomever takes care of it, as happens with novices. Also few people will come to see the copy and it will inspire little piety if the original is exposed to the public in the church.

The second reason is that it would ruin the chapel in the church, because the space that ought to be filled with a painting is not at all the right size for the statue, nor is the statue the right size for the space. The empty square inset, without being graced on any side by an arched enframement, could never form a niche that would please the eye of the connoisseur. Nor could the statue, which is only two *palmi* high [about 1½ feet], go well in a space more than twelve *palmi* high [about 8 feet, 9 inches]. And then, the ornamentation that they want to add there would only succeed in disturbing the experts, and putting a bad taste in their mouths. Bernini's chapel at S. Maria della Vittoria and that by Borromini at S. Giovanni dei Fiorentini are praised because they are pleasingly enframed, the figures are well proportioned to the site, and the light from the windows that shines directly on them adds grace and beauty. But this statue of the Blessed Stanislaus, with an awkward niche, with the statue turned around, and with all the light on the shoulders and the shadows on the face, can win for the chapel as much criticism as those other chapels win applause.

The third reason is that it would ruin the best part of the church because, since the church is uniformly oval, one also wants uniform components for the chapels, which can all be enjoyed at a glance from the midst of the church. Cavaliere Bernini was emphatic in wanting this uniformity, and therefore he persuaded the Most Excellent Prince Giovanni Battista [Pamphili] to have all four spaces made instead of just one that he wished to build lavishly in honor of St. Francis Xavier. This

advice was followed so firmly by the prince that he never wanted any other chapel in the church, which is his, to have any other facing, although several times there were requests to this effect. For this reason, right at the beginning, they had eight uniform columns of Sicilian marble brought in in order not to allow for any variation as to the quality of the stone.

It is not a good idea to depart from the wish of the Prince nor the opinion of Bernini. It seems even less appropriate to change the jasper columns, which form a series of rare beauty and top quality. Any other stone would destroy the uniformity and would never go well with the columns of the other chapels. It will never be as lovely as the jasper joined with the green and yellow in the Blessed Stanislas' chapel.

The flowered eastern alabaster that someone proposed cannot be found in high quality and uniform color in quantities as large as the 108 *palmi* that are needed for the two columns, being quarried in numerous small pieces of various kinds. Alabaster is inarticulate when seen at a distance, and the color appears weak, smoky, and lifeless. This one sees from the displays of the finest alabaster set on top of altars. This is why you do not see alabaster columns used in any chapel. It serves only for little tables or for mirrors, being enlivened with enframements of darker, more intense colors. Now the Prince will let it be done, but when he hears the new work criticized by experts, he will be able to complain that the will of the donor was not carried out and the advice of Bernini was not followed, all the more so because it is possible to make the Blessed Stanislas' chapel richer, more lavish and nobler than the others without destroying the uniformity, and without exorbitant expense.

If one could hope for as much as ten or twelve thousand *scudi* to spend on this chapel, then in such a case one could compensate for the damage to the unity by the richness and magnificence of the work. But today one cannot hope for such a sum, neither from the outside nor from the religious house, which finds itself distressed at the great expense of the canonizations that will probably take place, together with the expense of the chapel. Thus we see no reason to abandon Bernini's concept, which the Prince considered stabilized. Although no one will ever criticize the chapel for its uniformity, its diversity could bring on much unpleasantness and cause it to be criticized by everyone.

REFLECTIONS ON THE REASONS GIVEN FOR NOT TRANSFERRING THE BLESSED STANISLAS

The preamble speaks of [the proposal's] being universally rejected, and this is false. This universality is assumed but not proved. On the

contrary it is known that at the conference that the Father General held at the Collegio Romano on this matter with the architect and other experts, everyone approved this transfer except one priest to whom, notwithstanding his many virtues, cannot logically be attributed the quality of universality.

The other points are considered briefly as follows:

1. The piety that the statue is said to stimulate in the little chapel will be equally stimulated by a similar statue of the same shape in the same place, since it is not the material that stimulates piety but rather what is represented by it, whether it is marble or plaster or metal. In the church the statue will increase the faith. There it will be accessible to lay people of all sorts, of both sexes, whereas in the religious house it is visited by few, and rarely. It is false to say that the saints inspire little piety on the altars in which their bodies are. People visit the church of S. Anastasia, S. Cecilia, S. Leone in S. Pietro, S. Sebastiano, S. Agnese fuori le mura, [the chapel of] the Blessed Albertoni in S. Francesco a Ripa, [the chapel of] Pius V in S. Maria Maggiore, [the chapel of] St. Ignatius at the Gesù, [the chapel of] the Blessed Louis Gonzaga in S. Ignazio, all of which have both the body and the statue of the saint. They also visit [the chapel of] St. Theresa of Avila in S. Maria della Vittoria, [the chapel of] St. Philip Neri in S. Girolamo della Carità, and elsewhere where they venerate the statues of other saints, although the bodies of these saints are not there. But the statues of the saints are there and these excite piety. And why should not the Blessed Stanislas, represented by his statue, enjoy this esteem?

2. It is claimed that if another statue—one made of plaster—were placed in the little chapel in the religious house it would soon be broken. But it is hard to say on what this is based, since the images are adored, not caressed by those who venerate that which the image represents. The statement that if the statue were duplicated it would no longer be venerated is also without foundation, nor can anybody see why [this should be so]. If one induces piety, more of it will be induced by two, placed, however, in different locations. No one will ever say that the duplication of the images of the crucifixion, of the Virgin, or of the saints in many, many churches, diminishes piety. Instead the veneration given to God and the saints increases through the multiplicity of their images. To say differently comes close to the teachings of Molinos, who forbade all sacred images except for one. When images are miraculous they are duplicated to increase piety. This happened in the case of the [statue of the] Madonna of Loreto, the one in Peru called Copacavana, and many others. When they are not miraculous, in venerating them one does not think about whether they are originals or copies by an artist. Also, by having

the same artist make the copy of the Blessed Stanislas, it will be possible to say that both are originals. And both will serve to stimulate the same devotion in those who venerate them.

3. The reason advanced, that it would ruin the chapel, is without foundation, for the statue would beautify rather than ruin the chapel. It is falsely asserted that the site is the wrong size, because if one measures it one can see it is just right for the desired effect. How can anyone say that a square space cannot form a niche that is pleasing to the eye of the connoisseur? What architectural principle determines that niches must be arched, and cannot be square, or indeed oval, or any other shape that the architect likes? In almost all "pictures," so called because they are neither oval nor round [for "picture" the writer uses the word *quadro,* which means both "picture" and "square"], niches of all sorts are simulated and look nice in painting. Why then would not an arched, well-disposed niche containing the statue and placed in a real square enframement, please the connoisseurs? Grant it the disparity if you will, but then try it.

The statue is not just two *palmi* high as is maintained. It includes the bed and the base on which it rests. Nor does the niche have to be completely filled by the statue. By the same token one never sees ceilings and vaults so low that the rooms underneath are completely filled up by the people who live in them. Thus on what grounds can a person say that the statue cannot take its place properly in an empty space twelve *palmi* high? On the other hand it would be an error if one saw it set into a tomb, the way one sees the bodies of the holy martyrs in the catacombs of Rome.

The ornamentation that could be made should not be called disturbing and displeasing to the taste of connoisseurs, since everyone will see that it will be adapted to the most refined tastes. Otherwise one could say the same thing about all the ornamentation of the walls, all the statues and paintings, and it would be well to exclude any kind of decoration from the churches and palaces in which they are placed.

4. If one approves of the chapels by Bernini and Borromini, then it follows that one must approve of the chapel that is under discussion. Whether the rim of the opening is square or round does not demonstrate anything, as has been said. If one approves of it because it is arched inside, the legitimate deduction would be that if the empty space is arched inside it must be approved, like that by Bernini. But one sees that the chapel of the Blessed Albertoni in S. Francesco a Ripa, which is not arched, nonetheless is praised and approved of by the experts. It is said that the light would be behind the statue but that is false because the statue will have the light from the church in front of it. If that is

enough to illuminate the painting on the altar it will also be sufficient to illuminate the front of the statue.

5. Under number five it is boldly asserted that it would ruin what was most beautiful in the church, nor would one know how it would look with the base. The church would remain as is. By placing the statue in the chapel one would add a suitable and substantial decoration to the chapel. There remains [the question of] the uniformity of the chapels in relation to the architectural mass. These chapels are already decorated diversely, and are praised as being suitable to the church. Why should not the chapel of the Blessed Stanislas be enriched with such ornamentation? If Prince Pamphili did not want anyone else to build a chapel in the church it was so that the glory of his beneficence and his piety would not be diminished, as it would be if it could be said that it was not built entirely by him but in part by others. And it was not for the motive that is assumed but not proved. If one wishes the adornment of the columns to be Sicilian jasper, and if one denies greater ornamentation to the chapel of the Blessed Stanislas, in so doing one rejects the wish that everyone has to see the chapel of this saint richer and more beautiful than the others. The chapels in churches that are more ornate than the other chapels do not ruin or stand in opposition to the church. Otherwise we would have to demolish all [the chapels like that] that there are in Rome, beginning with S. Maria Maggiore, as well as that of St. Ignatius in the Gesù, the one of the Blessed Luigi Gonzaga in S. Ignazio, and many others built with vast treasure.

6. In the sixth point, flowered eastern jasper is rejected. But if one wishes to construct the chapel with richer adornment than the others, as is maintained, why should one choose Sicilian jasper, a very inferior and ordinary stone? Why not choose flowered jasper, a rare and splendid looking stone?

7. In number seven the preciousness and beauty of the chapel is not rejected but [the project] is refused because of the lack of money. In order to proceed in this matter with the necessary prudence and caution, the only way is to make a model, and color it so as to represent the projected ornamentation. This is what was decided on in the conference, but up until now has not been carried out. In this model Sig. Pietro Legros will arrange the ornamentation and the statue in a way that could be carried out in full scale. This done, it can be examined by experts, and determined whether or not it contradicts the badly thought out concept of those who propose baseless difficulties. With this too it will be possible to find out what is the pleasure of the Prince, who without doubt will act in accordance with the judgment of the experts, and not of persons of the sort who often prescribe medicine and remedies

for the sick without having studied the profession of medicine. Finally, with such a model, one will be able to see what kind of stone is most suited to the symmetry of the parts, and it will be possible to make an exact estimate of the expenses necessary for such a project. And thus, without letting one's fancy roam, it will be possible to work with security, and to the satisfaction of all.

NOTE CONCERNING SOME ERRORS IN MONSIEUR LEGROS' REPORT

1. At the conference very few people were in favor of having the model made. No one outside the conference was in favor of the transfer of the statue.

2. The stucco statue would soon be ruined and parts broken off by whoever had to dust it every so often.

3. The Most Excellent Prince Camillo [Pamphili], who built the church, and Prince Giovanni Battista never showed any desire to build the chapel. It is only that Prince Giovanni Battista, who wished to make, for his devotions, a richly ornamented chapel in honor of St. Francis Xavier, and to spend ten thousand *scudi* on it, was advised by Cavalier Bernini that with the same expenditure he should make all the four chapels uniform in order not to spoil the beauty of the church, as the beauty of S. Agnese in Piazza Navona would be spoiled if the four chapels beneath the dome were not uniform. All this is well known to those who are knowledgeable about this matter that took place about 43 years ago.

4. The columns of flowered jasper would cost no less than two thousand *scudi*, which would use up the larger part of the funds put aside for this chapel.

The other errors are left for the reader to examine with his own good judgment.

LIVES OF THE ARTISTS

Carracci

Giovanni Pietro Bellori (1613-1696) is known above all for his artistic theory (see pp. 5-16), but his Lives of the Modern Painters, Sculptors, and Architects, *which appeared in Rome in 1672, made an equally important contribution to the history of art. In his book he makes it clear that he has no interest in writing on all the artists of his time as others had done. Instead he deals only with a few, selected according to his own predetermined criteria. Those who meet Bellori's standards are the architect Domenico Fontana; the sculptors Alessandro Algardi and François Duquesnoy; and the painters Annibale and Agostino Carracci, Federico Barocci, Michelangelo da Caravaggio, Giovanni Lanfranco, Nicholas Poussin, Peter Paul Rubens, Anthony Van Dyck, and Domenico Zampieri, called Domenichino. He recognizes Caravaggio's genius only begrudgingly, and passes over Bernini in silence. But despite such prejudices, which reflect Bellori's strong classical bias, the choice is remarkable. Today no specialist in Baroque art would call any of these artists obscure, and some must be ranked among the greatest names of the century. It is also worth noting that Bellori's choice includes three Flemish artists and a Frenchman, an indication of Rome's position at that time as the leading international center of art.*

Bellori's essay on Annibale Carracci is to be read in the light of his preconceptions, which are often far from our own. He believed, as did most art historians only a generation or two ago, that mannerism was a degenerate and corrupt form of the art of the high Renaissance. Unidealized realism was equally to be condemned. Instead it was the paintings of Annibale Carracci that restored art to the lofty heights it had reached with Raphael. Their art fit his theories. Both Raphael and Annibale studied the human form directly, then idealized what they saw. Both studied the art of classical antiquity and drew inspiration from the antique.

Bellori also reflects the classical doctrine (which goes back ultimately to the Ars poetica *of Horace) that the purpose of great art is to instruct as well as to delight. According to this theory art, in order to reach the highest level, must deal convincingly with themes that encourage virtuous conduct, elevate the mind, or lead the observer to a morally correct choice. By far the largest section of his life of Annibale is de-*

voted to the frescoes on the vault of the Farnese Gallery. These paintings Bellori interprets, in accordance with Neoplatonic doctrine, as an allegorical struggle between heavenly and earthly love, which concludes by "showing that victory over irrational appetites elevates man to heaven."

There can be no doubt that the doctrine that art should serve to instruct both molded and limited Bellori's point of view. It worked well with Annibale's mythologies and his religious paintings, in which he could usually find some message of moral uplift, but he was hard put to apply the same sort of maxims to the landscapes. Instead he passed over them hurriedly, almost as if they embarrassed him. He never understood the nature of Annibale's contribution to the development of the classical landscape, which we find so impressive today. Bellori does discuss Annibale's caricatures, which he finds amusing, and one or two genre drawings, which he seems to have appreciated for their anecdotal value. He does not mention Annibale's genre paintings—perhaps he did not know them—but he would certainly not have approved if he had.

Nevertheless, Bellori remains by far the best single source for Annibale. Referring to Bellori's Lives *Martin writes, "Annibale Carracci is the real hero of the book, and the Life of that artist provides a valuable corrective to Malvasia's highly colored account . . . His descriptions of the great works of the Roman years, above all the Camerino and the Galleria Farnese, still form the indispensable starting point for the study of these monuments."* [1]

From Bellori's Le Vite de' pittori, scultori ed architetti moderni

BOLOGNA [2]

When the divine Raphael with the ultimate outlines of his art raised its beauty to the summit, restoring it to the ancient majesty of all those graces and enriching the merits that once made it most glorious in the presence of the Greeks and the Romans, painting was most admired by men and seemed descended from Heaven. But since things of the earth never stay the same, and whatever gains the heights inevitably must with perpetual vicissitude fall back again, so art, which from Cimabue and Giotto had slowly advanced over the long period of two hundred and fifty years, was seen to decline rapidly and from a queen become humble and common. Thus, with the passing of that happy century, all of its beauties quickly vanished. The artists, abandoning the study of nature, corrupted art with the *maniera*, that is to say, with the

[1] John R. Martin, *The Farnese Gallery* (Princeton, 1965), p. 11.

[2] The following passages are taken from Giovanni Pietro Bellori, *Le Vite de' pittori, scultori ed architetti moderni* (Rome, 1672), in the English translation, by Catherine Enggass, of Bellori's *Lives of Annibale and Agnostino Carracci* (University Park, Pa., 1968).

fantastic idea based on practice and not on imitation. This vice, the destroyer of painting, first began to appear in masters of honored acclaim. It rooted itself in the schools that later followed. It is incredible to recount how far they degenerated then, not only from Raphael but from those artists who had introduced the manner. Florence, who boasts of being the mother of painting because of her very glorious professors, and the whole of Tuscany were silent without the lauds of painting. Artists of the Roman School no longer lifted their eyes to the many antique and modern examples, consigning all praiseworthy advantage to oblivion. And although painting endured longer in Venice than elsewhere, neither there nor in Lombardy was that bright tumult of colors more to be heard. It ceased with Tintoretto, the last of the Venetian painters until the present. I have more to say that will seem fantastic: neither within nor without Italy could a painter be found, although not much time had gone by since Peter Paul Rubens first carried colors out of Italy. Federico Barocci, who might have been able to restore and give aid to art, languished in Urbino: he was helped by no one. During this long period of agitation art was assailed by two opposing extremes, one completely subjected to realism, and the other to imagination. The creators in Rome were Michelangelo da Caravaggio and Giuseppe d'Arpino. The first merely copied the bodies as they appear to the eye; the latter, no longer observing nature, followed his unrestrained instinct. And the one and the other, favored by the brightest fame, were admired and copied by everyone.

Thus, when painting was drawing to its end, other, more benign influences turned toward Italy. It pleased God that in the city of Bologna, the mistress of sciences and studies, a most noble mind was forged and through it the declining and extinguished art was reforged. He was that Annibale Carracci, of whom I now mean to write, beginning with his very rich nature from which sprang his happy genius, thus coupling two things rarely conceded to man: nature and supreme excellence.

For a long time Annibale had been anxious to go to Rome where the fame of Raphael and the works of antiquity attracted him efficaciously, and where men of the most elevated minds are wont to assemble. His goal was encouraged by the acquaintance and favor he had attained with the Duke of Parma. The fame of his brush had already traveled to that city and to other parts of Lombardy. Therefore Annibale was summoned when Cardinal Odoardo Farnese wished to adorn his gallery and some rooms of his celebrated palace in Rome with paintings.

THE FARNESE GALLERY

The gallery situated on the west front of the Farnese Palace was added by Giacomo della Porta at the order of Antonio da San Gallo.

It extends ninety *palmi* in length and twenty-eight *palmi* in width. The two lateral walls are divided lengthwise by pilasters and flat columns that support the cornice. The cornice is divided into seven spaces, three larger ones and four smaller ones, in such a way that each of the large spaces is flanked on either side by smaller spaces. Thus, on the cornice and on each side of the wall that rises round the circumference of the vault Annibale painted the frieze, with sham pilasters of chiaroscuro directly over the actual ones of about fourteen *palmi* in height that support the frieze. In the three larger spaces he transferred pictures in lifelike colors within frames of feigned stucco. In the four narrower spaces he made round medallions of a green-bronze color. Between the paintings, as between the medallions, are interspersed very beautiful figures of terms of feigned stucco. Their upper bodies imitate the human form, and their lower halves diminish into pedestals in the antique manner. These terms, which support the vault, are placed in front of the pilasters on bases. Some have brackets on their heads, which support the ornamentations higher up. Upon the bases on either side sit an equal number of nude youths painted in lifelike colors. They are turned toward the medallions and hold on to the festoons garlanding diverse masks, which give completion below.

In order to make the frieze more varied and in order to interrupt the unbroken order of paintings and medallions, Annibale painted in the middle of each side wall large pictures. With their gold frames they overlap almost half a medallion on either side. In this way the division is varied and enriched so that it could not be more pleasing to the sight. At the top center of the vault, is the great Bacchanal, embellished by a frame of feigned stucco seen from below. It is flanked by two octagonals, each more than sixteen *palmi* in length and nine *palmi* in width. Who could adequately recount the components of these decorations, seeing the whole arranged with such stupendous variety that the components in their similarity are dissimilar and constantly changing in beauty?

THE THEME OF THE PAINTINGS

Before describing the myths it is useful to point out the four cupids painted in realistic colors in the four corners of the gallery above the cornice, as the whole concept and allegory of the work depend on them. The painter wished to represent with various symbols the strife and the harmony between Heavenly and Common Love, a Platonic division. On one side he painted Heavenly Love fighting and pulling the hair of Common Love, symbolizing philosophy and the most holy law taking the palm from vice and holding it high. Therefore in the center of the light glows a wreath of immortal laurel, showing that victory over irra-

tional appetites elevates man to Heaven. On the other side he symbolized Divine Love taking the torch from Impure Love in order to extinguish it, but Impure Love defends himself and shields it by his side in back. The other two putti embracing are Heavenly and Earthly Love and emotions united with reason, of which virtue and human welfare consist. In the fourth angle Anteros is shown taking the palm from Eros in the way in which the Eleans arranged the statues in the *gymnasium:* Anteros felt that he had punished Eros unjustly. As a foundation for these moderated emotions Annibale added the four virtues: Justice, Temperance, Fortitude, and Charity, painted figures seen from below. They allude, along with the myths, to Heavenly and Profane Love.

ALLEGORY OF THE FABLES

Annibale continued in the gallery the manner observed in the first room we described, ordering various myths toward an end: the theme, as we have seen, is human love governed by Heaven. Thus the theme of love, so prominent in the various myths, displays its power, subjecting the breasts of the strong, the chaste, and the savage: the loves, that is to say, of Hercules, Diana, and of Polyphemus, whose jealous fury against his rival Actis is shown. The amours of Jupiter, Juno, Aurora, and Galatea reveal its power in the universe. The white wool that Diana receives from the god Pan and the golden apples given to Paris by Mercury are the gifts by which Amor sways human minds, and the discords provoked by beauty. The Bacchanal is the symbol of drunkenness, the source of impure desires. And since the end of all irrational pleasures is sorrow and punishment, because if Virtue is disregarded by others they are a prey to despair, he painted Andromeda bound to the rock to be devoured by the sea monster, symbolizing that the soul bound to emotion becomes the food of vice if Perseus—that is to say, reason and the love of the worthy—does not come to her assistance. Most beautiful is the allegory of Phineus and his companions transformed into stone at the sight of Medusa, who is meant as voluptuousness.

The medallions follow: Perseus abducting Orithyia; Salmcis and Hermaphroditus; the god Pan embracing Syrinx; Europa abducted by the Bull; Leander drowning; Eurydice returned to Hades. They represent the vices and the harm deriving from profane love, in contrast to Apollo flaying Marysis, which is meant as the light of wisdom removing the bestial outer skin from the soul.

The Cardinal wished to reward Annibale for his efforts in the execution of so many works since he had been in Rome, a period of eight years. And while Annibale expected the fruit of that Prince's gener-

osity, fortune opposed him through the evil guidance of a favored courtier, Don Juan de Castro, a Spaniard, who was wont to insert himself in all the affairs of his patron. That man made up an account of the bread, wine, and provisions for the entire time Annibale had been in the palace and debited him for it, and convinced the Cardinal to reward him with only five hundred gold *scudi*. That sum was brought in a saucer to Annibale in his room. Poor Annibale was struck dumb and was unable to react to the incident. His displeasure showed clearly in his face, not in regard to the money, which he certainly did not value, but by the thought of having wearied his spirits with no hope of a respite concerning the necessities of life, and of being an object of the iniquity of the mighty. Such is the infelicity of the court of princes and of the fine arts, when some oppress others in order to gain advantage and to appropriate all favor to themselves, driving out virtue with ignorance and presumption.

I cannot help but reflect on human affairs at this point, seeing that some few brush strokes, or—better—jests from his brush, now command an equal or greater price than he received for the Gallery. So much can the mere name of virtue, which in most cases is brought to light too late, do.

Annibale was adroit not only in making witticisms and jests with words but also with the jocularities of his drawings, many of them done by pen. Thus originated the delightful burlesque portraits or caricatures, as those drawings are sometimes called, of figures altered according to their natural defects, making us laugh by their ridiculous likeness. Such drawings, which bring out the worst features, he usually used for poets. He drew the portrait of a hunchbacked poet with Mount Parnassus on his back, together with a hunchbacked Apollo and Muse. In the same way he represented Marino in his gallery saying: "I carry Mount Parnassus on my shoulders." And to make known Annibale's ingenuity in accommodating burlesque lines to his drawings, he wrote under the portrait of an ugly longnosed courtier playing the part of a beau these lines:

> *Nature was anxious not to make him casually*
> *She enlarged his mouth and elongated his ears*
> *But forgot to fix his nose.*

Some of these drawings are in the hands of scholars, but those conserved in the book of caricature portraits that Signore D. Lelio Orsini, Prince of Nerola, has among his very select drawings, are the most humorous and delightful, with diverse jocularities of strange and mirthful faces drawn by pen and with pleasing captions. Annibale also employed physiognomy in another way, giving a human likeness to animals; but an even stranger imitation was with inanimate objects, since he would

transform a man or even a beautiful woman into a pot or jar or other implement.

From a poem by Cavalier Marino on the death of Annibale Carracci

> He who once gave to naught the power to be
> Behold is now himself to naught dissolved;
> He who gave canvas life 's a lifeless form.
> From him who from dead hues so oft evolved
> Live colors, death has now all colors shorn:
> Well might you find
> The way to make equal in kind:
> Nature as rich as his, as lush
> Had you his brush.

Caravaggio: Part One

Michelangelo Merisi da Caravaggio (1573-1610) holds first place among the painters of the Italian Baroque. This was not always so, but his works did make a great impression in Rome at the very end of the sixteenth century and the beginning of the seventeenth. This was apparently insufficient to win him a sympathetic biographer who understood what he was trying to do. The role is certainly not filled by Giovanni Baglione, who brought a law suit against him, nor by Joachim von Sandrart, who never met him, nor by Giovanni Pietro Bellori, whose life of Caravaggio appears below: [1]

Among the early critics who wrote more than a few lines on Caravaggio, Bellori is probably the most intelligent and certainly the most learned. That he included Caravaggio in his highly selective book of artists' biographies is by itself recognition that he considered him important. But he could not bring himself to like him. The trouble was that Bellori was an extreme classicist. This colored everything he wrote (see pp. 5-16, 70-75). Nothing that Caravaggio painted in Rome could really be called classical in a stylistic sense, and some of his early works have been interpreted as being consciously anticlassical, though the antithesis between Caravaggio's manner of painting on the one hand and the Baroque classicism of Annibale Carracci on the other is much stronger in the mind of Bellori (who wrote in the latter part of the seventeenth century) than it was when Caravaggio was still alive.

[1] Bellori's life was published in his *Vite de' pittori, scultori ed architetti moderni* (Rome, 1672), pp. 201ff. The text given below is abridged from the English translation in Walter Friedlaender's *Caravaggio Studies* (Princeton, 1955), pp. 245-54.

Bellori had one basic formula for the creation of beauty. The artist was to choose from nature the most beautiful objects and then select and combine the most beautiful parts of each. In this way it was thought that he would achieve an ideal beauty, superior to anything in nature. A corollary of the formula was to study the sculpture of the ancients and the paintings of Raphael, because the selective syntheses already made by these masters produced ideal beauty that was wholly admirable. In Caravaggio, however, Bellori saw nothing but a realist, plain and simple, incapable of abstraction. "The moment the model was taken away from his eyes," he wrote, "his hand and his imagination remained empty." Still worse, Caravaggio refused to study either ancient sculpture or Raphael's paintings. Probably the worst of all was his lack of decorum. Bellori notes with apparent approval that some of Caravaggio's paintings were rejected because of their vulgarity. Thus his Death of the Virgin, now in the Louvre, was unacceptable because the figure of the Madonna "imitated too closely the corpse of a woman." The Virgin and St. Anne, now in the Borghese Gallery, was rejected because "the Virgin and nude Christ Child were too indecently portrayed." The Madonna of Loreto, also in the Borghese (and today admired as one of the finest expressions of the intense but simple piety inculcated by St. Philip Neri), disturbed Bellori because of "the dirt on the Pilgrim's feet."

Caravaggio is also blamed for being the creator of the Caravaggiesque. "Many artists were infatuated by his manner and accepted it willingly, since without study or effort it enabled them to make facile copies after nature." Here Bellori is presumably referring to Caravaggio's close followers, men such as Valentin, Manfredi, Honthorst, or Caracciolo. But Bellori also complains that Caravaggio "received so much acclaim that some artists of great talent and instructed in the best schools were impelled to follow him." The "best school" was of course the one founded by Ludovico Carracci in Bologna. Its most famous graduate, who was a follower of Caravaggio (if only for a brief period), was Guido Reni. Bellori was probably also thinking of Rubens, who shows Caravaggio's influence during his early years, and of Guercino, who does not, but who drew on some of Caravaggio's sources with such similar results that he was often included among the Caravaggieschi.

Caravaggio is also held responsible for the introduction of low-life genre. His followers began to "imitate forms that were vulgar . . . With the majesty of art thus suppressed by Caravaggio, everyone did as he pleased . . . Now began the representation of vile things; some artists began to look enthusiastically for filth and deformity." This is to be read in light of the classical concept that the artist is to select the most beautiful, but it is equally an affront to the classical doctrine of instruction.

This last holds that the finest art is that which instructs the beholder by the vigorous presentation of morally elevated themes whose example he is encouraged to emulate. Art is thus endowed, if not with sympathetic magic, at least with very strong powers of suggestion. When the good gray Bellori saw paintings that represented street fights, gambling dens, drunkenness, cheating at cards, and young men carousing with women of easy virtue, he was outraged at their indecency.

But Bellori's view was not wholly negative. Caravaggio's new style was good for the art of painting, he admits, "because he came upon the scene at a time when realism was not much in fashion and when figures were made according to convention and manner and satisfied more the taste for gracefulness than for truth." Here Bellori is referring to mannerism, especially the affected, highly stylized, antinaturalistic forms of mannerism that were in vogue in late sixteenth century Rome. On their side the mannerists, "the old painters who were accustomed to the old ways," were appalled at Caravaggio's naturalism. They accused him of lacking artistic inventiveness. They said he painted the way he did because he did not know how to create graceful forms out of his own imagination, the way the mannerists did (or said they did) from theirs.

Bellori realized that Caravaggio's tenebrism was something quite out of the ordinary. He describes perceptively "the dark brown atmosphere of a closed room" with "a high light that descends vertically over the principal parts of the body while leaving the remainder in shadow." He understands, at least partially, one of the more abstract effects of tenebrism, which is "to give force through a strong contrast of light and dark." But Caravaggio's use of the stylistic form to enhance the expressive content of his paintings is something that entirely eluded him.

He preferred the early works of Caravaggio, which are free of tenebrism. This is no doubt because these paintings—notwithstanding their frequently unconventional and even "shocking" interpretation of subject matter—are stylistically quite close to the early Seicento classicism of Annibale Carracci and Domenichino that Bellori admired so much. In his early paintings Caravaggio used a hard, linear style coupled with bright, even lighting that permits a full description of small-scale detail, all of which has nothing to do with the Baroque.

Bellori probably never saw the South Italian canvases that Caravaggio painted in his last phase. There is no reason to believe he understood, even faintly, the deeply religious expression that animates so many of his canvases, not only in these last years but earlier. On this the sources are silent. We do know that his style spread like wildfire throughout Western Europe, inspiring artists as diverse as Velázquez, Terbrugghen, and Georges de La Tour.

From Bellori, *Le Vite de' pittori, scultori ed architetti moderni*

Demetrius, the ancient sculptor, is said to have been so eager to render the likeness of things that he cared more for imitating them than for their beauty. We have seen that the same is true of Michelangelo Merisi: he recognized no other master than the model and did not select the best forms of nature but emulated art—astonishingly enough—without art. The fame of the noble citadel, Caravaggio, in Lombardy was doubled by his birth since it was already the birthplace of Polidoro; both of them began as masons, carrying hods of mortar for constructions.

In Rome, he lived without a fixed lodging and without resources. Models were too expensive for him and without one he did not know how to paint, nor did he earn enough to take care of his expenses in advance, so he was forced to enter the services of Cavaliere Giuseppe d'Arpino. He was employed by him to paint flowers and fruits, which he imitated so well that from here on they began to attain the high degree of beauty so fully appreciated today. He painted a carafe of flowers in which he showed the transparency of the glass and of the water and in which one can see the reflection of a window in the room; the flowers are sprinkled with the freshest dew drops. He also made other excellent paintings of this kind, but he worked on such subjects with reluctance, feeling great regret at seeing himself kept away from figure painting. Thus he took an opportunity offered him by Prospero, a painter of grotesques, and left the house of Giuseppe to compete with him for artistic fame. Now he began to paint according to his own genius. He not only ignored the most excellent marbles of the ancients and the famous paintings of Raphael, but he despised them, and nature alone became the object of his brush. Thus when the most famous statues of Phidias and Glycon were pointed out to him as models for his painting, he gave no other reply than to extend his hand toward a crowd of men, indicating that nature had provided him sufficiently with teachers. In finding and arranging his figures, whenever it happened that he came upon someone in the town who pleased him, he was fully satisfied with this invention of nature and made no effort to exercise his brain further. He painted a young girl seated on a chair with her hands in her lap in the act of drying her hair; he portrayed her in a room with a small

ointment vessel, jewels, and gems placed on the floor; thus he would have us believe that she is the Magdalene [the painting is now in the Doria Pamphili Gallery, Rome]. She holds her face a little to one side, and her cheek, neck, and breast are rendered in pure, facile, and true tones, which are enhanced by the simplicity of the whole composition. She wears a blouse, and her yellow dress is drawn up to her knees over the white underskirt of flowered damask. We have described this figure in particular in order to characterize his naturalistic method and the way in which he imitates real color using only a few tints.

Caravaggio (for he was now generally called by the name of his native town) was making himself more and more notable for the color scheme which he was introducing, not soft and sparingly tinted as before, but reinforced throughout with bold shadows and a great deal of black to give relief to the forms. He went so far in this manner of working that he never brought his figures out into the daylight, but placed them in the dark brown atmosphere of a closed room, using a high light that descended vertically over the principal parts of the bodies while leaving the remainder in shadow in order to give force through a strong contrast of light and dark. The painters then in Rome were greatly impressed by his novelty and the younger ones especially gathered around him and praised him as the only true imitator of nature. Looking upon his works as miracles, they outdid each other in following his method, undressing their models and placing their lights high; without paying attention to study and teachings, each found easily in the piazza or in the street his teacher or his model for copying nature. This facile manner attracted many, and only the old painters who were accustomed to the old ways were shocked at the new concern for nature, and they did not cease to decry Caravaggio and his manner. They spread it about that he did not know how to come out of the cellar and that, poor in invention and design, lacking in decorum and art, he painted all his figures in one light and on one plane without gradations. These accusations, however, did not retard the growth of his fame. Caravaggio painted the portrait of Cavalier Marino, the most famous among men of letters, and the names of the poet and the painter were thus celebrated together in the academies.[1] The *Head of Medusa* by Caravaggio, which Cardinal del Monte gave to the Grand Duke of Tuscany [now in the Uffizi, Florence] was particularly praised by Marino. Thus it happened that Marino, because of his good will toward Caravaggio and the pleasure which he took in his works, introduced him into the house of Monsignor Melchiorre

[1] The whereabouts of the painting is not known today. There is some reason to doubt that it existed outside Marino's imagination.

Crescenzi, the clerk of the papal court. Michele painted the portrait of this most learned prelate and another one of Virgilio Crescenzi, who, as the heir of Cardinal Contarelli, chose him together with Giuseppino to execute the paintings in the chapel of S. Luigi dei Francesi. Then something happened which greatly disturbed Caravaggio and almost made him despair of his reputation. After the central picture of *St. Matthew* [destroyed in Berlin in World War II] had been finished and placed on the altar, it was taken away by the priests, who said that the figure with his legs crossed and his feet crudely exposed to the public had neither decorum nor the appearance of a saint. Caravaggio was in despair because of this affront to the first of his works in a church; however, the Marchese Vincenzo Giustiniani acted in his favor and freed him from this grief. He intervened with the priests, took the painting for himself, and had Caravaggio do another in a different way which is the one now seen above the altar. To show how much he honored the first painting he took it in his house, and later placed beside it paintings of the other three Evangelists: by Guido Reni, Domenichino, and Albani, the three most celebrated painters of the time. Caravaggio exerted every effort to succeed in his second picture; he tried to give a natural pose to the saint writing the gospel by showing him with one knee bent on the stool and with his hands on the small table in the act of dipping his pen in the inkwell placed on the book. He turns his face to the left toward the winged angel who, suspended in air, speaks to him and makes a sign to him by touching the index finger of his left hand with that of his right hand.

Caravaggio continued to be favored by the Marchese Vincenzo Giustiniani, who commissioned him to make some pictures, the *Crowning with Thorns* and *St. Thomas* placing his finger in the wound of the Lord's side; the Lord draws St. Thomas' hand closer to him and pulls the shroud away from His breast. Besides these half-figures he painted a *Victorious Amor* raising his arrow in his right hand; arms, books, and other instruments are lying at his feet as trophies. Other Roman gentlemen were also pleased with his works and vied with one another to obtain them. Among them was the Marchese Asdrubale Mattei, who had him paint the *Taking of Christ in the Garden,* which is also in half-figures. For Massimi he painted an *Ecce Homo* which was taken to Spain, and for the Marchese Patrizi he did the *Supper at Emmaus.* Here Christ is blessing the bread and one of the apostles seated at the table recognizes Him and stretches out his arms while the other apostle rests his hand on the table and stares at Him in wonderment. Behind the table are the host with a cap on his head and an old woman who brings food. For Cardinal Scipione Borghese he painted a somewhat different version of the subject; the first is in deeper tones but both are praiseworthy for

their imitation of natural color even though they lack decorum. For Michele's work often degenerated into low and vulgar forms.[2]

For the same Cardinal he painted *St. Jerome,* who writes attentively, extending his hand to dip his pen in an inkwell; for him he also painted a half-length *David* holding by its hair the head of Goliath—Caravaggio's own portrait. David, who is shown grasping the hilt of his sword, is represented as a bare-headed youth with one shoulder out of his shirt. The picture has the bold shadows which Caravaggio liked to use to give force to his figures and compositions. [Both the *Jerome* and the *David* are in Borghese Gallery, Rome.]

Caravaggio's preoccupation with his painting did not calm the restlessness of his spirit. Having spent some hours of the day in his studio, he would appear in various parts of the city with his sword at his side as though he were a professional swordsman, giving the impression that he attended to everything but painting. In a ball game, he had an argument with one of his young friends and they began to beat each other with the rackets. Finally, they resorted to arms, and Caravaggio killed the youth and was also wounded himself. Having fled from Rome, penniless and pursued, he found refuge in Zagarolo under the protection of the Duke, Marzio Colonna. Afterward he went to Naples where he immediately found commissions because his manner and name were already known there. In the chapel of the Signori di Franco in the church of S. Domenico Maggiore he was commissioned to do the *Flagellation of Christ* at the column. [It is still there today.] For the church of the Misericordia in the same city he painted the *Seven Acts of Mercy* [still in its original location], a painting about ten palmi long. Here one sees an old man who sticks his head out between the bars of a prison and sucks milk from the bared breast of a woman who bends down to him. Elsewhere in the painting appear the feet and legs of a dead man who is being carried to the sepulcher; the light from a torch carried by the man who supports the corpse shines on the white surplice of the priest, illuminating and giving life to the composition.

Caravaggio wished very much to receive the Cross of Malta which was usually given "per grazia" to notable persons for merit and virtue. He therefore went to Malta and, when he arrived, he was introduced to the Grand Master, Wignacourt, a French nobleman. Caravaggio portrayed him standing dressed in armor. [The painting is in the Louvre.] As a reward for this the Grand Master presented him with the

[2] The paintings mentioned in this paragraph are all lost with the following exceptions: the *Victorious Cupid* is in the Staatliche Museen, Berlin; the *Supper at Emmaus* for Cardinal Scipione Borghese is now in the National Gallery, London; and the *Supper at Emmaus* for Marchese Patrizi, which stayed in that family for over three hundred years, is now in the Brera in Milan.

Cross of Malta. For the Church of S. Giovanni he had him paint the
Beheading of St. John who has fallen to the ground while the execu-
tioner, as though he had not quite killed him with the blow of his sword,
takes his knife from his side and grasps the saint by the hair in order
to cut off his head. Salome looks on with fascination, while an old woman
with her is horror-stricken at the spectacle, and the warden of the prison,
who is dressed in Turkish garb, points to the atrocious massacre. Cara-
vaggio worked on his painting with such fervor that the priming shows
through the half-tones. [The canvas is in the Cathedral, La Valletta,
Malta.] In addition to honoring Caravaggio with the Cross of Malta, our
Grand Master gave him a precious chain of gold and two slaves along
with other signs of his esteem and satisfaction with his work.

But all of a sudden his turbulent nature brought this prosperity
to an end and caused him to loose the favor of the Grand Master; be-
cause of a very inopportune quarrel with a most noble Cavalier he was
thrown into prison and was subjected to misery, fear, and maltreatment.
With great personal danger, he managed to escape from prison in the
night and fled unrecognized to Sicily with such great speed that he
could not be overtaken. He hurried across Sicily from Messina to Palermo
and there, for the Oratorio di San Lorenzo he painted another *Nativity*
[still in its original location], representing the Virgin contemplating the
newborn Babe with St. Francis, St. Lawrence, St. Joseph seated, and an
angel above. The lights are diffused among the shadows of the night.

When this work was finished he felt that it was no longer safe
to remain in Sicily and so he left the island and sailed back to Naples,
intending to remain there until he received news of his pardon so that
he could return to Rome. At the same time seeking to regain the favor
of the Grand Master of Malta, he sent him as a gift a half-length figure
of *Salome* with the head of St. John the Baptist in a basin. [The identi-
fication of this work is uncertain.] These attentions availed him nothing,
for stopping one day in the doorway of the Osteria del Ciriglio he found
himself surrounded by several armed men who manhandled him and
gashed his face. Thus as soon as it was possible, he boarded a felucca,
and, suffering the bitterest pain, he started out for Rome. Through the
intercession of Cardinal Gonzaga he had already obtained his liberation
from the Pope. When he went ashore the Spanish guard arrested him
by mistake taking him for another Cavalier, and held him prisoner.
Although he was soon released, the felucca which was carrying him and
his possessions was no longer to be found. Thus in the state of anxiety
and desperation he ran along the beach in the full heat of the summer
sun, and when he reached Porto Ercole he collapsed and was seized by
a malignant fever. He died within a few days at about forty years of age
in 1609.

Thus Caravaggio finished his life and was buried on a deserted shore. Just when his return was awaited in Rome, came the unexpected news of his death.

Cavalier Marino, his very close friend, mourned his death and honored his memory with the following verses:

> Nature, who feared to be surpassed
> In every image that you made
> Has, Michele, now, in league with Death,
> A cruel plot against you laid;
> For Death with indignation burned
> To know that many as his scythe
> Cut down, still more and usurously
> Your brush contrived to make alive.

There is no question that Caravaggio advanced the art of painting because he came upon the scene at a time when realism was not much in fashion and when figures were made according to convention and manner and satisfied more the taste for gracefulness than for truth. Thus by avoiding all prettiness and vanity in his color, Caravaggio strengthened his tones and gave them blood and flesh. In this way he induced his fellow painters to work from nature.

He never introduced clear blue atmosphere into his pictures; on the contrary he always used black for the ground and depths and also for the flesh tones, limiting the force of the light to a few places. Moreover, he followed his model so slavishly that he did not take credit for even one brush stroke, but said that it was the work of nature. He repudiated every other precept and considered it the highest achievement in art not to be bound to the rules of art. Because of these innovations he received so much acclaim that some artists of great talent and instructed in the best schools were impelled to follow him.

With all this, many of the best elements of art were not in him; he possessed neither invention, nor decorum, nor design, nor any knowledge of the science of painting. The moment the model was taken away from his eyes his hand and his imagination remained empty. Nevertheless, many artists were infatuated by his manner and accepted it willingly since without study or effort it enabled them to make facile copies after nature and to imitate forms which were vulgar and lacking in beauty. With the majesty of art thus suppressed by Caravaggio, everyone did as he pleased, and soon the value of the beautiful was discounted. The antique lost all authority, as did Raphael, and because it was so easy to obtain models and paint heads from nature, these pictures abandoned the use of histories which are proper to painters and redirected themselves to half-length figures which were previously very little used. Now began the representation of vile things; some artists began to look

enthusiastically for filth and deformity. If they have to paint armor they choose the rustiest; if a vase, they do not make it complete but broken and without a spout. The costumes they paint are stockings, breeches and big caps and when they paint figures they give all of their attention to the wrinkles, the defects of the skin and the contours, depicting knotted fingers and limbs disfigured by disease.

Because of this Caravaggio encountered much displeasure and some of his pictures were taken down from their altars, as we have said to be the case of San Luigi. The same thing has happened to his *Death of the Virgin* in the Church of the Scala because it imitated too closely the corpse of a woman. [The canvas is now in the Louvre.] Another of his paintings, *The Virgin and St. Anne,* was taken down from one of the minor altars of the Vatican Basilica because the Virgin and the nude Christ Child were too indecently portrayed (as one can see in the Villa Borghese) [where it is today]. In Sant' Agostino [and still there], one is presented [with the Madonna of Loreto] with the dirt on the Pilgrim's feet and in Naples among the *Seven Works of Mercy,* there is a man who raises his flask to drink and lets the wine run into his open mouth in a coarse way. In the *Supper at Emmaus,* besides the rustic character of the two apostles and of the Lord who is shown young and without a beard, Caravaggio shows the innkeeper who serves with a cap on his head and on the table there is a plate of grapes, figs, and pomegranates out of season.

Caravaggio's way of working corresponded to his physiognomy and appearance. He had a dark complexion and dark eyes, black hair and eyebrows and this, of course, was reflected in his paintings. His first manner, with its sweet and pure color, was his best; in it he made the greatest achievements and proved himself to be the most excellent Lombard colorist but later, driven by his peculiar temperament, he gave himself up to the dark manner, and to the expression of his turbulent and contentious nature. Because of his temperament, Caravaggio was forced to leave Milan and his homeland and then to flee from Rome and from Malta, to go into hiding in Sicily, to live in danger in Naples and to die in misery on a deserted beach.

Caravaggio's colors are prized wherever painting is esteemed.

Caravaggio: Part Two

One side of Caravaggio, admittedly not the most profound but certainly authentic, is that of the dashing, hot-blooded young man in a long black cloak who wore a sword at his side and was ready to draw it at the drop of a hat. This aspect comes through with great immediacy

in the court records of Caravaggio's own day, two extracts from which we include below.

From testimony in court about Caravaggio

25 APRIL, 1604

PIETRO ANTONIO DE MADII OF PIACENZA, A COPYIST, STATES: [1]

"I was having dinner at the Tavern of the Blackamoor. On the other side of the room there was Michelangelo da Caravaggio, the painter. I heard him ask whether the artichokes were done in oil or butter, they being all in one plate. The waiter said: 'I don't know,' and picked one up and put it to his nose. Michelangelo took it amiss, sprang to his feet in rage, and said: 'If I am not mistaken, you damned cuckold, you think you are serving some bum.' And he seized the plate with the artichokes on it and threw it at the waiter's face. I did not see Michelangelo grasp the sword to threaten the waiter."

29 JULY, 1605

[The Clerk of the Criminal Court visited Mariano Pasqualone of Accumoli, a notary, in the office of Paolo Spada. Pasqualone testified on oath:]

"I am here in the office because I have been assaulted by Michelangelo da Caravaggio, the painter, as I am going to relate. As Mr. Galeazzo and I—it may have been about one hour after nightfall [8:30 P.M.]—were strolling in Piazza Navona in front of the palace of the Spanish Ambassador, I suddenly felt a blow on the back of my head. I fell to the ground at once and realized that I had been wounded in the head by what I believe to have been the stroke of a sword. As you can see, I have a wound on the left side of my head. Thereupon, the aggressor fled.

"I didn't see who wounded me, but I never had disputes with anybody but the said Michelangelo. A few nights ago he and I had words on the Corso on account of a girl called Lena who is to be found at the Piazza Navona, past the palace, or rather the main door of the palace of Mr. Sertorio Teofilo. She is Michelangelo's girl. Please, excuse me quickly, that I may dress my wounds."
[He was granted the permission he had asked for, and Galeazzo Roccasecca, Writer of Apostolic Letters, was examined next. He testified:]
"I saw a man with an unsheathed weapon in his hand. It looked

1 This document and the one that follows, taken from the court records of the Archivio di Stato in Rome, were first published by A. Bertolotti, *Artisti Lombardi a Roma* (Milan, 1881), pp. 68-69, 71-72. The English translations are from W. Friedlaender, *Caravaggio Studies* (Princeton, 1955), pp. 280, 284.

like a sword or a hunting-knife. He turned round at once and made three
jumps.

"... He wore a black cloak on one shoulder. I only heard the
wounded man say it could not be anyone but Michelangelo da Cara-
vaggio."

Caravaggio: Part Three

*The following epitaph is of great historical value since it provides
us with our only source for the date of Caravaggio's birth. Beyond this,
though written in an age of pomp, it is moving in its simplicity.*

An epitaph on Caravaggio

Michelangelo Merisi, son of Firmo of Caravaggio—in painting not
equal to a painter, but to nature itself—died in Port'Ercole—betaking
himself hither from Naples—returning to Rome—15th calend of August—
In the year of our Lord 1610—He lived thirty-six years, nine months and
twenty days—Marzio Milesi, Juriconsult—dedicated this to a friend of
extraordinary genius.[1]

Reni

*Although most of the early books on artists' lives dealt with all of
Italy and some even made an attempt to include the lands to the north,
the age of the Baroque saw the first full-scale studies devoted to the
development of art in local and regional schools. Among these are Raf-
faello Soprani for Genoa, Carlo Ridolfi for Venice, and Bernardo De
Dominici for Naples. The most important of the group is Count Carlo
Cesare Malvasia, an art lover and connoisseur who published his monu-
mental study of the Bolognese artists in 1678.[1]*

*Malvasia's writings must be considered with the understanding that
he thought Bologna was the epicenter of the universe. He missed few
opportunities to attack Vasari and through Vasari, the artistic supremacy
of Florence. Bolognese artists who left Bologna were under a cloud. Thus
for Malvasia, Ludovico Carracci, who stayed in Bologna, was a better
artist than Annibale Carracci, who went to Rome.*

*It must be emphasized that Malvasia was prepared to invent docu-
ments to support his point of view. The letter in his possession that he*

[1] This document, from the Vatican Library (Cod. Vat. 7927), *Inscriptiones et
Elogia* by Marzio Milesi, was first published by Roberto Longhi in *Pinacoteca*, I
(1928-29), 19. The English translation given here is from Walter Friedlaender, *Cara-
vaggio*, p. 293.

[1] (Reni) Carlo Cesare Malvasia, *Felsina pittrice, Vite de' pittori bolognesi*, 2 vols.
(Bologna, 1678).

claimed was written by Raphael to the Bolognese painter Francesco Francia in the year 1508 is now recognized to be written in a style that is completely characteristic of mid-seventeenth century Italian. It is in fact a fine example of Malvasia's richly Baroque prose.[2] Nevertheless, for the Bolognese artists of his day, many of whom he knew intimately, Malvasia is absolutely irreplaceable. He is our primary source for Guido Reni; sections from his life of Reni appear below.[3]

Guido Reni (1575-1642), who was trained in the Carracci Academy in Bologna, was naturally predisposed toward classicism. His one lapse, which is fascinating because it seems so out of character, is his Crucifixion of St. Peter, *now in the Vatican Picture Gallery. Here he is consciously imitating Caravaggio: copying as well as he can Caravaggio's rough peasant types and above all Caravaggio's powerful tenebrist lighting, while at the same time trying to retain some of his basic classicism in the poses of the figures and the over-all composition. To Malvasia's relief the aberration was brief. Reni soon returned to the clear, cool, highly decorative classicism that was to make him famous. But his style draws on many sources, not all of them classical. Malvasia mentions in several places his study of Veronese, whose art contributed heavily to Reni's palette and his broad handling of paint.*

Reni made two trips to Rome but for most of his life he lived in Bologna. There at the end of his career he developed a new style (his "second manner"), which, as Malvasia correctly predicted, was to prove fascinating to connoisseurs. In these late works most of the elaborately contrived garment folds disappear. The paint becomes thinner and the colors paler. At the same time the brushwork grows increasingly more free. The many different grayed-off hues are modulated with almost painful delicacy.

The personal life of the painter, or at least what we know of it, often has little or nothing to do with the way he paints. Attempts to apply psychoanalysis to the fine arts (as distinguished from children's paintings, and so on) have been disappointing. But if what Malvasia tells us is true, Reni may prove an exception. Outwardly he was neither heterosexual nor homosexual but utterly and completely sexless. He had an obsessive dislike and fear of women, whom he could not bear to have around the house, even as servants. He avoided older women like the plague, thinking they would cast spells on him. It upset him when he discovered a woman's blouse had touched his linens. That at the same time he lived with his mother, was apparently devoted to her, and spent a good deal of money on her is, in psychiatric terms, not at all incon-

2 Julius Schlosser Magnino, *La Letteratura artistica,* 3rd ed., ed. Otto Kurz (Florence and Vienna, 1964), pp. 529-30.

3 Malvasia, pp. 14-15, 78-81, 72-73, 58-59, 67-68.

sistent. The stern, forbidding face of the woman that stares out at us from the famous portrait (in the Picture Gallery in Bologna) that is traditionally described as Reni's mother could perhaps explain a good deal about what was wrong with Reni. The portrait that Reni made of himself as a young woman in a turban is, in this regard, equally interesting.

Reni's art must be considered within the context of his extreme piety and his intense devotion to the Madonna. Malvasia reports that in his own time his contemporaries speculated on the relationship between Reni, the virgin artist, and his beautiful, chaste representations of the Virgin Mary. Today we might be tempted to go further in our interpretation of his soft, wan, languid figures—the men (except for the evil ones) little differentiated from the women—with their eyes rolled up to heaven in pious devotion.

From Malvasia, *Felsina pittrice, Vite de' pittori bolognesi*

Thus [while still a youth in Bologna] Guido Reni's reputation grew and expanded outside his native land. He yearned to see once more and to revere his beloved Annibale [Carracci] and to admire the great frescoes of the Farnese Gallery, of which he had heard fabulous accounts. Counciled thus by Francesco Albani, invited to come by Cavaliere d'Arpino, and persuaded by patrons, he resolved to move to Rome. Arriving with Albani, he was well received and helped especially by d'Arpino, who was favorably disposed to aid him in order to make trouble for Caravaggio, d'Arpino's declared enemy. Thus he made an effort to get Reni work that was intended to be consigned to Caravaggio. This is what happened with the *Crucifixion of St. Peter* at the Tre Fontane outside Rome. D'Arpino promised Cardinal Borghese that Guido would be transformed into Caravaggio and would paint the picture in that dark and driven manner, which he did with skill, as we can see.

But Annibale did not like Guido being so close by. He could not help giving signs of his distaste, and complained to Albani for having brought him there. But if Guido was disliked by Annibale, so much more was he disliked by Caravaggio, who was very much afraid of the new manner, totally opposed to his own and just as pleasing. Why [he said] in the painting of the Crucifixion of St. Peter at the Tre Fontane did he steal his [Caravaggio's] style?

Like a bee amongst the flowers he passed thus amongst all things, sampling the most exquisite and most perfect. From Raphael, Guido took those figures that are so well-proportioned and correct. He adorned them with vestments of the ancients, taken over from their statues and given life, though at times he gave greater amplitude to the flourishes of the drapery, so that they resembled but were more daring than those

by Paolo Veronese. From Correggio, Reni took purity of pose and attitude. He loathed the liberties taken by Tintoretto, especially in sacred and devotional paintings, which require more moderate and decorous movement. From Parmigianino he took gracefulness. Reni studied the heads of his Madonnas with their half-closed, rather too large eyes.

He was not content with ancient [sculptured] heads alone to reinforce his concepts of beauty. He also procured new images and impressions of the most unusual ancient Greek medallions and from the most recondite cameos. At certain important religious ceremonies, in the early hours or during bad weather, he studied in church all the facial details of withdrawn older women, of the most circumspect young girls, even those excessively so. He was grateful for anything new, which always pleased him, since he knew how to make conform to his will, and as a result how to make harmonious those things which, because of their lacks and defects, had been abandoned by others.

He worked hard and insatiably in his last paintings, demonstrating himself in these to be always more learned, with [the results of] new research and a thousand pleasantries. In the complexions [of his figures] he used certain grays and blues mixed with half tones, which were also used by his pupils, Cagnacci, Castiglione, Maffei and others, but perhaps too boldly. These effects may be observed in delicate complexions, which convey a certain diaphanous quality. The effect is stronger and more evident when the light falls on the flesh, especially light that passes through closed windows, above all those that are glazed. And this is something that anyone can observe for himself, and is not Reni's imaginary invention, an idea without substance.

This is what is called Reni's second manner. Though it is unknown and strange, it will become unforgettable, make itself well known, and finally, win a secure place in the public's affection. Reni's second manner will always be more pleasing to the more learned as will the first to the more inquisitive. If among the common people the second manner will have the reputation of being too languid and too delicate, it will nonetheless be exalted by the connoisseurs as the most scientific, the most supreme.

The fear of God was always the first advice that Reni gave his pupils. Modesty he taught them by his own example. Hence in conversations and on happy occasions from which he could not withdraw without appearing hypocritical, sometimes when obscenities were mixed in, his good friends, watching him very closely, saw he did not take to them very well and blushed even at those used as metaphors and in *double entendre*. He was never heard to utter the obscene words in common use in Lombardy, even when suddenly overcome with rage.

It was generally thought that he was a virgin. He never caused the

slightest scandal. When observing the many lovely young girls who served as his models he was like marble. When he drew them he never wanted to be alone or hidden. A hundred curious eyes watched his comings and goings to try to find out something. When at most between vespers and nine o'clock he left his workshop not knowing he was being followed, he was always found spending his time now in one, now in the other of his two rooms, never hidden away somewhere else.

He was most devoted to Our Lady the Virgin Mary. In his youth he went every Saturday to gaze with reverence on her image in Monte della Gardia and every evening without fail as long as he lived [he offered devotion to] her image in the church of the Vita. Many believed, perhaps with too great credulity, that because of his great devotion the Virgin deigned to appear before him, he being no less a virgin. No painter of any century ever knew how to represent her with a greater combination of beauty and modesty.

Reni was of medium height, well formed, with an athletic build, and thus able to resist the afflictions and toil that Art demands. His complexion was very pale, with some coloring in the cheeks, and his eyes were sky blue. All in all, he was handsome, well made, and well proportioned. He was melancholic by nature, but also at times spirited and vivacious, thus suited to the inquiry and study that is appropriate for a painter. From these things derive certain visible external manifestations. He had about him a certain air of grandeur and gravity that exceeded his station in life, which produced in everyone, even those of high rank, a hidden veneration and respect. This one can see in the very beautiful and majestic head of a woman in a turban, placed [in the painting cycle] of the Life of St. Benedict, in which, as Reni himself said more than once, he portrayed himself in his youth.

One never smelt his body give off bad odors, although since he lived without the services of women (especially in his last years after the death of his dear mother) he was not furnished with the proper type of cleaning that they provide. He took delight nonetheless, in elegant clothing, which he blossomed out in quite wonderfully every so often. He dressed in a most noble and at the same time restrained manner, as was then the fashion: silk in summer and Spanish wool in winter. And in his account books I found entries of fifty and sixty *scudi* for every one of his outfits as well as equal amounts and more to clothe his mother.

He got up out of bed a little before nine to listen to Holy Mass, which he never failed to do. He often made use of the morning rest period [shut away] behind closed windows in order to discover designs for the paintings he was to make, or to think of refinements for finishing work already begun.

He had a fear of poison, and of witchcraft. Because of this he did not want any women in the house. He hated to deal with them but when he had to he pulled himself away quickly. He was afraid of old women and fled from them, complaining that every time he went shopping or stopped to do business he always found one near him. He wanted to have servants that were extremely simple if not actually simple-minded. Gifts of things to eat that came from important people and thus could not be returned (without his acquiring a name for insulting behavior) he left as food for worms and eventually threw out. Thus Cardinals Cornaro and Sacchetti, here in Rome, were mutually proud of the fact that he accepted theirs.

Having lost one of his slippers about the house he went into a rage because of his suspicion of sorcery. The same thing happened when he found a woman's blouse among his linens. He quickly had the linens rinsed in pure water and dried and he wanted that in the future his Marco do the laundry himself at the house.

One day while I stood watching him paint he asked me if someone could cast a spell on a person's hands so that either he could no longer use his brushes or would have to use them badly. Sometimes he composed things in his mind and saw, as if they were in front of him, the most beautiful things. But his hand pulled back and, firmly resisting the intellect, was absolutely unwilling to execute them. Becoming aware of what he was thinking, I said frankly, no. I did the best I could despite my youthfulness to provide him with some pertinent reasons. He told me he had learned a secret from a Frenchman in Rome through which, by touching someone on the hand in a friendly way, one could from that point on soon cause him to have an incurable illness, from which he would have had to die. But he also had the antidote for it.

Lanfranco

Giovanni Lanfranco (1582-1647) provides the essential bridge between two very different worlds: the classical tradition associated with Annibale Carracci and the High Baroque of Pietro da Cortona. Bellori, who wrote the passages on Lanfranco given below, is aware of this duality, though he himself is such a thoroughgoing classicist that he prefers to see the first signs of what we now call the High Baroque as merely a revival of well-established traditions of the High Renaissance.[1] It is, no doubt, Lanfranco's training, first with Agostino then with Annibale Carracci, that makes him acceptable to Bellori, who notes with approval that "he did not fail to study the works of Raphael."

But the great formative influence on Lanfranco was the paintings

[1] For Bellori as a theorist and an historian, see pp. 5-16, 69-70, 75-77.

of Correggio. These could be studied nowhere as well as in Parma, the city where Lanfranco was born and to which he returned for study and inspiration. Correggio is known for the delicacy of his colors and his rich atmospheric effects. But the thing that seems to have impressed Lanfranco most of all, so Bellori tells us, was his domical frescoes, which are filled with dynamic interpenetrating masses of abruptly foreshortened figures. In our own century there has been a great deal of discussion as to whether or not these frescoes are Baroque, or if not Baroque, at least proto-Baroque. On the other hand, they were painted by an artist who was recognized in Bellori's day as in our own as one of the great masters of the High Renaissance. Bellori regarded the High Renaissance as the climatic moment in the history of art. By following the traditional con-servative method of finding precedents in the past, Bellori (who had no place in his Lives of the Artists *for either Bernini or Cortona) is able to accept and even praise the most progressive aspects of Lanfranco's art, which we see today as a prelude to the Roman High Baroque.*

Bellori is most effective in his description of Lanfranco's frescoes in the dome of S. Andrea della Valle. He is quite aware of the complex problems of perspective that were involved. From Bellori we learn that Lanfranco constructed a four and a half foot model, almost like a minia-ture stage set, in which he could try out the effect of various solutions. In describing the unifying power of the lighting that seems to pour out from the figure of Christ at the center of the lantern, and engulf all the figures in the dome, Bellori compares the effect to a great choir in which the individual voices are lost in the blended harmony of the whole. Though he does not pursue the idea he seems here to anticipate the concept of Absolute Unity (in which parts are submerged in and sub-ordinated to the whole), which Heinrich Wölfflin, early in this century, advanced as one of the five central principals of Baroque art.

The last extract from Bellori's life of Lanfranco refers briefly to the painter's work in Naples, which played an important role in bring-ing Neapolitan artists into the main current of the Baroque. But its principal interest lies in its suggestion of the high scale of living that could be enjoyed by even moderately successful artists in the first half of the seventeenth century in Rome.[2]

From Bellori, Le Vite de' pittori, scultori ed architetti moderni

Giovanni Lanfranco never had to complain of the slowness of his hand or ingenuity. Nor was there anyone in his time who painted large works of greater beauty or with more abundant skill. Neither difficulty

[2] The following passages are taken from Giovanni Pietro Bellori, *Le Vite de' pittori, scultori ed architetti moderni* (Rome, 1672), pp. 366-68, 370-73, 380-81.

of invention nor uncertainty of brushwork appeared in them. Rather he showed such frankness in his colors that it indeed appeared to be his strong point and heaven gave him a surname and spirit to match. He unfolded the wings of his fine talent in painting at an early age. Marchese di Montalbo gave him courage to continue painting, placing him with Agostino Carracci, who at that time was painting in the service of Duke Ranuccio. Having been trained by this master, the first public work by Lanfranco's hand was the picture of the Madonna with several Saints in the chuch of S. Agostino in Piacenza. His spirit and ability in painting grew continuously. Since he was attracted to Correggio's manner he drew and painted his works. He was so enamored with the frescoes in the dome of Parma Cathedral that he made a small painted model of the dome. With it he practiced harmonizing and arranging the figures seen from below and foreshortened. As Lanfranco himself said, it is not enough to understand perspective and to know how, by rule, to scale the size of figures, if the figures are not accompanied by a certain grace in movement that makes them charming, as are those of Correggio. He held Correggio's style to be as praiseworthy as that of any painter he had studied. With the death of Agostino Carracci, Lanfranco, who was then over twenty years old, went to Rome to join the studio of Annibale Carracci who employed him in [the frescoes of] the Farnese Palace. He did not cease studying the works of Raphael. Lanfranco together with Sisto Badalocchi made etchings of part of the Vatican Loggias and dedicated them to their master Annibale. When Annibale died Lanfranco returned to see again his native land [i.e., Parma]. He stayed about a year there and in Piacenza and then returned to Rome. After the death of Cardinal Montalbo, he tried to get the [commission for the frescoes of] the dome of Sant'Andrea della Valle. The result was that the Abbot D. Francesco Peretti, who succeeded his uncle in name and in dignity, spurred also by the Theatine Fathers, who wanted the work in their Church finished quickly, was induced to divide it and give the dome to Lanfranco. This caused great bitterness in Domenichino who lamented it in vain, since at one time he had the commission for all the frescoes as is noted in his biography. But this change did not bring such damage to art that it did not still remain glorious. For in propounding so great a rivalry Lanfranco left to posterity an admirable example of his great genius. Up to the present day this manner has occupied and now holds first place. The highest praise is due anyone able to equal him.

Lanfranco started out with a model six *palmi* high, which followed the proportion and form of the dome. Inside it, as he had done in Parma, he arranged groups and figures painted in water colors in perspective, in order to check the whole work at once, saving his genius and brush for the innate fury of the actual painting.

The subject is a glorious vision with the mystery of the Virgin's assumption into heaven. The dome is formed of a half oval that is drawn up into a lantern at its central point. Its proportions are such that in order to accommodate his figures to it Lanfranco gradually made them smaller, working upward to the very summit. The Virgin sits in the middle raised up on a throne of clouds and angels. She is clothed in crimson with a sky blue mantle that falls from her shoulder draping her breast. Drawn up to and enraptured by the Divinity, she lifts her face and arms toward her Son who, radiant with light, descends to meet her. The figure of Christ is at the summit of the lantern. He appears with chest and arms bare and the rest of the body clothed in a white mantle diminishing in perspective. In the narrow space He appears large.

On the lower level of that great sphere saints appear among the white clouds. St. Peter sits above angels who hold the keys while he points out the glorious Virgin to St. Cajetan, founder of the Theatine Order, who emerges somewhat from the clouds, palm in hand and face raised. On the other side we see St. Andrew the Apostle who extends his hand to the kneeling figure of the Blessed Andrew of the Theatine Order, whose beatification was at that time pronounced by the Supreme Pontiff, Urban VIII. He too gazes intently at the Assumption. Figures of the Fathers of the Old and the New Law are dispersed around the whole circumference of the dome, in between diverse choirs of saints and virgins in various expressions of joy and admiration. Among them we see Adam, nude except for bits of foliage. Next to him, turning toward him, is Eve, who was the cause of the ancient guilt that Mary's parturition absolved. We see Noah, who with both hands raises up as an offering the Ark, symbol of the human race saved by the Mother of the Redemptor. The youthful Isaac next to his father Abraham carries the bundle of wood on his shoulder to the sacrifice. Moses holds the tablets of the Law. So it is with the other Saints and Apostles. Some are sitting, some lying, and some arise, applauding the triumph of the Great Mother. Thus with alternate intervals of air and light Paradise opens, amid splendid rosy clouds in the joyous, harmonious Glory of Angels. They draw upward and inward toward the center, in choruses of seated youths and maidens who, resplendent in reflected light, sing and play music with flutes, viols, timpani, and other instruments. At the summit they are drawn into smaller circles amid more intensive golden light, and become softened in the uppermost rays where the heads of the Cherubim glow within dissolving contours. So sweet are the colors that they make one hear the celestial melody in the silence of the painting.

At this point Lanfranco employed a rare device: he contrasted the glory ending in those luminescent rays with a festoon circling the base of the lantern, held on high by seven angels who stand out sharply. This

augments the force of the painting by the opposition of dark zones with the area of greatest light and by isolating the center. We see this device used in domes that are painted today. However, the principle light that Lanfranco used in this work comes from the glorious humanity of Christ painted on the interior of the lantern. Its shining field spreads over the figures in greater or lesser degree in accordance with how close or far away they are from it, since the light coming from the summit scatters its rays over them in conformity with their rank. By means of such a method within the boundaries of the greatest light and the greatest darkness opposed to it, the delicacy and the relief of the figures are formed. In the supreme unity of the parts and without demarcation they emerge imperceptibly. In this way each figure in those spacious zones has relief, although outlines fade away, revealing only some upper limits but without surface contours.

Thus with good reason this painting has been compared to a diapason wherein all the tones together form the harmony, so that we do not hear specifically any individual voice, but what pleases us is the ensemble, the total measure and tenor of the song. And just as that kind of music requires that it be heard at a greater distance, so the color at a distance blends together and appears most pleasant to the eye. Nor will we fail to note another artful effect of the painting. When seen from below the fresco expands into a vast space. But when one goes up into the dome to see the painting close at hand, it diminishes and its circumference narrows to half the size it seems to be from below, as anyone may find out for himself.

The principal figures are scaled to about thirty *palmi*. But the other figures become smaller in accordance with their position, the perspective and the distance. Lanfranco's frescoes are very well displayed above Domenichino's Evangelist figures [on the pendentives of the same dome], which, being more finished, more meticulously painted and closer to the eye, permit the vision of Glory to diffuse itself into the distance in a way better adapted to the whole. The harmony of such a stupendous painting partakes of the harmony of heaven. The eye never tires in admiring it as it travels through the spacious structure, and the concept makes immortal the name of the painter, even though he has emulated and imitated the great Correggio, drawing the same influences from one country, from one heaven. The prize of praise is rightfully his due if one considers the domes painted earlier, especially those without harmony and modulation, by Ludovico Cigoli in Santa Maria Maggore and by Cristofano Roncalli in Loreto. Nor among those who later undertook similar enterprises have any yet achieved such eminence with their brush. Thus Lanfranco is still the master of this kind of painting.

Lanfranco made a good deal of money in Naples, if we reckon ten thousand *scudi* for the paintings in the Gesù, five thousand for those in San Martino, six thousand for the dome of the Treasury of the Cathedral, over and above the work in Santi Apostoli, which is abundant. Nine thousand other *scudi* were given to him by the King of Spain for the diverse paintings he made for His Majesty, not to mention many others in different locations which he expeditiously finished. The more he painted, the more work flowed in, and the Neapolitan painters, unleashing their resentment against Domenichino who stayed apart from them, converged on Lanfranco. Lanfranco, on his part, was indebted to the Viceroy through whose favor he received commissions for works in Naples, including the dome of Gesù. With all the riches he acquired he did not leave much when he died to his son Signor Giuseppe, but together with his family he led a splendid life. He spent three thousand a year in Naples where he had a house. In Rome he had a vineyard at San Pancrazio with a villa which he and his friends painted.

His style retains the principles and training of the School of the Carracci and avails itself of the plan and disposition but not the adornment and shading of Correggio; rather he was bold in execution. He was successful in large-scale paintings to be seen at a distance. He used to say the air painted for him. In drawing he captured a realistic image with a few charcoal and chalk lines. Ideas came to him easily. He formed his thoughts quickly in a sketch or at most a water color. He did not linger over corrections and the expression of emotions, but succeeded in modulation and in facility. His manner of handling drapery with a few simple folds, without harshness or affectation in a way that marvelously complemented the concept of the color, is worthy of special praise.

Guercino

Francesco Scannelli, whose significant contribution to artistic theory is discussed elsewhere (see pp. 39-42), was a physician, art buyer, and connoisseur. He provides us with the earliest life of Guercino. The extracts we give below were published in Scannelli's Microcosmo della Pittura, *which appeared in 1657, while Guercino was still alive.[1] The life that Malvasia published some twenty years later tells us of many more paintings but gives us less evaluation and criticism.[2]*

Giovanni Francesco Barbieri (1591-1666), called Guercino because

[1] Selections from Francesco Scannelli, *Il Microcosmo della Pittura* (Cesena, 1657), are from the following pages in the following order: pp. 85, 360-65, 107, 114-15, 93-94.

[2] Carlo Cesare Malvasia, *Felsina pittrice, Vita de' pittori bolognesi* (Bologna, 1678), pp. 358-86.

of his squint, is, like Scannelli, intimately associated with the north Italian mainland. He was born and lived most of his life in Cento, a small town of no artistic importance about halfway between Bologna and Ferrara. He came down to Rome briefly (1621-1623) during the pontificate of Gregory XV Ludovisi, whose family came from Bologna, but when the Pope died he went back to Cento. He stayed there until 1642, when, after the death of Guido Reni, he moved to Bologna. There he spent the rest of his life.

There is no question that Guercino was, as Scannelli says, self-taught. In the small town where he grew up there was no one who could give him more than the barest rudiments of technique. Instead he learned from objects, not artists. The "magnificent panel" in the Capuchin church in Cento that influenced him so much is the Holy *Family with St. Francis, now in the municipal museum. This well-known painting, perhaps Ludovico Carracci's masterpiece, is aglow with Venetian colorism, which Guercino translated into his own work.*

Scannelli strongly disapproves of the way in which various well-established painters, among them Guercino, abandoned their earlier manner with the deep colors and dark shadows, and substituted instead light hues and bright, even lighting. These passages are particularly significant because they help provide the key to what otherwise would surely be the most troubling aspect of Guercino's artistic development. Before he went down to Rome Guercino's painting was strongly Baroque. It has even been said that his early canvases are the first to which the term Baroque may be applied fully, without qualification. After he came back from Rome his work took on a classicizing flavor. The dark shadows faded, the strong movement disappeared, the details emerged distinctly in clear light.

Guercino made these radical changes in his style to meet his patrons' demands.[3] Scannelli makes it abundantly clear (no doubt reporting exactly what Guercino told him) that the people who commissioned his earlier works complained that his dark shadows concealed the eyes, the mouth, the whole face, or other parts of the body, and sometimes even the movements of the figures.

The style that is often called Baroque classicism, with its clear, even lighting, sharp outlines, and attention to detail, obviously met these criticisms and assured Guercino of a continuing demand for his work. What it cost him, Scannelli sensed and most critics today agree, is the expressive intensity that is so vital a part of his early, non-intellectual

[3] Denis Mahon discusses the reasons for the change in Guercino's style in a series of brilliant essays in his *Studies in Seicento Art and Theory* (London, 1947). He deals with all aspects of Guercino in the sections of text plus catalogue entries that comprise his definitive *Il Guercino* (*Giovanni Francesco Barbieri, 1591-1666*). *Catalogo critico dei dipinti* (Bologna, 1968).

*manner. There is a certain poignancy in the section in which Scannelli
asks whether Correggio, the north Italian painter who is his special hero,
would have painted still greater paintings had he left the small pro-
vincial center where he worked and come down to Rome, where he would
have come into direct contact with the "best masters of the First School."
(As we know from the previous selections from Scannelli, the First School
was the Florentine-Roman, the Second School the Venetian, the Third
School the Lombard.) Scannelli calls on his friend Guercino to answer
the question. Guercino must certainly have been thinking not only of
Correggio, but of himself—it was in Rome that the pressure built up for
him to change his style—when he says that had Correggio come into con-
tact with the "best masters of the First School" (which for Scannelli
means, above all, Raphael and the classicism of the High Renaissance)
he would have lost his innate individual manner and produced works
inferior to his best.*

<div align="center">

From Scannelli, *Il Microcosmo della Pittura*

</div>

For the glory of painting Giovanni Francesco Barbieri was born
and lived. He was a universal man with a good, handsome naturalistic
style, which brought together, as rarely happens, bold, well-modulated
colors, and truly fine, powerful sculptural modeling. For this reason he
was everywhere recognized as an extraordinary and renowned master.

In his youth he lived a hard life lacking in almost everything. Sus-
tained by natural instinct alone, or perhaps through copying an ordinary
print, he painted the miraculous *Madonna of Reggio*. It can easily be
seen today on the outside of a certain house in the country not far from
Cento, where it stands as a testimonial to his fine talent. On another
house, this one inside Cento, one can see a frieze of putti in grisaille
on the upper part, also on the façade.

At a later date he turned to the study of the magnificent panel by
Ludovico Carracci that is in the church of the Capuchin fathers of Cento,
and copied it many times with relish. Through this means he took the
opportunity to make the acquaintance of Ludovico himself, who was then
working in Bologna, his beloved homeland. This extraordinary master
was greatly pleased to see the talented young man and his drawings.
Guercino was very much encouraged by Ludovico Carracci and assisted
with the right kind of help and advice as to stylistic matters. Proceeding
along these good lines, he formed a style that was similar [to Ludovico
Carracci's]. He applied himself to it with the results that one sees in the
picture of all the saints in the church of Santo Spirito and another smaller
one, likewise in Cento, that shows St. Charles praying together with two
angels that present him with the Instrument of the Passion. These two

paintings in particular are as much like the work of Ludovico Carracci as they would be if they had been made by his own brush.

But afterwards he tended to imitate nature too much, lacking, for the most part, other appropriate means besides the study of the works. In that period he made various other paintings. Applying himself in a spirited fashion to the study of empirical reality, he expressed the results in a series of works in both public and private collections [including] a canvas in the Cathedral of Cento that represents Christ giving the keys to St. Peter. Certainly even Michelangelo da Caravaggio himself never showed a greater degree of realism. Especially the figure of St. Peter, when you first see it, seems to be more a real thing existing in three dimensions than a painting. He painted another canvas in S. Agostino with various large-scale figures and the façade of the church of S. Agostino. The whole painting is executed in such a vivacious, skillful, and realistic manner that it is very similar to the exquisite work of Annibale Carracci.

When he went down to Rome he painted the huge canvas of S. Petronilla for the famous Basilica of St. Peter, and also the altarpiece for the high altar in the church of the Convertite on Via del Corso, and the beautiful painting of Aurora [in the Casino of] the vineyards of the Ludovisi. Also, in the Church of S. Crisogono in Trastevere he painted a very large picture on the vault representing the saint with various angels.

Guercino is still painting today. In Bologna he continues to hold first place, to the greater adornment of the painting profession. He continues to show proof of his extraordinary virtue and piety in that splendid chapel that he had built in the Church of the Rosario in his native Cento. The Chapel is rich and remarkable in all its parts, especially because of the fine paintings in it by Guercino. There is one painting in particular on the vault of the church that is in his first and more vigorous manner. This one and the others are among the best works by his famous brush.

[The following section deals with] investigations of the reasons why many [painters] today have changed their individual styles to the lighter manner.

Turning to more general and more adequate reasons we can observe similar changes not only in the works done in Guido Reni's and Peter Paul Rubens' second manner, but also today in the works of Giovanni Francesco Barbieri, of Francesco Albani, and similarly there are signs of it in the last things done by Pietro da Cortona. All of these men, who are the most capable and famous masters of our time, have afterwards, during the period of their greatest acclaim, changed over in their manner of working to the lighter colors. A more valid reason appears to be that

which previously the same painter from Cento [Guercino] made known to me. He showed me what happens when the taste of the majority of the people—especially those who commission works—is in that form. More than once he had heard complaints from those who had paintings that were done in his first manner that the eyes, the mouth, and other parts of the body were hidden because of too much darkness. For that reason they considered that some parts were unfinished. They asserted that often they could not make out the face, and sometimes even the specific action, of the figures. And thus to satisfy as well as he could most of the people, especially those who asked for paintings and had the money to pay for them, he had shown paintings in the lighter style.

[The following section contains] considerations as to whether Antonio Correggio, had he lived and worked with the advantages that his peers enjoyed, would have increased his capabilities.

On the negative side of the proposition is found the authority of that leading painter, Giovanni Francesco Barbieri, who believed with good reason that the opportunities would be of another sort, the opposite of fortunate. Such circumstances would serve only to deflect him from his customary perfection and innate sufficiency, which could not accept change without inevitable loss. It was offered in proof of this opinion that since he [Correggio] had been impelled by nature and through his own talent to a level of activity that was both superior and sublime, he would have been, for the most part, able to see only different and inferior paintings. From this it could be calculated that such things could easily take him from the proper path, and that similarly, by following the uncertain, he could easily have lost also that which was secure. It was said that if one considers the influence of the greatest artists of the First School, it could not help but be contrary in large part to the manner of his own genius. He would thus have become in such a situation a beginner, inferior to those with whom he now is considered equal and even superior. And in corroboration of this position they present as a bad example the highly talented Annibale Carracci and other good artists of more than ordinary ability, endowed with a fine manner, who after they had seen and studied the works of the First School, rather than improving, found in part that their exceptional skills had diminished.

Duquesnoy

Francesco Duquesnoy (1597-1643) came down to Rome from Flanders in 1618, when he was still a young man, but he always remained somewhat apart from and alien to the bustling artistic life of the city. Bernini's overwhelmingly dominant position in the field of sculpture left little room for others with different points of view. Duquesnoy's work was

essentially classical, at a time when the Baroque was in full swing. Unlike his good friend Poussin, he had no coterie of patrons. In his whole life he carried out only two large-scale commissions: a Sta. Susanna *for the church of the same name and a* St. Andrew *for St. Peter's. He managed to survive largely through his work as a restorer of ancient marble statuary. Little wonder that he suffered from prolonged periods of severe depression.*

Almost unnoticed in the midst of the fanfare surrounding Bernini, Duquesnoy evolved a type of putto so filled with grace, charm, and a sort of bittersweet winsomeness—in short, so evocative and appealing— that it became the prototype used by successive generations of artists (painters as well as sculptors) for the rest of the seventeenth and far into the eighteenth century. In the first passage given below we can see the impression that Duquesnoy's putto type made on the classical critic Bellori, who must have seen in it an especially successful exemplification of his own concept of the idealization of the real.[1] The letter from Rubens is still more significant, for it tells us of the appeal Duquesnoy's putti had for the famous painter whose work is often considered to most fully exemplify the Baroque.[2]

From Bellori, *Le Vite de' pittori, scultori ed architetti moderni*

Duquesnoy gave himself over wholly to the study of the Titian's putti when he had an opportunity to examine the celebrated painting of cherubs throwing apples in play, a canvas later given to the King of Spain but at that time in Villa Ludovisi in Rome.[3]

He completed the two wall tombs built into two piers in either side of the Church of S. Maria dell'Anima in Rome. One is for Ferdinand van den Eynde, a gentleman from Antwerp, the other is for Andrien Vryburch of Alkmaar. In the first tomb there are two putti who hold up a piece of drapery so as to reveal the inscription. The cloth veils part of the head of the one holding Death's timepiece in his hand as a mark of sorrow. This certainly is the most beautiful putto that Francesco's chisel brought to life. It is held up as an example and ideal by sculptors and painters as is its companion who turns on the other side and, bending, lifts up the drapery. The other tomb is made up of two putti who display a mantle with Andrien's inscription. There are also arms, the urn, and decorations.

[1] The passages are from Giovanni Pietro Bellori, *Le vite de' pittori, scultori ed architetti moderni* (Rome, 1682), pp. 271, 276, 281, 282.

[2] Rubens' letter is taken from Bellori, p. 284.

[3] This famous canvas, now known as *Workshop of Venus*, is in the Prado in Madrid. It was painted for Alfonso d'Este in the years 1516-1518. Cardinal Aldobrandini brought it to Rome in 1598, and the Ludovisi acquired it early in the next century. It remained in their possession until 1638, when it was given to the Spanish viceroy as a gift for King Philip IV of Spain.

Francesco devised his concept of the ideal form for putti from his study of Titian and from living models. He sought always the most tender examples, even babes in arms, and so softened the hardness of the marble that his figures appeared to be of milk rather than of hard stone. But even though they may be of the most exact imitation, their delicacy does not carry over into their actions, as he has them perform acts of strength and judgment that no infant could perform. Nevertheless those who imitated him (how easy it is to alter and carry to excess in the belief that one is improving) made the defect greater, swelling the cheeks, hands, and feet, enlarging the head and stomach to the point of ugliness; a defect that also spread among the painters.

Michelangelo in marble and in painting made putti vigorous but without delicacy, like Hercules. Raphael was the first to give them grace and lightness. He made them alert and with proportions emerging into loveliness. Titian and Correggio made them more delicately, as did Annibale Carracci, and in this Domenichino is reputed most excellent. He, more than anyone else, used them in his compositions, showing them in various ways as babes in arms and as adults with the actions and propriety suitable to each. Francesco Fiammingo held more to the delicate forms of infancy and in so doing brought forth the type that is followed today.

To Sig. Francesco Duquesnoy

I do not know how to express to you, Sir, my sense of obligation for the models you sent me and for the plaster casts of the two putti with the Inscription of Vanden in the Church of the Anima. And much less am I able to express the distinction of their beauty. It is as if nature rather than art had sculpted them, so that the marble is made tender by life. Even at this distance I hear praises of the statue of St. Andrew now being unveiled. Both individually and together with our whole nation, I rejoice and join with you in its fame. If I were not restrained by age and gout, which renders me useless, I would go there to rejoice at the sight and to admire the perfection of a work so worthy. I hope, nonetheless, to see you, Sir, here amongst us, and that Flanders, our beloved native land, will one day shine resplendent with your illustrious works.

From Antwerp, 17 April, 1640

Peter Paul Rubens

Cortona

Our most immediate and lively views of artists active in Rome around the middle of the seventeenth century come in good part from

Giovanni Battista Passeri (1610-1679). Passeri was primarily an artist, not a writer. Having studied under Domenichino, and being a friend of Algardi, he tended to support the classicists. But he was also perfectly capable of admiring (though not always of understanding) the Baroque. Passeri's Lives of the Artists *remained in manuscript until almost a century after his death, at which time it appeared in a truncated and somewhat garbled version.[1] That we know the* Lives *in its original form is due to the intensive studies made in this century by Jacob Hess, from whose critical edition are taken the sections of Cortona's biography that appear below.[2]*

Pietro Berrettini (1596-1669), called Cortona, is best known for his exuberantly Baroque painting. His contribution to the Baroque through his architecture is equally important, though it lies outside the scope of this book. As with most artists of his day Cortona's early studies were largely classical. He absorbed them selectively, however, so that he was able to incorporate a good deal into his personal statement of the Baroque. Cortona was one of a team of artists who made drawings for what the learned antiquarian Cassiano dal Pozzo hoped to make into a corpus of the remains of ancient Rome. Cortona's drawings of "various columns, urns and vases on which were represented sacrifices, bacchanals and other pagan ceremonies" were to provide him with endless poses, motifs, and the hefty men and women that became his basic figure types. We can tell from his paintings that the motifs that attracted him most were those closest to the Hellenistic tradition and thus most easily absorbed by the Baroque. Similarly, when Cortona studied Raphael, as every art student of that day was supposed to do, what he chose to copy was the Galatea: *the most dynamic, the most Hellenistic, the most nearly "Baroque" of all Raphael's work.*

Passeri's lines on Cortona's frescoes in S. Bibiena are included because they show he realized that these colorful, highly active scenes introduced a new note into seventeenth century Roman painting. But by far his fullest comments were reserved for the gigantic Glorification of Urban VIII, *which Cortona painted on the vault of the great hall in Palazzo Barberini. He worked on the fresco for six years, from 1633 to 1639, not twelve years as Pascoli says.*

The subject comes from a long poem by Francesco Bracciolini who had left the services of the Barberini when it appeared they had passed

1 Giovanni Battista Passeri, *Vite de' pittori, scultori ed architetti che hanno lavorato in Roma, morti dal 1641 fino al 1673,* ed. [and abridged by] Giovanni Lodovico Bianconi (Rome, 1772).

2 Jacob Hess, *Die Künstlerbiographien des Gio. B. Passeri, Eine Quellenkritsche Untersuchung zum römischen Barock* (Leipzig and Vienna, 1934), pp. 367-84. This critical edition is based on the study of several surviving holographs of Passeri's text, some of which Hess discovered.

their peak, then rushed to re-enter it when one became Pope. Bracciolini's poem is now lost, but the basic iconographic outline that Cortona took from it is described in Passeri.[3]

In the central panel the operative figure is Immortality. At the urging of Divine Providence she awards the Barberini Pope a crown of stars for the gloriousness of both his pontificate and his poetry. The four lateral panels allude allegorically to temporal aspects of the Pope's reign. Thus the Forge of Vulcan (with a cannon mixed in with the arms of ancient Romans) refers to Urban's strenuous efforts to rearm the Papal States, which included setting up a cannon foundry at Tivoli. In the same panel on the right, the belligerent figure chained to a pile of arms emphasizes the Pope's desire to keep the peace. The small panel with Hercules and the Harpies refers to the government's efforts to drive out vice. The two aerial figures in the same panel, one with fasces, the other with a cornucopia, symbolize Urban's justice and his bounty.

The opposite panel with Pallas Athena shows the victory of the gods over the giants. This, of course, is the classical equivalent to the Biblical theme of the fall of the rebel angels. In the mid-seventeenth century both symbolize the victory of the Church over heresy. The fourth panel has as its main protagonists Venus (on the left) and Silenus. In the center, passing beyond the frame, are two cloud-borne allegories, Wisdom and Religion, who rise above temporal passions, leaving behind the lusts of the flesh. The four small octagonal panels at the angles of the vault all contain scenes that illustrate the stoic virtues. That they intrude here, even in the glorification of the reign of a pope, serves to underline how widespread the cult of Stoicism had become, in Italy as in France, during the middle of the seventeenth century.

From Passeri, *Vite de' pittori, scultori ed architetti*

Pietro Berrettini was born in Cortona, a city in the ancient realm of Tuscany, whose ruler is the Grand Duke of the House of Medici. He was the son of Giovanni Berrettini, a stonemason by profession. But they were not exclusively manual laborers, that is to say, stonecutters, able to work only on blocks and ordinary things. On the contrary, they had some knowledge of design and of architecture. Giovanni Berrettini had several sons whom he put to work learning his profession. But seeing that Pietro was strongly drawn to painting, [his father] sent him to Florence and arranged for him to be lodged with Andrea Commodi (a Florentine painter who at that time had a certain reputation), in the

3 Space does not permit us to give Passeri's description in full. It is based on Girolamo Teti's *Aedes Barberinae* (Rome, 1642), which in turn is based on Bracciolini's lost poem.

hope that under his direction and discipline Pietro would progress along the proper path to painting. In 1611, for business reasons, Andrea had to come down to Rome. After he got there, finding he had to live there for some time, he was unhappy to have left Pietro in Florence, for he recognized him as a person who would make great progress in painting. Therefore he called him to Rome. Pietro was then fourteen years old. Two years later Commodi went back to Florence. Meanwhile Pietro applied himself to study, not losing a moment's time. He had already reached the point where he could paint things from his own imagination.

Knowing that Pietro loved Rome for the great opportunity it offered to study painting, and knowing that Pietro was reluctant to leave the city, before Commodi left Rome he arranged for a teacher for him. He entrusted him to Baccio Ciarpi, also a Florentine, and a painter above the ordinary level, with few equals as to good habits and character. Under the guidance of this good man, Pietro made progress. He studied attentively all the many things that one sees in Rome and made very accurate drawings. But his primary study was of the work of Raphael and Polidoro da Caravaggio. He also studied Michelangelo, as a foundation of his knowledge, especially in the refinement of his architecture. He also studied intensively Polidoro's beautiful paintings done in grisaille. There are some of these works now on the façades of Roman houses and there were more then. Cortona drew these façade paintings with great care because, he said, they taught him the true way to draw antiquities. By studying them he absorbed all aspects of the dress and manner of those times and learned all the qualities and customs of those people. Nor did he fail to study the statues and bas-reliefs of antiquity, especially various columns, urns, and vases on which were represented sacrifices, bacchanals, and other pagan ceremonies in order to learn the habits and customs of idolatrous peoples. In this way and with study he earned his bread as best he could. Being sober and continent, and making a virtue of necessity, he suffered every hardship without giving up his studies, which he continued to pursue night and day. Continuing under the direction of Ciarpi he made a copy of Raphael's *Galatea,* for his study, on a canvas as large as the painting. The *Galatea* is a fresco on the wall of the second loggia of the Palace called de' Chigi alla Lungara.

Cardinale Giulio Sacchetti, who had great affection for Pietro da Cortona, brought him to the attention of Cardinal Francesco Barberini, nephew of Pope Urban VIII, who was then restoring the church of S. Bibiana. Cardinal Sacchetti arranged to have Cardinal Barberini intervene with his uncle the Pope to have Pietro do some paintings in the church. He was pleased that Pietro was assigned part of the work. The

other part went to Agostino Ciampelli, a Florentine, who was then highly regarded, being in truth an artist with a manner of painting that was good for that period. When Ciampelli learned that the work was to be divided between him and Cortona he laughed and passed the word around among his friends that the Pope had given him a bean [dunce] for a rival and that it would take little effort to eat him up. When both the one and the other had finished their work it appeared that the "bean" that was easy to eat turned out to be very difficult to digest. For the newness and excellence of Cortona's manner brought about a change in the style of painting, turning it away from hard, frigid, and tasteless forms and toward a study of those things that are choice.

In that period Pope Urban VIII had bought for his family from the Sforzas the palace by the Four Fountains at Via Capo alle Case. He had it enlarged and decorated by Cavalier Bernini and had certain parts of it painted by various painters. Diverse persons were thought of for the vault of the great hall. Nevertheless, with the aid of a Jesuit father who was a great favorite of Cardinal Francesco Barberini, and I think also at the urging of Cardinal Sacchetti, it was agreed that Pietro should paint it. Cortona began immediately to carry out the assignment, on the basis of the poetic concept of Francesco Bracciolini of Pistoia, a poet who was well known in that period for all types of poetry dear to the Pope.

The proportions of this hall are ninety-five *palmi* long and fifty-three wide. Pietro divided the vault into equal parts. In the center he created a section of open sky of the same proportions as the main cornice but smaller, and he left similar openings in the four panels that surround the central section. In the four angles he creates the illusion of solid stucco supports, above which runs the main cornice that enframes the central panel.

Each angle contains four figures in various attitudes, also painted to imitate white stucco. At the top is an octagonal medallion, and in each there is a narrative scene in bas-relief. One expresses the virtue of Hannibal the Carthaginian in being moderate in the face of good fortune. Another shows the continence of Scipio Africanus toward the beautiful maiden who was his prisoner. The third shows the [stern] justice that the Consul Manlius executed on his own son, who, though victorious, had disobeyed him. The fourth expresses the courage and constancy of Mutius Scevola in burning his own right arm that had erred in not killing the King Porsena as he had intended to do.

In the central panel one sees a radiance of brilliant light and a majestic figure seated on a bank of clouds imbued with the rays of that resplendent light. The figure, which is seen from below, is grazing upward

at the glory of eternal bliss. In her left hand she grasps with regal grandeur a golden scepter. This is Divine Providence. Around her, and of necessity her companions, are the three theological virtues: Faith, Hope, and Charity. To her right is another figure on high, who holds with both hands a crown of luminous stars. This is Immortality, who is placed near Divine Providence and is the protagonist of the main theme. On a lower level appears a choir of damsels. They too are seated on luminous clouds. They are Justice, Piety, Eternity, Wisdom, Power, Truth, Beauty, and Modesty, who are shown to be subject to the word and command of Providence. Matched with them, on the right, is Time. He too is seated on clouds, which, to indicate that they are further away from the radiance of divine glory, take on tints from the blue of the air. With his left hand Time holds a scythe and with his right he holds up a child whom he is devouring. To the left are the Three Fates, who spin and cut short the thread of human life. At the far end of the central panel near the windows and the main rostrum of the hall three maidens are shown holding a verdant laurel wreath. In the center of the wreath we see three huge bees flying in formation to form the Barberini arms. These are the three principal muses: Urania, Calliope, and Clio, who by circling the bees with laurel wish to express the glory that the famous poetry of Urban VIII deserves. In the midst of the wreath another female figure holds up the great triple crown of the papacy. She is Rome, Queen of the World, having been raised to that dignity by reason that the papacy is Roman. Beside her is another figure who holds beneath the great tiara the two crossed keys, one of gold and the other of silver. She represents the glory that this Pope won on his election.

Above the wall on the long side, opposite the door where you enter the hall, is a gay feast of Bacchus. In it we see fat old Silenus carried by some fauns and female Bacchants who pass playfully around him. In the center of the panel there is a limpid and crystalline font that rises at the center of a great basin. The basin collects the falling waters to form a delightful bath within which some nymphs are bathing. They are pretty but comport themselves with great modesty and do not reveal themselves lasciviously. At the far side is a Venus lying on a soft rich bed. But she lifts herself up in fright because she sees in the air above Profane Love (who is her Cupid) put to flight by Celestial Love, who is aided by Purity. Purity, a maiden dressed in white, encourages Divine Love to drive off the lascivious and impure Cupid. Outside this panel on a group of white clouds we see the fine figure of a kneeling woman, looking something like a [Roman] matron, who holds an ancient tripod on which burn sacrificial fires. She is Religion. Next to her is another figure, this one of a lovely maiden who arises from the cloud to enter heaven carrying two open books, one in each hand. She is Wisdom.

On the opposite side above the entrance door there is a panel of the same size. In it is represented the smithy of Vulcan, in which three cyclops, with heavy blows of their hammers, are fashioning on a forge shields, helmets, cuirasses, lances, thunderbolts, and the other things that we see there. On the far side of the same panel is a seated male figure. He is unarmed, with his arms tied behind and chained on top of a heap of armaments. He is Bellicosity and is the prisoner of Peace, a virtue always sustained and practiced by the great Pope Urban. Nearby one sees a round Tuscan Doric temple with its doors thrown wide. Inside are flames and smoke as from a fire. Outside the panel, as on the opposite wall, one sees the noble figure of a great lady majestically seated. In her right hand she holds the caduceus of Mercury and in her left a gold key. She is Peace. Before her, kneeling, is Prudence, who holds a mirror into which she gazes. On the left one sees another maiden ready to receive her commands. She is Diligence. She too has a key in her hand and hurries to take it to close the Temple of Janus so as to calm the tumult of war. In the distance is an airborne damsel with two trumpets in her hands. She is Fame.

In the small panel on the side by the windows Cortona painted an enraged Hercules, with club in hand, who is beating and driving off some harpies. He has already killed one, on which he places his left foot. Now he concentrates on striking the other, who flies shrieking through the air across the edge of the feigned stuccoes that form the boundaries of the whole panel. Hercules represents that valorous virtue that keeps far from the State the ugly vices symbolized by the harpies. In the air but within the panel proper are two flying figures. One is Power, who carries on her shoulder the fasces that is suitable for Justice. The other, who is Generosity, pours profusely from a cornucopia coins, jewels, trinkets, flowers, and fruits. Many figures of diverse types kneel eagerly awaiting her favor.

The opposite panel, which is the same size, represents the precipitous fall of the Giants who presumed to make war against the gods, and who, to reach the heights of Mt. Olympus, piled Pelion on Ossa. We view them in the headlong descent of their precipitous fall. We see them fall with such shattering effect that they have fractured the whole upper part of those fictive stuccoes that form the enframement of the vault. They fall with those crumbling mountains to which in various chaotic ways they cling in the fury of their downward thrust. Agile and light as she flies through the air is a figure armed with helmet and cuirass, a woman girt with a light gown. By furiously brandishing a spear she shows through her blows and the fear she produces that she is the reason for their fall. This figure, who appears to be like Pallas Athena, is the superior virtue who is able to demolish the temerity, the audacity, and the presumption of the arrogant Giants.

Bernini: Part One

From the mid-seventeenth century until he died in December of 1680, Bernini was the most famous artist in the world. When at the time of his death Queen Christina of Sweden, a Catholic convert living in Rome, decided to commission someone to write his biography, she chose none of the Roman historians or art theorists but a Florentine, Filippo Baldinucci (1625-1696) to carry out the task.

At the time he received the assignment, early in 1681, Baldinucci already had a considerable reputation as a scholar. Born into the family of a Florentine merchant, he was sent to school with the Jesuits but soon turned towards art.[1] He studied first in the workshop of Jacopo Maria Foggini, a minor engraver and wood sculptor, and then with the painter Matteo Rosselli. His ability to make rapid portrait sketches and his general knowledge of art won him admission to the circle of art lovers and patrons that gathered around Alessandro Valori at the Villa d'Empoli. It is probably through this group that he came to the attention of the Grand Duke of Tuscany, Ferdinando II, who recommended him to his sister, Anne of Austria, to inventory and put in order an estate she had inherited in Mantua. There he studied the art treasures in the galleries of the Gonzagas, who had what was then one of the finest painting collections in Europe.

New opportunities opened for Baldinucci in Florence when in 1663 Cardinal Leopoldo de' Medici, a brilliant and enthusiastic patron of both science and the arts, ascended the Granducal throne. After seeing proof of Baldinucci's remarkable ability to attribute drawings to specific artists on the basis of their stylistic characteristics, the Cardinal put him in charge of cataloguing the large collection of drawings that belonged to the Medici, and commissioned him to buy more drawings to add to it. These drawings Baldinucci classified by artist and approximate date, and he arranged them in over a hundred volumes. The collection forms the nucleus of the print cabinet at the Uffizi Gallery in Florence, which is recognized today as one of the world's finest drawing collections. Baldinucci also helped enlarge the Medici's collection of paintings, placing special emphasis on adding artists and schools not previously represented. (The concept that a collection should try to be broadly representative was in itself quite a new idea.) He also established the Medici's famous and unique collection of self-portraits, which is today part of the Uffizi.

[1] What we know of Baldinucci's life comes chiefly from the biography written by his son Francesco Saverio, which remained in manuscript until published by Sergio Samek Ludovici in F. Baldinucci, *Vita del Cavaliere G. L. Bernino* (Milan, 1948), pp. 33-63.

Baldinucci traveled widely throughout Italy looking for paintings and drawings for the Medici. In this way he came into direct contact with many artists and was forced to evaluate endless works of art. Out of all this activity and study came the masterwork of Baldinucci's career, his encyclopedic history of painters, sculptors, and architects (Notizie de' professori del disegno da Cimabue in qua), which appeared in six large volumes, the first in 1681. The work is valuable today chiefly for those artists who were active during Baldinucci's lifetime. In compiling these lives he carried out intensive investigations of the available source material: account books, inventories, diaries, letters, and the like. His emphasis on documentation, which today we recognize as one of the basic components of art historical method, was so far ahead of its time that we find nothing similar until the nineteenth century.

Baldinucci's other writings are less monumental but solid. His Vocabulario toscano dell'arte del disegno, which appeared in 1681, is the first serious dictionary of art terms to appear anywhere. For its period it is absolutely definitive. It won for Baldinucci membership in the Accademia della Crusca, which then, and still today, makes itself responsible for the purity and rational development of the Italian language. In 1686, a decade before his death, he published the first general history of prints (Cominciamento e progresso dell'arte dell'intagliare in rame), a field only then beginning to be recognized as an independent artistic discipline.

Of all Baldinucci's works the one that has proved most valuable to the art historian (if the frequency with which it is cited is any indication) is his Life of Bernini. It is useful, of course, because it tells us what Bernini did (lost works that we know of because they are mentioned in Baldinucci are still turning up), but above all its value lies in the picture it gives us of a great artist as seen through the eyes of a highly knowledgeable and sensitive contemporary. Baldinucci was a connoisseur with a keen eye for style. In sharp contrast to the majority of seventeenth century critics, he understood and admired the Baroque.

From that part of his book where Baldinucci discusses in detail most of Bernini's major works we choose only one example, the section on the Four Rivers Fountain. It was commissioned by Innocent X, the Pamphili Pope, to embellish Piazza Navona, the square in which the family had their residence. When the new Pope ascended the throne, he had been appalled to discover the extent to which his predecessor, Urban VIII (Barberini) had drained the papal treasury in order to adorn and enrich his family. So strong were the cries of corruption that some of the Barberini fled to France. Anyone who had been connected with their

*family was automatically in disgrace in the eyes of the new Pope. Of
course this included Bernini, who had been the chief Barberini artist.
Innocent X attempted at first to have Allessandro Algardi substitute for
Bernini in sculpture and Francesco Borromini in architecture. The fol-
lowing passage shows how he came to agree, however reluctantly, with
the Barberini that Bernini was irreplaceable.[2] Baldinucci's description
is the main source for our understanding of the fountain's rather com-
plex iconography (about which there are still unsolved problems). But
its interest lies still more in the writer's obvious approval of Bernini's
daring and originality, that is to say, in aspects that for the most part
today we would call Baroque. Baldinucci grasps at once the importance
of the gushing water as an essential part of the fountain's design, its
integration with the rock masses, and the sound of the water in move-
ment as it splashes, gurgles, or murmurs. He is pleased with the way that
Bernini has tunneled out the travertine base so as to give the illusion
that the heavy granite obelisk is resting on air. And he is obviously de-
lighted with the theatrical effect of the waters of the fountain being
turned on suddenly and unexpectedly.*

*In the passages below that follow the section on the fountain, Baldi-
nucci attempts to evaluate Bernini and his work. He begins by stressing
the strength of Bernini's religious feeling. This is an aspect that needs
to be continually restated today. That his religious sculpture could be
understood outside the context of Catholicism is something that Bernini,
Baldinucci, and almost all their contemporaries would have found un-
thinkable.*

*When Baldinucci speaks of Bernini's drawings he does so as some-
one with a grasp of their freedom and spontaneity, their role in the cre-
ative process. He is also with the avant-garde in his approval of the way
in which Bernini fused architecture, painting, and sculpture. Such a syn-
thesis (which today we see as one of the major accomplishments of the
Roman High Baroque) Baldinucci recognized as something completely
new.*

*He agreed that a great artist should be aware of the rules but not
constrained by them. "Those who do not sometimes go outside the rules
never go beyond them" he quotes Bernini as saying. How different all
this is from the dry formalism of Bellori! It is undoubtedly Bellori's
Idea of Beauty that is being attacked when Baldinucci tells us that Bernini
ridiculed the endlessly repeated anecdote that the Greek painter Zeuxis*

[2] This and the following section are taken from Filippo Baldinucci, *The Life of
Bernini*, trans. by Catherine Enggass (University Park, Pa.), 1966.

was able to create a synthetic image more beautiful than that of any real woman by selecting, from various beautiful women, the most beautiful part of each. Bellori also quotes the anecdote, but in his case the concept of an eclectic synthesis based empirically on nature lies at the very heart of his artistic theory (see pp. 8-16).

The descriptions of Bernini's stage productions are especially interesting for the insight they give us of the close relationship between Baroque art and the Baroque theatre. From Baldinucci and other sources we learn of another dimension to Bernini's fabulous artistic creativity. We see him as a theatrical impresario, devising and carrying out productions filled with visual patterns of the highest originality and excitement: stage effects in continual movement; rising, falling, revolving platforms; live actors who seem to float through the air; startling pyrotechnics; amazing hydrolics.

From Baldinucci, *Vita del Cavaliere Giovanni Lorenzo Bernino*

The sinister impressions made by Bernini's rivals on the mind of the Pope were so effective than when Innocent X decided to raise the great obelisk brought to Rome by the Emperor Antoninus Caracalla, which had long been buried at Capo di Bove, and erect it in Piazza Navona as the crowning element of a most noble fountain, he had the leading Roman architects prepare various designs without asking for one from Bernini. But how great a petitioner for its possessor is true merit, and how well it speaks for itself! Prince Niccolò Ludovisi, who was married to a niece of the Pope and who was not only an intimate friend of Bernini but also had influence with him, prevailed on him to make a model of the fountain. In that model Bernini represented the four principal rivers of the world: the Nile for Africa, the Danube for Europe, the Ganges for Asia, and the Río de la Plata for America. A boulder or rock, open in the center, supported the enormous obelisk. Bernini made the model, and the Prince arranged for it to be transported to Palazzo Pamphili in Piazza Navona. There it was secretly placed in a room through which the Pope, who on a certain day was to dine there, had to pass as he left the table. On that very day, which was the Feast of the Annunciation of the Virgin Mary, after the procession the Pope appeared and after the repast went with the Cardinal and Donna Olimpia, his sister-in-law, into that room. Upon seeing such a noble creation and a design for such a vast monument he was nearly ecstatic. Since he was a prince of the clearest intelligence and of the loftiest thoughts, after spending half an hour or more around the model, continuously admiring and praising it, he burst out in the presence of the whole Secret Council with the following words: "This is a trick of Prince Ludovisi, but it will

be necessary to make use of Bernini despite those who do not wish it, since those who do not want his works must not look at them." He immediately sent for Bernini, and with a thousand signs of esteem and love and with a majestic manner, almost apologizing, he explained to him the motives and various reasons for not having made use of him before, and he gave him the commission to make the fountain after his model. Afterward and for the rest of his pontificate, Bernini was always in favor and held in the high esteem to which he was accustomed. Indeed, he was so much in the good graces of that pontiff that every week or so the Pope wanted him at the palace, and there he passed several hours in delightful discourse. It was often said that Bernini was a man born to associate with great princes.

But I do not want to pass too rapidly to other matters without first saying something about the fountain, which is counted among Bernini's most marvelous creations and which proved to be one of the most beautiful ornaments of the city of Rome. In the very center, then, of the length and breadth of the great Piazza Navona is situated at ground level a step or bank, so to speak, which forms a great circle about 106 Roman *palmi* in diameter. About 10 *palmi* from the two extremities lies a great basin symbolizing, I believe, the sea, in the midst of which there rises up to a height of about 30 *palmi* a mass or, let us say, a grotto made of travertine. This mass is tunnelled through so that from all four sides one can see through the other side of the piazza. By means of these openings the rock is divided into four parts, which are joined and united at the top. These four parts represent the four continents of the world. The sections, by broadening and jutting out in various craggy masses, provide places for four very imposing giant figures of white marble representing the four rivers. The Nile symbolizing Africa is the figure covering the upper part of his head with a cloth as an indication of the obscurity that long prevailed regarding the exact point from which it springs from the earth. Beside it is a very beautiful palm tree. The Danube, which represents Europe, is admiring the marvelous obelisk and has a lion nearby. The Ganges, which stands for Asia, holds a large oar indicating the great extent of its waters. A little below it is a horse. Finally, comes the Río de la Plata for America. It is represented by a Moor, and next to it are some coins to show the wealth of minerals abounding in that country. Beneath the figure is a terrible monster commonly known as the Tatù of the Indies. Around all these river allegories water brought there from the Trevi Fountain gushes in great quantities. In the basin at the water line appear some large fish in the act of darting into the sea, all of them most beautiful. One fish on the side toward Piazza Orsini is seen swallowing the water that sustains its life, and having taken in too great a quantity, it blows out the excess—a truly brilliant concept.

The pedestal stands splendidly at the exact center of the rock's summit, about twenty-three *palmi* high. Upon it rests the great obelisk about eighty *palmi* in height. It is crowned with a beautiful metal finial about ten *palmi* high upon which a gilded cross shines. Above rests a dove with an olive branch in its beak, the emblem of the Pamphili family. One marvels not a little to see the immense mass of the obelisk erected on a rock so hollowed out and divided and observe how—speaking in artistic terms—it seems to stand upon a void. The water falls in abundance; the sweet murmuring sounds and plenitude make it a thing of utility and delight to the commune.

When this great work was almost completed but before it was unveiled, that is to say, before the scaffolding and the cloth-covered framework that kept it hidden from the public's eye had been removed, the Pope wished to see it. Therefore, one morning the Pope arrived and entered the enclosure together with Cardinal Panzirolo, his secretary of state, and about fifty of his closest confidants. He remained there more than an hour and a half enjoying himself greatly. Since the water had not yet been turned on, the Pope asked Bernini when it would be possible to see it fall. Bernini replied that he could not say on such short notice, since some time was required to put everything in order. Nevertheless, he said he would see to it that everything was done as soon as possible. The pontiff then gave him his benediction and turned toward the door to leave. He had not yet gone out of the enclosure when he heard a loud sound of water. Turning back he saw it gush forth on all sides in great abundance. The Cavalier had, at the crucial moment, given a certain signal to the person whose job it was to open the water ducts, and he quickly had it coursing through the pipes to the mouths of the fountain. Bernini knew that the more unexpected it was, the more pleasing it would be to the Pope. Overcome by such originality and gladdened by so beautiful a sight, the Pope returned with his whole court. Turning to Bernini he exclaimed, "In giving us this unexpected joy, Bernini, you have added ten years to our life." As a greater sign of his pleasure the Pope sent to the home of his sister-in-law, Donna Olimpia, in Piazza Navona for a hundred doubloons to be quickly distributed to the men engaged in work on the fountain.

It is impossible to relate how, after the fountain was unveiled, the ideas of the great persons who gathered in that place changed from those they had held before about Bernini, and how he was applauded in public and in private. From that point he became the unique object of the praise of all the academies in Rome.

Before speaking of his last illness and death, which to our eyes truly seemed like his life, we should here mention that although it may

be that up until his fortieth year, the age at which he married, Cavalier Bernini had some youthful romantic entanglements without, however, creating any impediment to his studies of the arts or prejudicing in any way that which the world calls prudence, we may truthfully say that his marriage not only put an end to his way of living, but that from that hour he began to behave more like a cleric than a layman. So spiritual was his way of life that, according to what was reported to me by those who know, he might often have been worthy of the admiration of the most perfect monastics. He always kept fixed in his mind an intense awareness of death. He often had long discussions on this subject with Father Marchesi, his nephew, who was an Oratorian priest at the Chiesa Nuova, known for his goodness and learning. So great and continual was the fervor with which he longed for the happiness of that last step, that for the sole intention of attaining it, he frequented for forty years continuously the devotions conducted toward this end by the fathers of the Society of Jesus in Rome. There, also, he partook in the Holy Eucharist twice a week.

The Cavalier Gian Lorenzo Bernini was a man of average stature with a somewhat dark complexion and black hair that turned white with age. His eye was spirited and lively with a piercing gaze under heavy eyebrows. His behavior was fiery.

When not diverted by architectural projects, Bernini normally spent up to seven straight hours without resting when working in marble: a sustained effort that his young assistants could not maintain. If, sometimes, one of them tried to tear him away he would resist saying: "Let me stay here for I am enthralled." He remained, then, so steadfastly at his work that he seemed to be in ecstasy, and it appeared from his eyes that he wanted his spirit to issue forth to give life to the stone. Because of his intense concentration it was always necessary to have a young assistant on the scaffolding with him to prevent him from falling, as he paid no attention when he moved about. The cardinals and princes who came to watch him work would seat themselves without a word and just as silently, so as not to distract him for a moment, make their departure. He proceeded in this manner for the entire working session and at the end he would be bathed in perspiration and, in his last years, very lowered in spirits. But because of his excellent constitution a little rest would restore him.

I would now like to touch in a general way on some other of his fine qualities, qualities either given him by nature or which, through long and diligent effort, were always and everywhere the inseparable companions of his deeds and had become second nature to him. First of all, we can with good reason affirm that Cavalier Bernini was most singular in the arts he pursued because he possessed in high measure skill in draw-

ing. This is clearly demonstrated by the works he executed in sculpture, painting, and architecture and by the infinite number of his drawings of the human body, which are to be found in almost all the most famous galleries in Italy and elsewhere. A group of these drawings merits a worthy place in the library of the Most Serene Cardinal Leopoldo de' Medici, of glorious memory. The Chigi family possesses many, and a great number of them were sent to France. In these drawings one notes a marvelous symmetry, a great sense of majesty, and a boldness of touch that is really a miracle. I would be at a loss to name a contemporary of Bernini who could be compared with him in that skill. A particular product of his boldness in drawing was his work in that sort of sketch we call caricature or "charged strokes," which for a joke distorts in an uncomplimentary way the appearance of others, without taking away the likeness or grandeur if the subjects were, as often happened, princes. Such personages are inclined to be amused at such entertainment even when their own appearance is concerned and would pass around the drawings for other persons of high rank to see.

The opinion is widespread that Bernini was the first to attempt to unite architecture with sculpture and painting in such a manner that together they make a beautiful whole. This he accomplished by removing all repugnant uniformity of poses, breaking up the poses sometimes without violating good rules, although he did not bind himself to the rules. His usual words on this subject were that those who do not sometimes go outside the rules never go beyond them. He thought, however, that those who were not skilled in both painting and sculpture should not put themselves to that test but should remain rooted in the good precepts of art. He knew from the beginning that his strong point was sculpture. Thus, although he felt a great inclination toward painting, he did not wish to devote himself to it altogether. We could say that his painting was merely diversion. Nevertheless he made such great progress in that art that besides the paintings by his hand that are on public view, there are more than one hundred and fifty canvases, many owned by the most excellent Barberini and Chigi families and by Bernini's children. A very fine, lively self-portrait hangs in the famous gallery of self-portraits of great masters in the palace of the Most Serene Grand Duke of Tuscany.

Before Bernini's and our own day there was perhaps never anyone who manipulated marble with more facility and boldness. He gave his works a marvelous softness from which many great men who worked in Rome during his time learned. Although some censured the drapery of his figures as too complex and sharp, he felt this, on the contrary, to be a special indication of his skill. Through it he demonstrated that he had overcome the great difficulty of making the marble, so to say, flexible

and of finding a way to combine painting and sculpture, something that had not been done by other artists.

It is not easy to describe the love Bernini brought to his work. He said that, when he began work, it was for him like entering a pleasure garden.

There are many indications of that great esteem which he always aroused. As proof it will suffice to tell of the first time that Her Majesty the Queen of Sweden did him the honor of going to see him at work in his own house. Bernini received her in the heavy rough garment he was accustomed to wear when working in marble. Since it was what he wore for his art, he considered it to be the most worthy possible garment in which to receive that great lady. This beautiful subtlety was quickly perceived by the Queen's sublime genius. His action not only increased her concept of his spirit, but even led her, as a sign of her esteem for his art, to wish to touch the garment with her own hand.

Bernini had great knowledge and noble sentiments concerning the arts and those who professed them. To the general and habitual courtesy of those masters of art I here register my debt, as the fruits of this narrative come directly from them. Bernini wanted his students to love that which was most beautiful in nature. He said that the whole point of art consisted in knowing, recognizing, and finding it. He, therefore, did not accept the thesis of those who stated that Michelangelo and the ancient masters of Greece and Rome had added a certain grace to their work that is not found in the natural world. Nature knows how to give to every part its commensurate beauty, Bernini said, but one must know how to recognize it when the opportunity arises. In this regard, he used to relate that in studying the Medici Venus he had at one time come to the same conclusion in observing her most graceful gesture. But since that time, having made profound studies of nature, he had clearly observed exactly the same graceful gesture on many occasions. He held that the story of the Venus that Zeuxis made was a fable: that is to say, the story that Zeuxis had made her from the most beautiful parts of many different girls, taking one part from one and another part from another. He said that the beautiful eyes of one woman do not go well with the beautiful face of another woman, and so it was with a beautiful mouth, and so on. I would say that this is absolutely true, since the various parts are not only beautiful in themselves but in their relationship to other parts. Thus the beautiful shaft of a column is praiseworthy for the proportions it has by itself, but if one adds a beautiful base and a fine capital that do not go with it, the column as a whole loses its beauty. This principle of Bernini's agrees with another of his concepts. He said that in making a portrait from life everything consisted in being able to recognize the unique qualities of individuality that nature gives to each person

rather than the generality common to all. In choosing a particularity
one must pick one that is beautiful rather than ugly. In order to achieve
this end Bernini had a practice very different from the general run. He
did not want the person he was drawing to remain immobile. Rather
he wished him to move about and talk, since he said he then could
see all his beauty and, as it were, capture it. He said that a person who
poses, fixed and immobile, is never as much himself as he is when he is
in motion, when those qualities that are his alone and not of a general
nature appear. Such individuality gives a portrait its likeness.

In his works, whether large or small, Bernini strove with every-
thing in him to make resplendent all the conceptual beauty inherent in
whatever he was working on. He said that he was accustomed to putting
in no less study and application in designing an oil lamp than in de-
signing a very noble edifice. In preparing his works he would consider
one thing at a time. He gave this procedure as a precept to his disciples,
that is to say, first comes the concept, then reflection on the arrangement
of the parts, and finally giving the perfection of grace and sensitivity to
them. As an example he cited the orator who first conceives, then orders,
elaborates, and embellishes. He said that each of these operations de-
manded the whole man and that to do more than one thing at a time
was impossible.

Bernini declared that painting was superior to sculpture, since
sculpture shows that which exists with more dimensions, whereas paint-
ing shows that which does not exist, that is, it shows relief where there
is no relief and gives an effect of distance where there is none. However,
there is a certain greater difficulty in executing a likeness in sculpture
and, as proof, Bernini pointed to the fact that a man who loses his color
no longer looks like himself, whereas sculpture is able to create a like-
ness in white marble.

The great art in bas-relief, he said, was in making things appear
in relief that are not in relief. In speaking of high-relief, particularly
those in Alexander's apartment, he used to say that they were of little
technical skill since they are almost completely in the round, and are
what they appear to be, rather than appearing to be what they are not.
He said that among the works of antiquity, the Laocoön and the Pasquin
contain, in themselves, all the best of art, since one sees in them all that
is most perfect reproduced without the affectation of art. The most beau-
tiful statues existing in Rome, he said, were the Belvedere Torso and the
Laocoön, of those still whole: the Laocoön for its emotional content,
particularly for the understanding it displays in that leg, which already
being affected by the poison, seems to be numb. Bernini, however, said
that the Torso and the Pasquin seemed to him more perfect stylistically
than the Laocoön, but that the Laocoön was whole whereas the others

were not. He said the difference between the Pasquin and the Torso is almost imperceptible and could not be perceived except by a great man, but that such a man would find the Pasquin to be rather better. Bernini was the first in Rome to place the Pasquin highest. He told of one time being asked by someone from beyond the Alps which was the most beautiful statue in Rome, and that when he responded, the Pasquin, the foreigner thought he was joking so he went with him to prove it.

Bernini had splendid precepts concerning architecture: first of all he said the highest merit lay not in making beautiful and commodious buildings, but in being able to make do with little, to make beautiful things out of the inadequate and ill-adapted, to make use of a defect in such a way that if it had not existed one would have to invent it. Many of his works attest that his skill came up to that level. It is seen, especially, in Urban VIII's coat of arms in the Church of Aracoeli. There, since the logical space to place the emblem was occupied by a large window, he colored the glass blue and on it represented the three bees as if flying through the air, and above he placed the triple crown. He proceeded in a similar way in the tomb of Alexander VII and in the placement of the cathedra, where the window was turned from an impediment into an asset: around it he represented a Vision of Glory, and in the very center of the glass, as if in place of the inaccessible light, he portrayed the Holy Spirit in the form of a dove, which brings the whole work to a consummation. He put such ideas in practice more than once in the designing of fountains. The fountain for Cardinal Antonio Barberini at Bastioni is a fine example. Since there was very little water and very thin jets, he represented a woman who, having washed her hair, squeezes it to produce a thin spray of water, which satisfies both the needs of the fountain and the action of the figure. Though this is a concept that had been used earlier by another artist for a fountain for the Most Serene Grand Duke of Tuscany, we can believe it was also reborn in Bernini's charming fancy. In another fountain made for the Duke Girolamo Mattei for his famous villa at the Navicella he wished to do something great and majestic, but the water would only rise a little. He made a representation of Mount Olympus, on which he placed the figure of a flying eagle, an emblem of the Mattei, which also makes an effective reference to the mountain. He placed clouds midway up the mountain, since they could not rise to the summit of Olympus, and from these clouds rain fell. Another of his precepts should be brought forth since we are speaking of fountains. It is that since fountains are made for the enjoyment of water, then the water should always be made to fall so that it can be seen. It was with such a precept in mind, I believe, that in his restoration of the bridge of Sant'Angelo by order of Clement IX, he had the side walls lowered so that the water could better be

enjoyed. The eye then may see with double pleasure from the banks of the river the flow of water as well as the bridge above, ornamented with angels that allude to its ancient name.

He who pointed out that poetry is painting that speaks and, conversely, that painting is a kind of mute poetry spoke well. But if such a description fits poetry in general, it is much more suited to that kind of poetry called dramatic or illustrative. In such poetry, as in a beautiful historical painting, we note various persons of diverse ages, conditions, and customs, each with an individuality of appearance and action, with admirably distributed colors which form, as do the voices of a well-balanced choir, a beautiful and marvelous composition. Therefore, it is not surprising at all that a man of Bernini's excellence in the three arts, whose common source is drawing, also possessed in high measure the fine gift of composing excellent and most ingenious theatrical productions, since it derives from the same genius and is the fruit of the same vitality and spirit. Bernini was, then, outstanding in dramatic actions and in composing plays. He put on many productions, which were highly applauded for their scope and creativity during the time of Urban VIII and Innocent X. He created most admirably all the parts both serious and comic in all the various styles that up to his time had been represented on the stage. He enriched them further with such ideas that the learned who heard them attributed some to Terence, others to Plautus and similar authors that Bernini had never read. He created them all by the force of his genius. Sometimes it took an entire month for Bernini to act out all the parts himself in order to instruct the others and then to adapt the part for each individual. The keenness of the witticisms, the bizarreness of the devices through which he derided abuses and struck at bad behavior were such that whole books could be made of them, not without delight to those who might wish to read them. But I leave all of them for someone better. It was, nevertheless, wonderful to see that those who were the butt of his witticisms and mockeries, who for the most part were present at the performances, never took offense. Bernini's ability to blend his talents in the arts for the invention of stage machinery has never been equalled in my opinion. They say that in the celebrated spectacle *The Inundation of the Tiber* he made it appear that a great mass of water advanced from far away, little by little breaking through the dikes. When the water broke through the last dike facing the audience, it flowed forward with such a rush and spread so much terror among the spectators that there was no one, not even among the most knowledgeable, who did not quickly get up to leave in fear of an actual flood. Then, suddenly, with the opening of a sluice gate, all the water was drained away.

Another time he made it appear that by a casual unforeseen ac-

cident the theatre caught fire. Bernini represented a carnival carriage, behind which some servants with torches walked. The person whose job it was to perpetrate the trick repeatedly brushed his torch against the stage set as happened sometimes. It was as if he wanted to spread the flames above the wall partitions. Those who did not know the game cried out loudly for him to stop so that he would not set fire to the scenery. Scarcely had fear been engendered in the audience by the action and the outcry, when the whole set was seen burning with artificial flames. There was such terror among the spectators that it was necessary to reveal the trick to keep them from fleeing. Afterward there was another noble and beautiful scene.

Once he composed two prologues for a spectacle to be performed in two theatres, one opposite the other, so that the people could hear the play in one theatre as well as in the other. The spectators in the regular theatre, who were the most important and famous, saw themselves recreated in effigy by masks in the other theatre in a manner so lifelike that they were amazed. One of the prologues faced outward, while the other was reversed, as the parts were played. It was delightful to see the departure of the people—in carriages, on foot, and on horseback—at the conclusion.

The fame of the play *La Fiera,* produced for Cardinal Antonio Barberini during the reign of Urban VIII, will live forever. There was everything in it that one is accustomed to seeing in such gatherings. The same is true of the spectacle *La Marina,* which was done with a new invention and that of the *Palazzo d'Atlante e d'Astolfo,* which astonished the age.

It was Bernini who first invented that beautiful stage machine for representing the rising of the sun. It was so much talked about that Louis XIII, the French king of glorious memory, asked him for a model of it. Bernini sent it to him with careful instructions, at the end of which he wrote these words, "It will work when I send you my head and hands." He said he had a fine idea for a play in which all the errors that come from running the stage machinery would be revealed along with their corrections, and still another not yet presented, for giving the ladies away on the stage. He disapproved of horses or other real creatures appearing on stage, saying that art consists in everything being simulated although seeming to be real.

More could be said, which for the sake of brevity is passed over. I will close this section with Cardinal Pallavicini's familiar remark that Cavalier Bernini was not only the best sculptor and architect of his century but, to put it simply, the greatest man as well. A great theologian, he said, or a great captain or great orator might have been valued more highly, as the present century thinks such professions either more noble

or more necessary. But there was no theologian who had advanced as far in his profession during that period as Bernini had advanced in his.

It is not surprising, then, that one can say that Bernini was always highly esteemed and even revered by the great.

Bernini: Part Two

Chantelou's Diary *gives us a lengthy, almost daily account of Bernini's activities during his visit to France in the summer and fall of 1665.*[1] *Bernini, then in his upper sixties, came reluctantly, after protracted negotiations between the French government and the Papacy. The purpose of his trip was to build a larger and more splendid royal palace for Louis XIV on the site of the Louvre. It was considered fitting and appropriate, to the French at least, that the world's most famous artist should serve the world's strongest king.*

Bernini's trip to France was almost completely a fiasco. He liked the king but in general he thought he was living among cultural barbarians. He considered French architecture chaotic and French painting petty (except of course for Poussin, who was more Roman than the Romans). He marveled that the king (who liked Bernini's work) should have such good taste when he had only bad examples to go by. In his designs for the Louvre Bernini made no concessions to French stylistic preferences in architecture, French climatic conditions, or the like. His project was abandoned shortly after he left Paris and French architects took his place. The only thing he left behind him was the bust of Louis XIV that is now in Versailles.

Chantelou's Diary *is chiefly valuable for its history of Bernini's designs for the Louvre, but it is also prized for its sense of immediacy. The entries record conversations with Bernini a few hours, or at most a few days, after they took place.*

The author of the diary, Paul Freart, Sieur de Chantelou, was a French nobleman whom the king chose to act as a sort of aide-de-camp to Bernini during his stay in Paris. He could hardly have been better qualified. A long-time resident of Rome, he had a full command of Italian. He was also an art collector, a connoisseur, and a student of artistic theory.

The sections we have taken from the diary deal only with Bernini

[1] Chantelou's diary remained in manuscript until the late nineteenth century, when it was published by Louis Lalande in serial form in the *Gazette des Beaux-Arts* between 1883 and 1885. It was republished in Paris in 1930 with an introduction by G. Charensol. An edition in German, translated and edited by H. Rose, appeared in Munich in 1919, and one in Italian by Stefano Bottari in 1946.

as a sculptor, and are intended to suggest something of the boldness of his working methods. Thus he hollowed out sections of his statues to produce shadows so that the painting would become "coloristic," paralleling the effects of color in painting, or, looking at it in the Woelfflinian sense, so that the sculpture would become painterly (conceived in terms of light and shade). Similarly, for his portrait of Louis XIV, Bernini made endless sketches showing the monarch in the midst of his daily activities, talking, gesticulating. But in the end, when he had fixed Louis' features in his mind, he put the drawings aside so that he could focus not on the king's likeness but on the concept of kingship.

From Chantelou's diary

[Bernini] is an eloquent speaker. He has a gift all his own for expressing himself with words, facial expressions, and gestures, and for making things visible as pleasantly as the greatest painters could do with their brush.[1] Speaking of sculpture and the difficulty of having it come out well, and of obtaining the likeness, especially in marble portraits, he told me something remarkable that he since at every opportunity repeated. He said that if someone whitened his hair, beard, and eyebrows, and if possible, his pupils and lips, and then showed himself in that condition, even those who see him every day would have trouble in recognizing him. As proof of this he added: when a person falls into a faint the pallor that spreads over his face is alone almost enough to make him almost unrecognizable, so that we often say, "He doesn't seem himself anymore." Therefore, [he concluded] it is very difficult to obtain a likeness in a marble portrait that is all of one color. Then he said something still more extraordinary, that sometimes in a marble portrait it is necessary, in order to imitate the natural well, to create that which is not in nature. In order to render the bluish black that some people have around their eyes, the marble must be hollowed out at the point where these darkenings are, in order to give the effect of this coloration. This artifice, as it were, compensates for the deficiency of the art of sculpture, which cannot give color to things. Thus, he concluded, the natural is not the same thing as imitation. He added an observation about sculpture. In contrast to the previous observations, this one did not completely convince me: "A sculptor," he said, "creates a figure with one hand raised and with the other placed on his chest. Experience teaches us that the hand in the air ought to be larger and fuller than the other one placed on his chest. This is because the air which surrounds

[1] Taken from the entry in Chantelou's diary for June 6, 1665, as published in *Journal du Voyage en France du Cavalier Bernin,* ed. G. Charensol (Paris, 1930), pp. 25-27.

the first hand alters and subtracts something from the form or, to put it better, from the mass." I think that in nature itself this diminution would occur, and consequently what does not exist in nature must not be created in imitation. I did not tell him but later I thought of how the ancients took care to make the corner columns of the temples bigger than the others by one sixth, since, as Vitruvius says, being surrounded by a greater quantity of air, which devours their mass, they would have seemed thinner than their neighbors, even though in actuality they were not.

He [M. Colbert] went into the room where the bust stood [Bernini's unfinished portrait bust of Louis XIV]. Having looked at it for a long time, he expressed astonishment [to Bernini] at the progress of the work.[2] He found it so complete a likeness that he did not consider it necessary to work at Saint-Germain. The Cavalier replied that there was always something to do for those who want to do well. Up until now he had almost always worked from his imagination and had looked only rarely at his drawings. He had looked principally at what was inside (pointing at his forehead) where, he said, he had his image of His Majesty (otherwise he would only have made a copy in place of an original), but this was giving him a great deal of trouble. The King, in asking him for a portrait, could not have asked him for anything more difficult. He would strive to see to it that the portrait would turn out to be the least bad of all. In this type of portrait beyond the likeness, it is necessary to render what ought to be in the face of heroes.

The Queen, who remained to watch the Cavalier at work, was offered an armchair.[3] Abbot Butti read a quatrain about the pedestal that the Cavalier had planned to create. It is, as I have already said, a globe with the motto "small base." [4] The quatrain says:

> Bernini wracked his brain for the right thing
> To hold the bust of this so great a King,
> And then at last, having found none of worth,
> Said: For this Monarch small is e'en the earth.

Algardi

Giovanni Pietro Bellori, who wrote the passages on Algardi that appear below,[1] is renowned for his lives of the artists (see pp. 69-84, 92-96, 101-102) and his artistic theory (see pp. 5-16). For Bellori, the rigorous protagonist of classicism, Alessandro Algardi (1598-1654) was the artist who saved sculpture from the Baroque excesses into which Bernini and his

2 From Chantelou's diary for July 29, 1665, pp. 88-89.

3 From Chantelou's diary for September 19, 1665, pp. 201-2.

4 I am most grateful to Miss Irma Smith of the French Department of the Pennsylvania State University for having edited and corrected the above translation.

1 The sections on Algardi are an abridgement of his life from Giovanni Pietro Bellori, *Le Vite de' pittori, scultori ed architetti moderni* (Rome, 1672), pp. 387-402.

followers had plunged it. And it is true that the two sculptors were at times rivals, as the selection on the Four Rivers Fountain indicates (see p. 111). But today such polarizations seem simplistic. We see Algardi as an integral part of the Baroque era, more complementary than in opposition to the current represented by Bernini.

As Bellori suggests, Algardi's stylistic position is to a marked degree an outgrowth of his background. In Bologna he studied under Ludovico Carracci at his academy (called the Accademia degli Incamminati), that fountainhead of Baroque classicism that trained not only Annibale Carracci but Domenichino, Guido Reni, Albani, and a host of lesser Bolognese. After leaving Bologna Algardi stopped for some time in Venice where he must have studied the sculpture of such prominent Renaissance artists as Jacopo Sansovino and Alessandro Vittoria. After he arrived in Rome he was active for a number of years as a restorer of ancient marbles, above all for the Ludovisi who were also from Bologna. Such work could hardly help but influence him when he made sculpture on his own. In Algardi's early portraiture, to name only one instance, the impact of Roman Republican verism is especially noticeable.

Of all Algardi's works Bellori was most impressed by his huge relief in St. Peter's. It represents the miracle by which, through celestial intervention, Pope Leo I drove away from the walls of Rome Attila the Hun and the barbarian hordes that threatened to sack the city. In describing the work Bellori stresses the carefully balanced composition, the complex psychological interrelationships between the figures, the elaborate gradations of relief that provide so convincing an illusion of recession into depth, and the enormous scale of the relief itself, which makes so great an impression on the viewer. The whole panel is about twenty-four feet high. The principal figures, Leo and Attila, are almost eight feet tall. They stand in a plane about five feet deep, thus providing a space continuum that the observer seems to share.

From Bellori, *Le Vite de' pittori, scultori ed architetti moderni*

Among the families of Bologna, that of Algardi is not ignoble. Giuseppe, who belonged to it, worked at the silk trade in that city. His son Alessandro first started out in Latin studies and then, impelled by that inborn desire that thrusts us into action, dedicated himself to the study of sculpture. He also devoted himself with much profit to drawing and painting in the school and academy of Ludovico Carracci. At about the age of twenty he transferred to Mantua with Gabrielle Bertazzuoli, Architect to Duke Ferdinand, and entered the service of that ruler. At Mantua he did work in ivory and made various models of figures and ornaments that the Duke had cast in silver and bronze.

Having improved his talent through his work in the studios of

Mantua, Alessandro felt that desire which generally comes to those of high spirits—especially our artists—to move to Rome in order to establish himself in art.

He set out by way of Venice and after living there for some months arrived in Rome in the year 1625. The Duke of Mantua had recommended him to Cardinal Ludovisi, nephew of Gregory XV, who, having renewed the delights of the ancient gardens of Sallust on the Pincian hill, engaged Algardi to restore the statues, among which one notes especially a Mercury that Alessandro restored in the fine antique manner. Algardi therefore spent many years at these occupations, restoring antique statues, particularly some that Signor Mario Frangipani sent to France.

Eventually Pope Innocent X, recognizing the merit of this artist, chose him to execute the marble relief of the history of Attila, which was finished pursuant to the Pontiff's desire for the Holy Year 1650 and placed over the altar in St. Peter's. This panel shows the Holy Apostles Peter and Paul descending from Heaven and moving through the air on the clouds opened by the Angels. With angry countenance the Apostles threaten ferocious Attila. Their swords are grasped in their right hands. With the left they signal and command him to depart and not to enter Rome. The barbarian king, frightened by the sudden encounter, turns in flight. Looking backward at the Apostles ready to strike, he protects himself with one raised hand, and frightened and confused, brings forward the other in which he holds the baton. The sense of terror and of flight is not checked by the marble. Attila is nobly adorned. His mantle, fastened across his chest by a fibula, opens to reveal his cuirass and armour decorated in the antique manner. Opposite stands the saintly Leo in pontifical robes and crowned with a mitre. The Pope, undaunted, looks at Attila and points out to him above the apostolic protectors of the city who descend in the pontiff's defense. A cross-bearer and two bishops follow behind him, one rendering thanks to God, his face turned toward Heaven and his arms wide. The train-bearer on bent knee holds the end of the papal garment, as he gazes in wonder at Attila's sudden terror. Behind the barbarian ruler we see some of his soldiers on foot and on horseback with trumpets and various insignia. Here a captain signals them with his staff of command to continue on the way to Rome, being unaware of the transformation of the now terrified king who at that point turns toward the rear. He does not see the page nearby, a noble youth carrying his helmet and bow. All the figures come alive with emotions appropriate to their roles.

This narrative panel is thirty-two *palmi* high and eighteen *palmi* wide. It is composed of five pieces of marble fitted together. There are four main pieces and a smaller one to round out the top. The principal figures, Attila and St. Leo, are about fourteen *palmi* in height. Together

with the figure of the train-bearer they are almost free-standing. The other figures are in varying degrees of relief ending with those that barely project from the surface. Great was the diligence of this sculptor in handling such a large, complex theme, in the study of nudes, in the clothing, and in the development of the composition, all in harmony with the vividness and beauty of the actions and attitudes of the figures. Great too was his facility in the handling of marble even in dark and impenetrable depths. The chisels he employed were a good four or five *palmi* in length. When the panel was unveiled Algardi won the applause due for such noble sculpture. The Pope was so pleased with it that he had the Administration of St. Peter's basilica give him a supplemental remuneration of ten thousand *scudi*.

Salvator Rosa: Part One

Almost alone among seventeenth century artists, Salvator Rosa (1615-1673) has maintained a widespread and durable reputation, which is based at least as much on his personality and his legend as on his art. His considerable success as a painter came from his small landscapes, which showed scenes of wild, untamed nature. These he ornamented with small staffage accents: figures of bandits, travelers, or peasants. He was also known for his battle pieces and scenes showing the incantations of witches. Such subjects, taken collectively, Rosa's contemporaries called "caprices."

The success of his capricci *galled Rosa. His whole life he craved recognition as a painter of biblical scenes, history pieces, or complex allegories, always with heroic figures in heroic scale. Such themes (which were intended to instruct, and to strengthen the moral fiber of the viewer) were the only ones worthy of a great artist—so, at any rate, the critics of Rosa's day taught and he himself believed. He was prepared to provide such paintings at minimal cost to anyone who would take him seriously. Few did. In an age that had come to think of official art in terms of the High Baroque, as seen in the work of Cortona, or Baroque Classicism, as practiced first by Sacchi, then by Maratti, Rosa's romantic Neapolitan realism seemed suitable only for the small caprices—battles, bandits, witches—or still worse, for the* bamboccianti, *or low-life genre, that Rosa abhorred.*

As a practicing poet of some importance, a professional painter, and a man deeply interested in contemporary currents in both music and philosophy, there is no question that Rosa was an intellectual. Rebuffed in his attempt to win recognition as a painter of intellectual concepts, Rosa used rejection as a springboard for attack. Over the years he composed and circulated a series of poetic satires. These ridiculed the official

art sponsored by the papal court, above all the work of Bernini and Cortona, which for Rosa lacked moral content. Later his thinly veiled attacks spread to all aspects of the Establishment: the papal court, the Roman Curia, even the Papacy itself. Small wonder he won for himself a host of enemies, and for his poetry a place on the Index of forbidden books, which it held for almost two centuries.

Though in seventeenth century Rome it was quite normal for a patron to dictate, often in considerable detail, the subject of the painting he commissioned (Cortona maintained he never picked the subject of any of his own works and would refuse to do so if asked) Rosa's attitude was a milestone in the emergent concept of artistic independence. For the most part he himself decided what he would paint, and when he painted it he sold it from his studio. Then as now, the problem was for an artist to become known. For this Rosa counted heavily—more so than any other well-recognized artist up to this time—on the two major public art exhibitions held each year in Rome, as Passeri relates in the following passage.[1] The one was set up in the colonnades of the portico of the Pantheon, the other in the cloister adjoining S. Giovanni dei Fiorentini. Nothing was sold directly from these exhibitions, whose ostensible function was to use art to glorify the feast day of an appropriate saint. But Rosa seized the occasion to show the public something startling and new, which would enhance both his reputation and his sales. In so doing he moved sharply away from the old familiar traditions and toward a revolutionary view of the role of the artist, which has become familiar and traditional today.

From Passeri, *Vite de pittori, scultori ed architetti*

Salvator Rosa always loved applause and acclaim and he never wearied of working to achieve this end. He wanted his new work displayed each year at the celebrations at the Pantheon [St. Joseph's Day, March 19] and the church of San Giovanni Decollato [the feast of St. John the Baptist, August 29th]. He imagined himself becoming as important for paintings with large-scale figures as he had become for those with tiny ones. He strained every effort to appear to the public equal to anyone working in monumental proportions. He painted and exhibited a battle scene the size of the Bacchanal done in Volterra. It is a work worthy of admiration for its perfect expression of violent actions, the shouts of the combatants and the wounded, the interwoven masses of foot soldiers and horses, the killed, and the trampled upon, and

[1] The following passage is from Giovanni Battista Passeri, *Vite de' pittori, scultori ed architetti che anno lavorato in Roma, morti: dal 1641 fino al 1673* (Rome, 1772), pp. 425, 426, 432-35.

the dust raised; in addition there are several assaulted encampments, hills covered with small trees, and the confused movement of clouds, coupled with the masterly manner of his brushwork.

Rosa liked to paint canvases from his own imagination, and in this he found more satisfaction than through obedience to a restricted commission wherein his hands were not released to follow the freedom of his imagination. Therefore he gave free play to his inclinations.

With the passage of time his figures grew larger and he painted various compositions with histories, fables, and caprices. He exhibited them among the other pictures on the feast-day of St. John, while his so-called friends milled about, and by their hyperbole did him more harm than good. Since on that day it is customary to exhibit the works of famous painters, these fellows said to everybody: "Have you seen Titian, Correggio, Paolo Veronese, Parmigianino, Carracci, Domenichino, Guido Reni, and Signor Salvator Rosa? Signor Rosa fears neither Titian nor Guido nor Guercino nor anyone else." And they carried on so much about Salvator that honorable men were disgusted and began almost to hate him, as if he had instigated the boasting, of which he was innocent. That then is the good those busybodies bring a poor fellow. However all those acclamations have ended up by putting a price on works by him in the hands of those who had bought them for a crust of bread, and stimulated an infamous traffic at the cost of his other work.

He always fought to maintain that his larger paintings, those with figures approximately life size, were as valuable as the smaller and the tiny ones. He fell into such anxious frenzy because of so much opposition to this point of view that he decided never to paint small pictures again, although he was offered considerable sums to do so. Who knows whether he acted for good or ill, but one thing is certain. His exaggerated stubbornness deprived him of money that would have been sufficient to maintain him in a much more respectable state; and then too he would have given satisfaction to many people who regretted his strange behavior. It was said that when working in large dimensions his paintings were quite lacking both in over-all design and in the details, and that his way of using color was neither suitable nor natural for that type of painting; that his flesh tones were wooden and bloodless; that the expression on the faces of his figures was displeasing, inappropriately and rusticly conceived; that his colors were lifeless; that the garments did not form elegant and well-proportioned folds, and did not cover the nakedness of the figures in a natural and graceful way; that the contours of his forms were disorganized and confused; and that he had little understanding of the nude; and that he was quite incapable of bringing his works to that level of perfection to which a well-disciplined painter brings them, and that these failings applied to the whole painting and

to the parts. He was tormented when he heard praise that in landscapes he held the first place, that in seascapes he was singularly fine; that in tiny compositions of fanciful invention he excelled all others; that in battle scenes he was unique; that in his caprices and his scenes of the exotic and the recondite he touched the highest level; that he had no equal in mastery of the brush, that he was a true maestro in harmony of color; but that in his paintings with large figures, since he lacked the foundation that comes through study, he lost all those qualities that made his work beautiful.

As admirable as he was in other things so was he in poetry, which he practiced with much magnificence and singularity, even though many ignorant persons try to degrade their status by calling them satire. However, if they think the term "satire" is pejorative, then they are greatly mistaken. Satire is the most majestic, the most learned, and the most exemplary of all forms. In my opinion it is the terror of the gifted, even the most exalted, in that it greatly resembles a perfect apostolic action, being a severe lash that punishes vice. It is quite true that that makes it very difficult to manage. It is easy for those employing it to stumble into the trap of hitting the corrupt person rather than the vice itself. In that case it changes aspect, becoming a malignancy and a particularly evident hatred. But he who is able to use it wisely and to extract from it the fruit of reformation, and who is able to reveal the purity of his heart, which is not directed against the offending individual but acts from a just resentment of the functioning of evil—such a one is worthy of high praise. Certainly it is necessary in order to justify one's zeal that he who wishes to expose himself to these rigors be most pure in habit and blameless in his way of life, since a Zoïlus can scarcely act as the castigator of vice. With these his literary works Rosa makes for himself a broad road to glory. If they could be published so that the world was able to enjoy them he would be largely satisfied. But God knows what will become of them.[2]

Salvator Rosa: Part Two

Rosa's philosophical interests, like those of his contemporary Poussin, centered around Stoicism. In the seventeenth century this school of thought underwent a major revival, especially among the intellectual

[2] Rosa's satires, though banned by the Church, were clandestinely published in Italy, with Amsterdam (in Protestant territory and therefore beyond the Church's reach) given fictitiously as the place of publication. For the position Rosa holds now in Italian literature, that of a minor poet still worthy of note, see Carmine Jannaco, *Storia letteraria d'Italia. Il Seicento* (Milan, 1963), pp. 386-400.

bourgeoisie both in France and Italy. In its advocacy of a rigidly ascetic and incorruptible private morality, divorced from the morality of both Church and State, the Stoic position appeared to many as a constant reproach to the corruption and tyranny of the age. To those like Rosa who thought their age corrupt and tyrannical its appeal was irresistible. In his later years an increasingly large number of Rosa's paintings served to expound stoic themes, by illustrating, in various ways, the victory of the human will over the emotions. Thus he painted Diogenes Renouncing Civilization; Xenocrates Repelling the Lascivious Advances of Phyrne; Regulus, Faithful to His Oath, Returning to be Killed in Carthage; The Philosopher Throwing Money into the Sea.

From Filippo Baldinucci, *Notizie de' professori del disegno da Cimabue in qua*

For a long time a fervent desire grew within him, akin to his overwhelming appetite for glory, to appear in all he did and said to be a real philosopher.[1] To walk through the spacious colonnades of Athens in company with the Stoics of ancient times was the continual occupation of his thoughts. One does not see among his innumerable works, whether in poetry or in painting, anything that does not have or express some fine morality, or that does not represent some of those very renowned men [that is, the stoics] in their most memorable actions. Many, many of them he represented in painting and many in his engravings.

During the long period that he lived in Florence, and for many years afterwards, Rosa never wanted to accumulate money. Instead, all the money he earned he shared with his friends. To a person who tried to persuade him to save some money he replied, with philosophic freedom but also with resentment: you want to make me greedy for money but I tell you that I do and will do everything I can to destroy in myself the first stirring of desire for it that might occur.

Salvator Rosa: Part Three

Rosa was attracted to Stoicism intellectually, but emotionally he was incurably romantic. Both aspects appear in his paintings and his writings. What we know of Rosa has been extended by the publication of a large body of letters (many discovered only recently) that he wrote to his close friend, the Florentine poet Giovanni Battista Ricciardi.

[1] This paragraph and the one that follows are from Filippo Baldinucci, *Notizie de' professori del disegno da Cimabue in qua,* V (Florence, 1728), p. 588.

In the letter given below Rosa writes of Signora Lucrezia, the Neapolitan woman with whom he lived for many years. Though she was the mother of his sons, under Italian law he could not make her his wife while her first husband still lived. The marriage was actually to take place only when Rosa was on his deathbed.

At the time when this letter was written Rosa's enemies, especially those he had ridiculed in his satirical verse, had forced Lucrezia to leave him, under threat of arrest by the Inquisition for living in sin. From Rome Lucrezia fled to Naples, taking with her Rosalvo, Rosa's first-born son. What follows is one of the most sincere and moving passages in all of Rosa's writings. At the same time it offers further insights into why Rosa's art had such an appeal in the age of romanticism. In Rosa's volcanic outpourings we have more than a suggestion of the concept of the natural man unfettered by the rules of civilization, who, already foreshadowed in the sixteenth century with the revival of Longinus' tract On the Sublime, *emerges more clearly in the writings of Jean Jacques Rousseau, and comes to full flower in the passionate furor of Lord Byron.*

From a letter written by Rosa to Giovanni Battista Ricciardi [1]

Dear Friend,

For twenty-two days I have known no rest in body or mind. As soon as I eat enough to keep alive I howl, weep, and cannot stand the sight of a paintbrush. Now I really know that the errors of the wise are always greater than those of ordinary men. How stupid I was to agree that Signora Lucrezia should leave me. What a pig's ass I was, more beastly, more perverse than the greatest clown in the world. I swear to you by the little sense I have left that every time I think of it my head bursts, my bile boils, and I injure myself to pay with blood for my terrible stupidity, for such an ill-advised career. Oh shame! Am I he who began by intending to be the greatest man of the century? With the finest genius, with extraordinary prudence, with a plan of action? Oh shame! I am an idiot, an ass, a fool.

Yesterday Father Cavalli, in order to console me, tried his hand at spirituality to the detriment of his art. But my need and pain must be borne in my heart, since the liability I have brought on myself is so extreme. I deluded myself with the thought that going out more frequently and talking more often with friends would bring me relief. But fantastic as it seems, the minute Lucrezia set foot outside the house to leave for Naples with Rosalvo I was filled with hatred for my friends,

[1] Rosa's letter to Ricciardi is published by Uberto Limentani, *Poesie e lettere inedite di Salvator Rosa* (Florence, 1950), pp. 110-12.

for the light of day, and even for myself. Oh God! As soon as I began to kick myself for my stupidity, for my buffoonery, they quickly began to spread the rumor that mother and son left for no other reason than for me to marry that singing strumpet.

Now judge for yourself if such a thing could pass through a mind like mine, a mind filled with the most honored sentiments that a mind could ever possess—and I more proud than all the devils you could find. But even this scarcely pierces my heart, since it can be cleared up, and if four persons wonder about it a hundred will laugh, knowing it is impossible, even in thought, for a man as honorable as I. Rather it is the pain of feeling my way again, after the habit of so many years, served divinely like the gods, sustained by the incomparable spirit both of the mother and the son. How you would rejoice if you could see how splendidly Rosalvo has developed, particularly in regard to his generosity and his fine talent for painting.

And now I am alone, without maid, without servants, with no other companion except a cat, who to compound my misfortune turns out to be a tabby, that is to say, undomesticated.

I am beside myself and God help me that I do not end all my life's labors by losing my mind.

And all this arose through fear of landing by some misfortune in prison because of some damned cuckold of a spy for the Holy Office—may the soul of whoever created it be a thousand times cursed. I swear to you I would like to do worse than the Great Turk with his seraglio, not because I am tormented by lust, but because I enjoy the comfort and cordial company of women like Signora Lucrezia—if there be any like her in the world—which I do not believe. I beg you then if you have heart and humanity enough to put yourself in my place to bear with me and believe that in the whole course of my life I have never found myself in a greater labyrinth and more in need of relief and counsel.

If I don't become a hermit it will be a miracle due to the compassion of Heaven, which will not allow me to be more of a fool than what I confess to be already. O Signora Lucrezia, O Rosalvo, O peace, O quiet, O ease, where have you gone?

For the love of Christ, for the love of God, in your goodness console me, advise me! Never will I have greater need. If I do not get sick I will believe I am made of bronze. Nothing else. Wish me well and remember I have a grateful heart that loves and recognizes kindness.

From Rome on this day in February 1656,

Your true friend,
S. R.

Salvator Rosa: Part Four

The group of canvases that Rosa filled with scenes of sorcery, necromancy, incantations, and the like (among the most famous is his Saul and the Witch of Endor *in the Louvre) is no less romantic than his scenes of bandits in wild landscapes. Both stand in mocking opposition to the doctrine of ideal beauty as affirmed by Bellori and all the supporters of classicism. With his witches scenes Rosa provides us with an art of ugliness, filled with figures that are monstrous, grotesque, and deformed. As Luigi Salerno has pointed out in his recent monograph (Salvator Rosa, Rome, 1963, p. 39), Rosa was probably inspired, at least in part, by that strange blend of alchemy, chemistry, physics, and metaphysics that was in vogue in the late sixteenth century in Naples, where Giovanni Battista della Porta founded an Academy of the Occult and published in 1589 a book called* Magiae Naturalis. *In a broader sense these themes gave Rosa an opportunity to express (in rather literary terms) his sense of melodrama and exoticism. They also served to affirm his freedom from conventional restrictions.*

The following poem (which has been compared to Shakespeare's lines with the incantation of the witches around the cauldorn in Macbeth*), is a striking example of how closely Rosa's poetry can resemble his painting. The literary themes play so large a role in these pictures, the visual images are so dominant in this poem, that poem and painting become different aspects of a single thing.*

The Witch,[1] by Salvator Rosa

Since love does not succeed,
She said, filled full of rage,
To make faithful a traitor,
I will swing this foot,
I will open these lips,
I will cry from the depths
The forbidden incantations,
The deadly fatal art
With the force that will invoke
The very god of hell.
May the god's wrath avenge,
May the god toss and stir.
In the dark realms
May the god strike

[1] This poem, here abridged, is taken from U. Limentani, *Poesie e lettere inedite di Salvator Rosa* (Florence, 1950), pp. 48-50.

The evil, the accursed one
By whom I was betrayed.
Since the cruel one does not hear me,
Since lamentation has no value,
To deception, to deception,
To dishonor, to dishonor,
To enchantment, to enchantment,
And he whom heaven moves not,
Moves hell.

To tempt I need
Magic means
Profane signs,
Diverse herbs and knots
That can arrest the turns
Even of heavenly spheres;
Magic circles,
Icy waves,
Diverse fish,
Chemic waters,
Black balsams,
Blended powders,
Mystic stones,
Snakes and bats,
Putrid blood,
Slimy entrails,
Withered mummies,
Bones and worms,
Exhalations
That will blacken,
Sounds of horror
That bring terror,
Turbid waters
That will poison,
Fetid ooze
That corrupts,
That will darken,
That will chill,
That despoils,
That destroys,
That will vanquish
Stygian waves.

Within this fearful cavern
Where sunlight never enters
I'll raise infernal tumult;
I'll make a spirit of darkness;
I'll burn cypress and myrtle;
While slowly, oh so slowly
I crush his waxen image
And cause his living being
To die by secret fire.

Maratti

When Belloni, whose career we discuss elsewhere (pp. 5-8), wrote his life of Carlo Maratti (1625-1713) he drew heavily on first-hand knowledge.[1] He had followed Maratti's career from the time he was a young student, was responsible for getting him one of his first public commissions, chose him to paint his portrait, and during the latter years of his life became his close friend.

In Bellori's eyes, everything Maratti did was right. When the young artist was a student he studied like a man possessed, from early morning to late at night, ignoring equally bitter cold, suffocating heat, or the temptation to dally along the road late at night. Above all what he studied was the painting of Raphael, which according to Bellori was the best thing a painter could study. When he became older and very successful he charged very high prices for his work. This too was the best thing he could have done, because it helped set a precedent for the other, poorer painters who up until then had been paid too little. For this, Bellori was careful to point out, the other painters owed him a debt of gratitude. One doubts that it was paid. The virtues that made Maratti admirable did not make him very lovable.

The stylistic image of Maratti's art that is generally held, even today, derives largely from Bellori. It is an image based primarily on the artistic theories Bellori supported, and quite secondarily on the pictures Maratti painted. Bellori saw in Maratti the standard bearer of the classical tradition: its defender against low-life genre on the one hand and the high-blown Baroque on the other. As Bellori himself points out this position stems partly from historical precedence. Maratti studied under Sacchi, who studied under Albani, who studied under both Ludovico and Annibale Carracci, which is where the tradition of Seicento classicism began. It began with the idea that artists should abandon the fantasies of mannerism and return to the values of the High Renaissance, especially to Raphael, and that (at least to Bellori's way of thinking) they should base their concepts on a selective idealization of the real.

The abundant and billowy manner in which Maratti usually painted does not at all correspond to Bellori's image of him as a latter-day

[1] Bellori carried his life of Carlo Maratti up to the year 1695, a year before his own death. The painter lived on for almost two decades more, and Bellori's *Life*, completed by others, was published in Rome in 1732. I have in general used the text taken from Bellori's holograph in the Municipal Library at Rouen, published by Michelangelo Piacenti, *Le Vite inedite del Bellori* (Rome, 1942), pp. 73-136. But in a very few instances, where the manuscript seemed inadequate, I have substituted the text given in Bellori's *Vite de' pittori, scultori ed architetti moderni*, 3rd ed. (Pisa, 1821), pp. 136-237.

Raphael. *Although he is not a High Baroque artist he belongs to the Baroque age. His style, especially in his later works, is best defined as Baroque* détente *or* barocchetto: *a quieting down and a relaxation in the intensity of the High Baroque. Bellori himself points out that among the artists whom Maratti studied and admired most were Titian and Correggio—hardly painters we would call classical in the strict sense. And although he does not say so, Maratti's art owes a good deal to his master's chief rival: Pietro da Cortona.*

Maratti, like Bellori, represents the Establishment. He went to the right school, studied hard, learned all the right things, and was a big success with the best people. His position was so dominant that there is almost no mention of any other point of view. We are especially grateful then to Maratti for his indignant response to the heretics who dared say that Raphael's figures were like statues, that his painting was hard and dry, that his art lacked passion and boldness of spirit. This is a frontal attack on the whole classical tradition. By implication it is also a plea for greater artistic freedom—freedom for a more outward expression of the emotions, for more powerful rhythms, for richer colors, for looser, more spontaneous brushwork, in a word, for the full Baroque. It also foreshadows the erosion of classical theory that was to take place during the eighteenth century.

Maratti made a visual statement of his artistic beliefs in the form of an allegorical drawing that Nicolas Dorigny made into an engraving. We reproduce it as the frontispiece of this book. Bellori recognized its importance in his discussion, which follows below. The subject of the engraving is an art school or academy in which the students were taught what Maratti thought they should know. This includes a sound but strictly limited grounding in anatomy, perspective, and optics: as much as is necessary but no more. The warning not to spend too much time on these studies may be a veiled criticism of Andrea Pozzo, whose master-piece, The Triumph of the Jesuit Order, *in the church of S. Ignazio—perhaps the most spectacular demonstration of linear perspective in the whole history of art—was painted in the years 1691-1694, probably just about the time when Bellori was writing his life of Maratti.[2] For Maratti, however, there is no such thing as too much study of classical statues, several of which are on prominent display. We may at first be surprised by the apparent lack of any reference to Raphael, but a closer look shows us that most of the students working busily at their lessons are placed in poses that Maratti has copied from the figures in Raphael's frescoes. On a stool in the foreground is a smooth bare palette. No one*

[2] There is no way of being sure when Bellori began his life of Maratti or at what date various sections may have been added, but we do know that he died in 1696 and his biography includes events that took place in 1695.

is looking at it and it is not accompanied by an inscription. Bellori reads it as a symbol of color—not one of Maratti's strong points and often a secondary factor in the classical tradition. Finally, above on a cloud, are the Three Graces, who represent the element of artistic talent which Maratti regarded as indispensable. The allegory reflects Maratti's individual beliefs, but its significance is far broader. It sums up a point of view that dominated and heavily influenced the artistic scene in late seventeenth century Rome and was to remain dominant for many years to come.

From Bellori's *Vita del Maratti*

When he was eleven years old Carlo Maratti was sent to Rome, in the care of Bernabeo [his older brother] who taught him himself. After a year he enrolled him in the school of Andrea Sacchi, a master whose great worth is well known. Seeing the young man's fine character and the indications of great promise given by some drawings he had copied from the works of Raphael, Sacchi gladly took him into his school. There Carlo went about his studies with such enthusiasm and studied with such perseverance that he stayed there for twenty-five years, up until Sacchi's death.

Not a day passed in which he did not study the ever-praiseworthy works of Raphael. He continually applied himself to studying and selecting the most beautiful aspects of the art of those rooms [Raphael's stanze in the Vatican], where he was the first to come and the last to leave, unaware of heat or cold or the excesses of the seasons. Winter he endured without even warming himself, and summer without taking the [customary] midday nap. For nourishment and to sustain himself he took nothing else with him but a bit of bread and wine and some other light food. We should add that after having spent the whole day drawing, he left St. Peter's and the Vatican stanze to go in the evening to the Academy of his master, who lived a considerable distance away in Via Rosella on the slopes by the Quattro Fontane. When he had finished at the academy, after night had fallen, he set out again on as long a road or longer, without regard to wind or rain, and without stopping for anything else that would have delayed him on his way to Trastevere and as far as S. Pietro in Montorio where his brother had his lodgings. Once in the house, after having taken some refreshments, he was quick to begin his nocturnal vigil, and to exercise his talents with his own ideas for designs, from which he composed sketches and drawings.

In the year 1652 he finished his work in the chapel dedicated to St. Joseph in the church of S. Isidoro. He was commissioned to do the

work by the patron of the chapel, Sig. Flavio Alaleone, a gentleman from Rome. He received the commission through [the advice of] Giovanni Pietro Bellori, the author of this biography, who having taken note, from the moment Maratti entered Andrea Sacchi's school, of his fine character and the promise he gave of success in painting, judged him the best suited for that work. Thereafter the virtuous bonds of friendship grew between the two of them.

Concerning the prices of his works, which by some were deemed excessive, one can say that, after Guido Reni, it was Maratti who made painting profitable, induced by those who multiplied several times over the rewards of his efforts. He decided to convert this [rise in the price of his works] to his own use and in so doing opened to others the way to high rewards. This is particularly the case in Rome, where the painters need be much indebted to him, it being on his example that prices rose to levels that had not been quoted before.

Maratti always followed his original goal, which was to select and to imitate the beauty of nature, with the guidance of the best masters, both of antiquity and modern times, who lead us on the right paths and teach us to avoid mistakes. To this end, from the time that he first came to Rome, he used Raphael as a guide above anyone else. He used to say that with the other masters he was satisfied to copy their works in his mind, and to grasp as much as possible of the concept, especially of the works of famous artists such as Carracci, Correggio, Titian, and Guido Reni. He admired their paintings: the pleasing and noble appearance of the heads and the fine development of the drapery folds. But in Raphael, besides the concept, one always found more to think about in the various fine parts of the painting; and the closest to him was Annibale Carracci in his imitation of the beauty of nature. Though he ranged far and affirmed his talent in finding the most perfect forms, yet he did not fail to turn his eye once more to Raphael, as he did more than a few times in his maturity. Even nowadays he has been seen drawing in the Vatican stanze, thus assuming, without pretence, the role of a disciple. At times when it happened that he was in search of a handsome contour, or the expression of an emotion, or a movement of the body, or some other fine thing, he turned gladly to that learned Athenaeum, wherein, in so large a number of figures in those great compositions, Raphael has left examples of how much art can achieve in the imitation of perfection.

Together with these sound foundations on which he based himself, he did not fail always to keep in mind the excellent precepts given to him by Andrea Sacchi, an artist of great erudition, who provided a

fine example in his own paintings. In truth these precepts were very helpful to Maratti, coming as they did from the Carracci's great school. Andrea Sacchi's master was Francesco Albani and the teachers of Albani were Ludovico and Annibale Carracci, and Sacchi taught Maratti.

Maratti used to say that a good school could make a good student and that, on the contrary, when the master lacked the proper artistic principles, everything collapses, or that with great effort one makes little headway. Thus we see not a few that lose their way and fall behind because of the crooked paths of their preceptors, which they have followed. These new masters teach in their schools and through their books that Raphael is dry and hard, and that his manner is "statuine" (a word introduced into the language in our own day). They assert that he is without passion or boldness of spirit, and that his works were improved by his followers. But Maratti used to reject angrily the vulgar opinion current in our century that one should not follow Raphael, in order to avoid having a dry and "statuine" manner. He replied that rather it was their brains that were formed of rocks or stone. He cited the words of Nicolas Poussin, a most learned painter, who in regard to Raphael, because of his excellence, used to call him Raphael the Divine.

To a stupid painter who advised a young man not to get mixed up with Raphael, because he would find himself in difficulties which he would never get out of, and that he would never become a painter, Maratti replied: "Where are the painters and students who honor painting? [Nowadays] it is enough for something to bear a resemblance to nature, it is enough to please the eye. Using good colors is 99 per cent of painting. It follows that young people brought up on these ideas loathe study and work and avoid those goals that they must follow so that painting, instead of assuming its natural form, takes on the appearance of ghosts and fantasies, far in every way from the truth."

Maratti disliked another kind of master or modern censor, those who have learned something about perspective or anatomy and as soon as they look at a picture start to search for the vanishing point and the muscles. They repeatedly rail at, they accuse, they examine [the works of] the best artists, while in their hollow pretence they remain ignorant of how to put into operation any of the precepts of which they boast.

Maratti always valued perspectives and anatomy and thought they were necessary for a painter, the first for the correct placement and view of the figures; the second for the natural movement of muscles and joints and the bone structure that supports the limbs and the flesh. These are two fundamentals of painting. They regulate the eye and the figure. But he did not think that a young man should go so far into these things that he neglects other things that are very difficult and important. He should not try to square the circle, or with the nude search too much

under the skin, but should train himself in these fields just enough not to make mistakes in his figures.

In this regard we must refer to a very fine drawing that Maratti made for the Marquis del Carpio at the time when he was the ambassador of the Catholic king [that is, the King of Spain] to the [court of Pope] Innocent XII. The Marquis was a great lover of painting. Besides statues, marbles, and pictures in large numbers he also collected a considerable number of drawings by the most famous painters of the past and of our times, handsomely displayed in thirty books. For some of these drawings he commissioned the most renowned masters then in Rome. The subject was to be painting, and each artist was left free to represent it in his own manner, as he chose.

Maratti's concept was that of an academy and its school of painting with various figures intent on diverse studies: geometry, optics, anatomy, design, and color. In the middle is a master of perspective who, while pointing with both hands to the perspective lines, turns back to speak to his pupils and explain to them the first principles [of perspective] and how we see. A canvas on an easel is represented and on it is drawn the visual pyramid whose apex is the eye and whose base is the surface of the object [that the eye sees]. Behind is a very intent young man with a sheet of drawing paper and a book under his arm who expresses the desire to learn. By his feet is another person leaning over with one knee on the ground, who, placing a compass on a tablet, is forming geometric figures. On the canvas on the easel below the pyramid one reads the motto "as much as necessary" [*tanto che basti*]. This means, for the reasons cited above, that the young man, having learned the rules necessary for their study, should pass on [to other things] without stopping.

On the opposite side the students of anatomy are observing a skeleton [actually the model of a flayed figure] set up on a base. Here there is an old man who turns toward some young students. He is teaching them and pointing out to them the muscles and nerves. Below the skeleton on the base there is repeated the motto "as much as necessary" [*tanto che basti*].

Above there is a portico with an arched niche in which there is a statue on a pedestal: the Farnese Hercules by Glycon. Nearby are two other statues: the Venus de' Medici by Cleomenes and the Belvedere Antinöus, with their soft and strong young limbs. But here we read an inscription that is very different: "never enough" [*mai abbastanza*]. In good statues is found the model and the perfection of painting, along with the proper imitation [of examples] drawn from nature.

On the other side, where perspective is being practiced, the Three Graces appear, seated on clouds. Descending from the heavens to bless

the talented, they look down at the studies, the efforts and the works of art below and distribute their gifts to those that please them. From this derives the motto that one reads: "Without the graces all effort is in vain." [The inscription in the engraving, which is slightly different, reads: *Senza di noi ogni fatica è vana.*]

Finally, in front of the easel there is a stool with brushes and a palette with paints on it, ready to go to work, and to achieve painting's goals. In this spot, as an exhortation to good work, is the following motto [not in the engraving] "only through work does one acquire awards and honors."

Maratti means in this way to discuss and give his opinion about the study of painting, along with some observations on true talent and the ability to speculate, which are lost by spending a long time on this or that technique, without stopping for the more important things that are necessary for the work of a good painter and a good painting.

Giordano

Neapolitan sources present problems. For the biographies of most artists there is no substitute for Bernardo De Dominici. His book on the lives of the artists of Naples, which appeared in the mid-eighteenth century, has in more recent times won widespread and richly deserved fame for its mendacity.[1] But in the case of Luca Giordano (1632-1705) we have another biography that was written shortly after Giordano died, though it remained in manuscript form until it was published by Oreste Ferrari in 1966.[2] Its author, Francesco Saverio Baldinucci, is the son of Filippo Baldinucci, who was the most capable and painstaking of all the early biographers of the artists of the Seicento.[3]

Though Giordano lived only a few years into the eighteenth century, the light, airy, decorative style that he developed a good deal earlier anticipates to a surprising degree both the spirit and the manner of the new era. Baldinucci never really does put his finger on what there was about Giordano's art that was new, but he does tell us a good deal

[1] Bernardo De Dominici, *Vite de' pittori, scultori ed architetti napolitani,* 3 vols. (Naples, 1742-1743). De Dominici also published his life of Giordano separately, in 1720.

[2] Oreste Ferrari, "Una 'Vita' inedita di Luca Giordano," *Napoli nobilissima,* 3rd series, V (1966), 89-96, 129-38. The manuscript can be dated between 1710 and 1721. It mentions the death of Giuseppe Simonelli in 1710, and it speaks of Nicolò Malinconico as still living, though we know he died in 1721.

[3] For Filipino Baldinucci, see pp. 109-11. The younger Baldinucci draws on materials that his father had gathered including autobiographical notes written by Giordano himself in 1690. But he also made use of a variety of other sources, among them De Dominici, who seems to have supplied Baldinucci with most of his material on Giordano's stay in Spain. This last section, which we have eliminated from our selections, includes a series of comments by Velásquez (who died in 1660) on the work done by Giordano during his stay in Madrid (1692-1702).

about the sources from which it came. After some preliminary instruction from his father, Giordano was enrolled in the studio of Jusepe Ribera, whose work, even in the 1620's, was clearly Baroque. Later he studied under Pietro da Cortona, the artist who, more than anyone else, gave Roman High Baroque painting its definitive form. Giordano's homage to the classical masters was perfunctory. There is little to suggest he looked at the antique. Instead he became, in Baldinucci's words, "ever more in love with the beautiful paintings of Venice." From Titian, Tintoretto, and Veronese, he took the rich colors and open brushwork that enliven so many of his canvases. These sources he combined with the airy cloud-borne fantasies that he found in Cortona's late manner, especially in the frescoes in Palazzo Pamphili in Piazzo Navona. Out of this synthesis he produced a statement that at its best—for example in his famous painting on the vault of the upper gallery of Palazzo Medici-Riccardi—foreshadows Tiepolo.

Giordano's output was outrageously large. More than a thousand paintings have been catalogued as by his hand, and these are undoubtedly only the smaller part. He painted with phenomenal speed. This accounts in part for a certain looseness and spontaneity that characterizes so much of his work. The canvas Baldinucci describes, which he painted rapidly in a darkened room, blocking out the parts of the figures "more with his fingers than with the brush," is significant in terms of the art of such eighteenth century masters as Magnasco and Guardi. Its enthusiastic reception by the gentlemen who watched him paint it and then competed with one another to buy it shows a much more sophisticated and up-to-date art market in Naples than Giordano would have been likely to find in Rome, especially toward the end of the century.

Giordano's work is notably uneven. According to Baldinucci, he would paint anything for anyone at any price but would adjust his efforts to the amount of money the buyer was willing to pay. Happily for Giordano's memory, many of the more blatant potboilers can no longer be identified as his.

What is said about the canvases he painted in the styles of other masters should be taken with reservations. When he was still a student he probably on occasion tried to imitate as closely as possible other painters' styles. But after he became well established in his own right his paintings, though filled with the most various influences, always bear the stamp of his own distinct manner.

From Francesco Saverio Baldinucci's *Vita di Giordano*

Naples, that most noble city, was the mother of the famous Luca Giordano, who with his brush has enriched not only his native land,

but also all Italy and the most famous and outstanding cities of Europe as well. In the year 1632 Isabella Imparati, the wife of the Neapolitan painter Antonio Giordano, gave birth to a son. He was four years old when his father taught him the first principles of drawing. [Later his talents as a child prodigy] came to the attention of the Duke of Ascalona, Viceroy of Naples, who, wishing to see and make the acquaintance of the youth, showed him special favor, and then wanted to see him entered in the school of Giuseppe Ribera, called lo Spagnoletto, to whose care, with solicitude, he entrusted him.

Seeing how much his son had profited from his studies his father took him to Rome, where taking note of the fame that with good reason Pietro da Cortona enjoyed, he enrolled him in his school. Cortona had him draw and copy the beautiful things to be seen in the great city, both ancient and modern, painting as well as sculpture, beginning with the work of Raphael, which Cortona himself said that he had copied a dozen times. Because Giordano's father wanted him to acquire the ability to work at great speed, he always stood at his side, never letting him out of his sight, and saying to him every so often, "Luca, do it quick" [*Luca fa presto*]. Thus, within a short space of time Giordano was not called anything except Luca fa presto, first in Rome, then in Naples.

Having returned from Rome to Naples in his nineteenth year he began to put his work before the eye of the public. For the church of the Ascension belonging to the Celestine monks he painted a large picture representing the fall of Lucifer and his cohorts. For the Discalced Carmelites of S. Agostino he did a painting in the manner of Titian representing St. Thomas of Villanova in the act of distributing his patrimony to the poor. For the Discalced Carmelites of S. Teresa he painted two large pictures in the manner of Guido Reni and Paolo Veronese. But these and many other works that Luca made for the public did not prevent him from exercising the happy talent he always had for imitating the different styles of the best masters. During his rest period, thanks to his speed in painting, he was always ready to make small-scale pictures in imitation of Raphael, Albrecht Dürer, Titian, Giuseppe Ribera, and other famous painters. The greater part of these were bought at a low price from Luca's father by Gaspar de Roomer, a rich Flemish merchant living in Naples, as actually being by the hand of those masters in imitation of whom they were made. Then Roomer, who delighted in all sorts of business deals, sent some to Venice, to Flanders and to Germany, where they were bought for very high prices to his great gain.

By then Giordano, having become well enough known through the works we have mentioned in Naples and many others, decided in 1665 to take a brief tour through Italy. Leaving his homeland, he journeyed

to Florence, where he made an exceptionally fine painting measuring twenty-two *palmi,* for His Most Serene Highness, the Grand Duke Cosimo de' Medici, in which he depicted a *Triumph of Bacchus* with many figures arranged in fine and beautiful poses. Besides this he made other paintings for various Florentines. Then he left, and being even more in love with the beautiful paintings of Venice, there is where he went. He painted so many pictures in the course of the six months he spent outside Naples that his income rose to a point where, as he himself tells it, no other artist would have made as much in six years. Among the other large-scale works that he left in Venice was a big canvas in the manner of Ribera. Because of this work he was held in such esteem and the Venetian nobles competed so much with each other for his works that they scarcely gave him time for the slightest rest. He certainly would have had to stay there longer if he had not been called back in haste to Naples by Don Sebastiano Cortizzo on the orders of Philip IV, King of Spain who, wishing to furnish one of the large rooms of the Escorial, wanted Giordano to adorn it with twenty-two of his large paintings. Once back in Naples, he gave his hand to the pictures for the king. A part of them he made in imitation of Titian and Tintoretto, and the others he painted in his own original and bizarre style.

In about 1682 the Marchese Francesco Riccardi notably enlarged his handsome palace in Florence [Palazzo Medici-Riccardi]. Besides other important improvements he added a large and majestic gallery. For a time he was in doubt as to how to adorn its great vault, but finally resolved to have it painted by Giordano. The learned Senator Alessandro Segni, member of the Accademia della Crusca, provided the concept [of the iconographic program] and assigned to Giordano the realization of his wise and noble program. Giordano, who made twelve good-sized paintings as models for the ceiling, began to work and finished it in the space of two years. He received universal praise for having illustrated in the fresco the universal theology of the fabled Courtliness [*Gentilità*] and for depicting in their individual actions and vestments all those deities who dreamed of and paid homage to illusive superstition. [The painting covers] a long, wide barrel vault. Despite its unrestrained exuberance and the amplitude of the various figures and every species of animal and mountain, river, and landscape of all sorts, there is nonetheless no part of it that breaks away from the other parts. Instead it is so harmonic, not only in color but in arrangement, inventiveness, and expression that on first sight it astonishes all those, including artists, who consider it with an unjaundiced eye.

Turning now to Giordano personally and his individual qualities, one can say that he was of good height, had black hair, and a gruff,

severe face. But in fact in his conversations he was always most charm-
ing and humorous, sprinkling his conversations with witticisms and
stories when he had the chance. He liked to banter with everybody and
his jokes and witticisms often cheered the people he spoke to. He loved
his wife with continuing affection and took the opportunity to make use
of her as a model in his paintings. He upheld his profession both per-
sonally and in others, and never criticized other painters. He gladly
helped the poor in their destitution and need.

It was his custom every month to make a devotional picture to
provide of his own accord, through the value of the picture, a dowry for
some poor girl. Thus it happened that a young man in love with such
a person, who was poor and without dowry, could not obtain permission
from his own father to marry her. Hence he got himself a canvas, took
it to Giordano, and begged him to paint on it a Madonna and saints,
with which he could give his beloved a dowry. Giordano quickly took
the canvas and composed the whole picture on it with his fingernails.
Then he closed all the windows tight except for one, which he left open
little more than the width of a finger. Placing the canvas in the light
that came from this opening he began to paint, more with his finger
than with the brush, on that lighted surface that corresponded to the
length [of the canvas], making that part of the head, chest, legs, and the
rest that could be made out within the limits of the slit [of light]. Then
he moved the painting back and exposed to the light in the same way
an equal amount of canvas, which he painted. He did this several times,
thus bringing the canvas to completion. It turned out to be such a per-
fect work that several gentlemen, who were witness to this new and
difficult manner of painting, all wanted the canvas. It was put up at
auction among them and sold to the highest bidder for a high enough
price to provide a dowry for the girl and to content the young man, who,
to his complete satisfaction, married her soon after.

At times Giordano seemed rather avaricious and greedy for money,
since in the hope of making a few *lire* he would serve any worthless
person with any kind of picture. Although he never forced poor people
to pay him, if he was offered even a small amount of his due he never
refused it. In many cases he did not hesitate to turn out mediocre things,
and work whose quality corresponded to the payment he was able to get.
He excused himself by saying that he had three brushes, one gold, another
silver, and the third copper. By this he meant that the work he made
for public display or for great lords he did with all the skill he could
master, and from it hoped for gold. In other things that he did for
private clients who were gentlemen he exerted sufficient effort to be
able to get himself silver. And for those things that he did for the lower
classes, he put in just enough effort to extract the coppers that they paid

him. In truth this principle is not very praiseworthy in the case of those who practice it indiscreetly. But it was otherwise with Giordano, a discreet and charitable person who used it to keep everyone content and fully satisfied, especially if it was a poor simple person who paid no attention to the quality of the painting, but only to the [sacred] image represented in it, and had little to spend and often nothing at all. He also used to repeat in reference to this proposition the despicable proverb: *qualis pagatio, talis pintatio* [as the pay, so the painting, or, I paint what I'm paid].

Baciccio

Pascoli's Lives of the artists,[1] *which was published in Rome in the 1730's, is more valuable than is generally supposed. It is our primary source for the lives of a number of artists who were active at the turn of the century, among them Baciccio, extracts from whose biography appear below. Lione Pascoli (1674-1744) belongs, like the majority of Baroque critics, to the tradition of the well-educated amateur. By profession he was a jurist. He also assembled a notable collection of canvases by the artists of his age, including two* bozzetti *by Baciccio.[2] He also published a book of biographies of the artists of his native Perugia.*

Giovanni Battista Gaulli, called Baciccio (1639-1709), is the leading artist of the late Seicento. His youth in Genoa (which he probably left several years later than Pascoli says) is of great importance in the formation of his style, for it is here that he acquired the brilliant, highly saturated palette that became a hallmark of his early manner.

After Baciccio came to Rome he became Bernini's protégé. Not only do his paintings, from his early maturity on, reflect the influence of Bernini's sculpture, but as Pascoli points out, his career was advanced time and time again by introductions and recommendations from Bernini. There is no doubt that his great masterpiece, the Triumph of the Name of Jesus *on the vault of the nave of the church of the Gesù in Rome, is, in its compositional design, a reflection of the ideas of Bernini.[3]*

Pascoli says nothing of the bold compositional innovations of Baciccio's vault fresco, but he does grasp some of the Baroque aspects of Baciccio's portraiture: its sense of a living individual talking and moving, of an instant in time caught in the midst of change. The suggestion

[1] Lione Pascoli, *Vite de' pittori, scultori ed architetti moderni,* 2 vols. (Rome, 1730-1736).

[2] G. Boccolini, "La raccolta di Lione Pascoli nella Pinacoteca comunale di Deruta," *Rivista di R. Istituto d'Archeologia e Storia dell'arte,* VIII (1940-1941), pp. 129-43.

[3] See R. Enggass, *The Painting of Baciccio* (University Park, Pa., 1964), pp. 52-54; and Francis Dowley, *Art Bulletin,* XLVII (1965), pp. 294-300.

*that this too owes a great deal to Bernini is borne out if we compare
Pascoli's passage with those on Bernini's portraits written by Chantelou
(pp. 123-24).*

*In the rather self-consciously literary passage that we give at the
end of this section, Pascoli says that Baciccio's painting declined in
quality when he gave up his "strong, bizarre" manner and "gave himself
over to the imitation of those who abandoned the dark colors." What he
is saying is that he much prefers Baciccio's High Baroque style with its
rich, intense colors and strong rhythms ("bizarre" is one of the earliest
terms used to characterize forms that were called Baroque) to the Baroque
classicism of Baciccio's last phase, in which his colors became lighter and
lowered in intensity, and the rhythms more gentle. The change is one
that we have already seen in the case of Guercino. Pascoli suggests that
with Baciccio it was a matter of the erosions of old age but Baciccio's
late paintings show no signs of a weakening in technical skill. It is much
more likely, as in the case of Guercino, that he altered his style to meet
the demands of his patrons. He would also have been under pressure to
meet the competition presented by Carlo Maratti, whose cooler, paler,
quieter paintings were all the rage in late seventeenth and early eigh-
teenth century Rome.*

From Pascoli, *Vite de pittori, scultori ed architetti moderni*

I will begin by saying that the grandfather [of Giovanni Battista
Gaulli, called Baciccio] left Venice while he was still a young man.[1] He
had been born there of honest, well-bred and rich parents who, by a
turn of fortune, had fallen into bad times, and were, at the time of their
death, reduced to miserable circumstances. Being ashamed to live in
abject poverty in a place where he had been born into splendor, he
resolved to leave and to seek his fortune elsewhere. Finally he reached
Genoa, where he decided to remain. There he had a son whom he called
Lorenzo, who married and had various children. Within a brief space
of time all of them were dead of the plague, and there remained alive
only our Giovanni Battista. Coming out of school one day, he saw a
galley that was to bring the (Genoese) ambassador to Rome, and was
about to weigh anchor. The poor boy told the ambassador of his mis-
fortunes and said that he was studying painting and wanted to go to
Rome. The ambassador, who rather liked the boy's spirited manner,
ordered that he be taken along and treated as one of his household.
After arriving in Rome he housed him until he was taken in by a French

[1] The following selections are from Lione Pascoli, *Vite de' pittori, scultori ed
architetti moderni*, I (Rome, 1730), 194-95, 197-200, 207, 209.

painter. He was then fourteen years old, having been born on May 8, 1639.

Later he joined the household of Pellegrino Peri, a rich art dealer from Genoa, who had been after him for some time to get him to come to him, and for whom he did a great deal of work. It was in this period that Gaulli became friends with Mario de' Fiori, and with Bernini. Bernini introduced him to various families and they had him make a number of portraits, this being an area in which he was already excellent.

Having finished these and various other works that he did by the age of twenty-six, his reputation increased greatly, and he acquired such a name that Alexander VII himself wished to know him and he was introduced by Bernini. When His Holiness saw how well-bred, charming, and handsome the young man was, he ordered that any time he wished to speak to him he should be permitted to enter by way of the secret stairs, and he immediately had him make his portrait. It is still today in Palazzo Chigi.

Later the nuns of S. Marta opposite Collegio Romano commissioned him to paint the vault of their church, which he did promptly. Once unveiled, it was equally pleasing to the connoisseurs and to Father Oliva, General of the Jesuit Order. Father Oliva, who wanted to have the church of the Gesù painted, included his name among those that had been proposed to him. The list was limited to four: Carlo Marrati, Ciro Ferri, Giacinto Brandi, and Gaulli. However, before deciding he wanted to have the opinion of various artists who were his friends, and above all, the opinion of Bernini, in whom he had more faith than anyone else. Bernini told him sincerely that he should employ the last named of the group, and not to worry, because he [Bernini] would act as guarantor.

Then the contract was drawn up and he, being very eager, lively, and full of ginger, went right to work. As the work progressed it became clear that according to general agreement it would turn out badly, and would not be able to decorate the sites well, that is, it would not be able to decorate them as the Father General had supposed and as he himself had believed. Discussing the matter among themselves, the Father General and Bernini agreed that it should be enlarged, and that he should work without concern, and they would look after the amount of the increase in the recompense due him; and that he generously, without a shadow of doubt, having complete faith in their word, should increase it according to the need.

Gaulli's portraits are innumerable. He made them of all the cardinals, of all the important people who lived during his time and who came

to Rome, and of the seven popes who reigned from Alexander VII to Clement XI. In this field, without any doubt, he had great skill, and singular competence, so that with reason he can in portraiture be numbered among the most celebrated and expert masters that there have ever been. In making portraits he had a manner completely contrary to the one in common practice. He said he learned it from Bernini, who in making portraits did not want the person portrayed to stay motionless and hushed, but instead wished that they talk and move. He said that persons in movement are most like themselves. He said that the portraitist must produce a complete likeness in the portrait. He must select the most complimentary and graceful aspects, and reveal in this manner the most beautiful and flattering aspects of the face, while hiding the less pleasant and less affable side, in order to produce portraits that are pleasing and charming.

How ill-advised, in my opinion, are those who yearn for a long life! And how much, it seems to me, they deceive themselves, those who say that certain outstanding men either should never have been born, or should never die. How many, how very many of the dead would have been more glorious had they lived less long. Those few, we consider fortunate (and how few they are) that in old age are not abandoned by fortune. This truth was well known among the great emperors, from the first Caesar [Julius] to the fifth Charles [of Spain]. If one considers robustness, strength, and good health, there is no one who on becoming old does not either lose those things completely, or at least become weak and diminished. This is well known to all the aged, who bit by bit decline. If we consider such things as capability, wit, and disposition, what a great difference we perceive between those things that artists do when they are young men, and those that they do in old age. And this, unfortunately, can be seen by those who gauge without passion, and who examine with attention, and according to the evidence Giovanni Battista Gaulli shows it too. For if he had died after he had painted the pendentives of the dome of S. Agnese in Piazza Navona, the vault, pendentives, dome, and tribune of the Gesù, and the other work that he did at that time and shortly after when, still in his youth, he painted in a truly fine way and was completely attached to his [early] style, which was strong, bizarre, and pleasing, then he had no need to envy any other artist, even the most illustrious. But when he turned away from this style, and gave himself over to the imitation of those who abandoned the dark colors, then he changed. And the work that he did afterwards, though quite lovely, lost all that had made it most beautiful, so that although at first he was equal to the most famous, he became afterwards even less than himself.

With this I stop speaking of the works, the habits and all else that relates to this splendid man, who in Genoese dialect, rather than Giovanni Battista Gaulli, is called Baciccio.[2]

Magnasco

Our selections on Magnasco were written by Carlo Giuseppe Ratti and published in his book on the artists of Genoa in 1759.[1] Alessandro Magnasco (1667-1749), called Lissandrino, spent most of his active career in Milan, but he had been born in Genoa and he returned there toward the end of his life. It is during this final Genoese phase that Ratti got to know him, apparently rather well. His biography of Magnasco appeared in print only a decade after the artist's death.

After reading through all the earlier critics who were appalled when confronted with Caravaggio, incomprehensive of the contribution of Cortona, or who passed by Bernini in silence, it is a pleasure to turn to Ratti. Ratti belongs to the age of Enlightenment: the eighteenth century. He knew Magnasco's art was new and radical, but instead of being frightened by it he liked it.

The most striking things about Magnasco's work are the extensive use of very free open brushwork and the disembodied, flamelike figures. Speaking as a painter himself, Ratti is also very much aware of such unusual devices as leaving part of the priming coat uncovered and then using it as a component in the final color scheme. It was, in fact, the expressive qualities of Magnasco's technique that appealed to Ratti above anything else. He speaks contemptuously of the art patrons in Genoa who only wanted pictures that were slick, realistic, and had lots of detail. How modern of Ratti, how avant-garde, how much in the spirit of the twentieth century! (Or, from another point of view, which is held by the many advocates of social realism, how reactionary we are, how much in spirit of the eighteenth century.)

Magnasco's patronage is also characteristic of his period. Of course, there was a respectable market in Italy for genre paintings even in the seventeenth century. But without a pronounced increase in both the size and the secular orientation of the middle class it is doubtful whether, in Italy at any rate, an artist could have become well-to-do, as Ratti indicates Magnasco was, without finding it necessary to paint either frescoes or altarpieces.

[2] The Genoese diminutive of Giovanni Battista is "Baciccia," not "Baciccio," but "Baciccio" seems to be what Gaulli was called in Rome. Most of the seventeenth and early eighteenth century sources use this form.

[1] Carlo Giuseppe Ratti, *Vite de' pittori, scultori, ed architetti genovesi*, II (Genoa, 1759), 155-62.

Ratti was casually interested in Magnasco's subject matter: the bizarre brigands, the tormented friars, the exotic Jews, all of them apparently tempest-torn, whether they appear in a seascape, a landscape, or inside a building. For him they were all caprices, all equally charming, whether they represented a garden party or a hanged thief. Though we know no more than Ratti we are now not so sure that Magnasco was not trying to say something more. The meaning of his strange stories still eludes us.

The principal problem concerning Magnasco that continues to plague us is how to decide what he did and did not paint. From Ratti we get a very good first-hand idea of how complex these questions really are and how great is the consequent need for caution. Magnasco spent a considerable amount of time and effort adding his figures to other painters' paintings. Ratti tells us he supplied figures for landscapes by Clemente Spera, Carlo Tavella, and "others too numerous to name." Besides this, as Ratti reports, he had imitators even in his own lifetime: painters who did their best to paint like Magnasco even though they could not do so half as well. Today, of course, all these Magnascos—the real ones, the partial ones, and the "fakes"—are authentic eighteenth century paintings, over two hundred years old.

From Ratti, *Vite de' pittori, scultori, ed architetti genovesi*

Alessandro Magnasco was a painter with an extraordinarily lively talent. In his ability to paint with free, open brushwork not only were there none among us in the past who equalled him, but he had no equals even among those who followed. Thus the style born with him was with him extinguished and up until now has not been revived.

Alessandro, the son of Stefano Magnasco, a fine painter, was born in Genoa. In 1685 his father died and he was left in poverty. His mother, who remarried, continued for some time to support her son as best as she could until he was about ten years old. She then handed him over to the care of a Genoese merchant who had correspondents in Milan and promised to get the boy employment there. Alessandro came to Milan furnished with letters, as a result of which he was well received. He was taken in by a rich Milanese citizen, who cared for him dearly as soon as he came to know his fine character and his vivacious spirit.

When he was somewhat older Magnasco's guardian put him to the study of arithmetic so that he could help him in keeping accounts. But the young man, who had no inclination for such studies, said that he would much rather study painting. His guardian agreed and quickly took him to Filippo Abbiati, one of the most celebrated painters in Milan at the time, and turned him over to him. Under him Magnasco learned

the profession of painting, and he did so with incredible speed. In a short time he acquired the reputation of being an excellent and resolute painter. Although still young he was making things that were superior to the works of many experienced masters. He was especially successful in painting portraits. He made a good number of them and they were marvellously realistic.

After some time Magnasco gave up making portraits and applied himself to a kind of painting that had little figures and represented various delightful things. Through these works he gained so great a reputation that from then on he always wanted to continue making pictures in this way. He considered it to be on the very highest level in charm and delightfulness. The themes of those paintings were for the most part: convent schools with girls busy learning or carrying out domestic tasks; hermitages with Camaldolensian or Carthusian monks who chastise themselves or perform other acts of self-mortification and penitence. There are also monks studying; chapters of brothers; processions; missionaries preaching; thieves who attack people on the highways; shops of barbers, knife sharpeners, cabinet makers, and similar artisans; swindlers playing; rascals showing a magic lantern to children; corps of guards with soldiers busy at military exercises or the mechanical arts; and the like. But his favorite subject and one that he often repeated was that of the Jewish synagogue, a work that was very striking in its concept.

The figures in his paintings are usually scarcely bigger than a hand's span, and made with rare skill. They are painted with rapid, seemingly careless but artful strokes, strewn about with a certain bravura that is difficult to explain and cannot be imagined by those who have not seen it. He had in his manner of painting such bold self-assurance and such a special sort of carelessness that sometimes he left the priming coat of his paintings uncovered and in some places he used it to provide the coloring he needed.

The drawing in his pantings is very natural, and the nudes are represented with unadorned veracity. His compositions are amusing, and they are provided with chiaroscuro as lovely as you can see anywhere.

In Milan Magnasco also carried out some large-scale works. The Jesuit fathers have in their religious house an *Adoration of the Magi* that he made, which they hold in high regard. It is true, however, that Magnasco was not a painstaking painter. Hence those of his paintings that called for refinements did not come out as well as the others with free open brushwork. And he himself, who knew his own talents, stayed away as much as he could from undertaking works in which the need was for delicate gradations of color.

[The story is told that once when] the Emperor Charles VI, on his way from Spain to Austria, had to pass through Milan, Magnasco, like

all the other painters in town, had to make a picture to decorate the floats and triumphal arches that were being erected along the path he would take. Magnasco kept promising the picture but he never produced it. So it went up until the last day. He couldn't bring himself to make it until the night just before the emperor arrived. And when this painting was shown immediately, with the colors completely fresh and sparkling, it seemed so marvelous to the spectators that it received their applause in preference to [the works of] many other most worthy Milanese painters, who had shown the skills of their brush in such a magnificent display.

There were many painters in Milan at that time who, after having painted seascapes and landscapes then went to Magnasco to have him put in the figures. He was of service in this way to Perugini, a landscape painter, and to Clemente Spera, a painter of ruins and of architecture, and to others too numerous to name.

Magnasco had some followers in Milan who studied how to imitate his style. One of these was a certain Ciccio from Naples, who, although he had some ability, was still a great distance below the master. Another was a certain Coppa of Milan, but he didn't even come halfway up to the Neapolitan.

The desire to travel took Magnasco to various cities in Italy. He spent some time in Florence, where he took a certain girl from Genoa for his wife. There he had the opportunity to paint a good number of paintings for various gentlemen who liked the new style very much. They introduced him to the Grand Duke Giovanni Gastone, who promptly commissioned him to paint some landscapes with figures of hermits. These canvases are now kept in the Pitti Palace, which belongs to the Duke.

After a long stay in Florence Magnasco returned to Milan with his wife. There he continued to turn out his bizarre creations, to the same applause as before, and with an ever-increasing number of customers. From his work he drew emoluments that enabled him to live comfortably, with decorum, and even lavishly.

Magnasco returned among us in the year 1735. But his painting did not bring him in Genoa the honors it had brought him in Milan and elsewhere. His free open brushwork seemed of no account and even ridiculous to certain people who thought that the beauty of a painting consisted in a slick appearance, or in the slavish imitation of the least important small-scale details, to which a quick-witted and spirited person would not submit himself.

Magnasco was a painter of such talent and imagination that he yielded to none among us, and stood far ahead of many. His free, open brushwork should have redounded to his credit rather than to his low

esteem. But he found himself in a city where there were no good judges of that new style. This, plus the beginnings of old age, were the two reasons why he did little work in Genoa. Still, he painted some pictures with energetic brio. He made the friendship of Carlo Antonio Tavella, an artist who was exceptionally able in landscape painting and did a great deal of work for him. Into Tavella's paintings he introduced various small figures of hermits, shepherds, pilgrims, and other related ideas.

Magnasco's way of drawing was like his painting. Some drawings of his that I have show it. They are worked up with a few pencil strokes and shaded with lamp-black in a way that seems made to be ridiculed. But the mark of the master is always apparent. The expression that appears in those figures is so right and so well adapted to the various types of persons that I do not know if there is anything further that art can do.

As he increased in years Magnasco found he could no longer handle his brush because of the pronounced tremor of the hands that afflicted him. However, he never ceased to discuss his art, and he did so with unbelievable vigor and charm, so that it was a delight to hear him. He was always happy, and even though decrepit with age he seemed full of vigor and fire. He died at the age of eighty-seven [Ratti makes him five years older than he really was] and was buried in the parish church of S. Donato, near to where he lived. But after him there remains the glory of his name, which down through the long centuries will never die.

2

Spain

INTRODUCTORY NOTE

The seventeenth century was a remarkable epoch for the arts in Spain. The names of Velázquez, Murillo, Ribera, and Zurbarán epitomize the period's high level of artistic achievement. In addition to them, however, were a number of first-class artists whose lack of renown instills a proselytizing fervor in every lover of Spanish art. These painters, and the even less remembered sculptors, created works of beauty that express a profoundly Spanish view of the world. For this was the time when Spanish art outgrew its dependence on Italy and Flanders and discovered its own national style. In my selection of texts and documents I have tried to convey the unique and complex spirit that underlies this rich style.

Although the translations cover a wide range of material, certain ideas recur throughout. Unquestionably the most important theme is the tension between the forces of conservatism and innovation. The continuing struggle of the painters to raise their social status in the face of government opposition is a leitmotif in the artistic literature of the period. On another level, the insistence on the sacred duty of art to serve the Church is often repeated, and is reflected by the preponderance of religious subject matter in Spanish painting. In fact, the Catholic Church and the monarchy, bastions of tradition, loom large over the times as keepers of faith and power. This aspect is somewhat magnified in the contemporary texts, since the more advanced artists were inclined to practice rather than to prescribe and preach. Pacheco and Carducho were the most important writers on art in the seventeenth century, but their academic mentalities are behind the painting of their time. Velázquez, on the other hand, let his art speak for itself, and from it alone can we occasionally deduce how Spain's most revolutionary painter viewed his profession. Pacheco was certainly more receptive to innovation than was Carducho, but in both their treatises, as in other sources, the conflict between the new and old, between the individual and the establishment, between theory and reality, can be sensed.

Readers of this section of the book will soon be aware that I have not been faithful to its general title. In effect, no mention is made of artists who worked after 1700 nor of events that occurred after that date. My reason for this omission is a practical one: with so much fresh material on hand for the more studied artists of the earlier period, and so little space in which to make it known, I felt obliged to sacrifice even a token concession to early eighteenth-century Spanish art. More important victims of these circumstances include the painters who worked in Madrid during the last half of the seventeenth century. The high level of quality attained by such artists as Juan Carreño de Miranda, Claudio

Coello, Francisco Rizi, Francisco Herrera the Younger and others has been consistently neglected by admirers of Baroque art. My regret at omitting them in no way compensates for yet another slighting of their achievements.

ARTISTIC THEORY

The Aims of the Christian Artist

The most important Spanish writer on art in the seventeenth century was the painter Francisco Pacheco (1564-1654). Pacheco was orphaned while very young and was subsequently adopted by an uncle, a canon of the Cathedral of Seville and a formidable scholar. His uncle introduced Pacheco into his circle of friends, which included poets, humanist scholars, and theologians, and their influence was as important for his formation as his artistic training. In time Pacheco inherited his uncle's role as a leader of this group, which has inaccurately come to be called Pacheco's academy. It was in fact neither Pacheco's nor an academy in the modern sense. Rather it was simply a loose association of intellectuals who met as friends at irregular intervals to discuss matters of common interest. These interests are reflected in Pacheco's treatise, El arte de la pintura, *published in Seville in 1649, together with the artist's concern with the practice of painting.*

Pacheco worked on his book for at least forty years, and the result was a long and markedly uneven treatise. Its strengths appear when he talks about artistic practice and the artists he knew, including El Greco and his pupil and son-in-law, Diego Velázquez. But the long sections devoted to artistic theory are unequal in quality. The weakest parts deal with the humanistic theory of art, about which Pacheco offers little more than extensive quotations from Italian sources. However his involvement increases greatly when he discusses the problem of art in the service of religion. He himself was the inspector of art for the Inquisition of Seville, and it is the inquisitorial spirit that influenced his conception of the role of painting as a servant of Catholicism. At first, this attitude seems akin to the fundamental ideas of Catholic Baroque art. But Pacheco wished to protect the faith, not to make it easily accessible. His passion for orthodoxy and its concomitant fear of heresy reveal him as a child of the Council of Trent.

This philosophy is apparent in his book, in which he often strongly urges painters to consult learned theological advisers. Pacheco himself followed this practice, and at several points in the Arte *he offers prescriptions for religious iconography that he devised with his circle of learned friends. In fact, such is his obsession with iconographic orthodoxy that the last chapter of Book III was finally expanded into an appendix that is longer than the entire Book itself.*[1]

[1] See below, pp. 165-66, for a sample of Pacheco's instructions for painting a religious subject.

The following passage, which draws heavily on the Council of Trent's statement on art of 1563, sets forth ideals for painting, which Pacheco and most Spanish artists of the period attempted to follow.[2]

From Pachecho, *El arte de la pintura*

On the Aim of Painting and of Holy Images and on the Good They Do and Their Authority in the Catholic Church

When dealing with the aim of painting (as we have proposed to do), it is necessary to borrow a distinction used by the doctors of the Church, which serves to clarify our purpose. They distinguish between the aim of the work and the aim of the worker. Following this doctrine, I would like to distinguish between the aim of the painting and the aim of the painter. The aim of the painter, in his capacity as an artisan, will be by means of his art to earn a living, achieve fame or renown, to afford pleasure or service to another or to work for his own enjoyment. The end of painting (in general) will be, by means of imitation, to represent a given subject with all the power and propriety possible. Some people call this the soul of painting, because it makes it seem alive, so that the beauty and variety of colors and other embellishments become of secondary importance. Hence Aristotle said that, of two paintings, one inaccurate but displaying beautiful color and the other true to life but simply drawn, the former will be inferior and the latter superior, because the former contains the incidental and the latter incorporates the fundamental and substantial, which consists of reproducing perfectly, by means of good drawing, that which one wishes to imitate.

But considering the aim of the painter as a Christian artisan (which is our present task), he may have two goals or ends: one primary, the other secondary. The latter, and less important, will be to exercise his art for gain or renown or for other reasons (as I said above), but controlled by factors of time, place, and circumstance, so that no one may accuse him of abusing this art or working against the highest good. The principal goal will be to achieve a state of grace through the study and practice of this profession; because the Christian, born to achieve high things, is not content to restrict his activities to lower things, attending only to human rewards and earthly comfort. Rather, raising his eyes heavenward, he dedicates himself to a greater and more excellent goal that is found in things eternal.

. . . And if the aim of painting (speaking of it now as an art), is, as we said, to approximate what it intends to imitate, let us now add

[2] Francisco Pacheco, *El arte de la pintura* (Seville, 1649). Translated from edition of F. J. Sánchez Cantón, I (Madrid, 1956), 212-19; 236.

that when it is practiced as a Christian work, it acquires another more noble form and by means of it advances to the highest order of virtue. This privilege is born of the greatness of God's law, by means of which all actions (which otherwise would be considered vile), committed with thoughtfulness and directed to the final goal, become greater and are adorned the rewards of virtue. But do not think that art is destroyed or denied by this, but rather it is elevated and ennobled and receives new perfection. Thus, speaking of our problem, we can say that painting, which before had imitation as its sole aim, now, as an act of virtue, takes on new and rich trappings; and, in addition to imitation, it elevates itself to a supreme end—the contemplation of eternal glory. And as it keeps men from vice, so it leads them to the true devotion of God Our Lord.

Thus we see that Christian images are directed not only toward God, but also toward ourselves and our fellow man. For there is no doubt that all virtuous works may serve simultaneously the glory of God, our own education and the edification of our fellow man. And the more that these three elements are present, the more will the work be esteemed, for in these elements exists the totality of Christian perfection. . . .

As we have said, these images also serve us, for since Our Lord God desires everyone to praise Him with his body and soul, holy images help to express outwardly the reverence that we have within us, and allow us to dedicate this reverence to God as an oblation and kind of sacrifice. Thus we give proof of the obligations we have to Him, and of the boundless joy we feel upon seeing His Divine Majesty represented always before our eyes by a painting showing Him as Our Father and Lord.

Moreover, they give marvelous help in fulfilling both the practical needs and spiritual edification of our fellow men. If we consider the three qualities discussed by the philosophers—namely, the qualities of pleasure, usefulness, and truth—we see that holy images encompass them all perfectly, since we attain all these qualities by means of these holy images. Experience teaches us that nothing pleases the eye more than works of painting executed with perfection, as Petrarch says in this significant passage: "A well-painted picture gives us a pleasure that raises us to the realm of celestial love by leading us to its divine origin. For is there anyone who delights in the small brook and hates the spring where it is born?"

As for the quality of usefulness, they [holy images] disguise imperfections and thus please our senses; they bring splendor and beauty wherever they are displayed, for there is no place, no matter how lowly or crude it may be, that is not suitably enhanced by their decoration; and they preserve antiquity, for many things would now be forgotten

had they not been depicted; and they serve the common good by acting as books for those who cannot read. Much more could be said on this score, but we will now pass on to the quality of truth.

It would be hard to overstate the good that holy images do: they perfect our understanding, move our will, refresh our memory of divine things. They heighten our spirits . . . and show to our eyes and hearts the heroic and magnanimous acts of patience, of justice, chastity, meekness, charity and contempt for worldly things in such a way that they instantly cause us to seek virtue and to shun vice, and thus put us on the roads that lead to blessedness.

Besides what has been said, there is another very important aspect of Christian painting, which concerns the goal of the Catholic painter, who, in the guise of a preacher, endeavors to persuade the people and to bring them, by means of his painting, to embrace religion. For the sake of greater clarity, let us follow the teachers of oratory who differentiate between the means and the end of an orator. I call the means those which are employed to attain the end, and the end that which is the fundamental and ultimate purpose. Thus, as the means of the orator is speaking appropriately and to the point, so his end will be to convince us. . . . Thus the painter, like the orator, will be obliged to paint in such a way that he attains the desired end by means of sacred images. Would that our painters nowadays realized these obligations; but how many of them are capable of understanding these words of mine? Oh, what a shame it is, what a terrible shame!

This goal of persuading people will be achieved differently according to circumstances, just as in the case of the orator who, having as his basic desire to convince his audience, will nevertheless argue now for war, now for peace, now to punish or forgive or reward, and so on. Thus the painter may have several ends in mind, depending on the diversity of things he is called upon to depict. But I say that the principal goal of Christian images will always be to persuade men to be pious and to lead them to God . . . even though other specific goals may also be involved, such as leading men to penitence, to suffering with pleasure, charity, contempt of the world, or to other virtues, which are all ways of uniting men with God, which is indeed the highest end that the painting of sacred images can aspire to.

[Ed.'s note: At this point Pacheco launches into one of his frequent pedantic discourses. In this one he marshals the opinions of the great Christian scholars to corroborate the value of art in the service of God. Finally he concludes with the following paragraph in which he hints at a point he develops later on and which is entirely characteristic of Tridentine thinking on art: namely, that a great painter is not necessarily a good painter, in the Christian sense of the word.]

If it seems that I have departed from my intention in order to deal with the question of holy images, I will insist that if they are not the sole aim of painting, they are, nevertheless, the most illustrious and majestic part of it, the part which gives it greatest glory and splendor, because they are employed [to show] the holy stories and divine mysteries that teach the faith, the works of Christ and His Most Holy Mother, the lives and deaths of the holy martyrs, confessors and virgins, and all else that pertains to this. And because it imposes strict obligations of truth, naturalness, and decorum, wherein so few achieve success even though they be great painters, it is the most difficult part of this noble art.

The Iconography of the Virgin of the Immaculate Conception

Pacheco's direction for painting the Virgin of the Immaculate Conception is a typical example of his passionate interest in Catholic iconography. Besides listing the desired components of the picture, he supports each element with an authoritative reference or else appends his own learned justification, a practice which he occasionally carries to absurdity. To this extent his attitude exaggerates a genuine preoccupation of Spanish painters, most of whom allowed themselves greater latitude when depicting sacred subject matter. A comparison of a Virgin of the Immaculate Conception painted by Murillo with Pacheco's text is the best way to see how artists could stray from Pacheco's strict formulas.

The Virgin of the Immaculate Conception was one of the most frequently painted subjects of this period, for two reasons. First was the strong strain of Mariolatry that is traditional to Spanish Catholicism. Secondly, the doctrine that the Virgin was born without original sin was hotly debated in the first decades of the seventeenth century. Spaniards, and particularly Sevillians, were the leaders of an intensive campaign, conducted before Papal tribunals, to elevate the belief to the status of dogma. Hence, numerous representations of the subject were made in order to affirm the position and to encourage its diffusion.[1]

From Pacheco, *El arte de la pintura*

. . . Some say that (the Immaculate Conception of Our Lady) should be painted with the Christ Child in her arms because she appears thus on some old images that have been found. This opinion is probably based (as the learned Jesuit Father Alonso de Flores has pointed out) on the fact that Our Lady enjoyed freedom from original sin from the very first moment, since she was the Mother of God, even though she

[1] Francisco Pacheco, *El arte de la pintura* (Seville, 1649). Translated from edition of F. J. Sánchez Cantón, II (Madrid, 1956), 208-12.

had not yet conceived Jesus Christ. Hence from this moment (as the saints know) she was the Mother of God, nor did she ever cease to be. But without taking issue with those who paint the Child in her arms, we side with the majority who paint her without the Child.

This painting, as scholars know, is derived from the mysterious woman whom St. John saw in the sky with all her attributes.[2] Therefore the version that I follow is the one that is closest to the holy revelation of the Evangelist and approved by the Catholic Church on the authority of the sacred and holy interpreters. In Revelation she is not only found without the Child in her arms, but even before she ever bore a child. . . . We paint her with the Child only in those scenes that occur after she conceived. . . .

In this loveliest of mysteries Our Lady should be painted as a beautiful young girl, twelve or thirteen years old, in the flower of her youth. She should have pretty but serious eyes with perfect features and rosy cheeks, and the most beautiful, long golden locks. In short, she should be as beautiful as a painter's brush can make her. There are two kinds of human beauty, beauty of the body and of the soul, and the Virgin had both of them in the extreme, because her body was a miraculous creation. She resembled her Son, the model of all perfection, more than any other human being. . . . And thus she is praised by the Husband: *tota pulchra es amica mea,* a text that is always written in this painting.[3]

She should be painted wearing a white tunic and a blue mantle. . . . She is surrounded by the sun, an oval sun of white and ochre, which sweetly blends into the sky. Rays of light emanate from her head, around which is a ring of twelve stars. An imperial crown adorns her head without, however, hiding the stars. Under her feet is the moon. Although it is a solid globe, I take the liberty of making it transparent so that the landscape shows through. The upper part is darkened to form a crescent moon with the points turned downward. Unless I am mistaken, I believe I was the first to impart greater majesty to these attributes, and others have followed me.

Especially with the moon I have followed the learned opinion of Father Luis del Alcázar, famous son of Seville, who says, "Painters usually show the [crescent] moon upside down at the feet of this woman. But as is obvious to learned mathematicians, if the moon and sun face each other, both points of the moon have to point downward. Thus the woman will stand on a convex instead of a concave surface. . . ." This is necessary so that the moon, receiving its light from the sun, will illuminate the woman standing on it. . . .

In the upper part of the painting one usually puts God the Father

2 *Revelation* XII, 1-4.
3 Thou art all fair, my love; there is not spot in thee. *Song of Songs,* IV: 7.

or the Holy Spirit or both, together with the already mentioned words of the Husband. The earthly attributes are placed suitably in the landscape; the heavenly attributes can be placed, if you wish, among the clouds. Seraphim or angels can also hold some of the attributes. It slipped my mind completely to mention the dragon, our common enemy, whose head the Virgin broke when she triumphed over original sin. In fact I always forget him, because the truth is that I never willingly paint him, and omit him whenever I can in order not to embarrass my picture with his presence. But painters are free to improve upon everything I have said.[4]

Lope de Vega, The Case for Painting as a Liberal Art

The leading question of artistic theory in Spain during the seventeenth century concerned the social status of painting. Should it be considered a liberal art, or merely a craft? The problem was not a new one. It had been discussed in Italy since the time of Leonardo da Vinci, so that by 1600 painting in that country was usually ranked equally with poetry. But in Spain the question was complicated by the issue of the right to tax works by living artists. The treasury, hard pressed for funds to fight the empire's losing battles, decided that painters were craftsmen, not artists, and that consequently their works were subject to a sales tax called the alcabala. *The painters resented being classified with blacksmiths and tailors, not to mention paying a tax on the sale of their works, and so the battle with the treasury began.*

The fight was not easy; in fact, it was not won until 1677, when the government declared that painting was indeed a liberal art. This decision culminated almost a century of legal actions, which involved some of the leading artistic and literary personalities of the time. Among the first painters to bring suit against the treasury was El Greco. In 1603 he won his case against the tax collector of Illescas, who had demanded duty on the paintings for the Hospital of Charity. According to Antonio Palomino (El museo pictórico y escala óptica, *Book II, Chapter 3, section 3) this was but one of seven court decisions in favor of the painters that led to the final victory.*

The most fascinating of these cases is the one instituted in Madrid by the court painters Vincencio Carducho and Eugenio Caxes against an officer of the treasury in 1625. To assist their cause the painters enlisted some of the most respected legal and literary minds in Madrid. Their testimony was fortunately recorded in a small pamphlet of 1629,

[4] The painting that most approximates Pacheco's text is his own *Immaculate Conception* in the Church of San Lorenzo, Seville.

which was later incorporated as an appendix to Carducho's treatise, Diálogos de la pintura (Madrid, 1633). From the list of contributors one name stands out—Lope de Vega, the great playwright and poet. Lope's statement, which is translated below, assumes the form of a legal deposition and contains his answers to six questions concerning the case. The questions are lost, but the important ones can be deduced from Lope's answers. Although the text is a scribe's transcription of the testimony, the line of thought is unmistakably Lope's and affords us a glimpse of a great writer's ideas on painting.

Many of these ideas, it must be said, are not original. Often Lope follows a well-worn line of argument, which involves extensive citation of precedents from religious and secular sources. The Bible and ancient history prove both the antiquity and venerability of the art, while modern history (often in the form of anecdotes) shows how painting had continued to command respect up to that time. But occasionally Lope adds a thought that reveals his wit rather than his erudition, when he argues that because the Virgin Mary did not pay the tax of original sin, all those who paint her image are likewise free of any tax.

STATEMENT AND DEPOSITION OF FR. LOPE FÉLIX
DE VEGA CARPIO, ORDER OF SAN JUAN (HONORED
IN THE WORLD FOR HIS GENIUS, WHICH HAS
BEEN OFFERED IN SUPPORT OF THIS CAUSE) [1]

1. To the first question he responded that he was personally acquainted with the parties, whose works are as famous as they are admired. And since hearing of the announcement of this case, he has felt very strongly about it, owing to the veneration he has had for painting, a veneration shared by all civilized nations since the beginning of history. It was created by God, who became the first painter in creation when He formed man in His image and likeness . . . [Among men, painting] was begun by Aristides and perfected by Praxiteles. [God's role as the first painter] was thus recognized by Saint Ambrose in the hymn *Caeli Deus,* which is sung by the Church, the third line of which is

Candore pingis igneo.[2]

2. To the second question [about the nobility and honor of painting], he responded that . . . it is no more necessary to prove that painting is an art than it is to show that the sun has light. In addition to its own greatness, there is no liberal art that does not need it in order to

1 Vincencio Carducho, *Diálogos de la pintura* (Madrid, 1633). Translated from edition of D. G. Cruzada Villaamil (Madrid, 1865), pp. 371-78.
2 You paint with burning brightness.

express itself in terms of lines, circles, and figures. This can be seen in Philosophy, in the *Meno* of Plato and in the problems of Aristotle, and in grammar, perspective, rhetoric, geography, arithmetic, astrology, anatomy, fortification, architecture, and military art, and even in the philosophy of physical combat. St. John Chrysostom called it art in the superscription of Psalm Fifty:

Pictores imitantur Arte Naturam.[3]

. . . But all this wonderful greatness and all the excessive hyperbole that may be offered are beside the point when we come to sacred paintings. And he went on to say that the divine art that produces them cannot be mechanical, for that would imply a contradiction between the respect accorded to them and the lack of respect for those who paint them. He further stated that in the first temple raised to God, He wished seraphim and palms [to be depicted] there; and he added that since painters were not allowed among the Hebrews, as Origen points out, all that which has drawing, design, modeling, tracing, and primary lines should be called painting and belongs to the realm of art. He further stated that just because in the beginning, as Pliny writes, they painted only on wax and marble, painting did not cease to exist and to belong to art any more than the parts may cease to belong to the whole. And also it says in Third Kings, Chapter 7, that Solomon summoned Hiram, a famous artist, native of Tyrus, whom he called;

Plenus sapientia, intelligentia, et doctrina.[4]

Since the terms wisdom, insight, and learning were never applied to any mechanical function, it naturally follows that that which has wisdom, learning, and intelligence is a liberal art, in accordance with Divine Scripture . . .

For this reason St. Gregory, St. Damascus and the Venerable Bede said that paintings of holy images were like history and writing for those who cannot read; which opinion was held by St. Bonaventure as seen in the precise words of Book Four of his *Pharetra:*

Ut hi qui literas nesciunt, saltem in parietibus videndo legant, quae legere in codicibus non valent.[5]

The witness was well aware of this, and said he honored paintings for what they represented, which is the reason why they are adored; because the effigy is inseparable from the real person, who thus receives the affection and the attention of the viewer. . . . And he also said

[3] Painters imitate nature by art.

[4] Full of wisdom, insight, and learning.

[5] So that those who do not know may at least read by seeing upon the walls things that they have not the power to read in books.

that the reverence due to paintings of holy images, which the iconoclasts denied, was defined by the seventh section of the Council of Trent, and there one may perceive the esteem merited by the man who has made the painting. And it makes no difference to say that painting can indulge in lascivious subjects, such as St. Augustine speaks of in the First Book of his *Confessions,* with the example of the youth who saw the picture of Jupiter and Danaë. One painter's idea does not compromise the excellency of art . . . no matter where his will may lead him. For painting and poetry have the very same freedom to deal with any subject without damaging their integrity.

All civilized nations of the world have confirmed this truth, and the honors, privileges and exemptions granted to painting are frequently mentioned in their histories; Pliny deals with this at length in many parts of his *History,* to which the curious reader is referred. But also in our times Emperor Charles V admitted an outstanding sculptor to the Order of Santiago, Baccio Bandinelli, and the present Pope made Diego de Romulo a member of the Order of Christ, in appreciation of the portrait he made of him.[6] More important, Selin, the Grand Turk, asked Venice to make Titian a patrician for having painted Rosa Solimana. This title is of great authority in that illustrious republic, and was given to the Duke of Sesa in recognition of his valor. Also the King of Fez wrote to King Philip II asking him to send a painter. King Philip answered that in Spain there were two kinds of painters, some common and ordinary and others excellent and illustrious (words he must have read in Origen in rebuttal of Celsus, who, in making a distinction among painters says that some achieve miracles with their brushes—*Usque ad miraculum excellunt opera* [7]—while others were satisfactory, and others simply bad). Which kind did the King of Fez want? The Moor replied that one should always offer kings the best. And so Blas de Prado, a painter of Toledo and one of the best of our times, went to Morocco, where the Moor received him with extraordinary honors.[8] And thanks to the munificence of our prudent King [Philip II], Federico Zuccaro and Luca Cambiaso, who worked at The Escorial, returned to Italy as rich men, even though neither of them equalled the paintings of El Mudo,

[6] Baccio Bandinelli (1493-1560) was a Florentine sculptor. In 1528, he presented the Emperor Charles V with a bronze relief of the Descent from the Cross (Louvre, Paris), for which the Emperor conferred the habit of the Order of Santiago on him (1530). Diego de Romulo, also called Romulo Cincinnato (c. 1502-1593), was a Florentine painter who went to Spain in 1567, where he collaborated on the decoration of The Escorial.

[7] Their works continually excel to the point of wonder.

[8] Blas de Prado (c. 1546-1599), a little-known painter of Toledo, went to Morocco in 1593. For his role in the development of Spanish still life painting see below, p. 216.

our illustrious Spaniard . . .⁹ And also, when King Philip III heard that the Royal Palace at El Pardo had burned, he asked with great emotion if Titian's marvelous painting of Venus had been lost, and when he was told that it had been saved, he responded: "Well, all the rest is of no importance." ¹⁰ Also when the Prince of Wales, now King of England, came to Spain he sought out diligently all the best paintings that could be found, for which he paid extremely high prices.¹¹ And the King, our Sovereign Lord, whom God protect, learned and practiced the art of painting in his earliest years, which is sufficient in itself to free painting from the tax. Besides His Majesty, many other kings and princes and noble ladies have painted, as was seen in the case of Sofonisba, who was lady in waiting to Queen Isabel, and whose paintings are so highly celebrated today.¹²

And to prove further the excellence of this most noble art, no man has been born who has not painted in his childhood, be it with a pen, or chalk on paper, or on the walls, acting only on the impulses of nature, who is herself the first mistress of painting, and who never paid a tax to anyone from the moment God created her. It is also piously believed that the angels made many crucifixes and holy images, and that at the present time the portraits that St. Luke made of Our Lady, the Blessed Virgin, still exist and are venerated and produce countless miracles. Since she never had to pay the debt that we must pay on account of our first father [Adam], it would not be just that her images pay a tax or any tribute, but rather that the exemption of her purity be extended to all who paint her portrait. Because her holy image and the stories of her life, be they glorious, joyful, or sad, are the most widely painted subjects among Christians. He [Lope de Vega] further stated that since so many portraits are made of their Royal Highnesses, they [the portraits] should go about—to use a human term—with the privilege that corresponds to their unique station in life.

3. To the third question he responded that he never has seen or heard that painting was assessed for a tax, because it is a scientific liberal art. And to prove this truth by an example, he advised that they consult the records of the City of Madrid for the year that the Queen Doña Isabel de la Paz, the second wife of Philip II, entered there for the first

⁹ El Mudo ("The Mute") was the nickname of Juan Fernández de Navarrete (1526-1579). After studying in Italy, he returned to Spain where he became a court painter. He is best known for his paintings in The Escorial.

¹⁰ The painting referred to is the *Venus del Pardo*, now in the Louvre.

¹¹ Charles I was in Spain in 1623-1624. For another version of how he acquired pictures while in Spain, see Carducho's statement on p. 214.

¹² Sofonisba Anguisciola (1527-1623) came to Spain in 1559, where she was favored by Philip II (not Queen Isabel) and named a lady in waiting.

time.[13] For he heard his parents say that every tradesman had been ordered to the festivities, including soldiers and the officers with their flags and their drums and their guns, but only painters, embroiderers, and silversmiths were excepted. This being so, further proof is not necessary, save to mention the harm done to our nation, which will be considered barbarous by other nations if we do not recognize as an art that which is so recognized in all parts of Europe.

[The answer to the fourth question is omitted.]

5. To the fifth question he responded that to deprecate painters in this way would be to cut off the hands of painting, as Zonaras reports in the third volume that the Emperor Theodosius did to that famous monk because he painted holy images. But after the images were burned, God allowed him to paint without hands, a miracle which attests to how God is served when painters of holy images are honored. And he further stated that he fully believes that Spain would suffer the loss of excellent painters, which would be a great defect in so civilized a nation, a nation to which all the others of Europe are attentive because of the enviable superiority of the monarchy. He further stated that if honor is the mother of the arts, as was commonly stated by the ancients, it follows that the state that does not honor her arts does not merit any honor herself.

[The answer to the sixth question is omitted.]

And he swore in the formula of a priest, with his hand upon his breast, that he holds all this to be true, and that this is his belief. It being true to the best of his knowledge, he signed it on the fourth day of November of the year 1628.

Carducho Contra Caravaggio

After Pacheco, the most important theorist of the seventeenth century was Vincencio Carducho (1576-1638). The two have much in common, for both were artists whose writings and paintings depended heavily on later sixteenth-century Italian sources. In Carducho's case this is not surprising, because he was born in Florence. Even though he came to Spain when he was nine, he was raised under the influence of his brother Bartolomé and their traveling companion, Federico Zuccaro, a leading exponent of the maniera. *Under their guidance his art and thought were formed, so that his book,* Diálogos de la pintura, *published in 1633, in some measure reflects the attitudes of the preceding generation.*

The Diálogos *is a series of eight rambling conversations between the Master and the Pupil. Carducho's theoretical inclinations are best*

<hr>

[13] Philip II's second wife was Mary Tudor. Lope is actually referring to Philip's third wife, Elizabeth of Valois, whom he married in Spain in 1560.

defined by the Master's answer to the Pupil's question about how to be a good painter. "Draw, speculate, and then draw some more," he says. Once a high level of skill had been reached, art was to enter the service of God and King, performing with propriety, dignity, and seriousness. It is easy to imagine, then, Carducho's great consternation with the modern art of his time, which was triumphantly represented in Madrid by Diego Velázquez, Carducho's successful rival at the court. Carducho nowhere speaks directly against Velázquez; indeed he hardly mentions him at all in the entire book, undoubtedly because he meant to slight him. And, in any event, Velázquez was but one of many painters who had abandoned the precepts of academic mannerism to practice a more naturalistic style with which Carducho was not in sympathy. But surely he had Velázquez in the back of his mind when he unleashed the following accusation against the arch-villain of the naturalist painters, Caravaggio.[1]

From Carducho, *Diálogos de la pintura*

And thus with this simile we may say that none of these paintings is to be deprecated, although none is completely perfect nor completely without perfection; from all of them you could put together an excellent painter. For in each and every painting there is so much that is admirable and pleasing that it is as if we were offered to our minds and senses a banquet of excellent dishes, so well prepared in so many different ways that we could not choose one without regretting to leave another. Because leaving aside those of the divine Michelangelo and of the great Raphael (. . . dishes of this science that are both hearty and nourishing), who is going to send back the dish of Correggio, Titian, Parmigianino, Salviati, Taddeo Zuccaro, Baroccio, and those that we have named who have painted in Italy, Spain, France, Flanders, Germany, and England. . . . Suffice it to say that all of them enjoy fame, which makes them eternal in the memories of men, and heroic books and wise eulogies have been written in praise of them. . . .

In our times, Michelangelo da Caravaggio arose in Rome with a new dish, prepared with such a rich, succulent sauce that it has made gluttons of some painters, who I fear will suffer apoplexy in the true doctrine. They don't even stop stuffing themselves long enough to see that the fire of his talent is so powerful . . . that they may not be able to digest the impetuous, unheard-of, and outrageous technique of painting without any preparation. Has anyone else managed to paint as successfully as this evil genius, who worked naturally, almost without precepts, without doctrine, without study, but only with the strength of his

[1] Vincencio Carducho, *Diálogos de la pintura* (Madrid, 1633). Translated from edition of D. G. Cruzada Villaamil (Madrid, 1865), pp. 202-204.

talent, with nothing but nature before him, which he simply copied in his amazing way? I heard a devoted follower of our profession say that the coming of this man to the world was an omen of the ruin and demise of painting, and compare it to how at the end of this world the Anti-Christ, with false miracles and strange deeds, will lead to perdition great numbers of people, who will be moved by seeing his works, apparently so admirable but actually deceiving, false, and transitory, to say that he is the true Christ. Thus this Anti-Michelangelo, with his showy and superficial imitation, his stunning manner, and liveliness, has been able to persuade such a great number and variety of people that his is good painting, and his method and doctrine the true ones, that they have turned their backs on the true way of achieving eternity, and of knowing the certainty and truth of this matter. . . . I do not consider it prudence but rather madness to attempt to achieve perfection by blind chance when I can with science and art avoid going off the path, thus earning praise and rewards because of my understanding, not my luck. For without them, not even a chance success can be called art. . . .

LIVES OF THE ARTISTS

Alonso Cano

It is difficult to learn about seventeenth-century Spanish painters from their contemporaries, because few of them chronicled the activities of the leading artists of the day. Scraps of information can be gathered from works of artistic theory such as those by Francisco Pacheco and Vincencio Carducho, but biographers are nearly nonexistent during this period. An exception is Lázaro Díaz del Valle (1606-1669), a chronicler and singer in the court of Madrid, who was also an art lover. His position at the court brought him into contact with many of the artists attached to it, especially Diego Velázquez, whom he knew personally and admired intensely. In fact Díaz del Valle dedicated to Velázquez his valuable but unsystematic book Epílogo y nomenclatura de algunos artífices . . . , *written in 1656 and 1659. The book, more accurately a series of rough notes, was never published, but it survived in manuscript to be used by succeeding generations of historians of Spanish art until it mysteriously disappeared during the last century. (Fortunately copies of it had been made.) Strange and sad to say, Díaz del Valle never wrote Velázquez's biography and thus lost a unique opportunity to convey first-hand information about the painter. But he does supply important information about several other major Spanish artists, including Alonso Cano (1601-1667).*

Díaz del Valle's account of Cano is among the least well organized of his essays. In part this is due to the wide range of Cano's artistic achievements, for he was outstanding as a painter, sculptor, architect, and draftsman. Díaz's solution to the problem of organizing Cano's activities is to move from one artistic medium to another, a reasonable procedure if only he had collected the biographical information in a single place instead of entering it whenever a work of art reminded him of a fact. But this is a minor flaw compared to the precious and reliable information he conveys about one of Spain's greatest artists. Subsequent research has added greatly to our knowledge of Cano, but Díaz del Valle's biography manages to convey, however haphazardly, a good idea of the essential Cano.[1]

From Díaz del Valle, *Epílogo y nomenclatura de algunos artífices*

This is the true portrait of that famous and incomparable artist, the licentiate [*licenciado*] Alonso Cano, painter, sculptor, and architect.

[1] From Lázaro Díaz del Valle, *Epílogo y nomenclatura de algunos artífices. . . .* Translated from edition by F. J. Sánchez Cantón, *Fuentes literarias para la historia del arte español,* II (Madrid, 1933), pp. 387-90.

This singular man was born of noble parents in the illustrious city of Granada in 1600 [1601]. His father was Miguel Cano, a native of Almódavar del Campo, a man possessed of property, virtue, and a talent for architecture in which he was a well-versed artist. His mother was named María de Almanso, a native of Villa Robledo in La Mancha. Among their several children they had Alonso Cano, who seems to have inherited his father's talent, for from childhood he was dedicated to the practice of his noble art under his father's tutelage and guidance. His father, recognizing his natural skill, instructed him in the essentials of architecture, so that in a short time he gave signs of what was to come. For he became such a superior architect that he lighted the way for today's architects and showed them how to beautify their work, as can be seen in the new churches that His Catholic Majesty has ordered to be built in this city of Madrid. As an architect he made the triumphal arch that the shopkeepers built at the Guadalajara Gate on the occasion of the entrance and magnificent reception of Her Serene Highness Mariana of Austria, the second wife of the King of Spain, Philip IV, a work of such originality in the use of architectural members and proportions that it stunned all the other architects by its departure from the antique manner.[2] He also executed the monument that the Discalced Franciscans place in their monastery of San Gil during Lent, when all the artists come to study it to their advantage.

About this time Cano tired of the world and desired to retire to a religious life in order to assure his salvation by finding peace of spirit. When the chapter of the Cathedral of Granada heard of this, they asked him to join it and petitioned His Majesty to do the favor of granting him a prebendary in that church. And the King, knowing his many and admirable skills, honored him with the position.[3] Cano, once in possession of the post, designed and supervised the famous Church of the Guardian Angel in the convent of the Discalced Franciscan Nuns, in which the originality and arrangement is to be admired both in the whole and in its parts.[4]

In the cathedral he made a lectern of wood, bronze, and jasper that, in the opinion of artists who have seen it, is exquisite, and it is the most highly esteemed in all Spain for its good and noble design. And at the same time two silver lamps were made by his order and design. They hang over the main altar and, by reason of their originality and their design, surpass any that have been seen to this day in Spain.[5]

[2] Mariana of Austria arrived in Madrid on November 15, 1649.

[3] Cano assumed a prebendary in the Cathedral of Granada in 1652.

[4] The church was built between 1653 and 1661 and destroyed in 1810 during the French invasion of Granada.

[5] The lectern and lamps, executed between 1652 and 1656, remain in the cathedral.

As for the art of painting, in which he surpasses all the great artists of the day, he learned the rudiments from his master Francisco Pacheco, a resident of Seville and a renowned painter, spending eight months in his shop. After leaving this master he returned to his home and undertook the study of proportion and the investigation of anatomy and the variety of movements that the human body makes when the muscles move, so that in a short time he had surpassed all the artists in the city of Seville. At the age of twenty-four, having acquired considerable fame by means of his native talent and hard work, he suddenly stopped work on the paintings he was executing for the cloister Nuestra Señora de las Mercedes, announcing that he knew that he lacked the knowledge of perspective necessary for finishing the job properly, and that he valued his reputation more than the money this work would bring. And so, putting aside the art of painting, he began to work on sculptured altarpieces. Among the works he did was one for the main church in Lebrija, where he designed the noble architecture of the altarpiece and carved three over-life-size figures himself, one of the Virgin with the Child in her arms, one of St. Peter and one of St. Paul.[6] So widespread was the fame of this work that sculptors came from Flanders to make small-scale copies to use as models for the full-size replicas they would make upon returning home.

Another sculpture that he made for the Cathedral of Granada was an image of the Virgin of the Immaculate Conception, a little more than a foot high, which was placed on top of the above-mentioned lectern. When the Chapter saw how greatly the public and artists alike admired it, they removed it from the lectern and installed it in the sacristy to display it as one of the great treasures of the cathedral.[7]

This divine artist was so highly regarded that he came to the attention of His Excellency the Count-Duke of Olivares, Don Gaspar de Guzmán (His Majesty's Prime Minister), who tried to engage his services so that he could serve as the Superintendent of the Royal Works. But Cano refused the post and demanded more money; then the Count ordered that he be given not only the amount he had requested but a great deal more. After this he had no excuse for not coming to the court, and he entered the King's service in 1638. Under his protection and care, and much to the satisfaction of His Excellency, he executed a number of works and also repaired canvases that were damaged by fires in the Palace of the Buen Retiro.

Around this same time he did the memorable canvas depicting the miracle of St. Isidro, patron saint of Madrid, that is in the main altar right above the image of Our Lord in the church of Santa María Mayor

[6] Executed between 1629 and 1631; in situ.

[7] The statuette is dated 1655-1656 and is still in the Sacristy, Granada Cathedral.

in Madrid.[8] So widely acclaimed was this picture that Fr. Juan Bautista Mayno, a Dominican monk who is the King's painting teacher, said that, in his opinion, this canvas was the most consummate work he had ever laid eyes on.

In a side altar in the parish church of Santiago in Madrid is a painting by his miraculous hand showing St. Francis at the moment when an angel appeared to him with a flask of water, to signify the purity and cleanliness demanded of the priests of the Church of Christ.[9] Anyone, no matter how insensitive he is, will recognize in this picture the surpassing excellence of the brushes of this sovereign artist.

He also did some stupendous pictures for the Cathedral of Granada as well as for other churches in that city and also for private individuals. These works will always command their deserved esteem in the centuries to come.

Some paintings by his hand were in the houses of famous painters of Madrid, who used to copy them. One of these is a half-length image of Our Lady with her Blessed Son in her arms that today hangs at the entrance of the Chapel of Nuestra Señora del Buen Consejo in the Imperial College of Madrid.[10]

In 1658, when he was fifty-eight years old, he was ordained a priest of God in Madrid. May God keep him so that his resplendent works may bring greater glory to the arts he professes. For I can say that even before I knew him or talked to him, I esteemed him as a child of his works.

And in the Jesuit Church, in a chapel on the Evangelary side, there is a life-size picture by his hand of Our Lady of the Immaculate Conception accompanied by angels and seraphim.[11] I recommend this picture to the curious viewer because it presents all the components of his art.

Ribera as an Expatriate Artist

There is no satisfactory early biography of the emigrant Spanish painter Jusepe de Ribera (1591-1652). Undoubtedly this is because he went to Italy while still a youth and, after visiting Rome and Northern Italy, settled permanently in the Spanish possession of Naples. Palomino, for example, recounts more fanciful anecdotes than usual when he speaks of Ribera, although he correctly records his birthplace as the town of Játiva in the province of Valencia. In addition, Palomino mentions the many pictures that Ribera sent back to Spain and thus opens a fascinating question—Ribera's relationship to his homeland.

8 1646-1648; Prado, Madrid.
9 Now lost.
10 Destroyed in 1936.
11 Destroyed in 1936.

It seems strange that the painter, who had an appreciative public in Spain, should not have chosen to return there. The answer to this enigma is provided by the one seventeenth-century Spanish author who gives Ribera more than a passing mention. This is the Aragonese painter Jusepe Martínez (Zaragoza 1602-1682). His book, Discursos practicables del noblísimo arte de la pintura, *written probably around 1675 but not published until 1866, is a combination of artistic pedagogy and biography, typical of the period. The former part is a repetition of academic precepts, the latter, a valuable source; and it is here that Martínez reported his interview in 1625 with Ribera, during which the painter explained his attitude toward his mother country. Ribera, in a word, trusted the adage, "Familiarity breeds contempt," and thus chose not to return.*

Martínez's account is also interesting for its report of Ribera's preferences among Italian artists. Nowhere does he mention Caravaggio, the usual point of comparison with his style. Rather it is Raphael who is singled out for praise among Roman painters. Whether Ribera actually said what Martínez puts between quotation marks may be questioned. But the statement will seem true to any who have looked beyond the superficial affinity to Caravaggio and seen the sober monumentality that contributes so much to Ribera's greatness as an artist.[1]

From Martínez, *Discursos practicables del noblísimo arte de la pintura*

Finding myself in Rome in the year 1625, desirous of returning to Spain but not wanting to go without seeing something of Italy, I set out for the famous city of Naples, the most opulent city in all of Italy because of its many princes and grandees; [a city] whose greatness has seen more majesty than many kingdoms even though it is only a viceregency. In this court I found a famous painter, a close imitator of nature and a fellow countryman from the kingdom of Valencia, from whom I received much courtesy.[2] He took me to see some rooms and galleries of the large palaces, which I enjoyed immensely. But since I had come from Rome everything seemed small, because in the city there are more things pertaining to the militia and cavalry than to the art of drawing. I said this to my countryman and he confessed that it was so.

During our many discussions I happened to ask him why, because he had an international reputation, he did not return to Spain, since he could be certain that his works were venerated there. He answered me thus: "My dear friend, I have a strong impulse to go, but judging

[1] Jusepe Martínez, *Discursos practicables del noblísimo arte de la pintura,* c. 1675. Translated from edition by V. Carderera y Solano (Madrid, 1866), pp. 33-35.

[2] Although Martínez does not mention him by name, it is clear that he speaks of Ribera.

from the experience of many well-informed and truthful persons I find this drawback. During the first year I would be received there as a great painter, but in the second year no one would pay attention to me, because when people know you are around they lose respect for you. This is confirmed because I have seen some works by excellent Spanish masters that were held in low esteem [in Spain]. Thus I judge Spain to be a loving mother to foreigners and a very cruel stepmother to her own sons.

"I find myself very well accepted and admired in this city, and my works are paid to my satisfaction. Thus I will continue to follow the old adage which is as true as it is commonplace: Leave well enough alone."

I was satisfied with this answer and realized that what he said was true. Then I asked him if he wanted to return to Rome to see again in the original the pictures that he had previously studied. He sighed a great sigh, saying, "Not only do I wish to see them again, but also to study them again. For these works need to be studied and meditated on over and over again. Even though we are now painting differently, anyone who does not take these works as a foundation will end in ruin, above all in history paintings which are the acme of perfection. The paintings of the immortal Raphael in the Vatican Palace teach us; he who studies these works will be a history painter tried and true."

With these statements I discovered that those who said that this great painter was boasting that no one, ancient or modern, had achieved his level of excellence in painting, were malicious people of low character. He himself said in answer [to this accusation] that it was outlandish. . . .

Palomino's Life of Velázquez

Antonio Palomino (1655-1726), a painter of modest talent, was blessed with boundless curiosity about the history of his art. Using Giorgio Vasari as a source of inspiration, Palomino undertook the task of reconstructing the lives and works of Spanish artists, famous and obscure, from 1500 to his day. The result, published in 1724 as the third part of his lengthy Museo pictórico y escala óptica *and entitled* Parnaso español pintoresco laureado, *is the starting point for all students of Spanish painting.*

As a biographer Palomino is uneven, although given the enority of the enterprise this is understandable. Neither was he a professional historian in our sense of the term, but simply an assiduous amateur. This circumstance led him to write as many misleading passages as revealing ones. When he was enthusiastic about a painter, his account became a veritable gold mine of information. Documents, earlier sources, and art works were eagerly sought out, and many still exist to testify to

his industry and to guide current investigations. He is also an extremely valuable source for the painters of Madrid after the death of Velázquez (1660), many of whom he knew upon his arrival there from Córdoba in 1678. Often, however, he was content to accept hearsay information without further checking its accuracy, or to pad an artist's life with anecdotes based on formulas that can be traced ultimately to Pliny's Natural History. *(Here Ribera's* Life *comes to mind.)*

Palomino's biographies generally are not very extensive. The exception is his Life of Diego Velázquez, *the painter he revered above all others. There were two reasons for his admiration: first, Palomino genuinely loved Velázquez's art. Second, and perhaps more important, he was dazzled by the painter's phenomenally successful career as a courtier. Velázquez was the most convincing proof of the nobility of the art of painting, a point Palomino and other Spaniards were always at pains to prove. So when he came to tell of Velázquez's art and life he marshalled his forces and produced a very informative biography. His resources included an extensive first-hand knowledge of Velázquez's production, and the reader with illustrations of it in hand will easily identify many works described in the following pages. In addition, Palomino made use of writings which have not survived to our day, notably a biography by the Cordobese painter, Juan de Alfaro.*

The account is not without Palomino's typical faults but it is a fine introduction to one of Spain's greatest painters. In the following translation I have minimized the irrelevant parts, pruning here and there, occasionally chopping out whole sections.

From Palomino, *El museo pictórico y escala óptica* [1]

I. THE BIRTH, PARENTAGE, NATIVE COUNTRY, AND
EDUCATION OF VELÁZQUEZ IN THE ART OF PAINTING

Diego de Silva y Velázquez was born in the year 1594 [sic: actually 1599] in the illustrious city of Seville. His parents were Juan Rodríguez de Silva and Geronima Velázquez, both natives of Seville, both endowed with virtue, quality, and nobility. Velázquez used his mother's last name, a misusage common in Andalusia that occasionally causes great difficulties in law suits. His paternal grandparents were from the kingdom of Portugal, members of the noble family of Silvius, made famous by Silvius Postumus, son of Aneas Silvius. According to an ancient tradition, they are descended from the kings of Albalonga. . . .

[1] Antonio Palomino de Castro, *El museo pictórico y escala óptica. Part III: El paranaso español pintoresco laureado* (Madrid, 1724). Translated from edition published by M. Aguilar (Madrid, 1947), pp. 891-936.

. . . From his earliest years Velázquez showed signs of his good nature and breeding, although he was not particularly wealthy. His parents raised him simply to be sure, but in a God-fearing manner. He applied himself to humanistic studies, surpassing many in his knowledge of languages and philosophy. He also showed a particular inclination toward painting, and although he was talented and quick-witted in all his studies, it was in this that he excelled. . . . His aptitude for it strongly impressed his parents, and they allowed him to follow his bent at the expense of his other studies, since either by nature or luck he already had a good grasp of them. Thus they handed him over to the tutelage of Francisco de Herrera the Elder, a stern and unpleasant man, but an impeccable painter and artist.[2]

After a short time he left this master and went to Francisco Pacheco, a very virtuous man who was also erudite and intelligent about painting. He wrote several books on this subject and composed very elegant poetry, which was acclaimed by all the writers of the day.

Pacheco's house was a gilded cage of art, the academy and school for the greatest minds of Seville. And thus Diego Velázquez lived contentedly, practicing incessantly his drawing, the basic element of painting and the main gate to art. . . . He liked to paint lively scenes of animals, birds, fish, and kitchen still lifes as well as lovely landscapes and figures, all perfect imitations of nature that brought him great fame and esteem. One of these should be specially mentioned, the one called *The Water Seller*.[3] This shows a very poorly dressed old man wearing a tattered smock through which his chest and bony ribs are showing. Next to him is a boy getting something to drink. So famous is this painting that it has been kept right up to our times in the Palace of the Buen Retiro.

He did another picture of two poor men eating at a humble table on which there are different kinds of earthenware jugs, oranges, a piece of bread, and other things, all meticulously observed. . . . Another painting similar to this one shows a counter being used as a table. On top of it is a round pot with boiling water covered by a small bowl. The light, flames, and sparks around it are vividly rendered. Next to it are a clay jar, some plates and a porridge bowl, a glazed jug, a brass mortar and pestle, and a garlic bulb. Hung on the wall behind you can see a wicker basket filled with rags and other odds and ends. Presiding over all of this is an amusing boy in peasant dress holding a jug in his hand and wearing a bandanna on his head. . . .[4]

[2] Velázquez's apprenticeship with the Sevillian painter Herrera the Elder (c. 1590-1656) has never been proven.

[3] Apsley House, The Wellington Museum, London.

[4] A painting in the Art Institute, Chicago, contains most, but not all of the details mentioned in this passage.

In these early works and in his excellent portraits, which capture the spirit as well as the appearance of the subjects, he discovered how to imitate real life perfectly and inspired others to follow his powerful example, as the case of Pacheco proves. He painted similar subjects in imitation of Velázquez.

Velázquez rivaled Caravaggio for boldness in painting and equalled Pacheco in matters philosophical. He admired the former's taste and his keen painterly instincts, and choose the latter for master because of his erudition and experience. He was also inspired by Italian paintings by Pomarancio, Baglione, Lanfranco, Ribera, Guido Reni, and others that had been brought to Seville. But what most excited him were the works of Luis Tristán, a painter of Toledo and disciple of El Greco, with whom he shared a lively imagination and a taste for the unusual.[5] For this reason he proclaimed himself a follower of Tristán and abandoned the example of his teacher Pacheco, whose manner, as Velázquez realized right from the start, was too bland and pretentious, however learned, to suit his temperament. Velázquez was called a second Caravaggio because he always had his eye on nature and imitated it so skillfully. For his portraits he imitated those of Dominico Greco, which, in Velázquez's opinion, could never be praised highly enough. And how right he was, for the portraits have none of the delirium of his last works. We can define El Greco's art by saying that what he did well none did better, and that what he did badly none did worse. . . .

Velázquez also read various theoreticians of art.[6] He read Albert Dürer on the proportion of the human body; Andrea Vesalius on anatomy; Giovanni Battista Porta on physiognomy; Daniele Barbaro on perspective; Euclid on geometry; Moya on arithmetic; Vitruvius, Vignola, and other authors on architecture. Like a bee, he carefully selected what suited his needs and would benefit posterity. On the nobility of painting he looked at the treatise of Romano Alberti, written at the suggestion of the Roman Academy and Brotherhood of St. Luke. He worked out his *idea della bellezza* with the help of Federico Zuccaro's and adorned it with the precepts of Giovanni Battista Armenini. And he learned how to execute these ideas with speed and economy from Michelangelo Biondo. Vasari inspired him with his *Lives of Famous Painters* and Borghini's *Il Riposo* described how to be a learned painter. He completed his education by reading the Bible and ancient classics and other important things, thus fertilizing his mind with erudition and wide knowledge of the arts. . . .

[5] C. 1586-1624; one of El Greco's principal pupils.

[6] At his death Velázquez possessed a fairly extensive library, including many of the books given below. The list has been published by F. J. Sánchez Cantón, "La librería de Velázquez," *Homenaje a Menéndez Pidal,* III (Madrid, 1925), 379-406.

His apprenticeship lasted five years and during them he improved his art steadily. He married, choosing as his wife Juana Pacheco, daughter of Francisco Pacheco, an official of the Inquisition and a member of a good family. . . .[7]

II. OF THE FIRST AND SECOND TRIPS VELÁZQUEZ MADE TO MADRID

In this way Velázquez passed his youth. . . . He finished his studies and decided to go to the royal court to demonstrate the quality of his talent and to improve his art by seeing the pictures in the Palace and other royal residences as well as those in churches and noblemen's houses. He also wanted to view the paintings in The Escorial, the eighth wonder of the world.

Velázquez left Seville accompanied only by a servant and set out for Madrid, the court of the kings of Spain and theatre for the greatest talents on earth. He arrived there in April, 1622, and was visited by many noblemen who had heard about his talent. . . . He was shown particular kindness by Juan de Fonseca y Figueroa, a court official and man of renown who was an amateur painter and an admirer of Velázquez's art. At the suggestion of his father-in-law, Francisco Pacheco, Velázquez did an admirable portrait of Luis de Góngora that was acclaimed by all the courtiers.[8] But although he tried, he could not arrange to paint the King and Queen and so he returned to Seville.

In 1623 he was summoned to Madrid by Juan de Fonseca (who gave him fifty ducats for travel expenses at the order of Gaspar de Guzmán, the Count of Olivares and Prime Minister to Philip IV) and offered lodging in his house where he was well cared for. He did Fonseca's portrait and that same night it was taken to the Palace by a son of the Count of Peñaranda. Inside of an hour it had been seen and praised by all the grandees and by the Infants Carlos and Fernando. But the King himself was the most enthusiastic of all, and he ordered Velázquez to do a portrait of his brother. But it was thought better to do the King first, even though there would be a delay because of state business. In effect, it was done on August 30, 1623, and His Majesty and the Infants and the Count-Duke of Olivares were all delighted with it. The latter affirmed that until then the King had never been properly portrayed, although Vincencio Carducho and his brother Bartolomé, Angelo Nardi, Eugenio Caxes, and Jusepe Leonardo had all tried. . . . The life-size painting represented the King in armor and mounted on a beautiful horse, meticulously done after life even to the landscape back-

[7] The marriage occurred in 1618.
[8] Museum of Fine Arts, Boston.

ground. . . .[9] The Count-Duke of Olivares was very pleased with his fellow Andalusian and promised him that henceforth he alone would be allowed to paint the King and that all the previous portraits would be taken out of circulation. . . .

He ordered Velázquez to move his household to Madrid and made him the King's painter on October 31, 1623, with a salary of twenty ducats a month, exclusive of payments for individual paintings, plus a medical and living allowance. . . .

Also on this occasion His Majesty ordered that Velázquez be given a grant of 300 ducats and a pension of another 300, subject to a dispensation from Pope Urban VIII. And in 1626 he extended the privilege of a royal apartment, which is worth 200 ducats a year.

One day the King wanted a painting of the expulsion of the Moors by Philip III. . . . Velázquez painted this episode in competition with three other royal painters; Eugenio Caxes, Vincencio Carducho, and Angelo Nardi. Velázquez's painting surpassed all the others in the judgment of a jury named for the purpose (consisting of Fray Juan Bautista Mayno and Giovanni Battista Crescenzi) and was selected to hang in the main salon where it is to this day. . . .[10]

. . . In 1627 the King granted Velázquez the position of Usher of the King's Chamber with all its perquisites, a very honorable office. . . .

In this same year Peter Paul Rubens (that monstrously talented, skilled, and fortunate man) came to Spain as the Ambassador Extraordinary of the King of England in order to arrange peace with Spain . . .[11] As Pacheco says, he had very little to do with the local painters, but he struck up a close friendship with Velázquez, with whom he had previously corresponded, and praised his works. Together they went to The Escorial to see the famous monastery of San Lorenzo. They took great delight in admiring its points of interest and especially the paintings by Europe's greatest masters. These stimulated Velázquez's long-standing desire to go to Italy to see, contemplate and study those eminent paintings and statues that are the flaming torch of art and worthy to be imitated.

III. OF THE FIRST TRIP THAT VELÁZQUEZ MADE TO ITALY

To realize the great desire Velázquez had to see Italy and all of its artistic treasures, the King fulfilled an oft-repeated promise and gave

[9] Whereabouts unknown.

[10] Whereabouts unknown. The triumph of Velázquez in this competition over his rivals marks the completion of his ascendancy at the court.

[11] Rubens actually arrived in Madrid in August, 1628.

Velázquez permission to make the trip as well as 400 silver ducats and two years' salary. The Count-Duke also gave him another 200 gold ducats, a medal with the King's portrait, and many letters of introduction. He left Madrid in the company of Alonso Spinola, Captain General of the Spanish Army in Flanders. They embarked from Barcelona in August on the day of St. Lawrence, 1629.[12]

His first stop was Venice . . . where he stayed in the house of the Spanish ambassador, who received him with honors and invited him to his table. And because of the wars then going on, the ambassador gave Velázquez bodyguards when he went out into the city. They took him to St. Mark's and to the Doge's Palace, where all the rooms are adorned by the pictures of Tintoretto, Veronese, and other great artists. But what most impressed him was the Great Council Hall, which they say can accommodate 12,000 people. In this room is the famous picture of *The Heavenly Glory* painted by Tintoretto with such harmony . . . that one could say that his execution equalled his conception. . . . He also saw a large room painted by Titian with scenes from the wars of Chiaradadda. . . .[13]

During the time he was there he made many drawings after the paintings he saw, particularly Tintoretto's *Crucifixion,* an admirable invention full of figures that has also been engraved. He also made a copy of Tintoretto's *Christ Preaching to His Disciples,* which he brought back to Spain.

He fell in love with Venice, but because of the uncertain situation there (caused by the wars then going on), he decided to go to Rome. From Venice he went to Ferrara where he was received by Cardinal Giulio Sachetti, the Papal Governor. . . . The Cardinal insisted that he stay in his house during the visit and eat with him. . . . Velázquez was there two days and studied briefly but attentively the works of Garofolo. On his last night, he went to bid farewell to His Eminence, who kept him in conversation for more than three hours, speaking of one thing and another. He ordered that horses be provided the next day for his trip and that an escort take him as far as Cento, sixteen miles away. He stopped briefly in Cento [14] and, thanking his escort, followed the road to Rome by way of Loreto and Bologna, where he did not stop. . . .

He finally arrived in Rome, where he was to spend a year, enjoying the favor of Cardinal Francesco Barberini, the nephew of Pope Urban

[12] Spinola's first name was Ambrogio. He sailed with Velázquez on August 10.

[13] Palomino refers to the painting now known as the *Battle of Cadore*. It was destroyed by fire in 1527, and hence was never seen by Velázquez.

[14] Did Velázquez stop in Cento to visit with Guercino, who was living there at this time?

VIII, at whose orders he was lodged in the Vatican Palace. They gave him the keys to several living rooms, the main one of which was decorated with frescoes by Federico Zuccaro showing scenes from the Bible. However, he soon gave up these rooms because they were too isolated and he did not want to be alone. Instead he arranged for the Guards to let him enter the Palace whenever he felt like it, to draw after works by Raphael and Michelangelo's *Last Judgment*. . . . Velázquez spent many profitable days making drawings, some in color, others in pencil, of *The Last Judgment,* the Prophets and Sibyls of the Sistine Ceiling and of *The Martyrdom of St. Peter* and *The Conversion of St. Paul.* He also made drawings of the excellent paintings by Raphael in the Stanza della Segnatura. . . .

When he saw the Medici Palace near the Monastery on Trinità del Monte, he decided it would be a pleasant place to study during the summer because of its high location and excellent collection of ancient statues. He was there for more than two months, until a fever made it necessary for him to move to the house of the Count of Monte-Rey (Spanish Ambassador to Rome). During his sickness the Count was very kind to him, sending a doctor and medicines at his own expense until he was cured of his sickness. . . .

While he was in Rome Velázquez painted that famous picture of the brothers of Joseph who, out of envy, sold him to some Ishmaelite merchants and brought his clothing, stained with lamb's blood, to his father Jacob, who believed the boy had been killed by a wild animal.[15] No less famous is the other painting he did at the same time, the fable of Vulcan at the moment when Apollo brought him the news of Venus's adultery with Mars.[16] Here Vulcan has turned so white with alarm that he looks as if he has stopped breathing. Velázquez brought these two pictures back to Spain and offered them to His Majesty, who received them with deserved praise and ordered them to be hung in the Palace of the Buen Retiro. Later on the painting of Joseph was moved to The Escorial and is now in the chapter room there.

Velázquez decided to return to Spain since the King was in need of his services. On the way back he stopped in Naples where he painted a lovely portrait (to bring back to the King) of the Infanta María of Austria, Queen of Hungary. . . .[17] Velázquez returned to Madrid after an absence of a year and a half, arriving around the beginning of the year 1631. He was warmly received by the Count-Duke. Then he went to pay his respects to the King and to thank him for allowing no other

15 The Escorial.
16 Prado, Madrid.
17 María of Austria, sister of Philip IV, was then on her way to marry Ferdinand III of Hungary. The portrait is now in the Prado, Madrid.

painter to portray him and for waiting for him to do the portrait of the Prince Balthasar Carlos, which he then immediately did.[18]

It is impossible to imagine the warmth and openness with which Velázquez was received by such a great monarch. He ordered that a studio in the palace be given him in the North Gallery. His Majesty had a key to this room and used to come and sit there for a while to watch Velázquez paint, much as Alexander the Great often visited Apelles in his workshop, according to Pliny. . . . In addition, His Majesty honored Velázquez with the office of Gentleman of the King's Wardrobe, one of the most esteemed positions in the royal household. He also awarded him the Key to the King's Chamber, something that many knights desired. And continuing his rise, he ultimately obtained the position of the Gentleman of the Bedchamber, although he did not assume these duties until 1643.

Of the outstanding portraits he executed at this time, the best would be that of the Duke of Modena, who was at the court in 1638. . . .[19] The Duke bestowed many honors on Velázquez, including a very lavish gold chain that Velázquez used to wear on festive occasions at the Palace.

At this time Velázquez also did a famous painting of a dead Christ on the Cross, life size, that is in the cloister of the convent of San Plácido in Madrid.[20] There is a very close copy of it in the church of La Buena-Dicha in the first altar on the right as you enter the church. Both have two nails in the feet, which are placed on the supedaneum, following the opinion of his father-in-law [Pacheco] that four nails were used to crucify Christ.

In 1639 he did the portrait of Adriano Pulido Pareja, . . . Captain General of the Spanish American Fleet. . . . The portrait was done from life and is one of the most famous painted by Velázquez.[21] He even signed his name to it, something he rarely did. As he did on occasion, he used long-handled brushes, which enabled him to paint at a distance from the canvas. Thus, when you look at it up close it is hard to see what is going on, but from a distance it is a miracle. The signature reads as follows:

Didacus Velázquez fecit, Philip IV a cubiculo, eiusque Pictor, anno 1639 . . .[22]

Today this handsome portrait is owned by the Duke of Arcos.

[18] Balthasar Carlos was born on December 17, 1629. The portrait is identifiable as *Prince Balthasar Carlos with a Dwarf*, Museum of Fine Arts, Boston.

[19] The portrait of Francesco II d'Este is in the Pinacoteca, Modena.

[20] Prado, Madrid.

[21] Whereabouts of original unknown. A copy attributed to Velázquez's pupil and son-in-law, Juan Bautista del Mazo, is in the National Gallery, London.

[22] Painted by Diego Velázquez, Chamberlain and Painter to Philip IV, in the year 1639.

IV. How Velázquez Served His Majesty on the Military Expedition to Aragón

In 1642, Velázquez served His Majesty on the military campaign in Aragón to put down the rebellion in Catalonia. He returned to the court on Saturday, December 6.

In 1643, the King dismissed the Count-Duke of Olivares and ordered him to retire to Toro, forbidden to leave without the King's express permission. He died there on July 22, 1645, and was buried in the convent of the Discalced Carmelites in Loeches. Velázquez openly regretted this because the Count-Duke had, as it were, made him what he was and given him special honors. But in spite of this the King still continued to favor him as before.

Thus, in 1644 he was again ordered to attend the King on his return to Aragón where he was going to encourage his troops then engaged in the War of Catalonia. Velázquez was in Saragossa and Fraga with the King. . . . In Lérida, Velázquez painted a dashing portrait of His Majesty (life size, which was to be sent to Madrid) as he looked upon entering Lérida. Holding a marshal's baton and dressed in a plush red uniform and showing such a graceful air and majesty, it looks like Philip himself in the flesh. . . .[23]

Velázquez also painted two other portraits from life, one of Philip IV and another of his brother the Cardinal-Infant Fernando de Austria, both dressed in hunting costume, guns in hand, with a dog on a leash resting alongside. . . . These two paintings are in the Torre de la Parada, a place where the kings take their recreation. . . .[24]

He also portrayed admirably the Queen of Spain, Isabel of Bourbon, richly attired and seated on a beautiful white horse, the color of a swan.[25] It is of life size and hangs, together with a portrait of the King, in the Gold Room of the Palace of the Buen Retiro, flanking the main entrance. . . . Above this picture is another one with the portrait of the Prince Balthasar Carlos as a small boy, in armor and mounted on a horse with a general's baton in his hand. . . .[26]

He painted another portrait of the Prince being given riding lessons by his riding master Gaspar de Guzmán, Count-Duke of [Olivares and] Sanlúcar. This picture is now in the possession of his cousin, the Marquis of Liche. . . .[27]

Velázquez also painted another portrait of his great protector and

23 Frick Collection, New York.
24 Both are in the Prado, Madrid.
25 Prado, Madrid.
26 Prado, Madrid.
27 Whereabouts unknown.

Maecenas, the Count-Duke of Olivares, mounted on a spirited Andalusian horse. . . . The Count is wearing embossed gold armor and a hat with showy feathers, and has a general's baton in his hand. In the distant background can be seen the clash of two armies, in which the fury of the horses and the bravery of the fighters is to be admired. It is almost as if you were in the midst of the dust and smoke, hearing the clamor and shrinking before the carnage. This picture is life size, one of the largest paintings Velázquez ever did. . . .[28]

Another portrait that Velázquez did is of Francisco de Quevedo Villegas, a knight of the Order of Santiago, whose extraordinary genius can be seen in his published works where he shows himself to be the Martial of Spanish poetry and a second Lucan of Spanish prose. . . . [Velázquez] painted him with his glasses on since he usually wore them. . . .[29]

Velázquez also did a portrait of His Excellency Gaspar de Borja y Velasco, Cardinal of the Holy Church and Archbishop of Seville and Toledo. This portrait is now in the palace of the Duke of Gandía. . . .[30]

. . . On several different occasions he painted self-portraits, of which the most noteworthy is in the painting of the Empress, to be mentioned below.[31] At this time he also painted a large history painting of the capture of a fortified town by Ambrogio Spinola. It was done for the theater in the Palace of the Buen Retiro.[32] And [he also painted] a picture of the Coronation of the Virgin that was in the Queen's oratory,[33] as well as many portraits of famous people that are hung along the stairway that leads to the Gardens of the Realms in the Retiro Park where their Majesties enter their coaches.

V. On the Second Trip to Italy Made by Diego Velázquez at the King's Orders

In 1648, Diego Velázquez was sent by His Majesty to Italy as an ambassador extraordinary to Pope Innocent X in order to purchase original paintings and ancient statuary. . . .

Velázquez left Madrid around November of 1648. He embarked from Málaga with Jaime Manuel de Cardenas, Duke of Nájera, who

[28] Prado, Madrid.

[29] Whereabouts of original unknown. Copies are in Apsley House, The Wellington Museum, London and the Instituto de Valencia de Don Juan, Madrid.

[30] Probably identical with the picture in the collection of Ralph Bankes, Kingston Lacy, Dorset.

[31] That is, *Las Meninas*, Prado. See below, pp. 193-94.

[32] *The Surrender of Breda*, Prado.

[33] Prado, Madrid.

was going to Trent to meet the Queen María of Austria, daughter of Emperor Ferdinand III, and the Empress María.

They disembarked at Genoa . . . and Velázquez went on to Milan, where he did not fail to see some of the excellent sculpture and painting in the city, like the marvelous supper of Christ and His Apostles, a work of the hand of Leonardo da Vinci. . . .

Then he went to Padua and from there to Venice, which he was very fond of because so many great artists had worked there. He saw many works of Titian, Tintoretto, and Veronese, who were the artists that he had tried to follow and imitate since 1629, when he was first in Venice. There he found occasion to buy a painted ceiling with stories of the Old Testament by Jacopo Tintoretto. The most important of the paintings is oval shaped and shows the children of Israel gathering the manna.[34] Another picture he bought shows the conversion of St. Paul and another, *The Heavenly Glory,* also by Tintoretto, full of figures but harmoniously composed. It is probably a sketch for a larger work that is in Venice. . . .[35] He also bought a Venus and Adonis embracing with a little Cupid at their feet by Paolo Veronese, and some portraits. . . .[36]

He then set out for Bologna to see the singular painting of St. Cecilia with four other saints that is at San Giovanni del Monte, painted by Raphael of Urbino.[37] He also saw *St. Petronius,* a marble by Michelangelo and, over the door of the church, the bronze portrait of Pope Julius II.[38] In Bologna he sought out Michele Colonna and Agostino Mitelli, fresco painters by whom there are many works in Italy that attest to their excellence, in order to try to convince them to come to Spain.[39]

Next he went to Florence, where he found much to admire. . . . And having seen the best work of the city he went to Modena, where he was warmly treated by the Duke. He showed him his palace with all the interesting and fine things that it had, among them the portrait that Diego Velázquez had painted of the Duke when he was in Madrid. . . .

He went on to Parma to see the cupola of Antonio Correggio and the paintings of Parmigianino. . . . From there he departed for Rome

34 Prado, Madrid. The subject is actually the purification of the Virgins of Midian.

35 Prado, Madrid.

36 Prado, Madrid.

37 Pinacoteca Nazionale, Bologna.

38 San Petronio, Bologna.

39 Colonna (1600-1687) and Mitelli (1609-1660) did not answer Velázquez's call until 1658, when they arrived in Madrid. Their frescoes greatly influenced the painters of Madrid during the second half of the century.

where, upon arriving, he had to go to Naples to see the Count of Oñate, the viceroy of the kingdom at that time. . . . He visited Jusepe de Ribera, called *il Spagnoletto* in Italy, whose works in Naples bring credit to the Spanish nation.

He returned to Rome where he received the favor of Cardinal Astalli Pamphili, nephew of Pope Innocent X, and of Cardinal Antonio Barberini, Prince Ludovisi, and of Monsignor Camillo Massimi. He also met the most excellent painters of the time, such as Mattia Preti, Pietro da Cortona, Nicolas Poussin and Cavaliere Alessandro Algardi and Cavaliere Gian Lorenzo Bernini, both very famous sculptors.

Without neglecting his business, he did many paintings, chief of which was the portrait of His Holiness Innocent X, who bestowed upon him many very great and outstanding signs of favor. In payment of the portrait, the Holy Father sent him a gold medal and chain with the image of His Holiness on it. Velázquez brought back with him a copy of this portrait. . . .[40]

He also did portraits of Cardinal Pamphili; Donna Olimpia; Monsignor Camillo Massimi; Monsignor Abbot Hippolito, chamberlain of the Pope; of the Pope's majordomo [Cristoforo Segni]; and of Michelangelo, the Pope's barber; of Fernando Brandano, the head of the Pope's secretariat; Gerolamo Bibaldo and of Flaminia Triunfi, an excellent woman painter. . . .[41]

When he had been commissioned to paint the Pope, he wanted to prepare himself beforehand with an exercise of painting a head from life. So he did that of Juan de Pareja, his slave and a good painter in his own right. After it was finished it was suggested by Andries Smidt . . . that the painting be displayed in the Pantheon where pictures old and new were customarily hung on the day of St. Joseph.[42] This was done and the painting was universally admired. All the painters, regardless of nationality, agreed that, whereas all the other works looked like paintings, this one alone looked like Truth. Because of this, Velázquez was granted membership in the Roman Academy in 1650.[43]

Finally, because of the pressure of the King's frequent demands that he come back, Velázquez decided to return to Spain. . . .[44] He

[40] The original is in the Doria-Pamphili Gallery, Rome.

[41] Only three of these portraits have been identified: *Cardinal Pamphili* is in the Hispanic Society of America, New York; *Camillo Massimi* is in the Ralph Bankes Collection, Kingston Lacy, Dorset; and *Michelangelo, the Pope's Barber,* is in a private collection, New York.

[42] March 19, 1650. Andries Smidt was a Flemish painter who worked in Rome and Madrid. The portrait is now in the collection of the Earl of Radnor, Langford Castle, Wilts.

[43] Palomino's chronology is confused; Velázquez was admitted to the Academy of St. Luke in January, 1650.

[44] Palomino's long list of copies of ancient statuary acquired by Velázquez in Rome has been omitted.

embarked from Genoa in 1651, punctually obeying as always the orders of His Majesty. Although the passage was a stormy one, he arrived in Barcelona in the month of June. He went to Madrid and paid homage to the King, who honored him. . . .

VI. Philip IV Appoints Velázquez as Chamberlain of the Palace

In 1651, His Majesty bestowed upon Diego Velázquez the honor of Chamberlain of his imperial palace. He succeeded Pedro de Torres in this office and remained in it until 1660, when he died, exercising it to the complete satisfaction and pleasure of His Majesty. . . .

VII. A Description of Diego Velázquez's Most Illustrious Work [45]

Among the marvelous pictures done by Velázquez was a large canvas with the portrait of the Empress (then the Infanta of Spain), Margarita María of Austria, as a young child. . . . Kneeling at her feet is María Agustina, maid of honor of the Queen, giving her water in a small vessel. On the other side is Isabel de Velasco, also a maid of honor, who seems to be speaking. In the foreground is a dog lying down and next to it Nicolas Pertusato, a dwarf, who is stepping on it to show that it is a gentle animal in spite of its ferocious appearance. These two figures are in shadow and impart great harmony to the composition. Behind is Mari-Bárbola, a formidable-looking dwarf, and slightly farther back and in darker colors are Marcela de Ulloa, attendant to the ladies-in-waiting, and a bodyguard. On the other side is Diego Velázquez painting; he holds the palette in his left hand and a brush in his right. Around his waist he wears the key to the King's Chamber and on his breast, the Cross of the Order of Santiago that was added at His Majesty's orders after Velázquez died, because Velázquez was not a member of this Order when the picture was painted. . . .

The canvas on which he is painting is large, and nothing of what he paints can be seen because only the back part is visible.

Velázquez proved his great genius because of the clever way in which he reveals the subject of what he is painting. He makes use of the mirror at the rear of the gallery to show us the reflection of our Catholic kings, Philip and Mariana. In this gallery, which is called the Room of the Prince, where he used to paint, several pictures are seen indistinctly on the walls. These are known to be by Rubens and represent stories

[45] *Las Meninas*, Prado, Madrid. Palomino's identifications of the persons in the picture are accurate. Cf. F. J. Sánchez Cantón, *Las Meninas y sus personajes*, 2nd ed. (Barcelona, 1952).

from Ovid's *Metamorphoses*.[46] This gallery has several windows that are shown in perspective to make the room seem large. The light comes from the [picture's] left but enters only through the front and rear windows. . . . To the left of the mirror is an open door where stands Joseph Nieto, the Queen's Marshal. He can be clearly seen in spite of the distance and poor light. Between the figures there is atmosphere. The figure painting is superior, the conception new, and in short it is impossible to overrate this painting because it is truth, not painting. Velázquez finished it in 1656. . . .

The painting was highly esteemed by His Majesty and he frequently went to look at it. It was placed in the King's lower suite, in the office, along with other excellent works. In our own day, Luca Giordano was asked by Charles the Second what he thought of it and he answered, "Sir, this is the theology of Painting."

[Chapters 8 and 9, which deal with decorative commissions Velázquez supervised but did not execute, are here omitted.]

X. VELÁZQUEZ ATTENDS THE FRENCH AMBASSADOR
WHO CAME TO ARRANGE THE MARRIAGE OF THE
INFANTA MARÍA TERESA OF AUSTRIA. SOME PORTRAITS
HE EXECUTED AT THIS TIME. . . .

In 1659, Velázquez executed at the King's orders two portraits that were to be sent to the German emperor. One was of the Prince of Asturias, Felipe Próspero, who was born on November 28, 1651 at eleven thirty in the morning. . . .[47] He painted him standing up, wearing, as his age required, child's clothing. Next to him there is a white plumed cap resting on a stool. On the other side is a crimson chair on which he lightly rests his arm. In the upper part of the picture is a curtain, while in the distant part of the room is an open door. . . . A little dog is seated on the chair. . . . This is a portrait that Velázquez himself liked very much. . . .

The other portrait was of the Infanta Margarita María of Austria, painted with the majesty and beauty of her person. Her right hand rests on an ebony clock with figures and animals in bronze, which is on a small sideboard.[48] There is a circle in the middle of the clock with the chariot of the sun. And also in the circle is a small clock face. . . .

Velázquez seldom painted after these portraits were finished. Thus

[46] The two pictures have been identified as copies of *Pallas and Arachne* by Rubens and *Apollo and Marsyas* by Jacob Jordaens.
[47] Kunsthistorisches Museum, Vienna. The Prince was born on November 20.
[48] Kunsthistorisches Museum, Vienna.

we can call these portraits his last works and last in the perfection of his famous hand that raised him to such high repute.

XI. His Majesty Bestows on Velázquez a Most Singular Honor as a Reward for His Virtue and Service

In 1658, when Velázquez was with the King at The Escorial, His Majesty, considering his talent, ability, and personal merit, honored him with his choice of one of the three military orders. Velázquez chose the Order of Santiago. And if he had not died shortly thereafter, he would have risen to higher honors. . . .

XII. Velázquez Travels With His Majesty to Irún, Becomes Sick, and Dies

In March 1660, Velázquez left Madrid to arrange the lodgings for the trip to Irún of Philip IV and the Infanta María Teresa of Austria. Velázquez departed a few days before His Majesty. . . . They followed him to Fuenterrabía, where Velázquez had arranged the King's stay in the castle that had been prepared by the Baron of Batebilla, the Governor of San Sebastián. Velázquez was also in charge of the construction of the Conference House that was built on the Isle of Pheasants in the Bidasoa River near Irún.

He returned to Fuenterrabía with the King during the first days of June and attended all the functions pertaining to the arrangement of the marriage of the Infanta to the King of France, Louis XIV, held by the King in the Meeting Room of the Conference House. . . .

On Tuesday, June 8, the King left Fuenterrabía for Madrid with Velázquez in his company. . . .

When Velázquez returned home he was greeted by his family and friends with more surprise than happiness because rumors of his death had been circulating through the Court. But it seems that this presaged his imminent death.

On Saturday, July 31, Velázquez felt fatigued after having spent all-morning attending His Majesty, and he was obliged to return home. He soon began to suffer tremendous pains in his stomach and heart. He was visited by Dr. Vicencio Moles, the doctor of the royal family. Then the King, anxious about his health, sent Drs. Miguel de Alba and Pedro de Chávarri, physicians to His Majesty. Recognizing the symptoms, they said it was the beginning of tertian fever and that his unquenchable thirst was a sure sign of the manifest danger of this mortal disease. On the King's orders, he was visited by Alfonso Pérez de Guzmán, Patriarch of the Indies, who tried to console his spirit. And on Friday, August 6,

1660, at two in the afternoon, having received the Holy Sacraments and made his will, he gave up his soul at the age of 66 [sic: 61]. All mourned him, and not the least His Majesty, who at the end gave Velázquez to understand how much he loved and esteemed him.

Palomino's Life of Zurbarán

The brevity of Palomino's Life of Francisco de Zurbarán *(1598-1664) is one indication of the decline of Zurbarán's fame, which began in his later years and continued until the rediscovery of his art in this century. In his early and middle years, however, Zurbarán enjoyed great renown and success. In 1629, he was honored by an official invitation from the Town Council of Seville to resume residence in the city of his apprenticeship. Zurbarán accepted, and during the next twenty years he filled churches and monasteries in southern Spain with the impressive picture cycles by which we know him best. His participation in 1634 in the decoration of the Hall of Realms in the Buen Retiro Palace, Madrid, brought him recognition from the King, although the ten pictures of the Labors of Hercules are not among his best work. However, by the 1640's Zurbarán's production had begun to decline in quantity and change in quality. A shift in taste had rendered his stern, unflinching style too strong for an audience that now favored the mellower art of Murillo. The last years of his life, 1658-1664, were spent in Madrid, where he stood less chance of success than in Seville. The international Baroque style then in favor clearly was no place for this most Spanish of painters. The total eclipse that followed his death is epitomized by Palomino's remark that his paintings around Madrid "are not recognized as his work."* [1]

From Palomino, *El museo pictórico y escala óptica*

Francisco de Zurbarán, a native of the town of Fuente de Cantos and resident of the city of Seville, began his study of art in Estremadura with some disciple of the divine Morales.[2] Afterwards, in order to perfect his art, he went to Seville to the school of Juan de las Roelas and did so well that he earned the reputation of an excellent painter by means of the many works he did.[3] Particularly noteworthy are those by his hand in the small cloister of the Merced Calzada in said city, which

[1] Antonio Palomino de Castro, *El museo pictórico y escala óptica.* Part III: *El parnaso español pintoresco laureado,* Madrid, 1724. Translated from edition published by M. Aguilar (Madrid, 1947), pp. 937-38.

[2] Luis de Morales, called *el Divino* (c. 1520/25-1586) was an important Spanish painter of the sixteenth century.

[3] Zurbarán's artistic training is obscure. He was an apprentice in Seville of a very minor painter called Pedro Díaz de Villanueva, none of whose works are known.

show the story of St. Peter Nolasco, a famous work and excellent by any standard.[4] In this work, it is amazing to see the monks' habits, which, even though they all are white, are still different from each other by virtue of the tone in which they are painted, [and painted] with such admirable correctness in design, color, and texture that they outdo Nature herself. This is because this artist was so studious that he used mannequins when he painted drapery and a live model for the flesh tones, following the school of Caravaggio, a painter whom he liked so much that someone seeing his works, and not knowing whose they are, will not hesitate to attribute them to Caravaggio. In Seville there is a painting, nicknamed "The Painting of the Dog," in which he has painted a dog so lifelike that anyone looking at it fears its momentary attack. Also there is a figure of a young boy with sleeves of a certain kind of silver cloth, painted so that the material is immediately identifiable. A collector in Seville has a painting of a lamb by the hand of this artist, which he says he values more than a hundred live ones.[5]

Also by his hand are the paintings in the cloister of the Mercedarios Descalzos,[6] and those of the altarpiece in the monastery in Villa-García,[7] and the painting of the Magdalene in the church at Pallares dedicated to that saint,[8] and in the sacristy of the monastery of San Pablo, Seville.[9] Besides his many other pictures [in the monastery] there is a Crucifixion by his hand that can be seen only through the grillwork screen of the chapel. The chapel itself is poorly lit, so that all who see it and do not know it is a painting believe it to be a work of sculpture. The paintings in the Church of the Mercedarios Descalzos in Seville,[10] and in the college of San Bonaventura are also by his hand.[11] He also painted an altarpiece in the college of San Alberto in competition with Alonso Cano

[4] This series of twenty-two pictures was painted in 1628-1630.

[5] A picture of this subject signed and dated 1632 is in the Planidura Collection, Barcelona.

[6] The paintings in the cloister of this monastery, a striking series of martyred saints of the Order, were done in 1636 by Zurbarán and his atelier. Seventeen survive, dispersed among several collections.

[7] Now lost.

[8] Perhaps identifiable with a picture of this subject in the Museo de la Academia de Bellas Artes, Mexico City.

[9] Zurbarán's work for the Dominican monastery of San Pablo, 1626-1627, included fourteen scenes from the life of St. Dominick, portraits of Seven Doctors of the Church and a Crucifixion (now in the Art Institute, Chicago). The Crucifixion is the picture mentioned immediately below.

[10] Zurbarán also did extensive painting for the church of this monastery, the same one referred to in note 6. Over a period of years he completed five altarpieces for the church.

[11] The cycle of eight paintings of the life of St. Bonaventure was a collaborative work with Francisco de Herrera the Elder. Zurbarán's four pictures were done in 1629 and include *St. Bonaventure at the Council of Lyon* and *St. Bonaventure on his Death Bed*, Louvre, Paris; *St. Bonaventure and the Angel*, and *St. Bonaventure Visited by St. Thomas Aquinas*, formerly Kaiser Friedrich Museum, Berlin.

and Pacheco.[12] And in the cathedral he also did the pictures in the chapel of St. Peter.[13] Finally, he left so many pictures in Seville, and indeed throughout all of Andalusia, that they seem beyond counting. In the college of San Pablo in Córdoba, there are many half-length saints of the Order of Predicadores, superior work all, especially those beneath the main staircase.[14]

It is a well-known story that when he returned to live in Fuente de Cantos, his birthplace, the city of Seville sent a delegation to him, asking him if he would deign to come to live in Seville to honor it with his presence and eminent skill. Since there were at that time other famous painters in the city he agreed to go, as was befitting such an honor. It is certain that besides his talent he was a highly recommendable person because of his appearance, dress, and natural endowments. And they even say that they offered him a house. . . .

Finally he came to Madrid around the year 1650, called by Veláz-quez at the King's orders, where he executed the paintings of the Labors of Hercules that are in the salon in the Palace of the Buen Retiro over the large pictures.[15] And they say that when he was painting them, Philip IV, on one of the many occasions he came to watch him work, approached him one time and, putting his hand on his shoulder, said to him, "Painter of the King and King of Painters." He did many pictures for the Casa del Campo and other royal buildings, as well as for private individuals and various churches, where they are not recognized as his work. For example, in the church of Peñaranda I saw one of his pictures of the Incarnation that no one knew was his. It is held for certain that he died in Madrid in 1662 [sic: 1664] at sixty-six years of age, with esteem not only for his artistry but also for his virtue, both in Seville and in this court.

Palomino's Life of Murillo

Palomino's interest in Andalusia's favorite painter, Bartolome Esté-ban Murillo (1617-1682), stemmed from the days he spent in that region as a youth. Palomino was about twenty-five years old when Murillo died, and even though they never made acquaintance, Palomino tells us that he knew friends of the painter. Consequently his biography of Murillo is one of his steadiest performances and an excellent source of information. But, as often happens in Palomino, certain facts and dates

12 Several important painters of Seville, including the two mentioned above, worked for the Carmelite Church of San Alberto. The extent of Zurbarán's contribution is not clear.

13 This altarpiece, still *in situ*, was done c. 1630-1635.

14 All of these pictures but three now in the Museo Provincial, Córdoba, are lost.

15 This trip to Madrid and the execution of the Hercules cycle occurred in 1634. The paintings are in the Prado, Madrid.

have proved unreliable, notably the account of Murillo's trip to Madrid as a young man, which did not occur until 1658 when the painter was forty years old (Palomino is four years too early with Murillo's birthdate). It would be, in short, a typical performance by the painter-biographer were it not for an unwonted departure from biography into the realm of theory when he speaks of Murillo's international fame.

Even at this early date (1724), Murillo's art had begun to command the public attention that soon made his works much sought after, especially by French and English connoisseurs. Palomino was disturbed by the success of an artist whom he did not classify among the great, and explained it by noting Murillo's dependence on color rather than on draftsmanship. To his academic mind, the inferiority of color gave its users a wide public appeal denied to the sterner practitioners of line. Ironically, today Palomino's negative judgment is shared by many who dismiss Murillo's art as weak and sentimental. But those who are willing to look at his works with unprejudiced eyes will discover a subtle and accomplished master of man's tenderer emotions.[1]

From Palomino, *El museo pictórico y escala óptica*

Bartolome Estéban Murillo came from the town of Pilas, some five leagues from Seville, and from a very illustrious family, well known in that region. He was born in the year 1613, and in time went to Seville to study the art of painting, which he did in the school of Juan del Castillo (his uncle and a native of Seville).[2] After having learned enough to support himself by painting in the marketplace (which was a prevalent practice in those days), he painted a parcel of pictures for shipment to the Indies. Having thus acquired some money he went to Madrid, where, under the protection of Velázquez, his compatriot, he repeatedly saw the famous pictures in the Palace and The Escorial as well as those in other royal collections and private homes. He copied Titian, Rubens, and Van Dyck extensively and thus he greatly improved his sense of color. Neither did he neglect drawing, copying statues and studying in the academies in this city. And he learned the correction and grand manner of Velázquez, which were very important to him.[3]

He returned to Seville, where, painting after nature as he had seen Velázquez do, he began to show some of his works publicly. And since he had not been known before, everyone admired his works and

1 Antonio Palomino de Castro, *El museo pictórico y escala óptica,* Part III: *El parnaso español pintoresco laureado.* Translated from edition published by M. Aguilar (Madrid, 1947), pp. 1031-1036.

2 Murillo was born in Seville in December 1617. Although undocumented, Palomino's statement that he learned his art from Juan del Castillo (1584-1640) is generally accepted.

3 This story of Murillo's trip to Madrid seems to be a figment of Palomino's imagination.

thus his fame spread. Because people did not know his previous history, since he was not then a famous artist, they said that he had been shut up in his house all that time studying after nature, and in this way had acquired his skill. Thus I heard painters say in my youth.

He then painted that celebrated cloister in the monastery of San Francisco in which he used strong chiaroscuro, very different from his later manner.[4] He did all the pictures after nature, incorporating in them all that he had seen and studied. And although some foreign writers (such as Sandrart and some Italian) claim that he went as a boy to the Indies and afterwards to Italy, they are misinformed. I have investigated this point diligently, questioning very old people who, without exception, were his intimate friends, and such a thing never occurred. The only trip he made was the one to Madrid. It simply is not credible that this trip would have been forgotten in his region or by his intimate friends. One of his family who did go to the Indies was his son José Murillo, a skillful and promising painter who died there as a young man. But Murillo did not live so long ago that time would have obliterated the memory of such a trip, especially since he was alive when I was a boy thirty years ago. And although I had no personal contact with him, I knew who he was and was friendly with many of his household, who told me all about his life. The fact is that foreigners do not want to concede fame to any Spanish painter who has not passed through an Italian customshouse. They do not take into account that Italy has come to Spain by means of statues, famous paintings, prints, and books. Also many famous artists from there have come here and established a school and left their works here from the time of Philip II to the present. And Spaniards have gone to Italy to receive instruction, which they bring back.

After the work in the above-mentioned cloister, Murillo began to soften his color and to weaken his shadows, but with such great taste that no one, native or foreigner, has surpassed him. Thus it is that nowadays a painting by Murillo is more highly esteemed outside of Spain than is one by Titian or Van Dyck, so great is the seductive power of color for winning popular favor. For truly the men who have gained the greatest applause are not those who have been the greatest draftsmen, but those who have excelled in color. We cannot deny that Michelangelo, Raphael, Annibale, and all the Carracci school (without lacking skill in color) drew better than Titian, Rubens, Van Dyck, Correggio, and our Murillo. But in spite of this, the latter gained the greatest popularity because drawing, that superior excellence of all that is most refined and transcendental, does not move the masses.

How well this is proven by the works of Murillo that are to be

4 This series of eleven pictures, Murillo's first important work, was done in 1645-1646.

found in Madrid! A beautiful life-size Madonna with her Holy Child on her lap, now in the collection of the Marquis of Santiago, fascinates and charms by its sweetness and attractive beauty.[5] He also has another one of the same size. Don Juan Bautista Olabarrieta has another one, slightly different, and it is hard to know which is the more successful. Another Virgin and Child, this one half length, is owned by Don Francisco Herrera and is enchanting. Besides these, Don Francisco Artier has another five pictures, three yards wide by two yards high, that formerly belonged to Don Juan Francisco Eminente, each one of which is admirable. One is an oblong picture of a group of little angels frolicking in the sky, scattering flowers about, that is truly glorious to see.[6] Another with a high narrow format shows the glorious patriarch St. Joseph holding the Christ Child by the hand while above the heavens open up in glory. The other three are of St. Francis of Assisi, St. Francis of Paul, and St. Francis Xavier, each one admirable in its own way. There are many others in the hands of private collectors. And yet another of St. Joseph, half length, with the Christ Child is in the church of the Carmen Calzado in the Chapel of Santa Anna.

In Seville (which we can call his native city since he was raised and lived there) there are many magnificent pictures. For example, in the Baptismal Chapel of the Cathedral there is the great and celebrated painting of the Miracle of St. Anthony of Padua, wherein the saint is experiencing the sovereign favor of the Christ Child with a glorious accompaniment of angels and part of a church drawn in excellent perspective.[7] And at one side there is a table done with such skill that there are those who claim to have seen a bird try to sit on it while attempting to peck at the lilies that are in a vase.

No less commendable are the two portraits in the Cathedral of the two brother saints, Leandro and Isidoro, archbishops of Seville, done by the hand of our Murillo with singular liveliness and perfection.[8] Also in the Cathedral is the marvelous painting of the Virgin of the Immaculate Conception appearing in the open heavens accompanied by an admirable troop of angels, as well as a Nativity.[9] Also there is another painting of the Virgin of the Immaculate Conception in the Hospital de los Venerables Sacerdotes, which, like the others, testifies to the eminence of the brush of this superior artist.[10]

Another testimonial to his surpassing skill are the mute panegyrics

[5] Metropolitan Museum of Art, New York.
[6] Probably identical with the picture in the collection of the Duke of Bedford, Woburn Abbey.
[7] *In situ.*
[8] *In situ.*
[9] The so-called Immaculate Conception of the Chapter Room, Seville Cathedral.
[10] Prado, Madrid; the so-called *"Inmaculada* of Marshal Soult."

of the sixteen canvases in the Church of the Capuchinos in Seville, all very large and truly great pictures.[11] And especially one, which he used to call his special favorite, that shows St. Thomas of Villanueva distributing alms to the poor, one of whom, seen from behind, seems to be alive. On the main altar is the vision of St. Francis in the Porciuncula, more than six yards high, that truly makes it seem as if the heavens are opening up. There is Christ with the Cross looking at His Holy Mother, who is on the right hand side, interceding for the salvation of mortals, and so many beautiful angels that when the painters saw it, they said that until that moment they had never known what painting was nor how to paint a picture to be placed at that height.

No less praiseworthy are the paintings in the Church of La Caridad in Seville.[12] Here is the painting of St. John of God carrying a poor man on his shoulders assisted by an angel who lightens the load, for which help the saint looks up at the angel so admiringly that it explains the admiration of its [the picture's] admirers. There is another one of St. Elizabeth, Queen of Hungary, in which a poor little boy afflicted with ringworm is having his head shaved while he hugs his shoulders in such pain that you can almost hear him shrieking, so complete is the effect. Two other large canvases are there: one of Moses striking the rock to quench the thirst of the people of God; the other, of the stupendous miracle of loaves and fish, where there is such a multitude of figures and diversity of costume, expression, and ages that it is hard to know which picture is to be preferred. And the rest are of similar quality so that any lover or practitioner of art who enters there will be so absorbed in them that a long time will pass before he comes to his senses or utters a word.

He also did many paintings for Cádiz, especially of the Virgin of the Immaculate Conception. Of those on public display, the one on the main altar of the Church of the Oratorians is outstanding.[13] They paid him a hundred doubloons apiece for the pictures, which are two and a half yards high. And in the house of the Marquis of Pedroso there is another large picture about six yards high with Jesus, Mary and Joseph below, and the Father and the Holy Ghost in a burst of light above.[14]

He also did many pictures for private homes, but very few remain today because foreigners have taken advantage of the occasion offered by the calamitous times to carry them out of Spain. In Granada there is a

11 Murillo painted a total of twenty-three pictures for the Capuchinos of Seville during two periods, the first 1665-1666; the second, 1668-1670. Of the paintings mentioned below, *St. Thomas of Villanueva* is in the Museo Provincial de Bellas Artes, Seville; *The Vision of St. Francis* is in the Prado, Madrid.

12 This cycle of eleven pictures was executed between c. 1668-1674. The four pictures mentioned below are still in the church.

13 San Felipe Neri, Cádiz.

14 The National Gallery, London.

Good Shepherd on the door of the tabernacle in the Convent of the Sisters of the Guardian Angel, which is a marvelous thing. Equally marvelous is a small painting on copper of the Virgin of the Immaculate Conception in the prior's cell of the Carthusian monastery in that city. There are also some works in Córdoba, although a painting of the Virgin of the Immaculate Conception beneath the choir of the Convent of la Victoria that they say is by him I do not accept as original.

He was also an eminent portraitist, as witness the portrait of Justino de Neve, a priest of Seville (who upon his death left it to the Hospital de Venerables Sacerdotes), which closely resembles the subject and is well painted.[15] But best of all is the small English dog at his side, which live dogs often bark at because it looks as if it is ready to attack them. And the dogs wonder why it does not bark back since it seems to be alive. At the urging of his children he did a portrait of himself that was engraved in Flanders by Nicolas Amazurino.[16] Another self-portrait with a ruff collar has remained in the possession of his son, Gaspar Murillo.

Finally, our Murillo was favored by Heaven not only with eminent skill, but also with the blessings of human nature—goodness and amiability, humility and modesty—so that he never refused to take corrections offered by anybody. And thus for the celebrated painting of St. Anthony (in the Seville Cathedral), they say that he made use of Valdés [Leal] for the perspective of the church and table. For Murillo this was a tribute to his great modesty; for Valdés, an occasion to display his excessive vanity.

I learned in 1670, having just arrived at the Court, that they had recently displayed in public a painting of the Virgin of the Immaculate Conception by Murillo on Corpus Christi Day that stunned Madrid.[17] And when Charles II saw it and recognized its author, he let it be known that he wished the artist to enter his service. This intimation (I do not know whether it was a direct order) was acted upon by Francisco Eminente (a great protector of Murillo). Upon hearing of the offer, Murillo answered with the gratitude appropriate to such an honor; but since he was already advanced in age, [he said] it would be impossible to serve His Majesty. And Eminente, who needed to send the King something by Murillo's hand (Murillo himself wanted too much time to execute a painting because of his mistrust of the situation), Eminente sent His Majesty a picture of St. John in the Desert that he bought for 2,500 reales from Juan Antonio del Castillo.

[15] Marquis of Lansdowne, London.

[16] Murillo's self-portrait was engraved in 1682 by the Flemish engraver Richard Collin. The painting is now in the National Gallery, London.

[17] Palomino's memory fails him here; he did not come to Madrid until 1678.

Murillo was so modest that it might be said that he died from pure modesty. As he was climbing a scaffold to paint a large picture of St. Catherine that he was doing for the Capuchinos in Cádiz, he slipped and fell off it, and because he was not tensed for the fall he ruptured himself so that his intestines protruded. But in order not to show his weakness, nor to let himself be examined because of his great modesty, he died of this accident in the year 1685 at seventy-two years of age.[18] And he was such a generous man that when he died they found that in spite of all the many famous works he did, the only money he had was 100 *reales* that he had received the day before and sixty *pesos* in a drawer.

A word should be said about the famous skill Murillo had for landscapes, which often appear in his paintings. And thus it happened that the Marquis of Villamanrique decided to commission Murillo to do a series of pictures of the life of David, with the landscapes to be painted by Ignacio Iriarte.[19] Murillo suggested that Ignacio do the landscapes first and that afterwards he would put in the figures. Ignacio wanted Murillo to do the figures first and then he would fit in the landscape. Murillo, disgusted by these debates, told him that if he thought he needed him for the landscapes he was mistaken. And thus he did the pictures (which were brought to Madrid by the Marquis), figures and landscapes alike, which are as excellent as anything he ever did.

18 *The Mystic Marriage of St. Catherine,* still *in situ* in Cádiz, was Murillo's last commission. As far as is known, Palomino's account of his death is true, although the date was 1682.

19 Murillo painted a series of five pictures of the life of Jacob, to which Palomino is probably referring here. *Isaac Blessing Jacob* and *The Dream of the Ladder* are in the Hermitage, Leningrad; *Jacob Laying the Peeled Rods Before the Flocks of Laban,* in the Meadows Museum, Southern Methodist University, Dallas, Texas; *Laban Searching for his Stolen Household Gods in Rachel's Tent,* in the Cleveland Museum. *The Meeting of Jacob and Rachel* is lost.

ARTISTIC PRACTICE

El Greco Versus the Hospital of Charity, Illescas

*In the seventeenth century the value of a completed artistic com-
mission was determined by a process of evaluation called* tasación. *Nor-
mally the patron and artist would agree to entrust this evaluation to a
mutually chosen artist or group of artists* (tasadores), *who would place
a fair price on the work. Although the system had its shortcomings,
notably the selection of a truly unbiased jury, it generally worked well.
But when it failed, monumental legal entanglements often followed.
Nowhere is the failure of the system more apparent than in the case of
El Greco versus the Brotherhood of the Hospital of Charity in Illescas,
which resulted in a prolonged and bitter battle.*

*Illescas is a small town that lies on the main road between Madrid
and Toledo. Here El Greco came on June 18, 1603, to sign a contract for
the decoration of the high altar of the church of the Hospital of Charity,
a commission involving architecture, painting, and sculpture. The con-
tract, which follows below, sets the stage for the coming struggle.*

*In it El Greco committed two errors that later worked against him.
First he agreed to finish the work by August of the following year. Al-
though in general practice such deadlines were seldom met, it was a point
of potential conflict. Secondly, El Greco agreed to allow the brotherhood
to select the appraisers. This act of good faith was consistently betrayed
by the brotherhood, whose intentions to cheat the artist contrast with
El Greco's reasonable attempts to arrive at a fair settlement.*[1]

In the name of God Amen. Know all who see this public document
and its contents that we Luis Nuñez de León, President of the Hospital
and Brotherhood of Our Lady of Charity in the town of Illescas, and
Melchor del Castillo and Francisco López de Castro, priests, and Gaspar
Franco de Molina, Juan Ruiz de Cuellar, Gabriel Caballero and Alonso
Palomeque, overseers of the said hospital and brotherhood, having met
in council as is our custom, and in the name of the other brothers and
officials of this hospital and brotherhood, on the one part; and on the
other part Dominico Theothocopoli, Greek, resident of Toledo: We
declare that, for however much is agreed upon by said parties, I the said
Dominico will make an altarpiece [*retablo*] for the altar of the holy

1 From Francisco de San Román Fernández, "De la vida del Greco (nueva serie
de documentos inéditos)," *Archivo español de arte y arqueología*, No. 8 (1927), 172-73,
174-75, 180-82, 183-84.

image of Our Lady of this holy house in accordance with the design that has been seen by this council, which is the one showing the columns of the righthand side [of the altarpiece] that is signed by the here present scribe, and with the drawing of the front of the altarpiece that is attached to the drawing of the columns. Whereby for the said altarpiece for the said hospital and brotherhood I will be paid whatever is appraised by a person of said art appointed by the said hospital and brotherhood as long as he is not from Toledo, Valladolid, or Madrid. And this evaluation [*tasación*] must be made when the said altarpiece is in place over the altar, which I agree to have done by the last day of August of the next year 1604, when a celebration and procession in honor of the holy image will take place, so that when the procession is over, the image can be placed in its proper location in the altarpiece. And if I have not finished the altarpiece by the agreed date, 200 ducats will be subtracted from the amount of the evaluation. And on account, and as part of the payment, the council must give me 200 ducats every three months. Any money owed for the altarpiece in excess of 1,000 ducats, as determined by said evaluation, will be payed immediately upon the conclusion of that evaluation. . . .

And we the President and overseers of the said house and hospital agree completely to this contract and pledge our now and future property and income to its fulfillment and payment.

In proof of the foregoing we authorize this contract before the here present scribe and witnesses that are signed below. Dated and authorized in Illescas on June 18, 1603.

> [Signed] Luis Nuñez de León, Gaspar Franco de Molina, Juan Ruiz, Francisco López de Castro, Melchor del Castillo, and Dominico Theotocopuli.

2. El Greco finished the work one year later than the promised date, whereupon the brotherhood summoned two appraisers who were strongly biased in its favor. Furthermore, they made their estimate without ever consulting El Greco about such matters as cost of materials. In a document of August 4, 1605, they set the value of the altar at the insultingly low price of 26,802 reales (or approximately 1600 ducats), or about half the price later suggested by impartial appraisers. These terms were of course rejected by the artist, and he engaged a lawyer to present his case before the Council of the Archbishop of Toledo.

The legal brief makes it clear that El Greco's grievances extended beyond the question of money and reached into the realm of Christian decorum.

Illustrious Sir: As the representative of Dominico Theotocopuli, painter, in the lawsuit against the President and overseers of the Hospital

de la Caridad in Illescas, and in response to the evaluation and declaration made by Francisco Estéban and Francisco de la Torre, I say that in the interests of justice Your Holiness must repeal this evaluation and order a new one made, for the following reasons.

First, the said evaluation was made without consulting my client, as should have been done. As a result of this failure to consult him, everything that has been done is null and void and must so be declared. Consultation is of the essence in this case, since had my client been present he would have been able to make clear what had been done in this altarpiece and what it had cost. Since this was not done, this evaluation is unjust and unfair.

Second, the said evaluation is very prejudicial to my client because it does not even pay for the gilding of the altarpiece and chapel, which is the best and most perfectly made in Spain, as can be proved if required. Of the same quality is the architecture, sculpture, carpentry, and painting, so that the amount of the evaluation would not pay for even one of them, let alone the entire work. Thus the wrong committed is so notorious that it must be undone and corrected.

Third, the said appraisers acted very maliciously toward my client, and rendered such a low evaluation in order to bring him evil and harm and to destroy him. As if that is not enough, they have forgotten their duties as appraisers and set themselves up as critics, censuring and offering corrections of the painting. And what they find fault with and consider indecent, namely that some of the people in the group beneath the mantle of Our Lady of Charity are wearing ruff collars, is common practice throughout the Christian world.[2]

Therefore I oppose the said evaluation and ask and supplicate Your Holiness to order a new one, appointing persons who will be satisfactory and above suspicion and whose understanding of these arts is guaranteed. For in no other way can a just evaluation be made, and it is justice, above all, that I ask for.

[Signed] Doctor Alonso Narbono

Presented in Toledo on August 23, 1605, before the gentlemen of the Council of His Holiness by the said Dominico Theotocopuli.

3. El Greco's plea was favorably received by the Archbishop's Council, which sided with him throughout the case. Hence on September 20, 1605 another evaluation was made, and this time it came out in the artist's favor to the amount of 48,834 reales (or approximately, 3200 ducats). Naturally this prompted a countersuit by the brotherhood, which was presented to the Council on November 19, 1605. This document is the

2 See below, p. 208, for a more detailed explanation of the hospital's objection to the ruff collars.

most interesting in the history of the commission. Seldom in the history of art is the fallibility of the artist-patron relationship as lucidly exposed.

I, Antonio Suarez, in the name of the President and overseers of the House and Hospital of Nuestra Señora de la Caridad in Illescas in their suit with Dominico Greco, say that, besides what I have alleged on behalf of my client, Your Holiness should know and understand the imperfections and mistakes in the altarpiece in question so that Your Holiness can decide the just cause. The said imperfections and defects are the following.

First, the lateral parts of the altarpiece, where the holy sacrament is placed, are full of chinks and besides this, so poorly joined in some parts that you can stick a hand through the joints.

Second, the main reason why the altarpiece was made was so that the holy image of Our Lady could be dressed with the greatest decency. To this end, a door was made behind it, and made so imperfectly that the holy image does not fit through it. In order to take it out, it is necessary to twist and turn it, much to its detriment. This has to be changed and to do it properly will cost a great deal of money.

Item: all the paintings are done in such a manner that they cannot be seen at a distance. And at the same time, above Our Lady in the most salient part of the altarpiece is a painting of the Virgin of Charity, and there he painted a portrait of his nephew, Jorge Manuel, wearing a large ruff collar, as well as other identifiable persons, which should be completely eliminated from this painting because they steal attention from everything else in the painting. It was for this reason that the original appraisers declared that they should be removed as indecent.[3]

Item: My client had an oratory made at the cost of more than eight hundred ducats, with a window that looks out on the main altar so that the king and other princes could hear mass comfortably. He [El Greco] placed a massive sculpture of a prophet, which was not included in the original plan of the altarpiece, that completely blocks the window and renders the oratory useless. Hence it is necessary for Your Holiness to order the said Dominico Greco to show you the plan and model he presented for said work.

Another thing: He gilded the entire chapel right down to the floor, whereas he should have left a margin of at least a yard and a half,

[3] The painting of the Virgin of Charity was originally placed in the attic of the altarpiece instead of its present low position to the right of the main chapel. Although El Greco's son and pupil, Jorge Manuel (1578-1631), collaborated on the Illescas commission, his alleged presence in this picture is an invention of the hospital's lawyer. The hospital's ludicrous obsession with the ruff collars worn by the supplicants resulted in ordering them to be painted out. They reappeared after the picture was cleaned in 1940.

realizing that it was going to get dirty, as indeed it did. This is one reason for the high cost [of materials].

Another thing: Above the sanctuary and the host where the holy sacrament should be, he placed two angels that must be removed from there because their size and form are not compatible.

Another thing: He placed two massive statues of Virtues on the top of the altarpiece, which he made of such poor wood that after less than two years they are rotten and worm-eaten.

Another thing: He did not fulfill the condition of the contract stating that the altarpiece was to be installed by the end of August 1604. So it was necessary for the hospital to incur various expenses to move the holy image of Our Lady. For this I ask that a fine of 200 ducats be assessed as per the contract to reimburse the hospital for its expenses.

Therefore, since this cause is so holy and so pious and favorable to the service of God Our Lord and His Most Glorious Mother, and to the good and welfare of the poor, I ask and supplicate Your Holiness to favor it and to declare that the evaluation is just and lawful, that it be obeyed and executed, declaring the second one null and void, since it contradicts the contract and causes enormous injury to the said hospital, by giving order that it not be maintained. If Your Holiness will order that the faults cited in this petition be reformed and corrected and done as is fitting at the cost of the said Dominico Greco, and subtracted from what he ought to have received from the aforesaid first estimate, I will offer myself to give information on all this and give proof when necessary. I beg to be received in order to give this proof with the necessary declaration, and I request justice and the costs for it.

I swear by my legal oath,

Antonio Suarez

4. As a result of this rebuttal of the second evaluation, the Archbishop's Council, on December 19, 1605, ordered yet another one to be made and selected the appraisers itself to insure impartiality. Their opinion of January 26, 1606, which follows below, was even more strongly in El Greco's favor and refuted point by point the objections of the brotherhood. The appraisers placed the total value of the work at 53,333 reales (or approximately 3500 ducats).

The tone of finality in this document is completely misleading, for the suit was to drag on through another year of acrimonious action and counteraction. The brotherhood petitioned both the Royal Chancellery and the Papal Nuncio to intervene on its behalf. On his side, El Greco instituted an action to attach the goods and chattel of the brotherhood as payment of its debt. Finally a fourth evaluation was made on March 16, 1607 by one Martin Gómez, who was friendly to the Brotherhood.

His price was the lowest yet suggested—23,085 reales *(or approximately 1500 ducats). By this time El Greco would not endure further loss of time, money, and energy, and on the following day he accepted the terms of this last evaluation.*

THE EVALUATION OF FERNANDO DE ANUNCIBAY AND JUAN RUIZ DE ELVIRA, JANUARY 26, 1606

Illustrious Sir: We, Fernando de Anuncibay, painter and resident of the town of Siruela, and Juan Ruiz de Elvira, sculptor and resident of Manzanares, declare that in fulfillment of a decree by Your Holiness we went to the town of Illescas to see and appraise the altarpiece and work done by Dominico Greco, painter and resident of this city, in the chapel of the Hospital of Nuestra Señora de la Caridad in order to execute what was ordered us by the said decree and by the members of your council; namely, particularly to investigate the alleged defects in that work. We have seen the lawsuit that has been made and what the president and overseers of the said hospital have alleged as well as the original contract and design of the said work. And having heard both sides of the argument and seen the evaluations made of the said work, first by Francisco de Torres and Francisco Estévan and second by Pedro López and Miguel González; and having seen and considered all the work, including painting, sculpture, carpentry, gilding, and polychromy, done by said Dominico Greco, I, Fernando de Anuncibay, find that the gilding of the altarpiece and chapel together with the painting and polychromy and polished marble of the prophets are worth 24,973 *reales.* And I, Juan Ruiz de Elvira, find that the wooden altarpiece and carpentry and sculpture together with the sketches, costs of travel, assistants and final assembly are worth 28,360 *reales;* and having also appraised the gilding and painting I concur with the judgment of Anuncibay.

As far as the alleged defects of the work are concerned, the first thing we say is that the [construction of the altarpiece in the area of the] niche and tabernacle of Our Lady is done with great perfection and decorated with consideration and aptness for the site. At the same time the altarpiece is gilded well and made of long-lasting wood; and what they say about a poorly aligned column is self-contradictory and unworthy of consideration since the altarpiece is well designed. As far as what they say about the statues of the Virtues being partially made of canvas, they are made of wood in the exposed parts. The canvas that they have put in the back, in our opinion, was put there to prevent people from seeing them before they were set in place. Neither is it subject to deterioration since it is primed with gesso and other protective elements unlike canvas to be used for painting. They also claim that a large statue of a prophet

located on the side of the altarpiece blocks the view of the mass from the King's oratory. However, it is an estimable idea to have adorned the chapel with those two prophet figures set in niches facing each other, because they harmonize with the altarpiece in such a way as to make a good composition. And in the place where he put the prophet they [the hospital] had arranged to put two painted canvases on each side in such a way that more would be covered with the canvases than is occupied by the prophet, which is placed, as we are informed, where they [the hospital] planned to put a window.

As for their objection about the gilding of the chapel extending down to the bottom of the altar steps, it was suitable to do this because it imparts authority to the work. Had it been stopped short, as they suggest, it would have looked as bad as a priest's robe that only comes down to the knees. . . . The paintings on the altarpiece and in the chapel are very good and executed with the necessary skill. And if they cannot be seen clearly, it is because they are set in a recessed chapel. The ruff collars that they object to in the portraits in the painting of the Virgin of Charity are acceptable, since they are usually worn these days. In fact, it is more realistic to have them since it makes the figures look like supplicants. Otherwise they could be images of other saints and not portraits of ordinary men. And the small angels that are adoring the cross of charity, to which they also object, are suitably accommodated and give the desired effect.

They also raise the point about the door behind the central opening in the altarpiece through which the image of the Virgin is dressed and lowered from her throne for processions. They say that the door is too small so that they have to turn the image on its side when they take it out. This has been looked at and the door can easily be made larger. It has not been done because they did not think the impost could be broken through on account of its strength. However this can be easily and inexpensively done.

Thus it seems to us by God and our consciences. This is an evaluation only of the cost of the work and of the gold, wood, sculpture, and assembling of the altarpiece, and of the painting and the artistic mastery, the work and cost of assistants, and of the money spent by the artist. Without wishing to offend either of the parties, we sign our names.

<div style="text-align: right">

Fernando de Anuncibay
Juan Ruiz de Elvira

</div>

Paintings by Titian in the Royal Palace, Madrid

The Hapsburg rulers of Spain were great lovers of Italian painting. Charles V was the first of them to indulge the passion, but his successors,

by comparison weak in many other ways, were no less ardent in their admiration of Italian art. The royal palaces of Madrid and The Escorial were filled with masterpieces of the Italian Renaissance, which acted as a major catalyst in the formation of seventeenth century Spanish art. Young artists considered it a requirement to study them as we see in Palomino's biographies, where we often read of almost miraculous stylistic conversions by novice painters when they initially confronted paintings by Titian and Veronese.

Some idea of the number and scope of the collection can be gathered from the galleries of the Prado Museum, which inherited many of the royal pictures. The number, of course, has been greatly reduced through loss by accident (notably the conflagration of the Royal Palace in 1734), war (Napoleon's generals carried off scores of the paintings), and export for sale. The great number of Venetian works among the remaining pictures accurately reflects the taste of the Spanish kings. Titian, above all, was the great favorite, and the influence of his art in Spain during the seventeenth century was impressive.

The extent of Titian's paintings in the royal collection is documented by inventories made in the seventeenth century, and they are required reading for students of Titian and Spanish art alike. But perhaps a more palatable way to sample this information can be found in a part of Carducho's Diálogos de la pintura. *In this section, the Master and the Pupil compare notes on paintings by Titian and others that were then hanging in the Royal Palace, Madrid. This brief glimpse behind the Palace walls conveys a notion of the art in its setting as well as a malicious bit of gossip about the Prince of Wales, later Charles I of England.*[1]

From Carducho, *Diálogos de la pintura*

Master: There are many oil paintings [in the palace], and the most esteemed of all have always been those by Titian, in whom color reaches its full power and beauty. [They include] the Four Furies on four large canvases—*Sisyphus, Tityus, Tantalus,* and *Ixion.*[2] The last two are originals and the other two, copies by Alonso Sánchez Coello, the famous Portuguese painter, although they are regarded as originals by Titian.[3]

[1] Vincencio Carducho, *Diálogos de la pintura* (Madrid, 1633). Translated from edition of D. G. Cruzada Villaamil (Madrid, 1865), pp. 349-52.

[2] *Tantalus* and *Ixion* are lost; *Sisyphus* and *Tityus* (sometimes called *Prometheus*) are in the Prado, Madrid. They are now usually considered original works by Titian.

[3] Alonso Sánchez Coello (1531/2-1588) was born in Spain but went to Portugal at an early age. He is best known for his portraits, which are in the style of Antonis Mor; upon his return to Spain, he was court painter to Philip II.

Also two pictures of Diana at her bath, each a different composition; [4] another picture in which Cupid is striking a glass ball with his quiver while holding onto a beautiful woman. In this it shows how strong an honorable woman's prudence must be, because like glass it breaks with a single blow of love; another of Faith, which is transported to the barbarous idolatry of India by the armed might of Spain; another picture of Venus looking in a mirror held by Cupid; [5] another of the rape of Europa.[6] There is also an Andromeda that is a copy, as are a Danaë and the golden rain, a Diana and Callisto, a Lucretia and Tarquin; [7] also an Adam and Eve that is original,[8] together with the half-length portrait of the invincible Charles V and the portraits of the Empress, King Philip II,[9] the Doge of Venice,[10] and a dwarf. And there is a large picture of King Philip II standing, making an offering to Prince Fernando, who was born in the year 1571, the same year as the great naval victory of Lepanto.[11] This allegory was painted because they thought that Spain had been given a needed successor in that year, and also to celebrate the glorious victory over such a powerful enemy. Thus the Turks are cast down at their feet and an angel descends from Heaven with a palm branch and utters the motto, *Majora tibi* [*And may you accomplish greater deeds*]. And in the distance, daubed in, is the battle itself. Of the same size is another canvas with his father, the Emperor Charles V, in armor on horseback.[12] These two pictures adorn the new grand salon that has balconies facing the plaza. All of these pictures are by Titian.

In the same salon there are other pictures of similar size by Peter Paul Rubens, Eugenio Caxes,[13] Diego Velázquez, Jusepe de Ribera (who is called *Españoletto*), Domenichino and Vincencio Carducho, and below them are others of smaller size. Hanging above all of these are the Four

[4] Carducho is probably referring to the pictures of *Diana and Callisto* and *Diana and Actaeon*, both in the Ellesmere Collection, National Gallery of Scotland, Edinburgh. Below, Carducho mentions a copy of this composition, which might be identical with one of these two pictures.

[5] A version of this picture is in the National Gallery, Washington.

[6] Isabella Stewart Gardner Museum, Boston.

[7] These may have been original works, since authentic versions of these pictures were in Spain at one time. Only *Danaë and the Golden Rain* remained in the Prado. *Perseus and Andromeda* is in the Wallace Collection, London; *Lucretia and Tarquin* is probably the one in the Fitzwilliam Museum, Cambridge. For the *Diana and Callisto*, see above, note 4.

[8] Prado, Madrid.

[9] There are portraits of the Empress Isabel and Philip II in the Prado, but they cannot surely be identified with those Carducho mentions so briefly here.

[10] Titian painted the portrait of Doge Andrea Gritti, a version of which is in the National Gallery, Washington.

[11] Prado, Madrid.

[12] Prado, Madrid.

[13] Eugenio Caxes (before 1577-1634) preceded Velázquez as painter to the king.

Furies that, as we said, are by Titian. These are the ones that I can remember having seen, although I know there are many others that I have forgotten because they were less singular.

Pupil: You have reminded me of all the ones by Titian, as well as several others, among them two half-length pictures of Our Lord, two of Our Lady and a small Bacchus and a portrait of the Duke of Saxony [14] and another of the Duke of Lanzgrave, all of them excellent. The altarpiece of the chapel, that shows the Triumph of the Lamb, is by Michael Coxie, who copied it for Philip II from one that is in the city of Ghent, by the hand of Jan van Eyck of Bruges, who, as we said, invented oil painting.[15]

Master: You are right, I had forgotten those two portraits. Also the two portraits that the Marquis of Leganés has in his house, that were given to him by the King, and others that are in the Royal Palace. Many of the ones we have mentioned were in grave danger when the Prince of Wales (now King of England) was here.[16] He tried to collect as many of the available paintings and drawings as he could without paying for them. Most of them came from the remainder of the collections of the Count of Villamediana and Pompeo Leoni (persons who exercised great care to collect the best things they could).[17] And the King and other noblemen gave the Prince many pictures when they saw how he loved them, including one by Titian of Antiope with some shepherds and satyrs on a large canvas that was in the Palace of the Pardo, where it escaped the fire that occurred there in 1608 [1604], which destroyed so many pictures. . . .[18]

Pupil: And why didn't the Prince take the other fables by Titian?

Master: I saw them crated, ready to send to England, including the *Bath of Diana,* the *Europa, Danaë* and the rest of them. But after the recent events they remained here.[19] I don't know which is more ennobling; generosity or the possession and appreciation of a beautiful object. For sometimes such objects bring renown and esteem to an entire nation.

[14] A copy of the portrait of Johann Frederick, Elector of Saxony, is now in the Prado. The original is in the Kunsthistorisches Museum, Vienna, and may once have been in Spain.

[15] Coxie's copy of the Ghent Altarpiece, finished in 1559 for Philip II, is now divided between the Staatliches Museum, Berlin, the Musée des Beaux Arts, Brussels, and the Alte Pinakothek, Munich.

[16] The Prince of Wales, later Charles I, was in Madrid in 1623-1624.

[17] Pompeo Leoni (c. 1533-1608) was son of the Milanese sculptor, Leone Leoni and a sculptor himself. Most of his adult life was spent in Spain, where he worked extensively for Charles V and Philip II.

[18] *The Pardo Venus,* Louvre, Paris.

[19] Carducho refers here to the war between Spain and England, that began in 1625 as a result of the refusal of Charles I to honor his promise to marry the Infanta María, daughter of Philip III.

On the Painting of Flowers and Fruit

Although still life painting was widely practiced in Spain during the seventeenth century, its origins as an independent genre are obscure. The best clues to a solution of the problem are supplied by Francisco Pacheco, who in various places in El arte de la pintura *speaks about still lifes. One section of Book III is especially revealing. In it Pacheco intends to advise on how to paint a still life. Instead he offers first, his low opinion of the genre and second, a short and random history of its initial development. It is perhaps among these obscure names that the creator (or creators) of Spanish still life painting will someday be found.*

A note of caution about the application of this passage should be added. Pacheco is speaking here only of pictures of flowers and fruit and does not mention the very characteristic Spanish subject called the bodegón, *or kitchen still life. In his mind, the two were distinct, and he discusses the* bodegón *in another part of his book (Book III, Chapter 8). This distinction between* florero *(flower piece) and* bodegón, *although not always clear in later examples, is an important one to keep, for it is possible that the two have separate origins and early histories.*[1]

From Pacheco, *El arte de la pintura*

The painting of spring flowers from life can be very entertaining, and some have even reached eminence in this field, particularly the famous Florencio of Flanders. . . .[2] Neither was antiquity lacking in this amusing genre, for the founder of this type of painting was Pausanias Siconius. In his youth he fell in love with Glisera, a maker of garlands, and in imitation of her he brought to art an innumerable variety of flowers. . . . In our own time there is no want of painters who are fond of the entertainment afforded by this genre, which can be easily learned and gives delight by its variety. Among those who have done it with power and skill can be counted Juan van der Hamen, archer to Philip IV.[3]

Oil painting is most suitable for this genre, because you can retouch over and over again and refine the colors so that they truly imitate natural flowers. You must also master the painting of vases of glass, clay, silver, and gold, and the little baskets in which flowers are usually placed,

[1] Francisco Pacheco, *Arte de la pintura* (Seville, 1649). Translated from edition by F. J. Sánchez Cantón, II, pp. 125-27.

[2] Pacheco is probably referring to Frans Floris (1516-1570).

[3] Juan van der Hamen y León (1596-1631), whose father was a painter from Flanders, was one of the leading still life painters in the seventeenth century.

and the use of lighting and the arrangement of all these things. And occasionally good painters can amuse themselves this way, although it does not lead to artistic glory. . . .

The painting of fruit travels the same road, although it demands greater skill and poses greater problems of imitation because it sometimes figures in serious history painting. Blas de Prado painted it very well, and when he went to Morocco on the King's orders, he took some paintings of fruit with him, which I saw, that were very well done.[4] His disciple Padre Juan Sánchez [Cotán], before he became a monk in the Cartuja of Granada, was very well known for his work in this genre.[5] Antonio Mohedano painted pictures of fruit very well, as is shown by the festoons that he did in fresco in the cloister of San Francisco,[6] and Alonso Vázquez was not far behind, as can be seen in the famous canvas of Lazarus and the Rich Man, now in the possession of the Duke of Alcalá.[7] There, in a cupboard with containers of silver, glass, and clay, he placed a wide variety of food and fruit, and a copper flask immersed in water for chilling, all painted with much dexterity and decorum. But he did something that other painters of fruit do not do; namely he did the figures as skillfully as the other things. I have also tried this exercise, as well as flower painting, and I do not judge it to be very difficult. Juan de van der Hamen did it extremely well, and was even better with sweetmeats, surpassing in this part the figures and portraits that he did. Thus he became more renowned for this, much to his displeasure. For this reason it seems to me that perhaps the great painters can make use of these genres in their history paintings. But they should try to put greater care in painting living things, such as figures and animals, which are more highly thought of. And because there are no set rules for this type of painting, except the use of fine colors and exact imitation, let us pass to another matter.

[4] The role of Blas de Prado (c. 1546-1599) in the history of Spanish still life painting is a mystery whose solution might tell us much of the origins of the genre. No still lifes have been attributed to his hand, only a few competent but uninspired figural compositions. But his pupil Sánchez Cotán (see below) was the first known distinguished still life painter in Spain.

[5] Juan Sánchez Cotán (1561-1627) was the author of hauntingly beautiful still life paintings (see *Still Life with Quince, Cabbage and Cucumber,* Art Gallery, San Diego, California). In 1603 he became a lay brother of the Carthusian Order and worked at the monasteries of El Paular and Granada.

[6] Antonio Mohedano (1563-1625) was a fresco painter who worked in Córdoba, Seville, and Antequera.

[7] Alonso Vázquez (c. 1565-1608) worked in Seville from 1589-1603. The picture mentioned above is in a private collection, Madrid, and is illustrated as plate 116A in Kubler and Soria, *Art and Architecture in Spain and Portugal and Their American Dominions* (Baltimore: Penguin Books, 1959).

Directions for Painting Wooden Statuary

The painting of statuary, which was banished from the mainstream of Western art during the Italian Renaissance, was never abandoned in Spain, where it continued throughout the seventeenth century. For the Spaniards, the painted statues removed the image of the deities and saints from the realm of abstraction to a level of reality at which the icons became accessible. Because of the importance of the painting for sculpture, the wooden statues and reliefs were usually executed by a sculptor in collaboration with a painter or painters. The painter could either be a pintor de imaginería, *a painter of sculpture who worked exclusively on polychromy, or an easel painter who had passed the examination of the polychromers' guild. In addition, specialists in the painting of gilt drapery, called* estofadores, *were also used sometimes, and for large altarpieces, gilders, or* doradores, *could be employed. The* pintor de imaginería, *far from being a second-class artistic citizen, was highly regarded; and many leading painters, such as Zurbarán, Velázquez, and Valdés Leal, are known to have qualified for the office.*

Among those who practiced polychromy was Francisco Pacheco, and it is thanks to him that we have a record of how the most difficult part of sculptural painting was done in the seventeenth century. In his Arte de la pintura, *Pacheco describes the technique of* encarnación *or the painting of flesh tones and, by extension, of facial expression. The technique, which is quite complicated, is largely self-explanatory. One point does, however, call for comment; this is Pacheco's recurrent contrast between glazed flesh tones and matte flesh tones or finishes. For him, the glazed tones, achieved by application of a final coat of varnish, were repugnant because the way in which they reflected light did not approximate the true quality of human flesh. On the other hand, the matte tones, which he claims to have introduced in Seville, satisfied the desire of the seventeenth century for a more realistic painted statuary.[1]*

From Pacheco, *El arte de la pintura*

God in His mercy banished from the earth these glazed flesh tones and caused the more harmonious matte flesh tones to be introduced. This is a more natural kind of painting which permits retouching several times, and allows the beauties we see today. It is true that since ancient times, forward-looking men have used them, as we see in some sculp-

[1] Pacheco, *El arte de la Pintura* (Seville, 1649). Translated from edition of F. J. Sánchez Cantón, II (Madrid, 1956), 103-10.

tured scenes in old altarpieces. But, if I may be so bold to say, I was among the first in Spain to revive the practice which gives new importance and vitality to good sculpture; and if not the first in Spain, then at least the first in Seville to use them since 1600. For on January 17 of that year I painted with matte flesh tones a bronze cast of a Crucifix by Michelangelo which Juan Bautista Franconio, a notable silversmith, molded from the one he brought from Rome. Soon the method became so popular that the other craftsmen began to follow it. It would be excessive to mention the many famous things in this city made by Gaspar Núñez Delgado and Juan Martínez Montañés which were finished by my hand; but some must be mentioned because there is no other way to prove this invention: the *St. John the Baptist* at San Clemente and the *Ecce Homo* of clay made by Gaspar Delgado; [2] the *St. Dominick of Portacoeli* by Juan Martínez and the two heads of Saint Ignatius and Saint Francis Xavier in the Casa Profesa and the Christ that Don Mateo Vázquez gave to the Carthusian monastery. Above all, this same artist's *Penitent St. Jerome* of San Isidoro del Campo should be mentioned, for among present-day sculpture and painting it has no equal.[3] It has even caused some good painters to venture the opinion that excellent painters can do any kind of painting, and that if they wish to paint sculpture they will do it better with their feet than those who have learned the skill. But they are mistaken in this belief, because when they do it, they lack the delicacy and neatness of those who deal with it all the time. . . . This is because they disdain the practice and do not wish to make a study of it, as may be done. For there should be absolutely no doubt that the natural quality in a well-painted portrait head, and the way in which colors and highlights are used in the eyes and mouth [to bring out] softness of skin, can also be achieved most admirably on good sculpture, as all admit who have seen those painted by me in matte finish. This is such a well-known fact that it excuses me from bragging. . . .

Let us now discuss how it is done. Painting with a matte finish will always be more successful if the wood has been finely finished and smoothly polished. Good sculptors will make it unnecessary for the painter to spend a great deal of preparation on his working surface.

[2] Gaspar Núñez Delgado (active in Seville 1581-1606) often worked in terracotta. The statue of St. John the Baptist painted by Pacheco was executed in 1606 and remains in the Church of San Clemente.

[3] Juan Martínez Montañés (1568-1649) was one of Spain's greatest sculptors. His long career evolved in Seville. The statues on which Pacheco says he collaborated are among Montañés's most important. They can be identified as follows: *St. Dominick of Portacoeli*, c. 1605-1609, Museo Provincial de Bellas Artes, Seville; *St. Ignatius Loyola* and *St. Francis Xavier*, 1610, Chapel of the University of Seville; *Christ of Clemency*, 1603-1606, Seville, Cathedral; and *St. Jerome in Penitence*, 1610-1613, altarpiece of San Isidoro del Campo, Santiponce. For another aspect of the relationship between Pacheco and Martínez Montañés, see pp. 221-26.

It was thus with Delgado and Martínez. After having given [the parts to be covered by] the flesh tones a coat of glue, and having gone over it with a polishing cloth, it should be given two or three coats with [a mixture made of] lustreless gesso and a little white lead, all mixed with a water base and sizing. After it is dry, sand once or twice until everything, hair and beard and all the elevations and depressions, remains without a single rough spot, and is very soft and smooth to the touch. Then prime all the flesh areas with flesh-tone oil colors mixed with a drying agent. This must be the first thing to be carried out in figures in the round, whether they are to be gilded and burnished or oil painted. Thus the preparation of faces, feet, hands, and other flesh surfaces must be the first thing that is done and primed, and something that must pass under the eyes of the master in charge, because it is the principal element of his work. It must also be the last to be finished and [it is] where the real skill of the artist shows.

After the priming is very dry, the flesh colors will be made with a mixture of powdered colors, as for oil painting; and, if it is a holy image or a Christ Child, the colors will be made beautiful by mixing white and vermilion only, because time produces in oil a yellowish effect. If they are of penitents or aged people, perhaps some ochre or reddish ochre may be mixed, adjusting the tones as the subject requires. The tones of a holy image or Christ Child [may be adjusted] by adding vermilion and a little Florentine red, and if the color is to be still darker, it can be blended gradually and touched up with red-ochre and a little vermilion, using for the recessed areas the flesh tone with a little touch of shading, as in easel painting. And where the hair meets the forehead or the neck, use a middle tone made from the same flesh colors and a darkening element, lightening the color where it meets the flesh, so that it does not look chopped off and hard. After this, paint the hair with fine lines, avoiding hardness, as is done in nature and in good paintings, even though the hair is black. And because this procedure is not observed, we often see hair surfaces that are very crudely brushed on, especially in figures of the Christ Child, in which some are wont to brighten it by putting flecks of gold leaf over a deep black, which makes the hair look as if it were made of bronze and brass. One should realize that the highlights of hair must be of the same color as the hair, and that gold must harmonize with the color of the hair, as occurs in the blond hair of good paintings. I have used it in light-colored hair not by pouring it on top, but by using fine strokes. However, I will not use gold in anything if I can imitate what I want by using colors. . . .

After [the first coat] is dry, a soft polishing cloth will be passed over it, and one will begin to give a second coat with the flesh color that

is to be permanent. Take care always to prepare more than enough of the flesh color of the forehead, neck, and hands, since they have the largest surface and require the greatest quantity, and to keep it soft, even though the figure is finished, because then you are in a position to retouch and to refine details as much as you like. And with the flesh highlights take the same care, and make sure there is always some left over. Finally, the color used for the hair must be kept, and by lightening the color, one must bring out the highlights, as is done in good painting, and must brush this lightly over [the areas transitional to] the flesh.

[In painting the face] one must always begin by outlining lightly the forehead and eyes. The eyebrows must be marked first in fresco preparatory to the detail work. I do not use eyelashes [of real hair] because they spoil sculpture, but rather strokes of color smoothly blended together. Experience has taught me one other thing, and this is that in scenes of medium and low relief I have yet to see anyone use shadows in the flesh parts as they are used in the areas of clothing. By doing so, the figures are made to appear more rounded as in pictures, although in relief they actually do seem to stand apart from one another [without the need for this technique]. But considering that the figures that are painted [without shadow] appear flat when they are in low relief, I have used relatively light shadows not only in the clothing but also on the flesh surfaces, depending on the distance between the figures. I believe that I am also the first to do this. Thus I attracted [the attention of] painters the first time I used it, which was in the scenes of medium relief of the altarpiece of St. John the Baptist at San Clemente.[4]

Another technique that the great masters are wont to use is to add heads and half figures, distant full figures, buildings, and landscapes [in order to enrich] simple stories done in medium relief. Thus Antonio de Arfián, in the altarpiece of Saint Paul in the scene of the Visitation, added heads . . . by means of burnished gold that appear to have volume. Also in the Conversion of St. Paul, he amplified the story by adding figures on horseback in the distance.[5] And Vasco Pereira, in the altarpiece of San Leandro, in a Scourging of Christ made the column part of a building in very high relief.[6] And Alonso Vázquez, in the altarpiece of the Church of the Santísima Trinidad, in the Nativity scene added in the distance the appearance of the angel to the shepherds (things which mere painters of drapery [*estofadores*] cannot do), all of which is worthy of imitation.[7]

[4] Same commission mentioned in note 2.

[5] Antonio de Arfían was a minor painter of the second half of the sixteenth century who worked in Seville.

[6] Vasco Pereira, a native of Portugal, was active as a painter in Seville during the last third of the sixteenth century.

[7] See above, p. 216, note 7.

To continue, let me add that also in these times, with the excess of cast metal objects, particularly crucifixes and figures of the Christ Child, the art of matte-finished flesh tones on all metals has been introduced. If the figures are well made, and if they are small, it will be sufficient to prime once or twice that which is to be flesh colored, going over it when dry with a polishing cloth. But if they are lofty subjects, such as figures of the Christ Child, or large images that are not very well made, in addition to a thick priming, I do not object to the application of glazed flesh tones first in order to prepare the surface better and smoother. I would avoid [the application of glazed flesh tones] as often as possible, for in fact it detracts from the effect of good sculpture. And with wooden objects I would not do it on any account and have never done so, even when great care is taken in the priming and sanding.

Finally, after the faces that have been painted with matte flesh tones are very dry, it is well to varnish the eyes only with a very clear dark varnish, regardless of the material [of the sculpture]. An egg white varnish, applied twice, is very good for this because, as everything else is matte, the faces come alive and the eyes sparkle.

Pacheco's Quarrel with Martínez Montañés

In 1621 two of Seville's most eminent artists interrupted their friendship with an acrimonious argument. The record of this debate between Francisco Pacheco, the painter-theorist, and Juan Martínez Montañés, one of Spain's greatest sculptors, is an important document for understanding the division of labor used in making polychromed wooden statuary.

The dispute resulted from a contract signed by Martínez Montañés on November 6, 1621, to execute the large altarpiece for the Convent of Santa Clara. Martínez Montañés was assigned complete control of sculpture, painting and gilding in contrast to the usual practice of contracting each division with qualified masters. When news of the contract reached the painters, they became outraged at this violation of their essential rights. And of course the fact that Montañés intended to keep three quarters of the 6,000 ducat payment, leaving the rest for the painter, fueled the fires of discord. Apparently a lawsuit was threatened, but whether the quarrel ever reached the courts is unknown, for all but one of the documents that explain the situation have been lost. But this remnant affords a clear idea of what occurred.

The document is a short tract by Pacheco, signed and dated July 16, 1622, which explains in detail the position of the painters, whom Pacheco was representing. The subtitle, A Reply to Montañés, *establishes the fact that the sculptor had spoken first, and some of what he*

said can be inferred from Pacheco's brief. His reply is divided into two parts: in the first he recites the routine arguments that establish the antiquity and nobility of painting. But in the second, he becomes very specific and defines the rights and limits of each branch of polychrome statuary. The tone is surprisingly acerbic and proves the importance attached to the practices sanctioned by usage and confirmed by law.[1]

From Pacheco, *A los profesores del arte de la pintura*

To the Practitioners of the Art of Painting
(A Reply to Montañés)

I find myself obliged, because of what I owe to this noble faculty (although the least of its sons), to cast some light on the differences between it and sculpture. This would not be necessary if my book were published.[2] But it is with the greatest modesty possible that I shall speak in this paper, heeding the present circumstances so that part of it may serve as a memorandum to the judges should they deign to do the honor of glancing at it. . . .

[Sections on Antiquity and Nobility of Painting omitted]

The Difference Between Painting and Sculpture

But let us come to the difference between these two arts, which is the principal aim. Some have wished to consider them as a single art, since their sole aim is to imitate things, be they artificial, natural or imagined. But the fact is, they have different definitions, and that of painting, which I am obliged to know, can be put this way: Painting is the art that teaches how to imitate with lines and colors, as I explain at great length in the first chapter of my book.

How much more vividly painting imitates, without being dependent on any other art, can be seen in an example. The portrait of the Emperor Charles V will be more easily recognized by all when it is strikingly painted with the colors of a Titian than when made of wood or marble by any sculptor of equal caliber. And so it is with any other image you can name. This is because color reveals the passions and concerns of the soul with greater vividness. The figure of marble and wood requires the painter's hand to come to life. But painting needs no one's help to do this. Pliny writes of notable examples of the deceptions wrought in antiquity by famous men of this art. And so that you can see how venerable

[1] Francisco Pacheco, *A los profesores del arte de la pintura* (Seville, 1622). Translated from edition of F. J. Sánchez Cantón, *Fuentes literarias para la historia del arte español,* V (Madrid, 1941), 267-74.

[2] He is referring to *El arte de la pintura.*

is the practice of great sculptors employing great painters to give their works life, Pliny gives this example. When Praxiteles was asked which of his marbles he liked most, he answered, those on which Nikias has set his hand: hence Nikias painted the sculpture of Praxiteles. The painter works by adding, the sculptor by taking away.[3] The obligations of a painter are much greater, because he imitates all of God's creations—the sky, water, trees, the animals and fish, storms, fires, and so on, with all their different colors. But what the sculptor imitates is limited. Painting is the most universal, most delightful, most spiritual, most useful of all the arts, because almost all the other arts make use of her; and her practitioners have been more notably honored than those of any art, as can be seen in every age by the favors and praises bestowed upon them. And although this has also happened to sculptors, the ratio is one to a hundred.

LAWS GOVERNING THE PAINTING OF STATUARY

It remains to get to our principal point and to finish this discourse by saying something about the Ordinances of Painters drawn up in the times of the Catholic Kings Don Ferdinand and Doña Isabel, those just and holy rulers. The First Ordinance divides painting into four parts and functions, and says that he who has been examined in one may use that one and no others.

The Third says that gilders are not permitted to paint the faces of large-scale figures without being examined in that practice. The Eighth says that the artisan who has been examined in one of the four parts cannot make use of another person examined in the same part to do something in one of the other parts, but can only use one who has been examined in that part. In the Sixteenth it says that he who is only a gilder cannot even apply gilding where there is painting or on sculpture in the round.[4] All of this applies to practitioners of the art of painting, and if they are restricted in this manner, so that they cannot use any part except that in which they have been examined, how much more does it apply to sculptors, carvers and carpenters. And so it says in the Eighteenth Ordinance: "Moreover, neither master carver nor carpenter shall be allowed to paint, but only those masters examined in the trade, under pain of punishment," which is 600 *maravedís* for the first offense, 1,200 for the second, and 1,200 *maravedís* and nine days imprisonment for the third. In accordance with these laws, the only way out for Juan Martínez Montañés and the others is to take the examination [for paint-

3 Pacheco's definition is based on the distinction between carving and modeling made by Michelangelo in his letter to Benedetto Varchi, published as part of Varchi's *Due Lezzioni* (Florence, 1549).

4 That is, the gilder may work only on the architectural and decorative parts of an altarpiece, but not on the parts containing figures.

ing], which upon passing it will entitle them to use painting and to accept commissions for it.

REBUTTAL OF MARTÍNEZ MONTAÑÉS

Let us discuss briefly the points he offers in his defense. He says that he hires certified masters for the works and pays them better than do their patrons. Of course if he discovers that the painters he finds do not know how to do the work, then he says that he will teach them. What a lot of nonsense it is for someone who has never learned painting, nor has even studied it, to think that he knows more than those who have spent their whole lives learning the theory and practice of it.

But out of courtesy let us concede that he knows how to teach this skill (which is not so); if the Ordinances, as I have noted, prohibit painters who have not been examined to do this kind of work, why should they permit it to those who have learned another art altogether? And if they fine and punish painters for breaking this law, how much more justified is it to take action against other artists who do not know about painting? [You can just imagine the] righteous indignation with which they [the sculptors] would take action against these same painters if they undertook works of sculpture or carpentry!

But let us suppose . . . that the sculptors were authorized to collaborate with examined painters and to divide the payment so that they could keep whatever they could get for themselves. Would this, by any chance, be legal? Would not this constitute a monopoly of the commissions for the best work around Seville? . . . He [Martínez Montañés] does not understand that it is tyranny to distribute 6,000 ducats for the altarpiece of the convent of Santa Clara in this city so that he takes 4,500 ducats for himself, leaving the rest for the poor painter, who deserves as much as himself, according to traditional practice.[5] He will say that the patrons sought him out, asking and begging him to take charge of the whole work, because they trusted him and did not want to be defrauded by the painters. Only God knows why they think this could happen and whether they were persuaded by him to believe this. But once they put their confidence in him he was obliged to find the best masters and this he did not do. Rather he sought out those who would lower their price to allow him a greater share. All this shows the lack of sincerity in the agreements and contracts made under the guise of mutual convenience, when only his is in question.

And if, as he says, he is so eminent that he can teach an art that he has never learned (nor acquired as a gift of God) and instruct the

[5] The poor painter was one Baltasar Quintero, who actually received 1,550 ducats for his work, according to a document dated August 3, 1623.

painter, I ask, are the other sculptors, carvers and carpenters of Seville also entitled to do this? Or the others that will come afterwards? Is it justice to break the law for his sake? Or that new laws be made against the common good and against such justified and sacred practices? Or that it is useful and profitable for sculptors and carvers to take care of anything but their wood? One thing is certain, that ever since altarpieces have been made for churches, and works of great importance and expense made by order of the priests for their buildings and monasteries, they have contracted for each part separately, agreeing upon each thing with the masters examined in sculpture and painting. Thus if any damage or injury occurs, it is only necessary to call the one who was in charge of the particular part. If this arrangement has been altered upon occasion, and the work commissioned from a single sculptor or painter, it has been only because he was a master examined in both the arts and had given public demonstration of his skill.

And although some mercenary or ignorant painters submit (under pressure) to be instructed by him, they have no reason or justification to call him "master," even though he showed them a thing or two. Because not only can people of good taste instruct mediocre painters, but even humble craftsmen can instruct the greatest artists, as in the case of the shoemaker who enlightened Apelles about the shoes on one of his figures. But he did not become his master on this account. On the contrary, having given stupid advice about correcting other things, he was severely reprimanded by Apelles with the sententious words reported by Pliny in Chapter 10 of the book referred to: *Ne sutor ultra crepidam* (A shoemaker should only judge shoes).

I saw two clever men in my own house point out to a certain sculptor (as highly regarded as Juan Martínez Montañés) a fault that he had made in the tunic of a St. Jerome in Penitence, saying to him that the collar looked like a leather belt and that the buttons were on the wrong side. And in our presence he brought out his tools and took off the buttons and altered the collar because he agreed that the criticisms were just. But, I ask you, is it fair to call my friends masters of equal skill?

To those who say that painting clothing and faces on sculpture is different from the art of painting, I will not respond because I have already said that it is the same and because our Ordinances explicitly say so. And it would be even greater foolishness to give an intelligent answer to his statement that it is something very different [the painting of sculpture], because it is easier than drawing and painting a picture with a story.

Neither will I set about judging the defects in his works, although those who know in Seville find them even in his most careful produc-

tions. Because I am convinced that he is a man like any other and thus it is no wonder that he errs like the rest. For this reason I would counsel my friends to cease praising or damning his works, because he does the former better than anyone while there is no lack of people to do the latter.

And this will suffice to fulfill my obligation to answer the wild imaginings and dreams of Juan Martínez Montañés. On this occasion it has been necessary to expose the truth and to answer for my art, with the guidance of those learned men whose pardon I ask for this extended discussion.

<div align="center">

July 16, 1622 (Signed) Francisco Pacheco

</div>

Index

ITALY

SPAIN

5/24/99 midwest 12.71 ((4.95) 752 32 —